Rita Mielke

THE KITCHEN
HISTORY · CULTURE · DESIGN

Feierabend

CONTENTS

KITCHENS TODAY

Modern Kitchens

Country Kitchens

Designer Kitchens

Foreword

Have you been in your kitchen already today? For a quick coffee? Perhaps breakfast with your sweetheart? A cup of tea with your neighbor? Sitting down to a meal with your children? Then you are in good company, as more and more people are being drawn – ever more often – into the kitchen. After decades of being reduced to banal functionalism, the kitchen is now making a huge comeback as a living space, being rediscovered as a place with tremendous quality of life and again becoming the focus of domestic existence.

This new enthusiasm for the kitchen has many facets. Architects are developing new concepts of big kitchen-living rooms and siting them in a central position in the house or apartment. Designers are devoting their creativity to the furnishing and equipping of the showplace kitchen. Engineers and computer specialists are creating high-tech professional appliances and the futuristic world of domotics – the use of technology for comfort and convenience in the home – that will make it possible to network all the technical appliances and functions in a private household. The selection of kitchen furniture and equipment has never been greater, the range of styles wider, or the technical equipment more professional than is the case today. No wonder the followers of the contemporary cult of the kitchen invest billions every year in the interior of their favorite room.

Even ten years ago, many skeptics might have suspected that these changes were no more than a cover for the renaissance of the "ornate show-kitchen", which was first and foremost a matter of creating an image and showing off. However, the current trend actually proves just the opposite. Along with the rediscovery of the kitchen as a living space

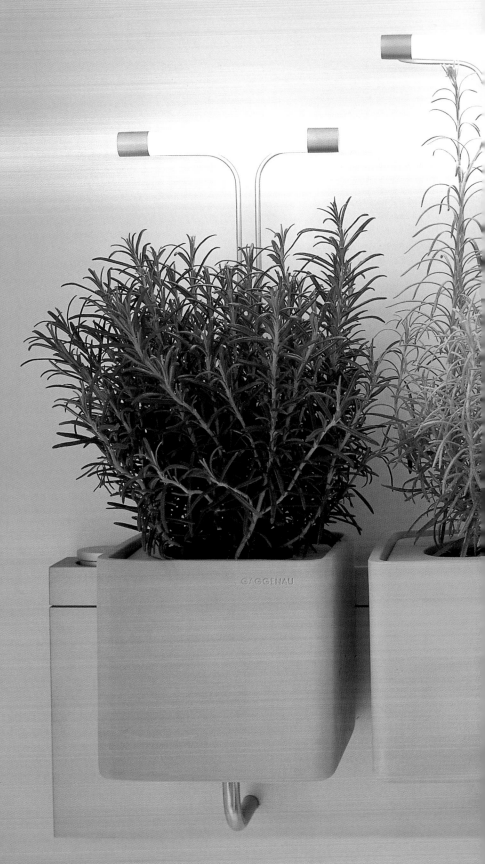

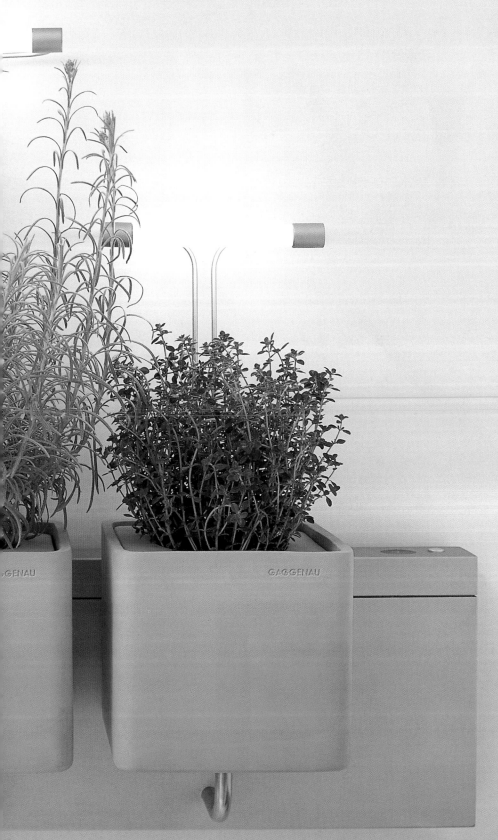

there is a new passion for cooking. Though fast food and ready meals may sometimes be indispensable when people need to eat quickly, whenever they have the free time and the opportunity, they indulge in "proper" cooking, alone, in pairs or in groups. The art of cooking – as a complex sensual experience – is enjoying great popularity, and no longer only among women.

All this has not come about by chance, according to the psychologists. The more globalized the world becomes, with people jetting across it every day, and the more abstract the connections in their lives become, the more they yearn to anchor themselves emotionally, to make certain of their roots. The new, lively kitchen culture – expressing an ancient nostalgic longing for the fire that warms and creates a feeling of community – might provide an explanation for all those parties where the guests prefer to crowd into the kitchen, for the joint banquets where amateur chefs gather round the cooker in their spare time, and not least for the solid family table that is finding its way back into many a kitchen.

A wide arc stretches from the fireplace of our earliest ancestors to the modern living space with its high-tech equipment. Across it run the cords of a multi-layered, highly complex and not always linear history, to which society and commerce, architecture and technology have all contributed. As we follow this history, we can find explanations of how the kitchen came to be what it is – once again – today, the "warm heart" of domestic life, and a center of high-quality social and emotional communication.

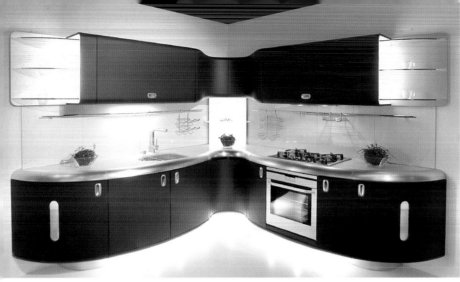
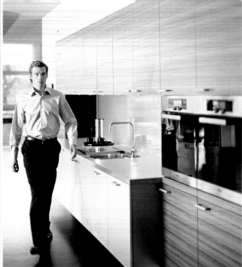

THE NEW ENTHUSIASM FOR THE KITCHEN EVERYDAY DOMESTIC LIFE FROM FAST FOOD TO PROFESSIONAL EQUIPMENT AND FINE COOKING AS A HOBBY

"The basic element of good cooking is memory" (Georges Simenon)

Guido Brunetti, by profession a commissario in the City of Venice Police and the likeable protagonist of a dozen contemporary crime novels from the pen of the American writer Donna Leon, is a typical example. "Cocooning" is the term applied – by those who chart the variations in the spirit of the age – to what keeps the honest criminologist happy in the sometimes oppressive sadness of his daily work, i.e. taking refuge in his apartment, plunging into the emotional security of his family, cutting himself off from the "hostile" world outside. Brunetti's favorite room is the kitchen, the place where – over a leisurely meal, a glass of wine, and long talks with his wife and his two teenage children – he has the most sensuous and intense feelings of living and enjoying life.

The "happy return of common activities around the hearth" (Stilwerk, p. 16), as they are celebrated every day in Guido Brunetti's household, is part of a complex new culture of living, based in equal measure on a refocusing on primitive human needs, and on the achievements of modern design and innovative technology. These apparently paradoxical phenomena have the kitchen as their meeting place, and prove to be surprisingly compatible. For instance, having the most up-to-date technology is a prerequisite for comfort in the kitchen; it simplifies time-consuming work processes, and gets rid of cooking smells and mountains of washing up – equally noiselessly in both cases, thankfully. It is important, in modern kitchen design, that the furniture hides the technology from the eye of the beholder, in order to emphasize the comfort of the room. The less the kitchen looks like a kitchen, the more easily it can appear as an uncluttered living space; the less obviously functional it is, the longer the sense of well-being lasts.

Technology and functionality do not play a subordinate role in the kitchen, even when they are cleverly integrated and hidden. On the contrary, professionalism is trendy. If you want to cook like "the greats" – the chefs of four- and five-star restaurants, and the many famous television cooks – you

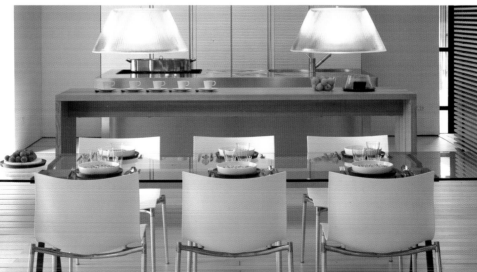

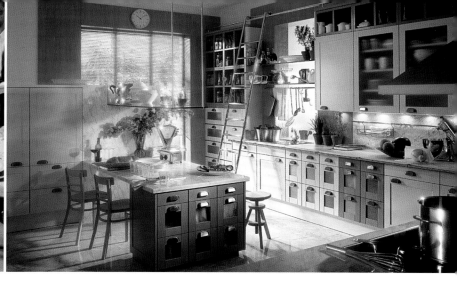

have to have the very best equipment. The goods offered by kitchen equipment suppliers attempting to make the experience and results of home cooking appealing to people cooking in their own kitchens range from the spectacular induction hob to the automatic steamer, and from the intelligent sensor cooker hood to the stainless steel knife block.

Critics of modern kitchen euphoria complain that the increasingly sophisticated equipment on the one hand will lead to a decrease in domestic skills on the other. "The less time the wife has to look after the home, for example because she has a job, and the less culinary expertise she has, the more likely people are to buy a high-tech automated kitchen. ... Maybe they also buy expensive built-in kitchens, because they cherish the hope that technology will make up for their lack of the ability and desire to cook" (Andritzky, *Oikos*, p. 133). The suspicions of the famous systems design researcher Helmut Krauch, formulated at the end of the 1970s when radical emancipatory changes were taking place in society, are out of date today. There is no lack of desire or ability to cook, but the status of the job has changed. What was once a wifely duty is now chiefly considered to be therapeutic, a hobby or leisure activity that men are also adopting with increasing enthusiasm.

Convenience and fast food products do not conflict with this development, but rather complement and support it. As a result of the changes in social and family relationships, there is little time for preparing meals and sitting down to eat together, so sandwiches and hamburgers or packet soups, canned goulash and frozen fried rice provide unpretentious basic catering and lots of little snacks between meals during the busy working day. On the other hand, people will gladly put more effort into a proper meal – take more time over choosing the dishes and collecting the ingredients, and much more trouble over the preparation – in the hope of getting greater enjoyment and pleasure from eating it. It is no longer a question of either/or with fast food and fresh cooking, it is a decision as to whether to have both, depending on the situation.

Slowfood, a movement that campaigns for such things as a renewed appreciation of fresh natural products and unadulterated foodstuffs, is gaining in popularity. Consumers have long known the value of buying fruit and

(*Above, left to right*): *Sistema Americana*, Giemmegi; + *INTEGRATION*, Poggenpohl; *EFC*, Boffi; *system 20*, bulthaup; *SE 7007 MR*, SieMatic.
(*Below, left to right*): WMF; *Kuoco*, Driade; Alno; *system 25,* bulthaup; *Achillea*, Driade.

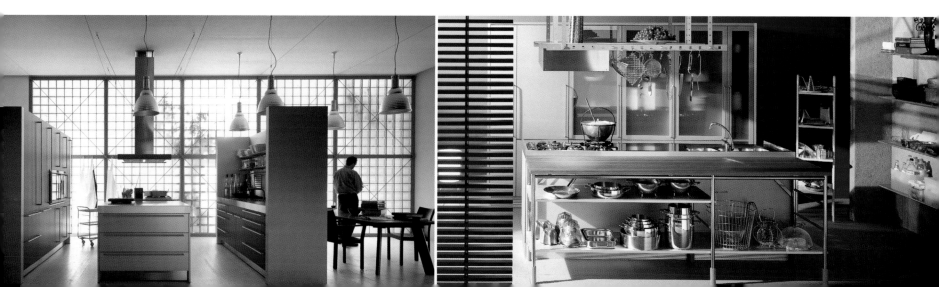

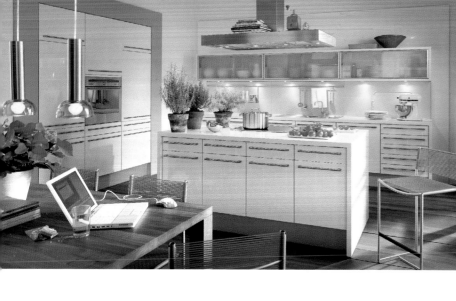

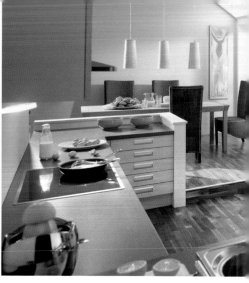

vegetables, eggs, potatoes, and cheese direct from the producer or at the market. They are very keen to use these goods in the kitchen, and if they lack the basic knowledge or want to practice advanced cookery skills, there are cookbooks, cookery courses, and television programs – and often friends or members of the family who are talented cooks – ready and willing to offer help.

One of the most startling developments is the way husbands have discovered the kitchen and cooking. By husbands we do not mean house-husbands who have exchanged roles with their wives or partners, voluntarily or involuntarily taken over running the house and bringing up the children, steadfastly enduring their fate – including the cooking – but rarely overjoyed by it. Things are quite different with those who call themselves amateur chefs and describe their pottering about in the kitchen as a leisure activity. They are a completely new social phenomenon – if you ignore exceptions like the famous cookery expert and secret agent Thomas Lieven in Johannes Mario Simmel's novel *Es muß nicht immer Kaviar sein* (It can't always be caviar). The reason for men's striking change of heart after centuries of stubborn refusal to enter the kitchen (by which we mean the private, not the professional kitchen, as over the years it has interestingly been almost exclusively men who have made a

career for themselves as chefs), remains a matter of conjecture. Perhaps it is the fascination of modern kitchen technology, and the fact that it makes the work so incredibly easy. Or maybe it is the many prominent media personalities who confess to a passion for cooking, or the fact that working women have been forced to retreat from the domestic bastion of the kitchen. The main reason is probably the "guaranteed bonus of appreciation" (Andritzky, *Oikos*, p. 14) that comes from cooking for friends and guests.

In trend researcher's terminology, "sociotainment" (Stilwerk, p. 15) is the name for the growing desire of many of our contemporaries for something more than "cocooning" and "homing." In the face of progressive individualization – and isolation – at work and at home, they need to find an entertaining and easy-going way of creating social intimacy. Cooking for yourself and eating alone satisfies the empty stomach, but not the hunger for appreciation and emotional feedback. A common love of cooking brings together single people, groups of men, or pairs of friends. It gives groups of people with a common interest a reason to get together for a time, while remaining uncommitted, and it also offers them an emotional haven – if we cannot live together, at least we can cook for one another. The old saying that the way to a man's heart is through his stomach is

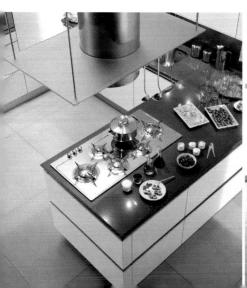
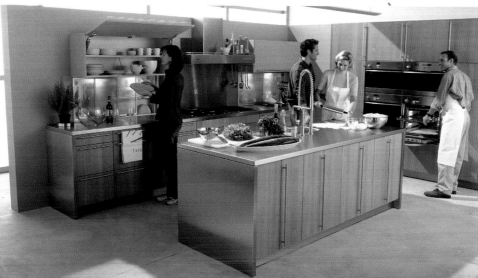

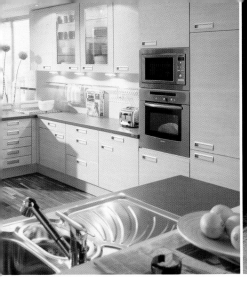 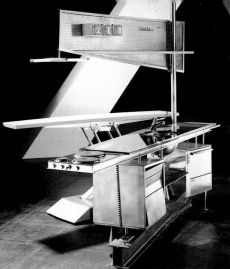

thus given a new interpretation, modified to suit the times. Of course, the number of single person households is rapidly increasing everywhere but, in comparison, the number of meals eaten in company is remarkably high. In a representative Emnid survey in Germany in 2004, at least half of those questioned indicated that they ate at least once a day with friends or members of the family.

The icons of the new kitchen culture are free-standing islands containing worktops or cookers, and the dining table. While cooker islands literally bring the preparation of a meal into the center of social activity, the dining table is the symbol of the kitchen as a multi-functional living space. This is the place for eating and drinking, talking and laughing, and all other forms of social interplay and togetherness.

The spiritual father of the kitchen island and the new communicative kitchen culture is the designer Otl Aicher. During the 1980s, he was commissioned by the kitchen manufacturer, bulthaup, to work out a philosophy of the kitchen – *Die Küche zum Kochen. Das Ende einer Architekturdoktrin* (A kitchen for cooking. The end of an architectural doctrine) – which was much appreciated by passionate amateur cooks and gourmets alike. Other designers, such as Hasso Gehrmann, Luigi Colani, Stefan Wewerka, or the artist-architect

Coop Himmelb(l)au, also took up the theme, producing kitchen designs, furniture, and appliances. In practice, not all their ideas proved to be suitable for everyday use. Many a vision is overtaken by reality – like the sci-fi kitchen dreamed up by the Italian Futurist Filippo Tommaso Marinetti. "The wonder ... lies in the possibility of transmitting foodwaves by radio," he wrote in 1932. "What is more, the idea is not so unusual. If the radio can broadcast suffocating and soporific programs, it will also be able to transmit an extract of the best dinners and breakfasts. What a land of milk and honey!". Abstract Utopias are not setting the standards as much as concrete emotions, needs, and requirements. "In the kitchen, man is a social being. The kitchen is a function of man's social nature. Cooking is only a pleasure when others join in eating. And cooking is even more of a pleasure, if others join in the cooking" (Aicher, *Die Küche zum Kochen* [A kitchen for cooking], p. 39).

(*Above, left to right*): *Avance FG*, Leicht; Alno; *Alnostyle*, Alno; Kitchen art object *Mal-Zeit* by Coop Himmelb(l)au (1989), ewe; Alno.
(*Below, left to right*): *Idea*, Snaidero; Miele; *Küchenbaum* (Kitchen Tree) by Stefan Wewerka (1984), Tecta; *system b* (1982), bulthaup; Kitchen Study by Reiner Moll Design.

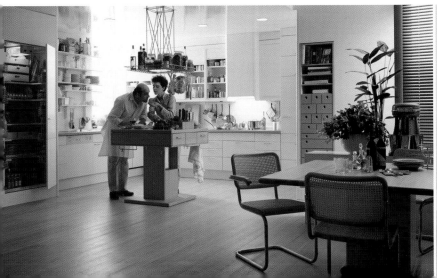 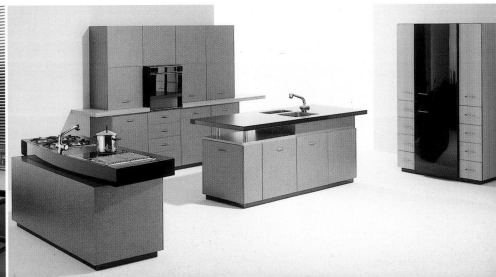

FROM THE "ONE-ROOM" KITCHEN TO THE FITTED KITCHEN
KITCHEN HISTORY

In the beginning there was fire. The story of *Homo sapiens* began several hundred thousand years ago with the discovery of its power to provide warmth and light. A few more millennia passed before man understood the connection between fire and warmth and the preparation of food. In the meantime – somewhere around 80,000 years ago – Neanderthal Man mastered the arts of making fire and cooking. Perhaps it was the chance event of a piece of mammoth flesh emerging crisp, tender and aromatic from its baptism of fire after being unintentionally dropped into the flames that first gave them the taste for barbecued meat and spit-roasted joints.

From these first open fireplaces to the *oikos* of ancient Greece, and from there to the modern fitted kitchen of the 20th century, the development of the kitchen has been both complex and complicated. The ability to handle domesticated fire was not the only contributory element. The kitchen as a room, its size and shape, its situation in the house or apartment, and its functions changed many times under the influence of social and architectural conditions. Not until relatively late, in Renaissance times, did people start thinking about the kitchen as a place for preparing meals and how those meals

related to the rest of the living area. Since then, all the theories about kitchens and their practical implementation have swung backwards and forwards between two contradictory ideas – a concept of integration that defined the kitchen as a space for living, and a concept of separation that attempted as far as possible to cut off the practical, functional cooking and working area from the rest of the house. Who preferred which concept at any particular time was a question of ideology and the spirit of the age, of theoretical (architectural) visions and practical (house-building) conditions – and it has always been something of a matter of taste.

OIKOS, STEW, KITCHENS IN THE CELLAR
EARLY KITCHEN HISTORY

The history of the kitchen area begins with an integrated "primeval state," as for many centuries the kitchen was the only room, or at least the main room in societies that were structured mainly around agriculture. They lived and worked, ate and slept in the narrow area around the fireplace. People and animals lived under one roof. All the members of a common household were involved in the domestic work, which also included all kinds of ancillary kitchen activities – from butchering to the preserving of food. It was not by chance that

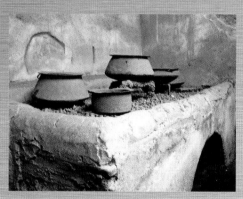

High Roman standard kitchen: raised hearth with cooking utensils from the Villa Vettii in Pompeii, 1st century A.D.

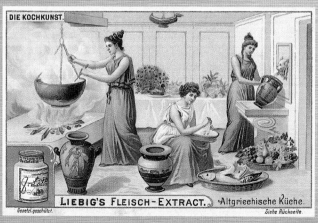

Cauldron over an open fire in an ancient Greek kitchen. Collectible card for the Liebig company's Meat Extract, c. 1900.

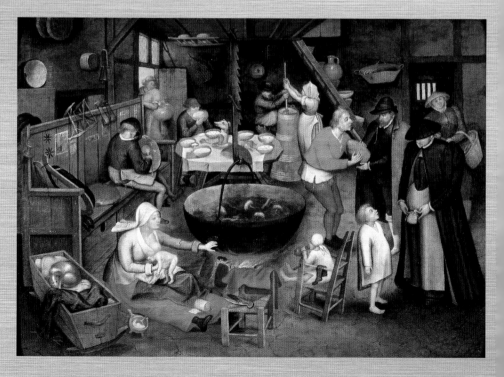

Cooking, eating and living in one room: Pieter Brueghel the Younger (1564–1638) *Visiting the Farm*, oil on canvas, 16 × 22 ins/41 × 57 cm, Johnny van Haeften Gallery, London.

the Greek concept of *oikos* included "both the house itself as an architectural entity ... and also the running of a house, i.e. the household, and finally the social organization living within the house, i.e. the family" (*Geschichte des Wohnens* [History of living], p. 545).

The Greeks cooked over an open fire. Pans and broilers, cooking pots on stands that made it possible to vary the distance from the heat, and even double boilers, where the pot containing the food was placed in a second pot filled with water, provided a significant cuisine and variety of foods.

The ancient Romans also liked to eat well. The Epicurean enjoyment of the pleasures of life was expressed in the form of sumptuous orgiastic banquets, prepared by a team of professional cooks and staged as a culinary spectacle in the manner of "Trimalchio's feast," as in the impressive description given by the satirist Petronius. Tall brick ovens with several fireplaces, often built at a sufficient distance from the dining room to keep away the smells and smoke, formed the workplace of the kitchen staff. However, this kind of separation of the kitchen was the exception and was confined to the privileged strata of society until well into the 15th century. The mass of the rural population in ancient Rome could only dream of that kind of luxury in connection with cooking and the kitchen. They had to make do with a primitive hearth, if they had any fireplace at all, or get their *puls* – a simple porridge – and their bread from one of the many local cookshops. But at least they had a legal right to "bread and circuses" paid for by the state. For a long time porridge and stew were the only basic foods that, for all those people whose hearths were only big enough to take a single pot, it was technically practicable to cook.

The Renaissance brought changes not only in society, but also on the kitchen scene. The social spectrum was broadened by the growing groups of privileged city-dwellers, families of craftsmen, merchants and traders, which led to new structures in the household. The ideas of the famous Italian architect Andrea Palladio (1508–1580) on the ideal layout for a bourgeois manor house were widely circulated, but the kitchen did not come out of it too well. Because of the heat of the fire, the smoke and soot, the strong smells, and loud noises, Palladio considered the kitchen area as one of the inferior, unpleasant parts of a house and recommended that it should be sited in a remote spot, if possible even in the cellar. At the same time the kitchen area became a factor of social distinction in two respects. First, it separated the peasants' and later the workers' kitchens, which remained more or less attached to the "one-room" concept until the 20th century, from the decentralized kitchens of the middle and upper classes. Second, it led to a distinction in the internal domestic area between the master of the house and his family, who usually gave the whole kitchen wing a wide berth, and the kitchen staff, who were permitted to enter their master's rooms only in order to serve the meals.

13

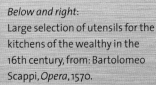

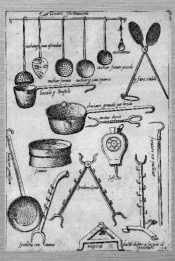

Below and right:
Large selection of utensils for the kitchens of the wealthy in the 16th century, from: Bartolomeo Scappi, *Opera*, 1570.

The fire walled in and at table height:
The Ideal Kitchen, engraving from
Florinus' *The Wise and Righteous*
Father of the House, Nuremberg 1750.

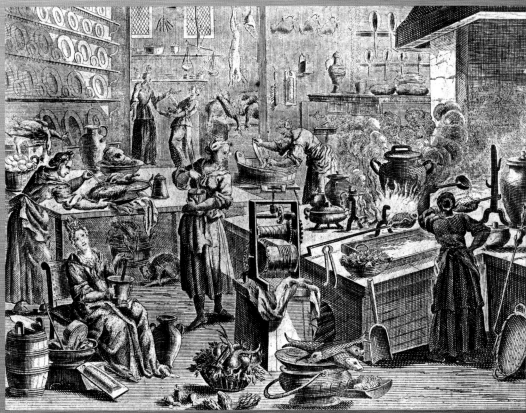

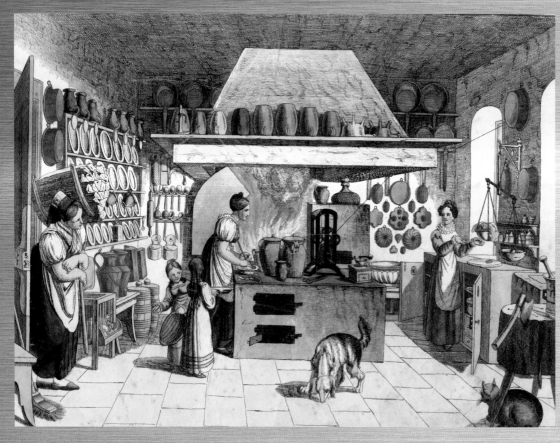

The fire walled in and a chimney to take away the smoke – kitchen luxury in the early 19th century: *The Kitchen*, contemporary colored engraving, ascribed to Johann Michael Voltz (1784–1858), 7.5 × 10 ins/19.5 × 26 cm, c. 1830. Collection Archiv für Kunst & Geschichte, Berlin.

The kitchen – right at the bottom of the hierarchy of rooms in the 19th century. *Upstairs and Downstairs*, title page of *Practical Cookbook* by August Weiss and Ernst Marticke, 1875.

There was no shortage of utensils in the kitchen itself. As many as 80 objects – from dough trough to bread bin, and from pewter jug to iron pan – are to be found listed in historical kitchen inventories of that time. A comprehensive insight into the high Renaissance kitchen is given in the book written by the Pope's personal cook Bartolomeo Scappi, who was often called the "Michelangelo of the Kitchen" on account of the elaborate banquets he arranged. In 1570, he published his *Opera*, a book in which he presented the various areas of the kitchen and the individual activities that took place in them, showing with the help of numerous illustrations how the spit, waffle iron, bellows, and the many different tools were used at the time – and probably for a long time afterwards.

By contrast, the process of separation within the house turned out to be fatally damaging for the kitchen area itself. The decoration and equipment were determined by purely functional and utilitarian considerations until well into the 19th century. While architects, furniture and fabric manufacturers, artists and craftsmen were continually refining the requirements of prestigious living, the kitchen remained unembellished, a room without any such aesthetic pretensions, with plain furniture and simple equipment. Even when tall apartment buildings began to appear in large numbers in the cities, and all the rooms had to be accommodated on a single floor, the kitchen continued to be conspicuously undervalued as a matter of architectural and social principle. The prestigious, generously proportioned living rooms mostly overlooked the street, whereas the kitchen was confined to the smallest possible floor space and situated on the dark, courtyard side, where no visitors could reach it. This was the province of the servants and kitchen maids.

Progress in the kitchen was a long time coming. Even such an innovative discovery as the pressure cooker, first demonstrated to the members of the Royal Society in London by the Frenchman Denis Papin in 1682, foundered initially on the rock of the unpredictability of open fires, which caused so many pots to explode and so much food to end up on the kitchen walls. And the earliest cast iron pots coated with heat resistant white enamel, first produced in Germany in 1788 and heralding a new era in kitchen utensils, were in the beginning more often used to decorate the kitchen than for cooking.

Irrespective of all the other political upheavals in European society, the actual kitchen revolution did not begin until the second half of the 19th century, when all the social and technical innovations of industrialization encroached on the kitchen area as well. For the first time, engineers, architects and furniture manufacturers, not to mention doctors and sociologists, focused not on what was to be cooked, but on how and where it was to be cooked and what it was to be cooked with. The kitchen itself became a sensational subject, arousing controversy and starting an endless – as yet unbroken – chain of innovations both great and small that, within a few decades, radically changed what had previously remained almost unchanged for centuries.

Pots, pans, and plates neatly arranged on shelves: typical, turn of the century, middle-class kitchen, 1898.

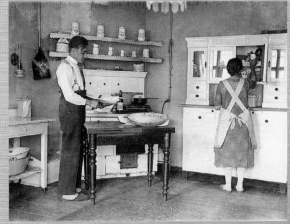

White is hygienic: Berlin kitchen, 1929.

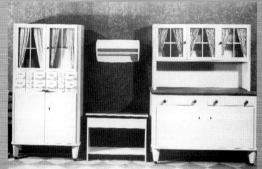

Individual co-ordinating units: in 1923, Poggenpohl introduced their "Ideal" kitchen, with a central cabinet with glazed upper section and two extension units.

CLEAN AND WHITE
HYGIENE IN THE KITCHEN

As recently as the beginning of the 19th century, hygiene conditions in Europe and America were appalling. Human and animal waste was left lying in the streets and courtyards, open sewers ran through the middle of towns, and polluted water was used for drinking and cooking. Every year infections and epidemics were responsible for a huge death toll. People knew little about hygiene, and did not appreciate the significance of the connection between cleanliness and health.

At the end of the century, the situation changed under the influence of important scientists like Ignaz Semmelweis, Joseph Lister, Louis Pasteur, and Robert Koch. The most significant discoveries affecting people's everyday living conditions were made by Doctor Max von Pettenkofer, who is considered to be the founder of hygiene research. The complete renovation of the plumbing and sewage systems in many European cities was the result of his experimental investigation of diseases such as cholera.

It was a long time before the idea that hygiene was also a matter for private households, and that the kitchen in particular was an obvious breeding ground for all kinds of pathogens, was accepted by large sections of the population. In many cases it was left to the doctors to introduce their patients to cleanliness in the home and kitchen, and to food hygiene. In France, special hygiene assistants were trained, and employed mainly in working class districts. In Germany, the industrialist Karl August Lingner organized the first International Hygiene Exhibition in 1911, which attracted more than 5 million visitors. Prior to the outbreak of World War Two, the Hygiene-Museum, opened in Dresden in 1927, organized more than 1,200 exhibitions all over Europe, with over 30 million visitors. The warnings given by the hygiene experts had two consequences for the kitchen area. The first was the discovery of the color white, and the second was the rise of the kitchen cabinet.

At the turn of the 19th and 20th centuries, white painted kitchen furniture and whitewashed or white tiled walls came to be considered the epitome of cleanliness, particularly in middle-class households. Any dirt was easily visible against a white background and smooth white surfaces were also easy to clean. At the critical moment, bright kitchens with as much light and fresh air as possible were obvious signs of progress in the kitchen, even if many housewives initially found it difficult to acquire a taste for the almost clinical sterility and coldness of the room.

Another child of the new hygiene-consciousness was the kitchen cabinet. For a long time, most kitchen equipment had been proudly and decoratively displayed on shelves along the kitchen walls; now it was a matter of protecting as many utensils as possible from dust, damp and flies, and all the associated

risks of disease. Most of these cabinets were in two sections, with a deep bottom section and an upper section with glass doors providing storage space for pots, kettles and pans, as well as crockery and small kitchen gadgets. A flexible alternative to the later kitchen units, kitchen cabinets – which could be plain or richly decorated according to the manufacturers' taste, and were supplied in many different materials and sizes – enjoyed great popularity until well after the war. For instance, in the years before 1960, more kitchen cabinets than built-in kitchen units were produced and sold in Germany. And many of these treasured old friends, evoking such fond memories, have ended up at antique dealers, where they still have their admirers – or even attract new ones.

As well as these fundamental matters of hygiene, technological progress in the kitchen – running water, gas, and electric ovens, and improved ways of keeping food – has ensured a rapid reduction in the health risks that were around in the kitchen in the first few decades of the 20th century.

HAPPINESS LATE IN LIFE
TECHNOLOGY MOVES INTO THE KITCHEN

The home and kitchen remained largely unaffected by the rapid technological progress of the 19th century. Long after the first railways had begun to run,

the first steam-powered machinery in the textile industry had been set in motion, and telegraphy had revolutionized communication across land and sea, conditions scarcely different from those of the Middle Ages still prevailed in the kitchen, with candlelight and open fires. And when the first electric stove and a fully electric kitchen with oven, grill, immersion heater, and electric samovar were shown at the Chicago World's Fair in 1893, it must have appeared to the vast majority of housewives as pure science fiction, bearing no relation to reality.

However, the Austrian industrialist Friedrich Wilhelm Schindler, who showed the all-electric kitchen in America, was anything but an unworldly idealist. In his own house, which was finished around 1888, electricity was already being used for cooking, ironing and vacuuming, years before the Chicago exhibition. On the other hand, Schindler had made sure of having sufficient cheap electricity available by having his own hydroelectric power plant on site. He had probably underestimated what a long and arduous process it would be to provide blanket coverage of town and country households with the necessary prerequisites for full electrification.

The same thing had happened with gas. As early as 1809, the first European cities had been supplied with gas, which was used mainly for street lighting. In the 1830s, the first cast iron gas stoves came onto the market in England – but for decades the demand was so small that an exhibition

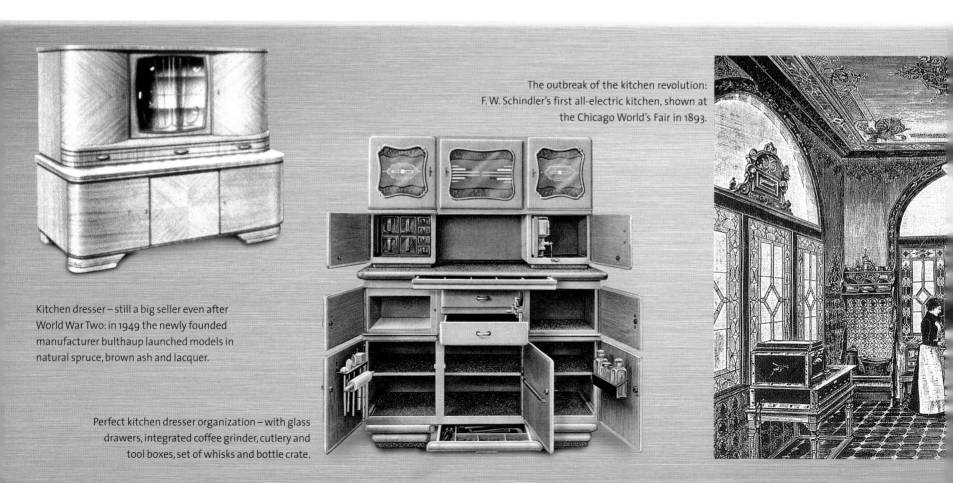

Kitchen dresser – still a big seller even after World War Two: in 1949 the newly founded manufacturer bulthaup launched models in natural spruce, brown ash and lacquer.

Perfect kitchen dresser organization – with glass drawers, integrated coffee grinder, cutlery and tool boxes, set of whisks and bottle crate.

The outbreak of the kitchen revolution: F. W. Schindler's first all-electric kitchen, shown at the Chicago World's Fair in 1893.

was arranged in 1879, to instruct potential customers in the (safe) operation of gas appliances, and the many possibilities for their use. However, the manufacturers of gas stoves and other gas-powered kitchen appliances were not really able to "step on the gas" until after the turn of the century, when gas as a source of power also reached private households on a large scale. The development of an electricity supply to private houses was equally slow – and also had the disadvantage of being extremely cost-intensive. For instance, thirty years after the Chicago World's Fair, no more than a quarter of households in Berlin had electricity, and there were only 5,000 households with an electric stove in the whole of Germany. And even a good ten years later, when electricity was readily available in the kitchen, chaos reigned because of the many individual appliances, each of which had to be individually plugged into the socket.

Faced with such imperfect solutions – and countless technical hitches – it is not surprising that housewives everywhere in Europe and America did not exactly react with euphoria to the innovations in their kitchens. Imagine what a bizarre adjustment it must have been for them to change from a coal-fired cast iron stove to the first gas cooker, and from that to an electric stove. If, in addition, the food was burnt or only half cooked, because of the housewife's lack of experience in using the new forms of energy, she could thank her lucky stars if the kitchen range was still in place. At least you could rely on them.

No wonder that many households held on to them as an alternative and complement to the gas or electric stove until well after the war.

In the decades before and after World War Two, the committed manufacturers of household appliances took it upon themselves to keep on improving their products both technically and visually, and smooth their path into the kitchen – and into housewives' hearts – by working hard at persuading people. AEG, for instance, worked for many years with the designer and graphic artist Peter Behrens, who left his mark on both the image of AEG appliances and the associated advertising. In 1925, Siemens launched the *Volksherd* onto the market. The "people's stove" was something even the less well off could afford, and its electricity consumption was moderate. Starting in the 1930s, Bauknecht developed smaller motors for household appliances, making it possible for the first time to talk of small appliances.

The war years meant that housewives had other things to occupy them than reorganizing their kitchens with the help of the new technology. So the triumphal march of broadly based modern kitchen technology became a part of post-war reconstruction that took place after 1950.

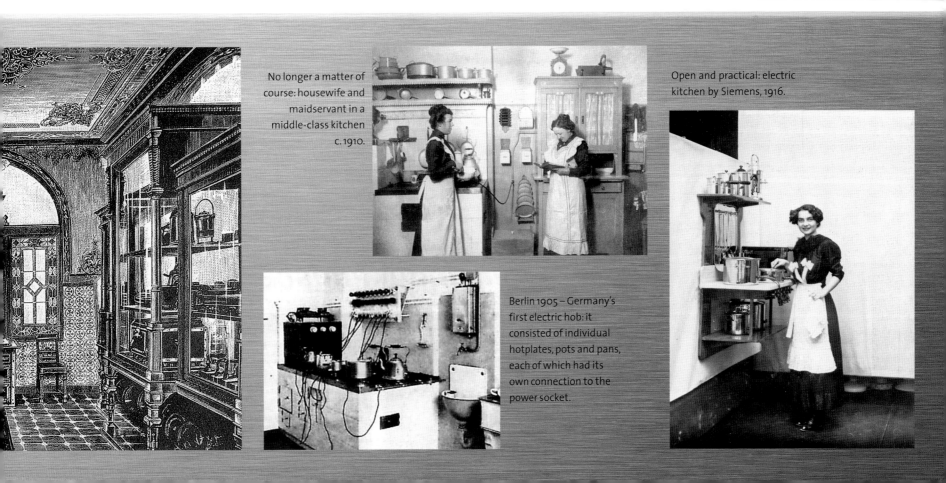

No longer a matter of course: housewife and maidservant in a middle-class kitchen c. 1910.

Open and practical: electric kitchen by Siemens, 1916.

Berlin 1905 – Germany's first electric hob: it consisted of individual hotplates, pots and pans, each of which had its own connection to the power socket.

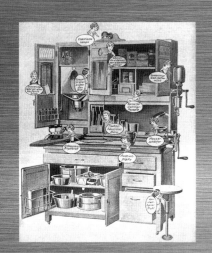

American-style rationality in the kitchen cabinet: magazine advertisement c. 1915.

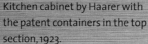

Kitchen cabinet by Haarer with the patent containers in the top section, 1923.

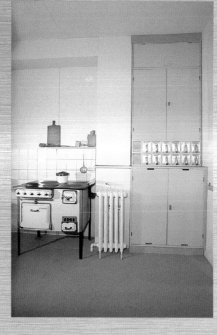

Interior of the Frankfurt Kitchen by Margarete Schütte-Lihotzky, Römerstadt type D, 1927.

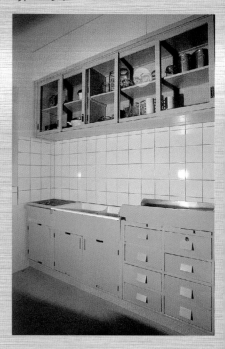

Interior of the Frankfurt Kitchen by Margarete Schütte-Lihotzky, Römerstadt type D, 1927.

"FORM FOLLOWS FUNCTION"
NEW RATIONALITY IN THE KITCHEN

In matters of cookery, European and especially French supremacy was unchallenged during the 19th century, though the Americans were just beginning to play a leading part in discussions about the kitchen. And it was three women – Catherine Beecher and her sister Harriet Beecher-Stowe, the author of *Uncle Tom's Cabin*, and the "household engineer" Christine Frederick – who caused a real stir in the second half of the century. Their publications were not about the kind of kitchens full of servants that were so highly valued in middle-class Europe. They were much more interested in housewives who had to manage their homes single-handed, as well as being a mother and possibly having a job outside the home as well. American women were convinced that, in order to be able to do justice to all these tasks, efficiency and labor-saving were the top priorities in the kitchen. Short cuts, technological aids, and the optimum use of space were important components of the "ideal" kitchen.

Their ideas received scientific backing from the concept of rationalization developed by Frederick Winslow Taylor (1856–1915), whose time and motion studies optimized workflow in industry and laid down the time needed for each individual stage in the process. There was no reason why elements that appeared to be right for the factory of the future could not also be sensible for the functionalizing of the kitchen?

When, after some delay, Taylorism and the new American ideas on rationalizing the kitchen reached Europe, they found a society in upheaval. Industrialization and its social consequences, followed by World War One and the general economic depression, brought about radical changes in the private living conditions of people in general – and women in particular. The days of willing hands in home and kitchen were coming to an end. In the organization of its everyday life, the family had to rely on itself and above all on the skill of the housewife. Easing her load, simplifying the activities to be carried out and structuring the household as rationally as possible became a socio-political challenge that summoned not only the representatives of the early women's movement into the arena, but also forward-looking architects committed to the principle of functionality known as "form follows function." The kitchen, which had been shamefully neglected for centuries, unexpectedly progressed to become the subject of showpieces of avant-garde European architecture. Almost all the great architects of the 1920s contributed their ideas to the building of social housing and kitchen design.

The high point of this development was the Frankfurt Kitchen designed by the Austrian architect Margarete Schütte-Lihotzky. She arrived in Frankfurt in the mid-1920s and, in collaboration with the city architect Ernst May, who

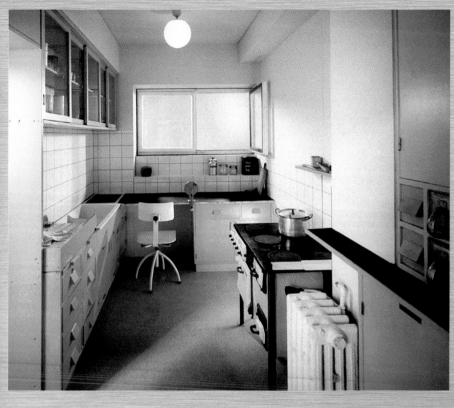

Frankfurt Kitchen by Margarete Schütte-Lihotzky, Römerstadt type D, 1927.

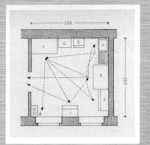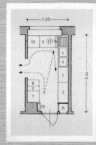

Ground plans of a typical 1926 kitchen (left) and the Frankfurt Kitchen (right). The broken line indicates the distance that must be covered to carry out the various tasks. In the old kitchen you have to walk 19 m, compared with only 8 m in the Frankfurt Kitchen.

Jacobus Johannes Pieter Oud, kitchen from the Deutscher Werkbund exhibition *Die Wohnung* (the apartment), Stuttgart, 1927.

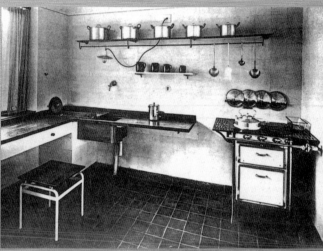

was engaged on the planning of an ambitious housing program called *Das Neue Frankfurt* (The New Frankfurt), she put into practice her ideas of the kitchen as a purpose-built work laboratory, with fittings and fixtures planned in detail and positioned at the optimum working distance from one another. Her designs were modeled on the kitchens of the Mitropa railroad dining cars, which allowed highly efficient performances to be achieved within an extremely narrow space. Margarete Schütte-Lihotzky believed they could be adapted for the private home, so her ideal kitchen was based on a design in which all the carefully selected elements were built in and precisely positioned. For instance, in order to provide optimum lighting, there was a sliding lamp, which was attached to a track on the ceiling, and could easily be pushed back and forth by means of a handle. A draining rack was provided for the washed dishes, which made drying dishes largely unnecessary. Flour was kept in a special oak drawer, because the tannic acid contained in the wood prevented weevils from getting into the flour. For storing all other foodstuffs, most of which still had to be kept loose in those days, Margarete Schütte-Lihotzky used a system invented by the engineer Otto Haarer.

In 1923, shortly before the completion of the Frankfurt Kitchen, Otto Haarer had exhibited a kitchen cabinet at various trade fairs, which had an upper part composed entirely of aluminum containers. These patented containers, which combined the properties of a drawer with those of a jug,

were light, practical, and hygienic. Margarete Schütte-Lihotzky adopted this construction and integrated it into her Frankfurt Kitchen. The fact that her kitchens occupied no more than 70 square feet (6.5 square meters) in total, fitted very well with the requirements of the new social housing, which was geared to small housing units at reasonable rents.

Of course, this meant that the kitchen had lost all its charm as the "warm heart of the house." But at the same time it had been liberated from long years of scorn and neglect, and moved into the center of creative activity. What is more, the kitchen became the point of departure for planning by architects who developed a kind of interior environmental planning, in which they started with this "function center" and built the housing around it, working outwards *vom Kochtopf zur Fassade* (from the saucepan to the façade). More than 10,000 apartments with Margarete Schütte-Lihotzky-style kitchens were built in Frankfurt, and the design also met with international acclaim. Among others, Louis Loucheur, the French Minister of Labor at the time, had plans drawn up for 260,000 municipal apartments with Frankfurt Kitchens. The German model also had a lasting influence on kitchen planning in Sweden, where it was developed into the Sweden Kitchen. After World War Two, the fitted kitchen made its way back from Sweden to Germany.

The "new kitchen" was also taken up elsewhere. For example, in the *Weissenhof Siedlung*, an architectural exhibition set up in Stuttgart in 1927, the Dutch architect Jacobus Johannes Pieter Oud showed a kitchen that was linked to the other rooms in the apartment by a sliding glazed window. This functioned as both a means of visual communication and a serving hatch, so that the kitchen was no longer merely an isolated working area. The list of furnishings to be included in both this kitchen and what became known as the Munich Kitchen came from the German household reformer Erna Meyer. She had started by thinking about the traditional kitchen-living room, which she developed for the Munich Project into something more like a living room with a kitchenette and variable furnishings. She criticized the Frankfurt Kitchen for being cramped, having furnishings and equipment that could not be varied to suit the individual, and for its purely functional nature. At first Erna Meyer's designs were also influenced by ergonomic questions, such as what activities could also sensibly be carried out sitting down and what height a work surface should be so that a housewife could work at it without stooping.

In Berlin, Bruno Taut was moving towards a model in which the kitchen was the "factory of the house," organized on labor-saving principles of limited space and high efficiency. The kitchens of the housing estate called "Uncle Tom's Cabin," which was built in woodland on the edge of Berlin in 1927, were influenced by his ideas. They were distinguished by having all the elements built in, including, among other things, a spacious refrigerator, roomy kitchen cabinets, a space-saving foldaway work-table that could be pulled down from the wall by a handle, and chairs that could also be folded away.

In the USA, Frank Lloyd Wright advocated the model of the integrated kitchen. For him, the kitchen, cooking, and eating were the center of family life – and therefore of all architectural concepts as well. The open plan concept is a feature of his "organic architecture," with flowing transitions of space and materials between the kitchen and dining or living areas. With ideas like these, which he put into practice in a number of private houses, Wright remained a lone voice crying in the wilderness of contemporary kitchen design, despite the fact that he came so much closer to the feelings and the practical requirements of many housewives than most other kitchen architects.

At first these sober, rational kitchens aroused little affection in the hearts of housewives. The step forward from the old-style kitchens they were used to, and which were associated with fond memories to these new functional workspaces, which were devoid of any coziness, was too great. So it took a few decades and the dawning of a new social era after World War Two before the space-saving kitchen finally triumphed on a grand scale.

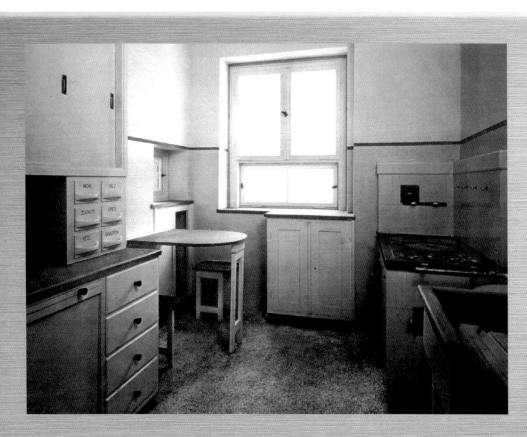

Bruno Taut, Reform Kitchen from the "Uncle Tom's Cabin" estate, Berlin 1927.

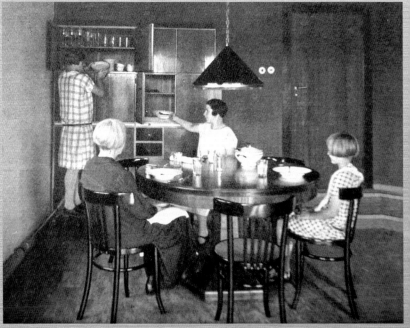

Dining table and cupboard with hatch through to the apartment kitchen by Bruno Taut, 1927.

THE COMMUNAL HOUSEHOLD
THE ONE-KITCHEN HOUSING COMPLEX

Not all kitchen reformers – and especially not all the proponents of women's rights – thought that the efforts of the early 20th century to rationalize the kitchen and kitchen tasks had gone far enough. The German Social Democrat Lily Braun, for example, thought that even if they had the smallest, most practical kitchens, women were still prevented from taking their place beside men in the class struggle. She therefore pleaded for the abolition of kitchens in private houses and proposed that the community should take over central responsibility for daily catering.

The ancient Romans had already had communal kitchens to allow the state to provide the poor with free bread and porridge, and even centuries later, the reputation of being patronizing charitable institutions usually still clung to them. For many poor souls they were indispensable but disliked. The Frenchman Charles Fourier (1772–1837) was the first to put forward the idea of communal catering in a completely new context, seeing it as a contemporary alternative to all domestic and family catering structures. A passionate socialist and avowed feminist, Fourier considered the family to be a social structure that was doomed to extinction, and would have to be replaced by communes and cooperatives. The home for one of these communities of 1,500 or more people was to be a people's palace called a "phalanstery," a communal house, divided up in accordance with Fourier's ideas into separate living quarters and rooms for communal use. The living quarters did not have a kitchen, as the community restaurant was responsible for catering for all.

Fourier's ideas were put into practice by one of his passionate followers, the industrialist Jean-Baptiste Godin, who had made a fortune from the manufacture of stoves and ovens. Godin's "familistery," completed in 1865, was a sensation and attracted journalists from all over the world to the quiet city of Guise, assuring the spread of the bold French ideas on communal living and cooking.

Around 40 years later various European countries also saw the formation of a "one-kitchen housing complex" movement, which took up and developed the French approach. In Letchworth in England, Ebenezer Howard, the father of the Garden City movement, built the Homesgarth cooperative, which consisted of 16 loosely connected houses and apartments. All the meals were prepared in a central kitchen, and everybody ate together in large dining rooms. In 1914, also in Letchworth, they built the Meadow Way Green housing scheme, where the individual occupants were responsible for planning the weekly menu and buying the food, but cooks were employed to do the actual work in the kitchen. A one-kitchen apartment house was built in Copenhagen in 1907. In Berlin, four such houses were opened in 1909 in the suburbs of Lichterfelde and Friedenau.

Kitchen cabinet in the residential building by Bruno Taut, 1927.

Scullery in the residential building by Bruno Taut, 1927.

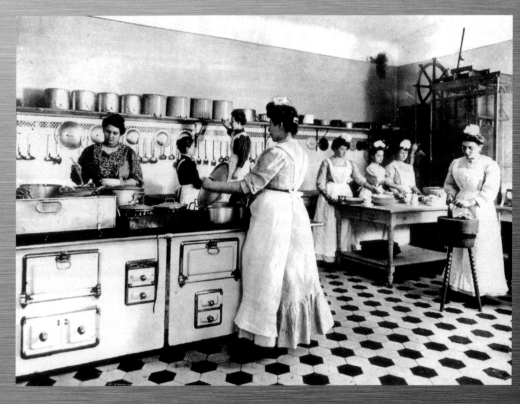

Central kitchen in the one-kitchen apartment house in Friedenau, 1908.

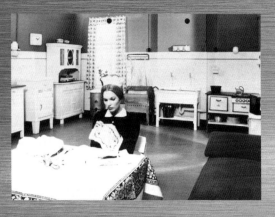

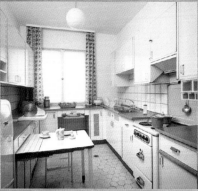

Harmonization of kitchen appliances and furniture: fitted kitchen by Werner Sell, 1938.

Daring look: Siemens fitted kitchen of 1957.

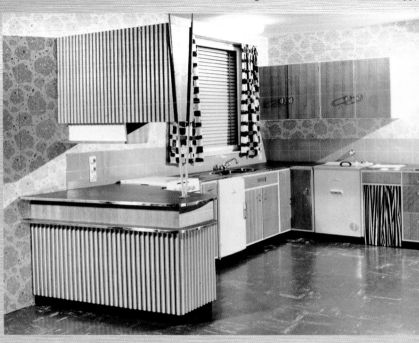

Above:
Everything is there but nothing matches: old-style kitchen with *Protos* oven, washing-machine, spin-drier and refrigerator, 1932.

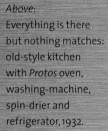

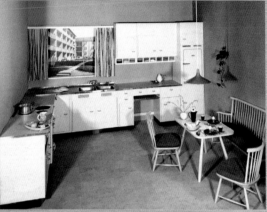

Wall to wall. Poggenpohl brought out the first fitted kitchen, *form 1000*, in 1950.

Finally, in 1922 came the Heimhofsiedlung in Vienna, where, unlike Meadow Way Green, the occupants themselves were responsible for the communal kitchen.

The criticism of one-kitchen housing complexes, especially from middle-class circles, who saw them as threatening the fundamental social pillars of marriage and the family, has never ceased. But after their initial euphoria, the occupants too lost their appetite for constant communal meals. In Berlin-Lichterfelde, for example, two years after the complex was opened, most of the apartments had already been modernized to include a kitchen of their own. In 1912, the central kitchen was completely converted into a restaurant. The only one of these initiatives to survive for any length of time was Meadow Way Green, where people lived, cooked, and ate according to the original communal principle right up until the 1970s.

WALL TO WALL
THE TRIUMPH OF THE FITTED KITCHEN

After 1933, progress towards the modern kitchen was suddenly interrupted. The political situation left the German avant-garde architects, designers, and entrepreneurs isolated, and their creative kitchen designs were put on ice for over ten years.

Nevertheless, developments – especially in Germany – in the early 1930s had been extremely promising. For instance, the kitchen furniture manufacturers Poggenpohl had launched their Reform Kitchen in 1928 and caused a sensation two years later with their non-porous, ten-layer polished surfaces, which could be kept perfectly clean (and were so named, because they went through a total of ten processes, being polished five times and lacquered five times). The Reform Kitchen was an attempt to adapt the advanced but unrealistic ideas of kitchen reformers like Schütte-Lihotzky to fit the practical realities of the everyday situation in the kitchen and the home. Instead of rigid elements, it consisted of a range that included a dresser, china cabinet, store cupboard, shoe cabinet, sink, table and chairs. Additional furniture or individual electrical appliances could be combined with it if required.

The engineer Werner Sell had set himself the goal of combating the widespread kitchen chaos by harmonizing the individual appliances and adapting them to suit the other furnishings. He just managed to exhibit a promising model of his fitted kitchen in 1938, but of course it could not go into mass production until after the end of the war.

During the war years, they made progress in the kitchen in America – especially with regard to greater use of technology within the home – and also in Sweden, where the concept of the Frankfurt Kitchen in the sense of a "cozy

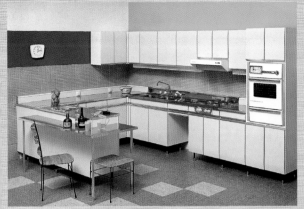

With integrated handrails: great progress resulting from small changes – the *Siematic 6006* from 1960.

Sober and practical, with no sign of luxury: fitted kitchen by Siemens, 1964.

The courage to use color: Alno 1965.

Below:
From the extendible kitchen to the mature fitted kitchen: Poggenpohl launched the *form 2000* at the Cologne Furniture Fair in 1962.

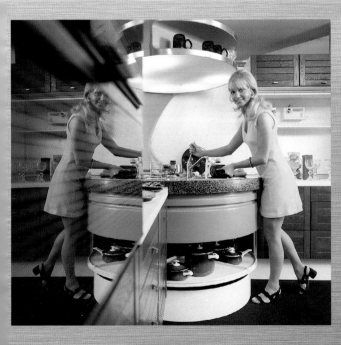

Futurism in the kitchen: *Center 2000* by Alno, 1971.

functionalism" was further developed and finally found its way back to Germany in the guise of the Sweden Kitchen.

When the worst of the postwar crises in Europe had been overcome and people everywhere were looking ahead, the hour of fitted kitchens and modern electrical appliances had come. Following the American model, German, French and Italian housewives were now allowed to demonstrate progressiveness within the four walls of their own kitchens. There was no shortage of supplies. Poggenpohl brought out their first fitted kitchens as early as 1950. Kitchen cabinets and dressers were divided into top and bottom parts, which could be individually hung or placed next to one another from wall to wall. Many other furniture manufacturers also recognized the signs of the times and started producing kitchen units of the correct dimensions to produce a uniform effect. With the first front-loading washing machine in 1951, Constructa established itself as the leading supplier of household technology, which reached a temporary peak in the 1960s. From then on, the refrigerator, washing machine, and electric cooker were the darlings of every housewife.

The challenge of the next years consisted of adjusting the range of kitchen appliances, matching up the kitchens with the appliances, and harmonizing their form and function. In Germany, an important step along this road to integration was the founding in 1956 of the *Arbeitsgemeinschaft Moderne Küche* (Modern Kitchen Association), which started with ten kitchen and appliance manufacturers as members, and had a good hundred by the end of the 1960s. DIN Standards, set up in 1957, were another step towards improving the "combinability" of kitchen furnishings and appliances.

The influence of pre-war kitchen ideology remained unchallenged on only one point. Despite all the manufacturers' protests, and with no consideration for the real needs of housewives, the concept of the minimal kitchen continued – even in the DIN recommendations. During the postwar boom, kitchens with a surface area of less than 45 square feet (a little over 4 square meters) were installed in several apartments and houses. A surface area of over 100 square feet (10 square meters) was seen as the height of luxury.

Formica (known by many different brand names in various countries, e.g. Resopal in Germany) became the very epitome of the modern kitchen. This new material, which was extremely strong, heat resistant, and "easy-care," had a meteoric rise in the kitchen. Anyone who was "with it" danced to rock 'n' roll, wore nylons, and owned a fitted Formica kitchen.

However, Formica also pushed the desensualization and uniformity of the kitchen to the extreme. The smooth white surfaces, distinguished at most by different kinds of handle – with scarcely a hint of color (despite a big campaign in 1968 in the German magazine *Schöner Wohnen* on the subject of "Color makes the kitchen beautiful"), and rarely any sign of wood or decorative elements – meant that it was entirely lacking in coziness, individuality, as well

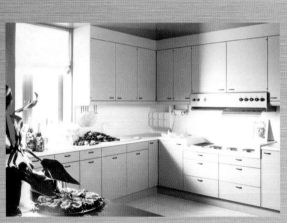

Concern for optimum functionality: kitchen design by bulthaup, model *concept 12* from 1974.

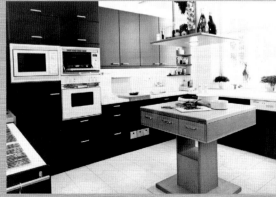

High-tech experiments by Siemens: experimental kitchen with oven and integrated microwave, 1986.

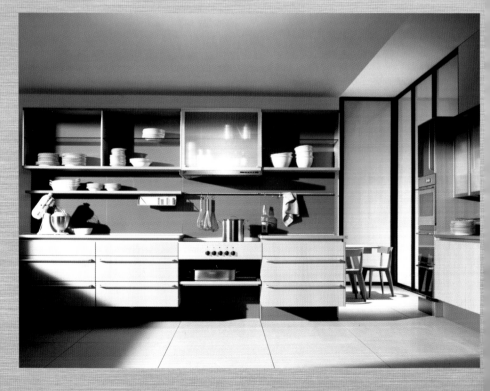

Beauty and functionality: *form 2800 Image*, Poggenpohl 1996.

as variety. In the late 1970s, the time was ripe for a change of direction. At this very moment, the kitchen manufacturer bulthaup commissioned the designer Otl Aicher to produce a study, which was to lay the philosophical foundation stone for the long-overdue change.

HASSO GEHRMANN AND LUIGI COLANI
FUTURISM IN THE 1970S' KITCHEN

At the beginning of the 1970s, two designers – the Swiss Hasso Gehrmann, and the German Luigi Colani – roused a broad section of the public from their peaceful fitted-kitchen sleep. In 1970, Gehrmann exhibited the "Technovision" kitchen project, which he had designed for the firm of Elektra. In the same year, Luigi Colani presented his dream of a house on a pillar soaring high above the ground, which was also intended to include a spectacular round kitchen.

Gehrmann's Technovision was the first fully automated kitchen, and a bold anticipation of a catering center entirely controlled by computer. It was a freestanding unit within the living room, doing away with the separation between the living and working areas; it was made of bright red plastic, and every operation could be carried out while seated by means of keys and pedals. The preparation and cooking of food was celebrated here in the sight of all those present as if on a private altar. There could not have been a more radical break with the tradition of keeping the kitchen work separated behind the closed kitchen door.

Hasso Gehrmann planned this kitchen as the "perfect helper" for the housewife. His real objective was to organize kitchen work efficiently on ergonomic principles. In the early 1970s, Technovision became a real crowd-puller at many trade fairs – in Cologne, Paris, and Milan. The concept of the kitchen as a machine had a lasting fascination at least as much for its technology-loving male contemporaries as for the rather more practically minded housewives. However, it never went into mass production.

Colani, the visionary of German design, favored soft, natural forms, and made constant references to the most primitive living space in nature, the cave. His round, high-tech kitchen, contained in a sphere, was a kind of functional area "docked" with the central living room like a spacecraft, and it invited associations with the cave and with the imaginings of science fiction, which had received fresh impetus from the first manned moon landing in 1969.

Colani's individualistic kitchen plan has not been mass-produced, any more than Hasso Gehrmann's Technovision. But both made a radical break from the traditional ideals of the kitchen and called into question the principles on which they were based. The message of these two designers is that kitchens can be very different and do very much more. Developments since the 1980s were, very belatedly, to prove them right.

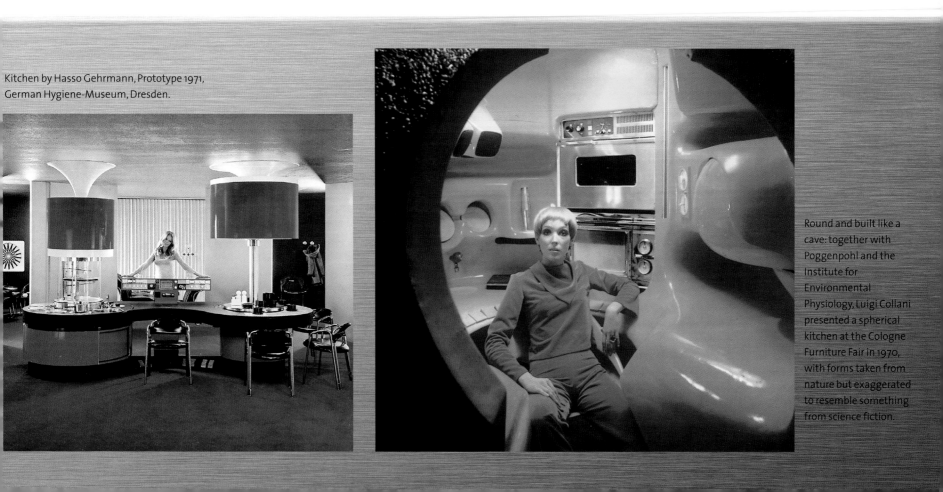

Kitchen by Hasso Gehrmann, Prototype 1971, German Hygiene-Museum, Dresden.

Round and built like a cave: together with Poggenpohl and the Institute for Environmental Physiology, Luigi Colani presented a spherical kitchen at the Cologne Furniture Fair in 1970, with forms taken from nature but exaggerated to resemble something from science fiction.

Stewpot on the fire: medieval kitchen, collectible card for the Liebig company's Meat Extract, c.1900.

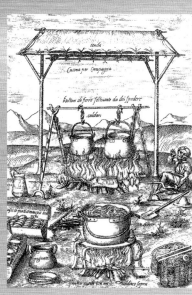

Cooking in the open air: two large cauldrons over a fire and a water cauldron on a stand. From *Opera*, Bartolomeo Scappi, 1570.

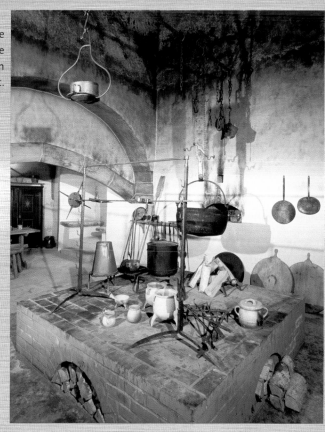

Still no chimney: interior of the 16th-century castle kitchen in the north wing of Burg Allstedt in Sachsen-Anhalt.

FIRE, WATER, ICE
KITCHEN AIDS AND APPLIANCES

Elementary human needs, such as hunger and thirst, have been the inspiration for the history of kitchen development over thousands of years. Elemental powers, especially fire and water, have also played a leading part in it over long periods. The achievements of modern technology – gas and electricity – did not appear on the scene until quite late, but when they did, they revolutionized the work of the kitchen within a few decades. Following in their wake came kitchen aids and appliances, which radically changed the preparation of meals and all the other jobs, from preserving to washing up. The range of kitchen machinery has expanded at breakneck speed. If electric ovens and refrigerators at first seemed like the height of luxury, only a few decades later it is more or less taken for granted that any kitchen will have a microwave, cooker hood, multi-purpose blender, coffee maker, egg boiler, electric carving knife, electric juice press and food cutter.

We are now on the threshold of a new kitchen revolution. The digital kitchen equipment of the future is way ahead of the preceding electrical generation when it comes to intelligence. The freezer signals when the frozen cream cake has finished thawing and is ready to eat, the refrigerator orders supplies of milk and cheese in good time over the Internet, and the stove knows when the saucepan of potatoes must come to a boil and the pan full of schnitzels should start frying. There is only one snag with the 21st-century version of the fairy-tale command "table, lay yourself." Along with the – presumed – burden of work in the kitchen, it also takes away people's creative urge, and the anticipatory pleasure connected with the shopping, preparation, and cooking of a meal. Whether housewives and househusbands will one day be able to obtain intelligent, high-tech kitchens in mass-produced form is still in the stars, since decisions affecting all our basic physical well-being are not only taken in the head, but also as the result of our gut feelings.

THE WARM HEART OF THE HOUSE
ROUND THE KITCHEN FIRE

Today's nutrition experts must shudder to think what an unbalanced and unhealthy diet our ancestors lived on – only meat from the spit, and tubers and roots that had been roasted in an open fire. No question of gentle blanching and steaming to preserve the vitamins. Several thousand generations of *Homo sapiens* had no way of cooking other than roasting or broiling over an open fire.

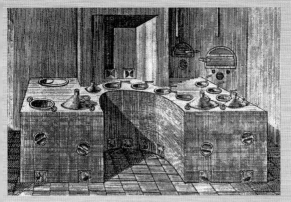

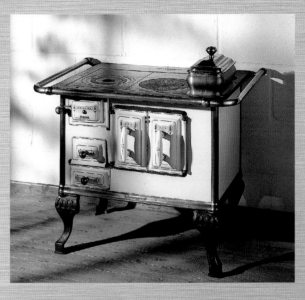

Popular combination: the economy oven by Neff, 1920, was designed to burn coal and wood.

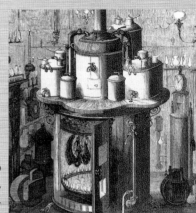

Above:
A gigantic range for the outsize kitchen. From the Count of Rumford's *On Kitchen Ovens and Appliances*, Weimar 1803.

Jewel of the middle-class kitchen: old-fashioned stove by the Küppersbusch company, c. 1879.

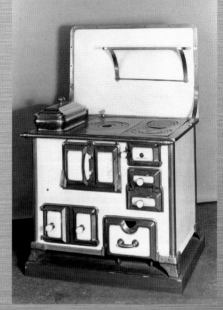

Gas invades the kitchen: gas hob and oven from Southampton, woodcut, c. 1860.

New methods first became available with the invention of the heat-resistant cooking pot, which hung over the fire, or later stood on a metal stand, and made it possible to regulate the heat supply by varying its distance from the fire. We have this discovery to thank for porridge and stew – and not least the blessings of hot water.

In the Middle Ages, it was not so much the quality of cooking as the quality of life in dwellings centered around the open hearth that was improved by the development of the chimney, which took the place of the smoke-holes in the roof or walls that had been the usual outlet until then. A degree of comfort had arrived earlier, when people began building a wall round the fire and raising it to knee or table height by putting it on a plinth. A chimney hood, a kind of vault in the roof, collected the rising smoke and drew it outside. The favorite fuel for open fires was wood, which was burned in such quantities – and so inefficiently – that by the middle of the 16th century, Councilor Zwick of Constance made public his design for the "Art of Saving Wood." This was a triangular fire-chamber enclosed by a wall on three sides and covered with an iron plate, allowing the pots to be pushed directly into the heat from the front. Its shape was already recognizable as the precursor of the enclosed cooker, which was first produced by the Englishman John Sibthrope in 1630. He enclosed a coal fire in a huge metal casing. Unfortunately for Sibthrope, the people of the 17th century were simply not ready for his pioneering invention.

Even some two hundred years later, when the famous physicist, statesman and officer Benjamin Thompson, Count of Rumford, gave much thought to the improvement of the kitchen fireplace and how it could best be used, his innovative designs were for the most part only installed in large kitchens. After all, how could they have found room in the somewhat restricted space of a middle-class kitchen for his colossal U-shaped stoves, which were built around the cook?

Nevertheless, the Count of Rumford's work marked the beginning of a decisive new era for kitchen stoves in private houses as well, as his idea of making the fireplace and cooker more flexible by freeing them from their attachment to the wall or the floor was the first step towards the oven becoming a movable kitchen appliance.

The 19th century was the age when cast iron stoves in all shapes and sizes, some plain, some highly ornamented, and later even enameled, took European households by storm. Their names have gone down in history as the *Sparherd* (economy stove) or *Kochmaschine* (cooking machine), and they encouraged the development of the art of cooking, because they marked the final exit of the stewpot and the beginning of a new era of plain middle-class fare, with vegetables, potatoes, and meat prepared separately in individual pots and pans.

At almost the same time as the cast iron stoves, the first gas cookers caused a sensation. They were produced in England in small numbers from about 1830 – but at first they did not meet with great enthusiasm on the part

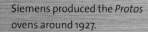
Siemens produced the *Protos* ovens around 1927.

The first automatic ovens with pre-set temperatures appeared in 1935.

Small and compact: AEG electric cooker from 1910.

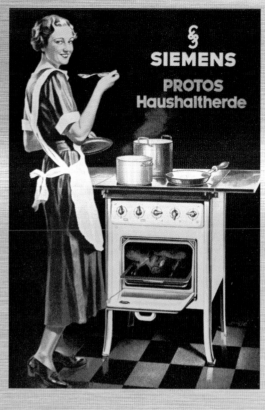

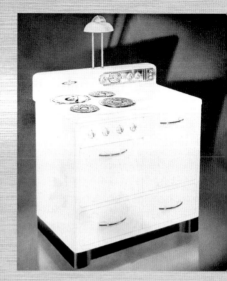

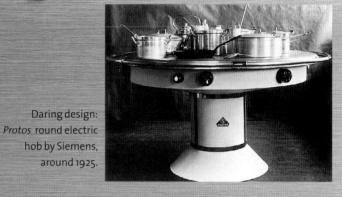

Daring design: *Protos* round electric hob by Siemens, around 1925.

White and clean: enameled electric stove by Frigidaire, 1937.

Who says the best stoves always have to be built in? The free-standing stainless steel cooker by Siemens is the center of attention in any open-plan kitchen.

Tepan Yaki, Electrolux: "*Tepan Yaki*" means something like "to roast on the iron plate" and represents new, healthy cooking.

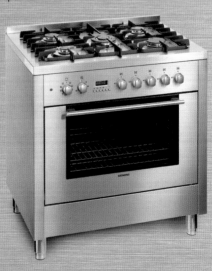

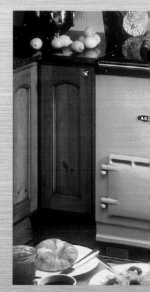

Above:
In Miele's independent hotplates, the sensor controls are clearly laid out on the front of the appliance.

Aristocratic black in a broad stain-less steel frame: the oven from the *Valido* design range by Imperial with its extra-wide front is very satisfying in form and material.

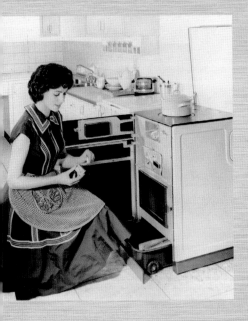

Still popular: coal-fired auxiliary cooker from the 1950s.

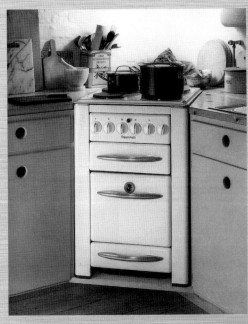

Electric stove by Küppersbusch from the 1950s, with a warming compartment between the control panel and the oven.

Oven with a window: Siemens fitted oven, 1975.

First compact microwave combination in Europe, Siemens 1984.

At a practical viewing height: compact oven *Quantum Speed* by Siemens.

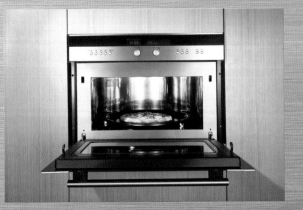

Free-standing work and cooking surface: product development *Plan* from Electrolux.

For the demanding cook: stainless steel gas hob by Gaggenau.

A stove with character: the Aga range, developed in Sweden in the 1920s, conquered first England, then the rest of Europe. The heavy, cast-iron, heat-storing stove enjoys cult status among professional cooks, and looks good in any kitchen.

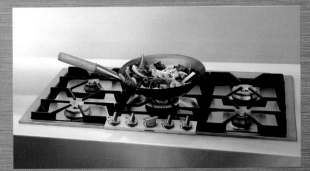

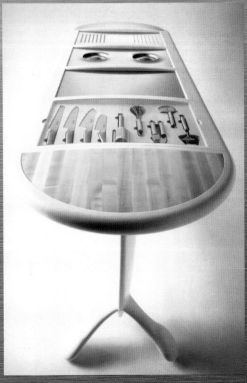

Expensive technology: electrically driven ice and cooling machine, AEG, 1912.

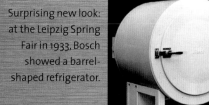

Surprising new look: at the Leipzig Spring Fair in 1933, Bosch showed a barrel-shaped refrigerator.

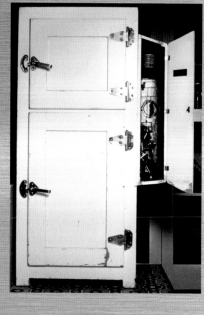

In 1925, Electrolux launched the first refrigerator to use absorption technology on the European market.

Like a white cabinet: Frigidaire, 1925.

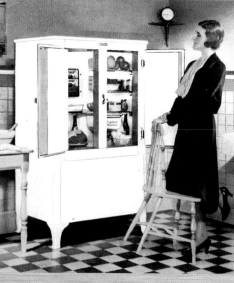

Refrigerator of the Future, designed by Raymond Loewy, Electrolux, 1938.

At a time when every kitchen did not necessarily have a refrigerator, "everything appetizingly fresh" was a convincing argument in advertising. Cinema advertisement for Bosch refrigerators, 1932.

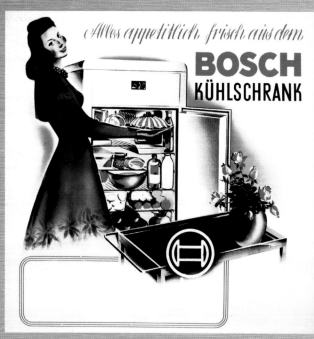

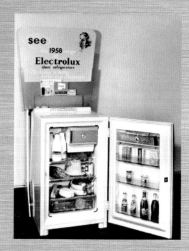

Electrolux absorption refrigerator from 1958.

The housewife's pride and joy. *L460* refrigerator from Electrolux.

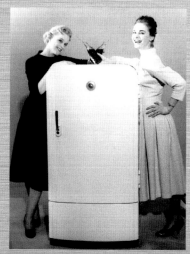

With the chiller, Siemens brought new dimension to food storag Salads, vegetables, meat, and fis kept fresh for days at 32°F (0°C

of housewives. The electric cooker, launched on the market seventy years later, fared no better. As long as the fear and skepticism about the new foreign technology were stronger than the appreciation of its convenience, neither gas nor electric cookers had any real hope of success, and the market launch phase, as it is known today, lasted for decades.

Times have changed, and with them the attitude to technology. Nowadays it is trendy to be progressive. Anyone who is in tune with the spirit of the age swears by the latest technical achievements, even when they have no genuine added value. The manufacturers of kitchen appliances have an easy time of it today selling their latest high-tech machines to housewives and househusbands. Who would seriously admit – when confronted with microwaves, induction technology, and pressure steamers in every self-respecting kitchen – that they are still happy and contented with their old white electric cooker made in 1957?

WELL-CHILLED IS HALF-PRESERVED
ICE IN THE KITCHEN

Nowadays, anything good is "cool." And we appreciate anything "cool" that comes from the refrigerator – lemonade, champagne, beer, and sausages – because cold means fresh, and fresh is good. The only remarkable thing is that cheese only tastes really good when freed from the fridge, and tomatoes and fruit only release their fragrance when they have got up to room temperature. The innovations that have arrived in the kitchen along with the new cooling technology are both a blessing and a curse: a blessing, because they prevent foods that do not keep very well from going off too quickly and have made a huge range of new products, milk-based products for instance, marketable; a curse, because the mere fact the refrigerator is so user-friendly (anyone can chill things) has driven out every other form of preserving and storage (drying, smoking, pickling, jam making etc.) – a loss not only of ancient cultural techniques, but also of quality and variety of taste.

No other household appliance has had such a rapid rise as the refrigerator. The first "ice-boxes," which still had to be filled with ice, appeared in American homes in the mid-19th century. In Europe, the Swedish manufacturer Electrolux launched the first refrigerator based on the user-friendly absorption technology in 1925. But in Germany in 1940 fewer than 1 percent of private homes had "domesticated cold" in the form of a white, cabinet-shaped cooling apparatus – in the USA there were already over nine million at this time. The true refrigerator era began in Europe in the postwar period; within a few decades market saturation had reached almost 100 percent. Even the smallest kitchen has room for a refrigerator. You can still imagine life without one, if you are tempted to try a couple of weeks' vacation away from the blessing of civilization.

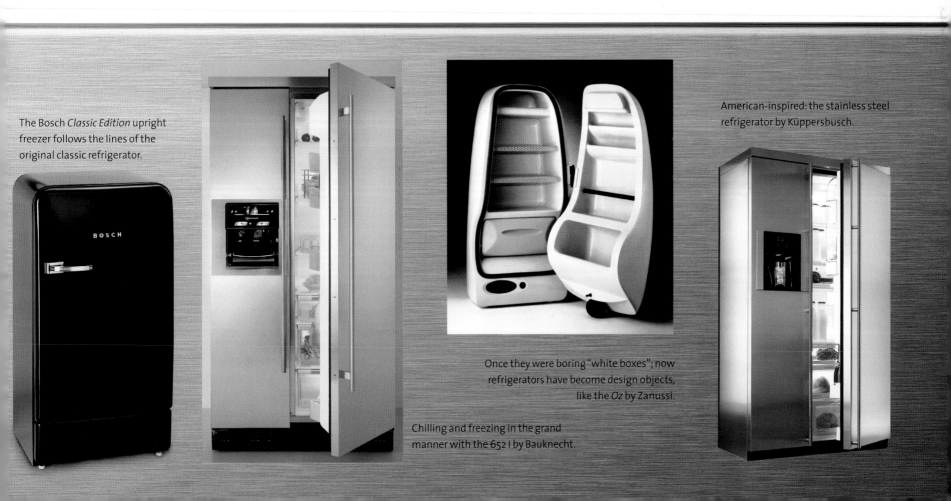

The Bosch *Classic Edition* upright freezer follows the lines of the original classic refrigerator.

American-inspired: the stainless steel refrigerator by Küppersbusch.

Once they were boring "white boxes"; now refrigerators have become design objects, like the *Oz* by Zanussi.

Chilling and freezing in the grand manner with the 652 I by Bauknecht.

While the refrigerator takes care of the short-term need for fresh food, freezers are aimed at the now almost outdated human need to store food. Nothing is worse than having to live from hand to mouth; nothing is more delightful than being able to put fresh asparagus on the table in the middle of winter as if just picked, or swiftly conjure up a menu out of the freezer when visitors arrive unexpectedly at your door. With their capacity to store foods for a long time, home freezers are the modern equivalent of the food cellar. They are the logical and indispensable link in a long chain of industrial frozen goods, which begins where fish, meat, or vegetables are prepared and quick-frozen, then sent on their way to the consumer. Without the benefits of modern technology many foodstuffs would not be nearly so widely available all year round all over the world: many ready meals – from creamed spinach to pizzas – could not be so easily stored. However, opinions among housewives differ when it comes to certain products. Can beans from the freezer compare with the taste of their cousins out of jar or a can? Are frozen fish fingers really fish at all? Can the taste of a chicken ever recover from the shock of being frozen? And have frozen mixed vegetables even a tiny amount of vitamins left in them for the hungry stomach? Here we are getting down to the nitty-gritty of contemporary diet-consciousness. But it would probably not occur to anyone to cast serious fundamental doubt on the merits of the arctic cold of the handy cabinet or chest freezer.

Like the cooker and the coffee maker, the refrigerator and freezer have long been taken for granted as part of the everyday world of consumption and cooking, but with one notable difference. While today's cookers have to look good as well, over the last fifty years those nice, practical, rectangular cooling units in private homes have cleverly evaded all the efforts of designers to pep them up.

TRANQUIL SOURCE OF PURITY
WATER IN THE KITCHEN

Nothing is taken so much for granted in the kitchen as running water. A gentle turn or a push of a lever, and water flows. Carefully measured or in a powerful jet, cold, lukewarm or hot, fully softened and, of course, free of unhealthy pollutants – water in the kitchen is comfort pure and simple. Water for the first early morning coffee, water to wash fresh fruit for the children, to clean the breakfast table, cook the pasta and steam the vegetables, wash up a pan, wash your hands and the worktop umpteen times – a day without water would immediately lead to chaos in the kitchen. The fact that you can now – theoretically – have access to an unrestricted supply of the water that comes bubbling out of the faucet (even if in practice ecologists are sensibly advocating

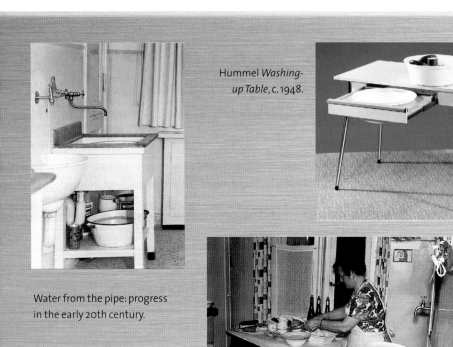

Hummel *Washing-up Table*, c. 1948.

Water from the pipe: progress in the early 20th century.

Crockery as far as the eye can see – and it all had to be washed by hand.

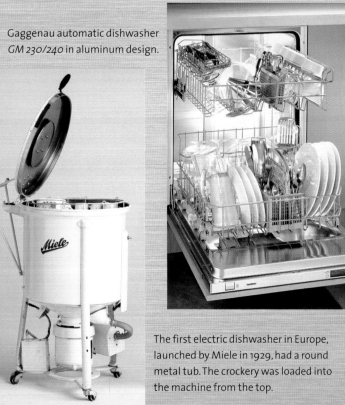

Gaggenau automatic dishwasher *GM 230/240* in aluminum design.

The first electric dishwasher in Europe, launched by Miele in 1929, had a round metal tub. The crockery was loaded into the machine from the top.

moderation in its use), makes it easy to forget that, a hundred or even fifty years ago, running water could by no means be taken for granted in many kitchens.

This is quite surprising, as the ancient Romans already access to ingenious water and sewage systems. And even the medieval master builders were able to assure the supply of fresh water, at least to great castles and monastery complexes. It was more difficult to provide a universal supply in the growing cities. The well on the corner of the next street and later a water pump in your own back yard were already an achievement. Water jugs for fresh and bowls for waste water were a part of the image of the kitchen in those days, just as water carriers, who brought large quantities of water to the house, for example for the laundry, were part of the everyday image of the street. Around the middle of the 19th century, extensive sewerage systems first brought the long-needed progress in providing fresh water and removing waste water in the great cities of Europe. It took a further hundred years to guarantee a water supply to almost 100 percent of households. As recently as 1954, a national census in France showed that, at that time, little more than half of French households (58.4 percent) had access to running water in the home; by 1973 it had risen to 97 percent.

When water became available from a pipe in the wall, the attitude to cleanliness in the kitchen changed. Never before had there been so much wiping and scrubbing and washing. And it also changed kitchen furnishings.

Grandmother's portable washing-up bowls became huge sinks to be fixed to the wall or more decorative enamel basins. These did not necessarily fit into the design of the kitchen and stood out like foreign bodies in the kitchen interior until the unit system of the fitted kitchen took them over too. Nowadays a high-class ceramic sink – fitted diagonally across a corner or integrated into a free-standing kitchen island with a whole row of basins, a special waste-disposal unit, and other refinements – is the visual and technical highlight of the kitchen area.

The introduction of the dishwasher could do nothing to change that. However practical this relatively new invention may be for dealing with the tiresome washing of dishes, it cannot replace the multi-functional sink. In the 1960s, many kitchen experts dared to predict that within the next ten to twenty years doing the dishes would be a thing of the past, because people would only be using disposable plastic plates. At that time, belief in the future of the dishwasher was not strong, whereas the enthusiasm for plastics was unchallenged. It is gratifying that reality also proves trend predictions wrong from time to time. Disposable plates never achieved greatness as kitchen utensils, whereas the dishwasher has slowly but surely continued its invasion of the kitchen. Almost noiseless and installed at a convenient height, it is now an important part of the efficient, time- and labor-saving equipment in the kitchens of almost two-thirds of households.

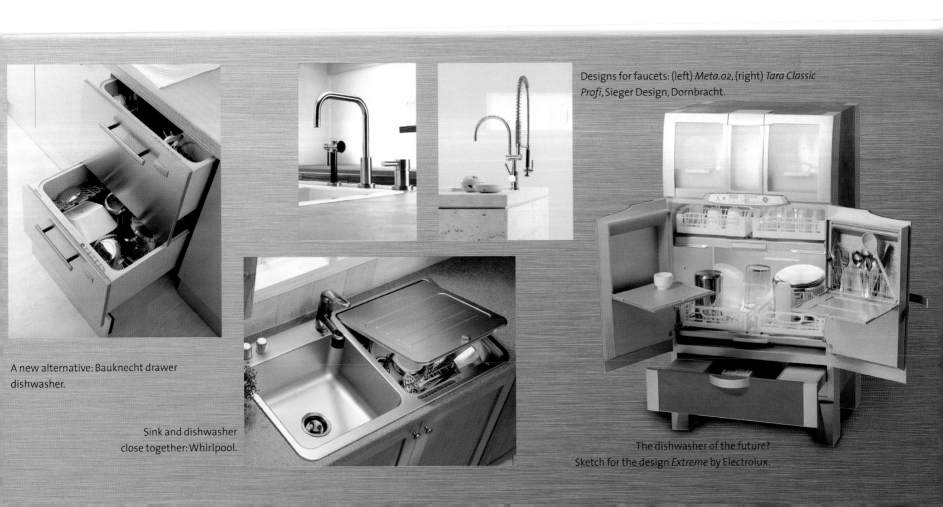

A new alternative: Bauknecht drawer dishwasher.

Sink and dishwasher close together: Whirlpool.

Designs for faucets: (left) *Meta.02*, (right) *Tara Classic Profi*, Sieger Design, Dornbracht.

The dishwasher of the future? Sketch for the design *Extreme* by Electrolux.

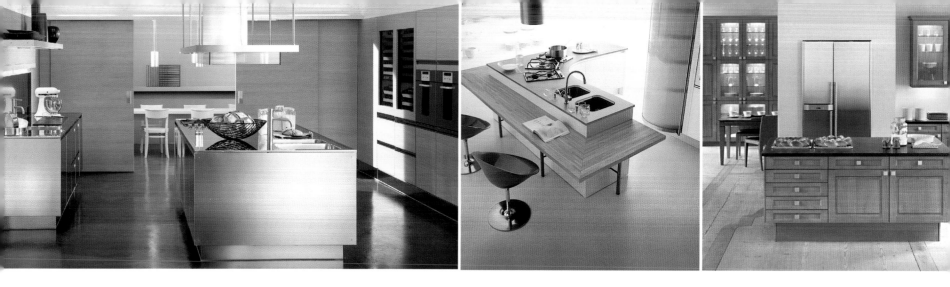

INDIVIDUAL, HIGH-QUALITY, AND FULL OF CHARACTER

"The kitchen and cooking are becoming central to our way of life. And as work will always retain the character of work, what matters is to give the fixtures and fittings of the kitchen the excitement of a craftsman's workshop, with professional standards, so that we can once again enjoy using our hands. Cooking will always be a hands-on job, but we must nevertheless recognize that one of the benefits of industrialization is that it gives us time, plenty of time, to have the chance to use our hands again. The culture of craftsmanship, with its special standards of quality, is on the way back, this time through the back door. If we want to eat well, we must use our hands. Otherwise we will become completely lost in the monotonous beauty rolling off the production line."

Otl Aicher, *Die Küche zum Kochen* (A kitchen for cooking), p. 37

At the beginning of the 1980s, when Otl Aicher – commissioned by the kitchen manufacturer bulthaup – presented his truly amazing ideas on the kitchen as the central room for domestic life in the future, it brought him into direct conflict with the reality of the omnipresent Formica fitted mini-kitchen. In practice, however, as he insisted on reminding us, he had already witnessed a kind of preliminary run as, in the aftermath of the student unrest in the 1960s, the good old kitchen-living room had made quite a comeback in student communes and shared accommodation. What those students did – enhancing the status of the kitchen as the focus of communication for different sized groups of people living together, sharing the domestic chores equally between men and women, and developing a new "sociability through work" (as Aicher called it) in the kitchen – already included important elements that were also contained in Aicher's concept. However, in his case, the emphasis was not only on the social and sociological implications, but also to a great extent on the culinary aspects. For him, the new kitchen culture went hand in hand with a new culture of cooking and, above all, eating.

Developments in the decades that followed proved Aicher right in many areas. Of course, the large-scale rebellion against the industrialization of foodstuffs he perhaps hoped for did not take place. Without convenience foods, which make life simple, quick and easy, daily life in the modern kitchen could probably not function most of the time. But at least people's awareness of the fact that a constant diet of nothing but frozen foods and ready meals cannot make you happy or healthy has been heightened, and they realize that fresh food, freshly bought and freshly prepared, represents a genuine and, what is more, creative alternative.

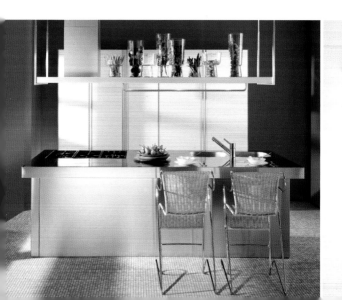

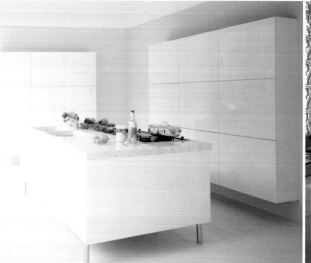

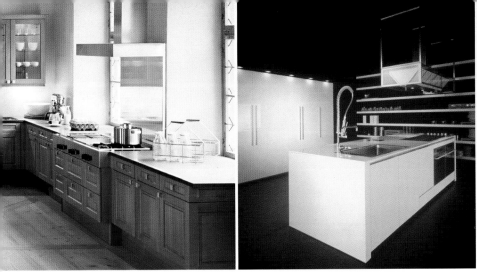
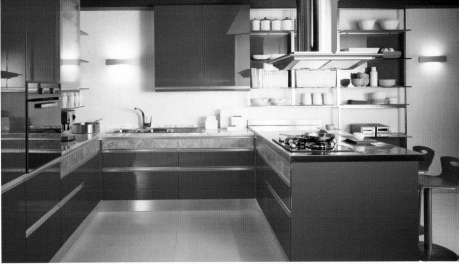

Alongside this change in awareness with regard to food, there has also been a change in the attitude to the kitchen. The time had long been ripe for saying farewell to the faceless conformity of sterile, white, utilitarian rooms, giving them a new look, and restoring the lost quality of life. The manufacturers of kitchen appliances and furniture reacted promptly, and within a few years they were supplying the market with an almost endless selection of kitchen equipment in every style. The range of goods on offer extends from the elegant country kitchen to the high-gloss, high-tech kitchen with no visual frills, from warm wood to cool marble, from pastel shades of lime and cream to vibrant red, so choosing the kitchen they prefer quickly becomes an agonizing task for customers. Minimalist, purist, traditional or futuristic, emotional or cool, dainty or elegant: anything goes. Whether you put together your own kitchen on the construction kit principle, place antique treasures and stainless steel cabinets in cool designs side by side in an exciting juxtaposition, or have a custom-tailored kitchen, is today a matter of personal wishes, needs, and requirements. If you know what you want from a kitchen, you will be able to find the perfect solution. But if you are undecided, you can easily lose sight of the overall perspective in the sea of endless possibilities.

Moreover, recent architectural trends also take account of the new enthusiasm for kitchen-living rooms, by allotting them a bigger area that allows space for kitchen islands and dining tables, and by using open-plan – or at least semi-open plan – designs to create a fluid transition between the cooking, eating, and living areas. So, in many cases, we have almost come full circle to the one-room kitchen of the olden days.

The almost unlimited choice of furnishings allows the maximum scope for individuality. This is true of the room and how it is arranged, as well as for the activities carried out between sink, cooker and dining table. Thus the kitchen has long since left behind the neutrality of the purely functional. The way people furnish their kitchens, the way they live, work and cook in them, offers penetrating glimpses into their personality and lifestyle. Seen from this point of view, an invitation to cook something together therefore involves a kind of intimacy that should not be undervalued.

(*Above, left to right*): *Convivium*, Arclinea; *Misura*, Effeti; *FP 552*, Poggenpohl; *Case System 5.0*, Boffi; *Zeffiro*, Scavolini.
(*Below, left to right*): *Kuoco*, Driade; *Nuvola*, Dada; *Soviore*, Schiffini; *Malaga*, Scavolini; Design study *Theatre*, Whirlpool.

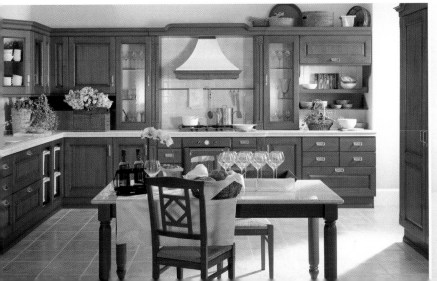
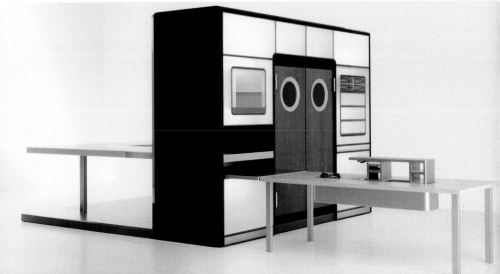

MODERN KITCHENS

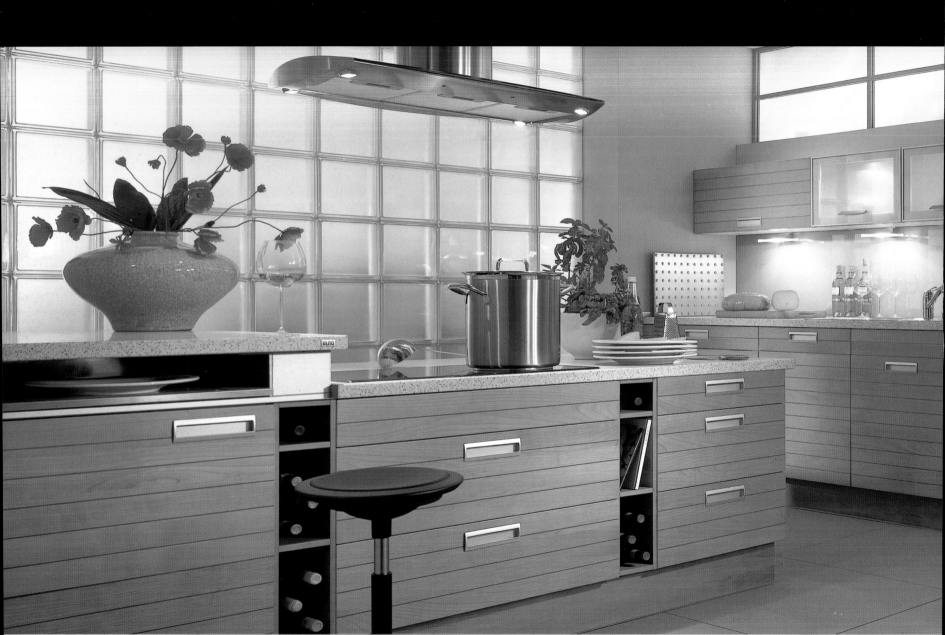

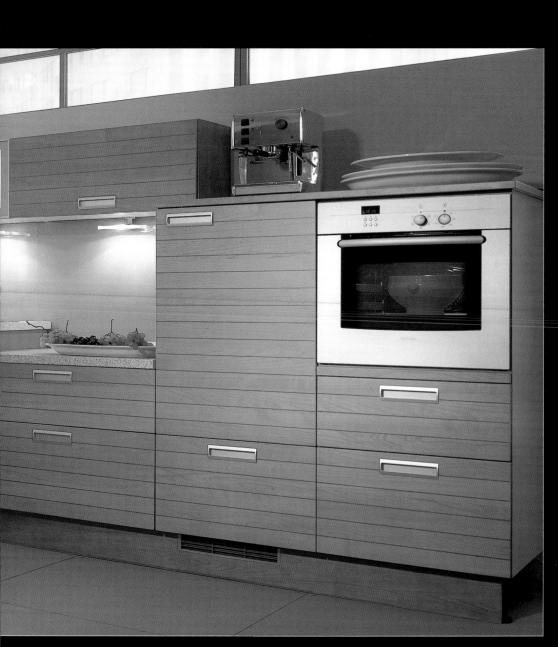

MODERN CLASSICS FOR THE "HEART OF THE HOME"

It can by no means be taken for granted that beauty and intelligence always go together. But today's kitchens prove that it is possible. Intelligent technology makes all kinds of kitchen chores simpler and less arduous and, at the same time, there are appliances on offer – from the juicer to the electric steamer – that look so refined and elegant we could not wish for anything more. That is as it should be, because today's kitchen furniture also combines optimum functionality with a high degree of aesthetic sophistication.

And at last, the days when the kitchen was regarded as the poor relation in the house or apartment are a thing of the past. Nowadays, the "cooking center," which has long since outgrown the status of a mere "cooking laboratory," is the focus of attention for interior architectural design, both with regard to spatial requirements, and in respect of equipment and furnishings. Generous proportions and high quality are among the features of the modern kitchen. Top quality materials – stainless steel, glass, lacquer, and wood – are being used in exciting combinations. Clean lines, impressive shapes, and subtle detailing assure inimitable elegance.

Modern kitchens now have character and charm. That could be one of the most likely reasons why hanging out in the kitchen is so popular that friends and guests willingly lend a hand with preparing the meal, and are happy to stay there to eat and drink and have a chat. And, of course, every kitchen reveals a lot of things about the personality of those who live with it and in it. Nobody can hide behind the uniformity of a white, wall-to-wall, fitted kitchen any more. The various ways of dividing up the space, and combining different shapes, colors and materials for doors and worktops, allow unlimited scope for highly individual kitchen design. This creates the optimum conditions for a feeling of well-being in the room that, more than any other in the last few decades, has made a whole new career for itself as a living room.

Alnoline pro, Alno

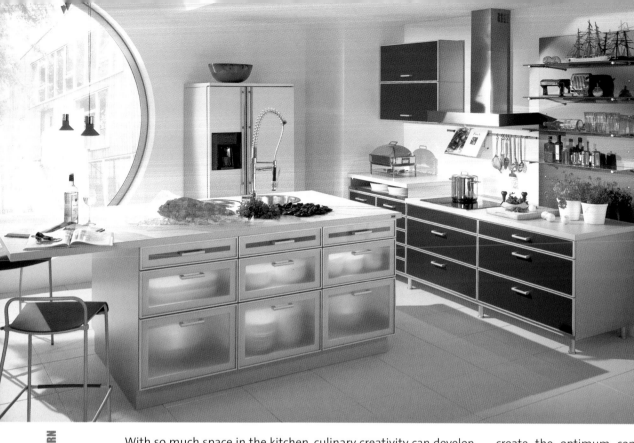
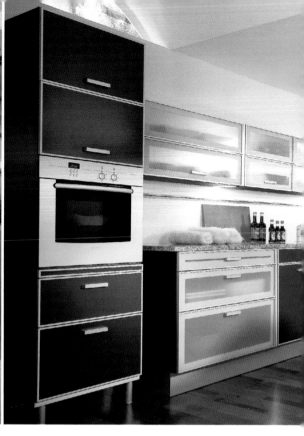

With so much space in the kitchen, culinary creativity can develop unhindered. Large free-standing preparation and cooking islands create the optimum conditions for experimenting in cooking together and enjoying one another's company.

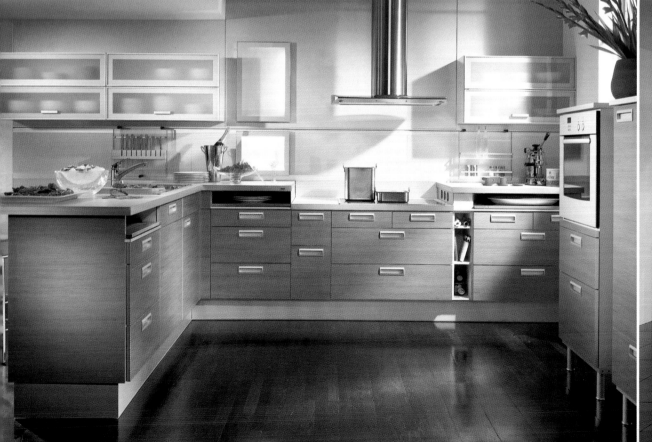
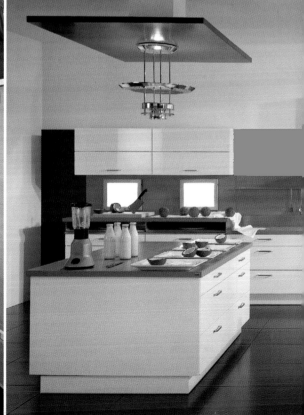

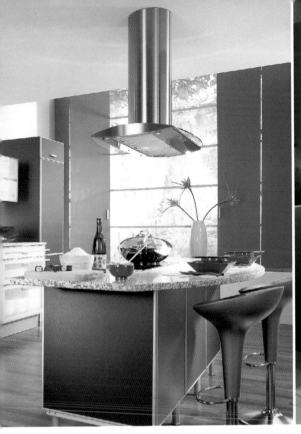
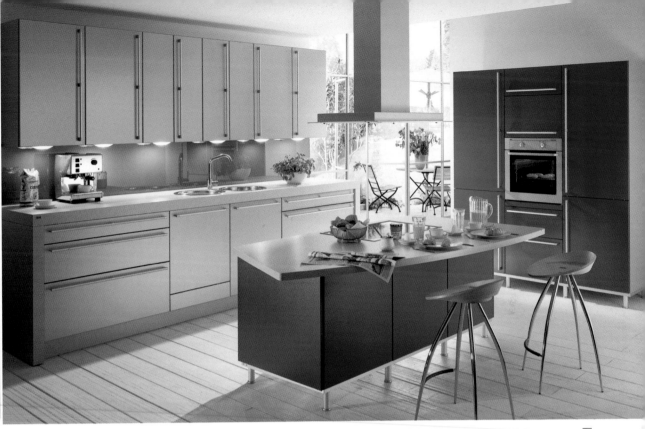

Lapis or azure blue, graphite or arctic gray, mocha or high-gloss vanilla, the different finishes of Alno kitchens fulfil in their users the creative need for color. These variations are indeed a delight to the eye.

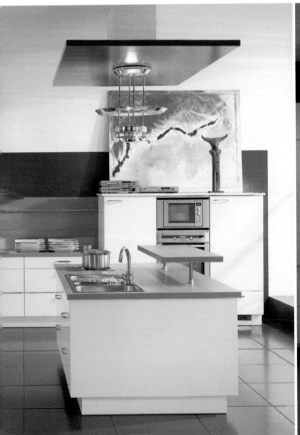
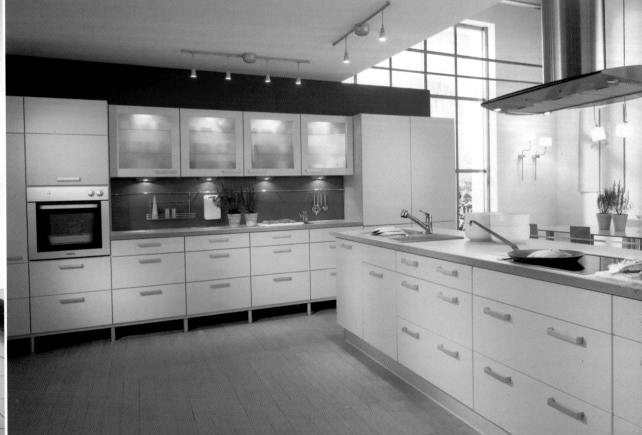

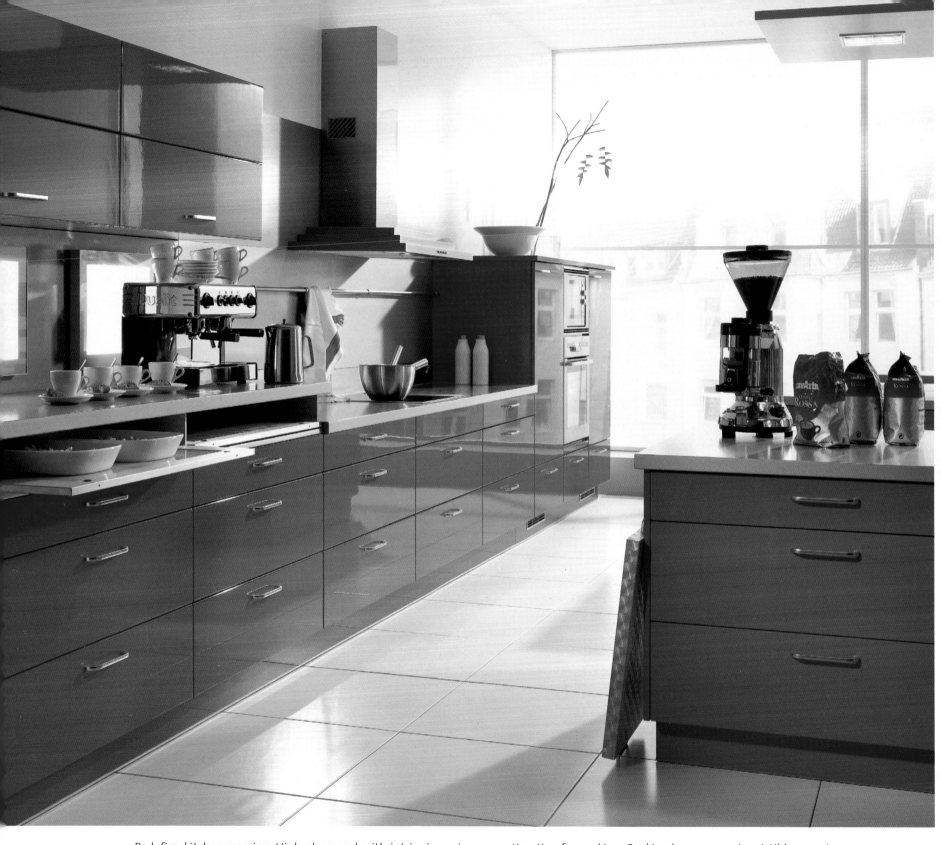

Red: fire, kitchen, passion. High-gloss, and with intriguing mirror-effects, this *AlnoGrand* model develops almost magical powers of attraction for cooking. Cooking becomes an irresistible experience for all the senses.

Viable in the metropolis and with small town experience: *AlnoPlan* kitchens look good anywhere. The gentle elegance and flexible individuality of their modular units creates space for the most varied lifestyles.

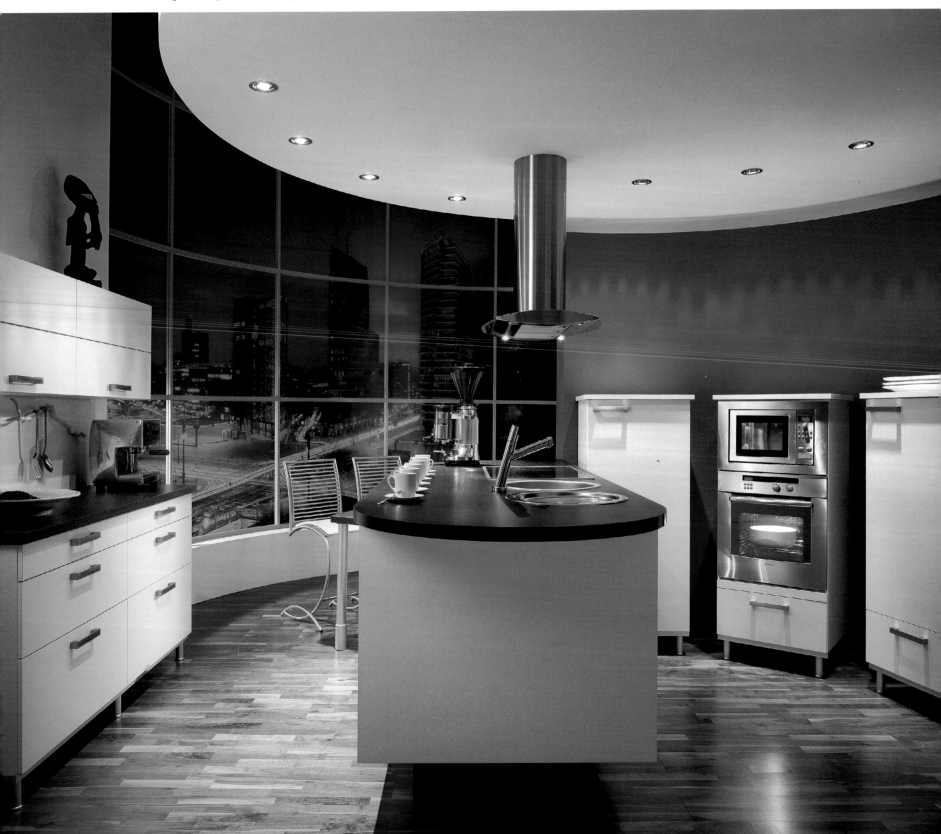

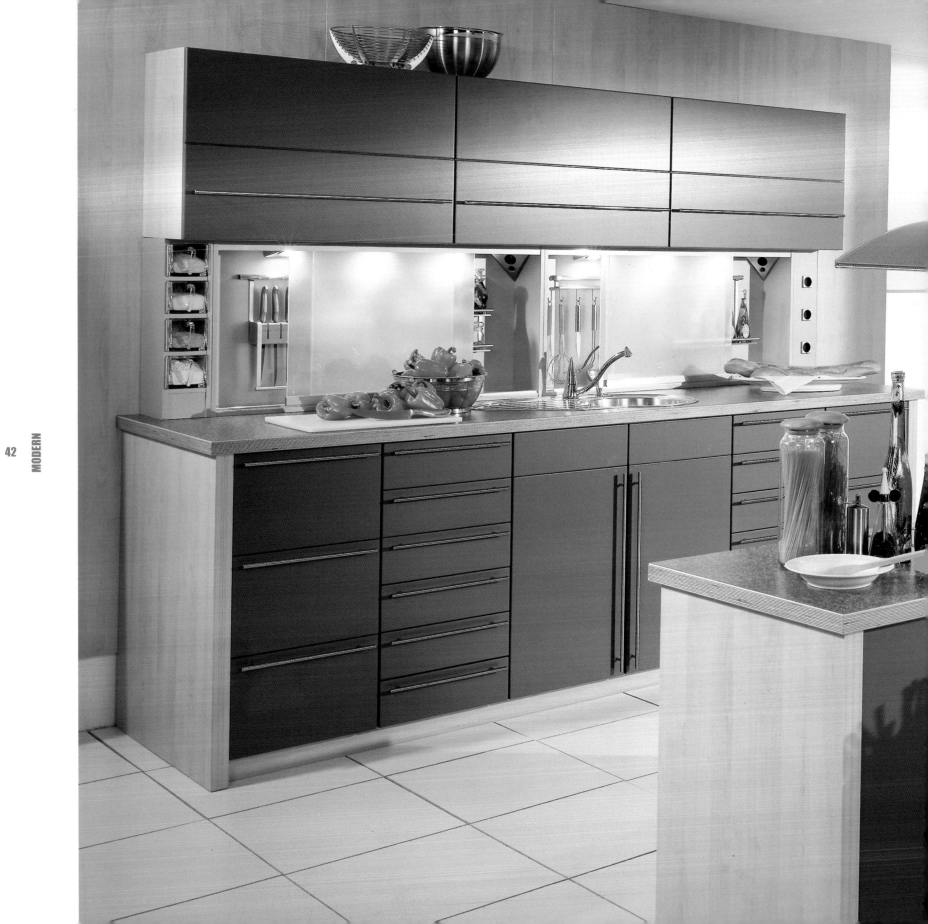

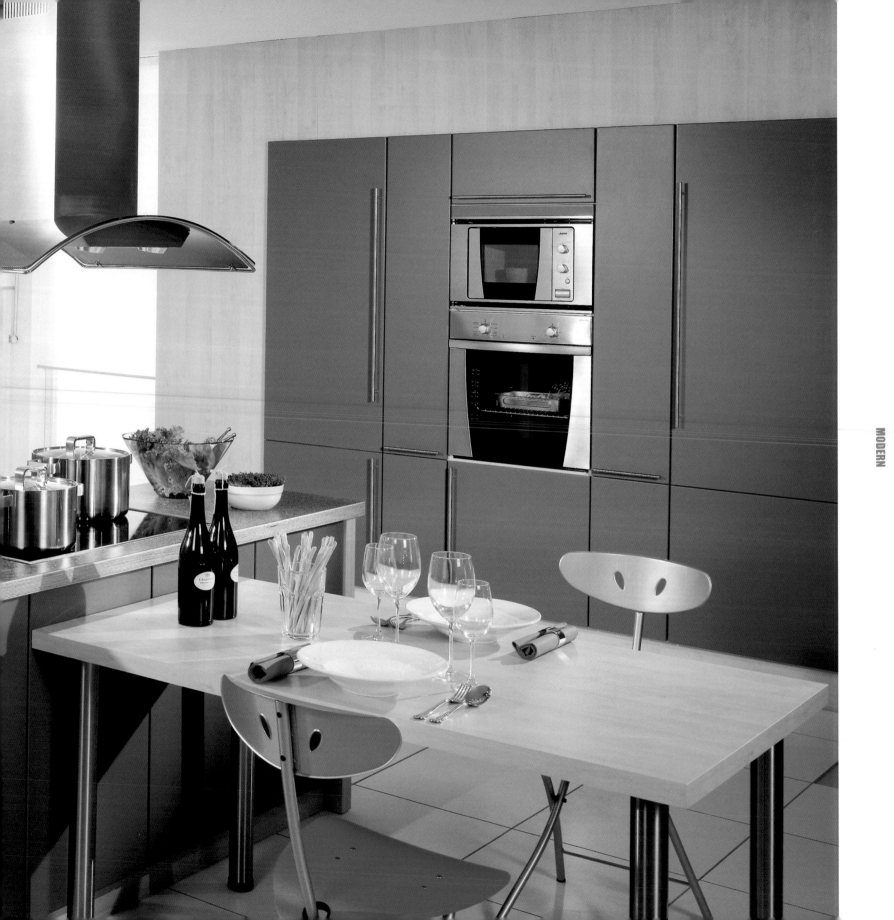

Modular structure by bauformat: the warm look of wood, and unusual combinations of materials and colors – for instance, shadow gray and velvet beech on the preceding pages – ensure an unusual look, making them ideal kitchens for nonconformists.

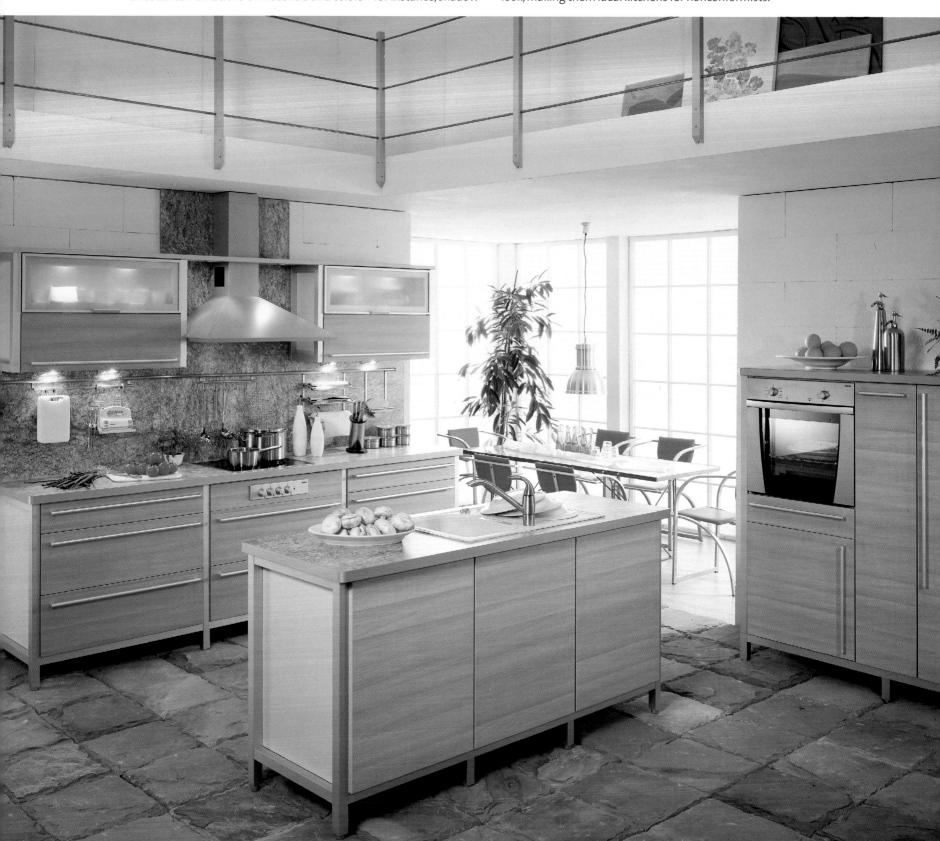

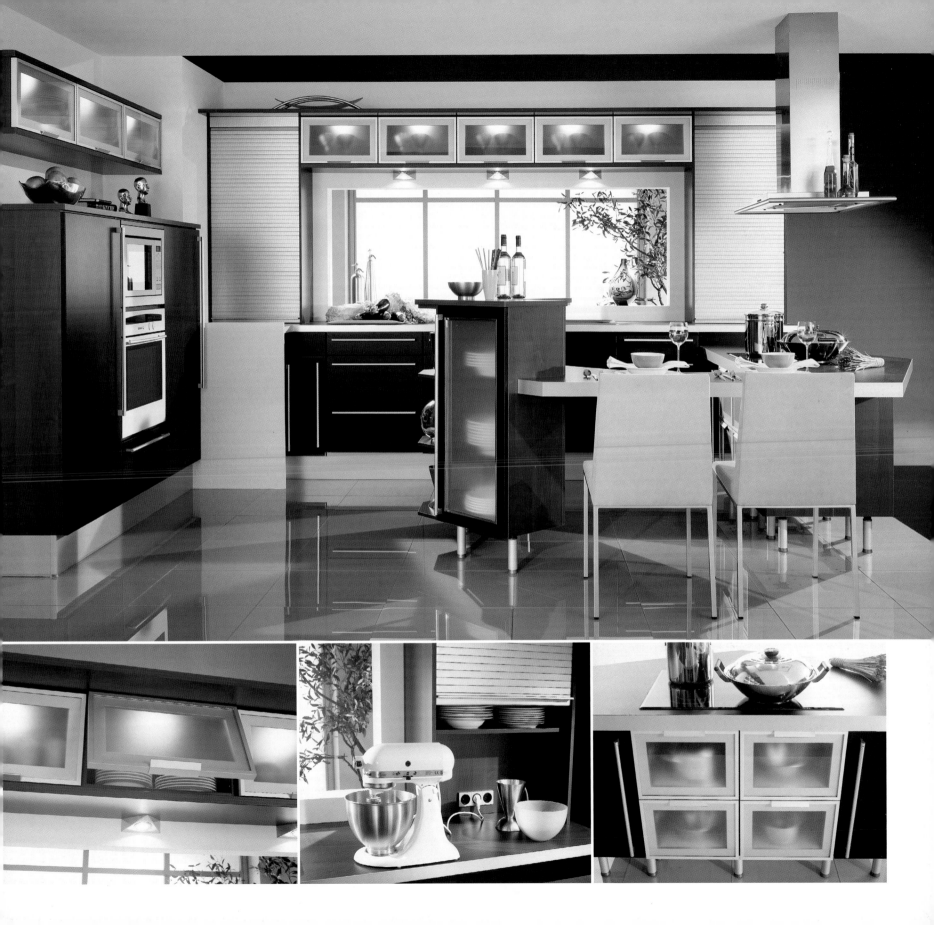

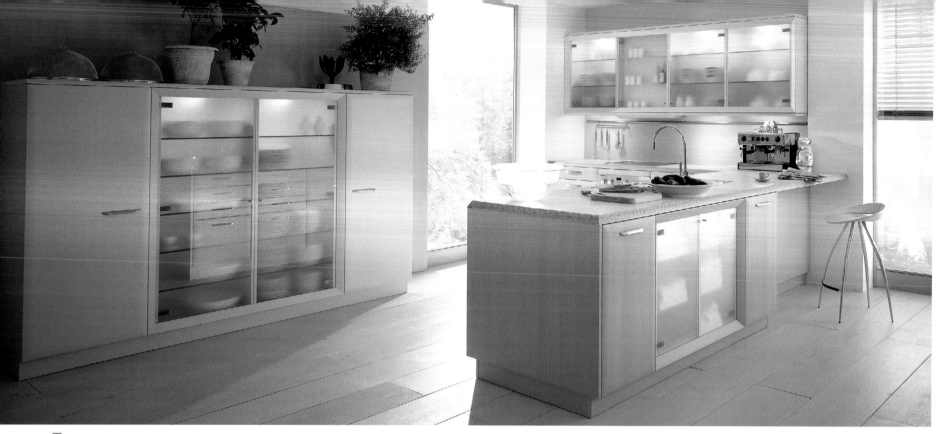

True luxury lies in reduction. So kitchens by Rational like the *Scala* (above) or the *Cambia* (below) put the emphasis on simplicity and minimalism in order to create a warm, modern look, and wide open spaces.

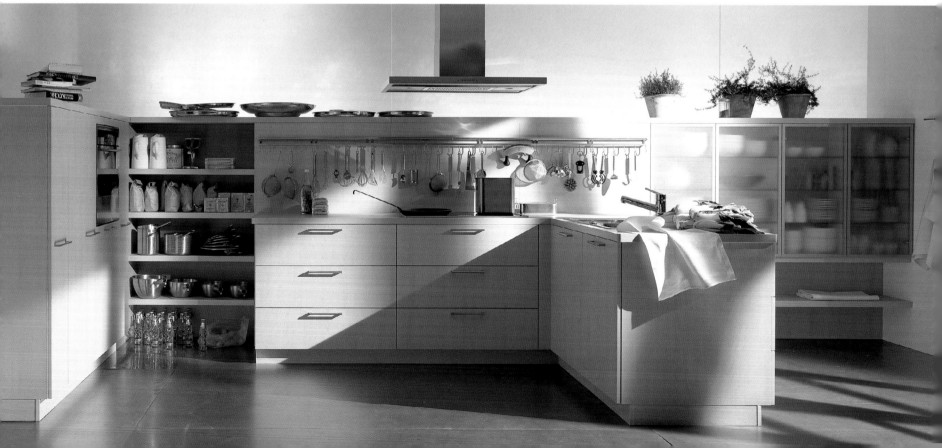

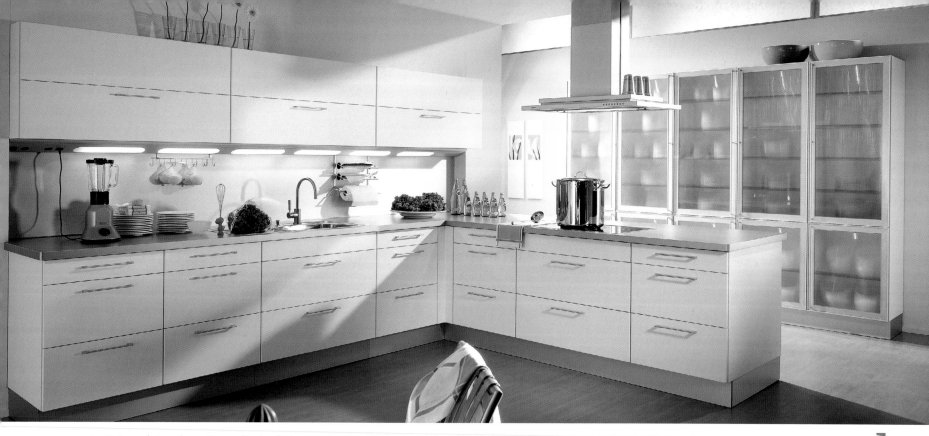

In *Futura* (above) or *Senso* (below), large glass surfaces are of great importance for all models, as they ensure lightness and fascinating, ever-changing effects of light. These are kitchens that are a delight to live in (Rational).

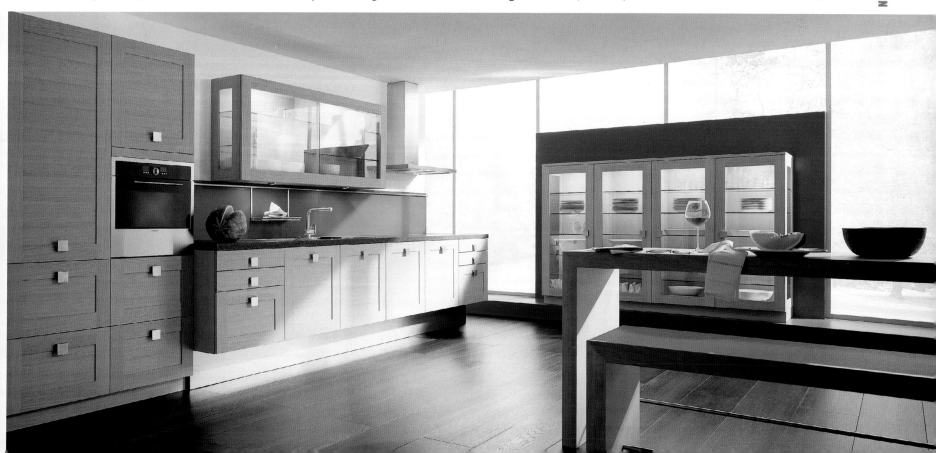

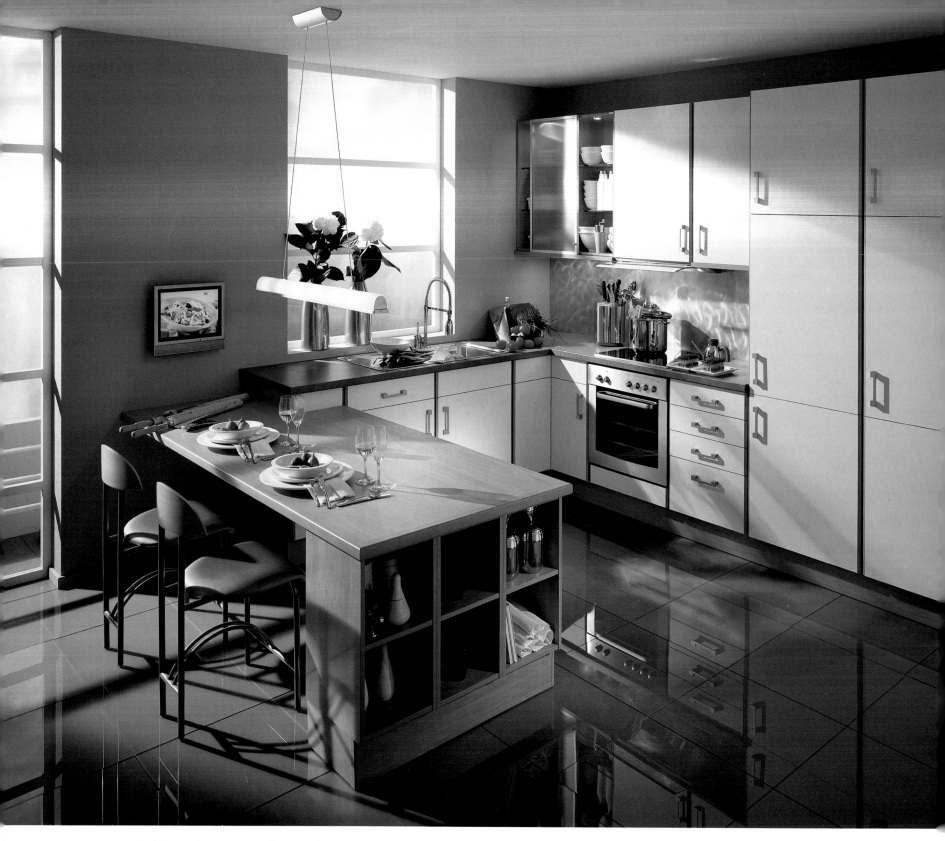

Cooking and eating together – and two people plunging into the feel-good ambience of a Wellmann kitchen. Its clear forms help provide peace and tranquillity for the spirit and allow you to leave your everyday life outside.

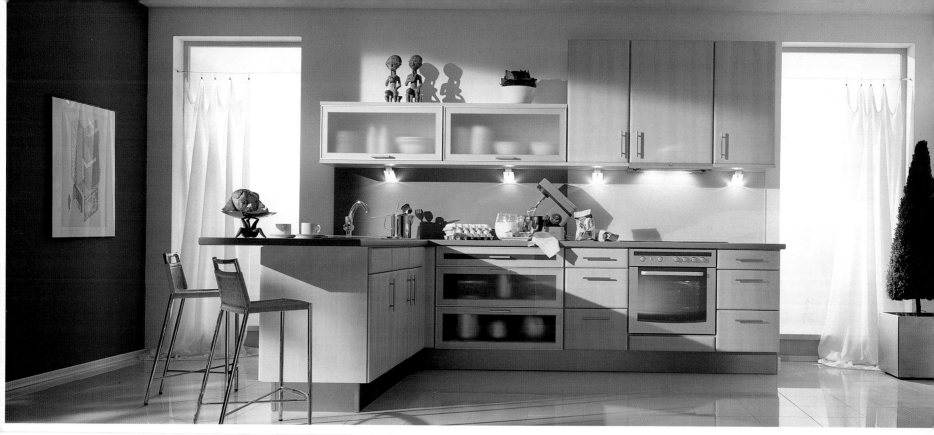

Nordic-inspired (above) or based on straight lines (below): whichever Wellmann kitchen you choose, you will be sure to find form and function ideally balanced, providing optimum conditions for high-class cooking.

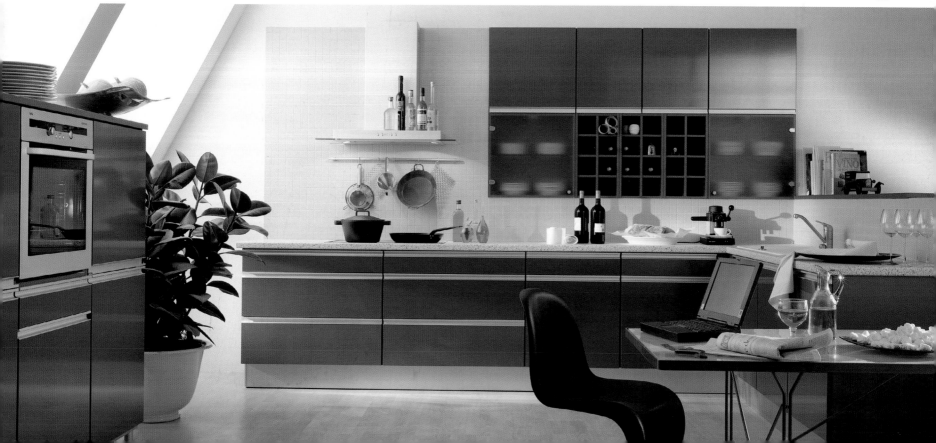

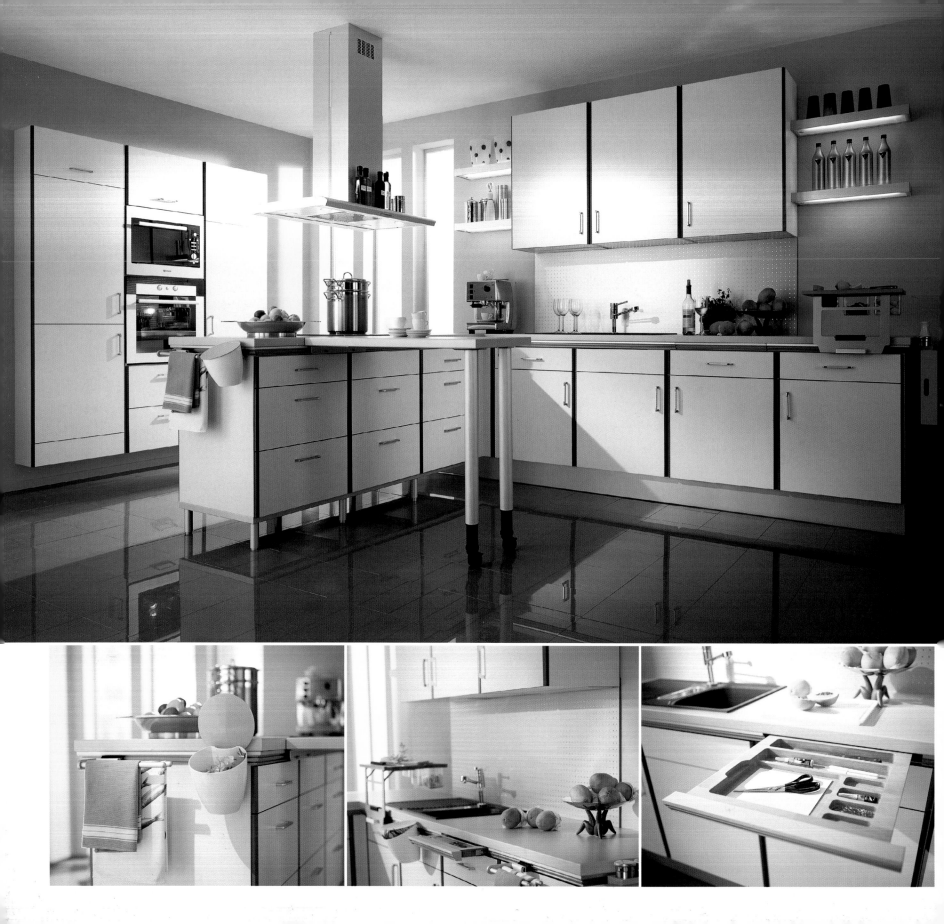

The future of the kitchen has already begun with Wellmann: *Trackline* (left) has an adjustable table on castors and innovative elements, and the *Alu-Rack* system (below) is modular and offers freedom in organizing the floor space.

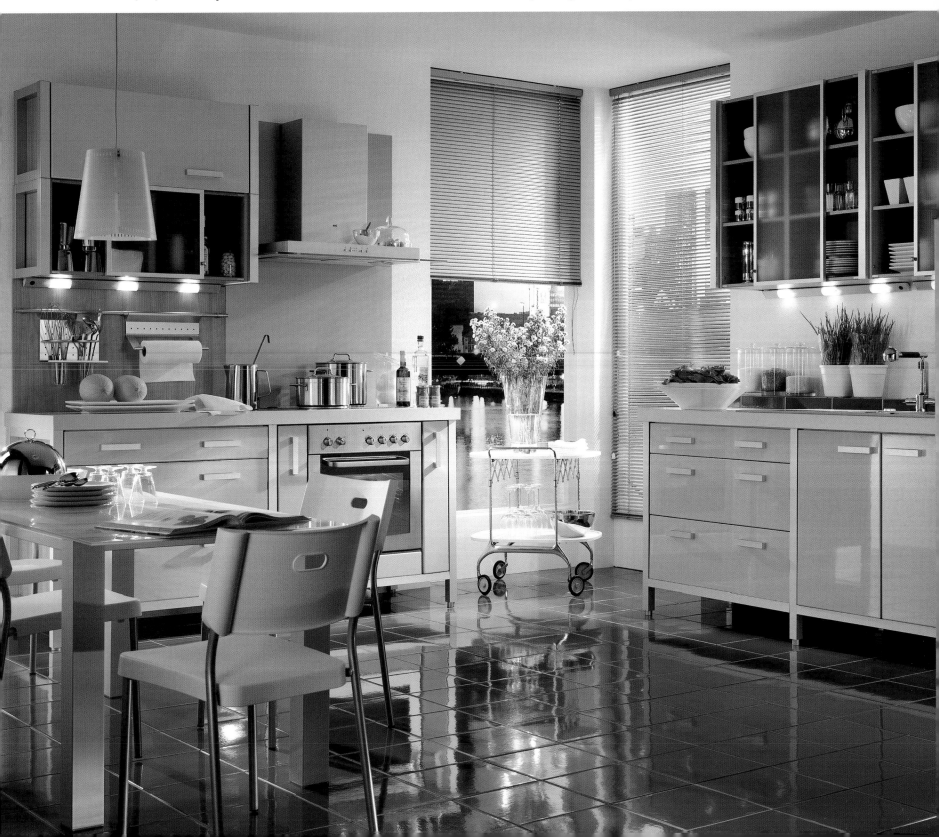

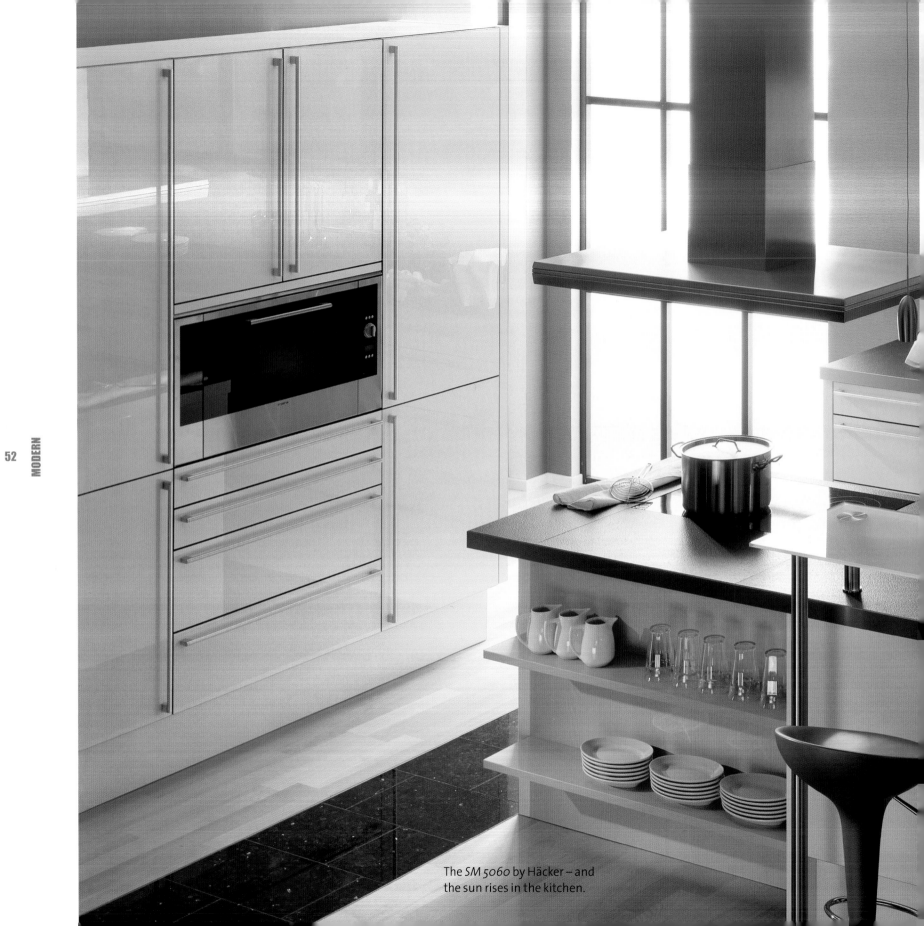

The *SM 5060* by Häcker – and
the sun rises in the kitchen.

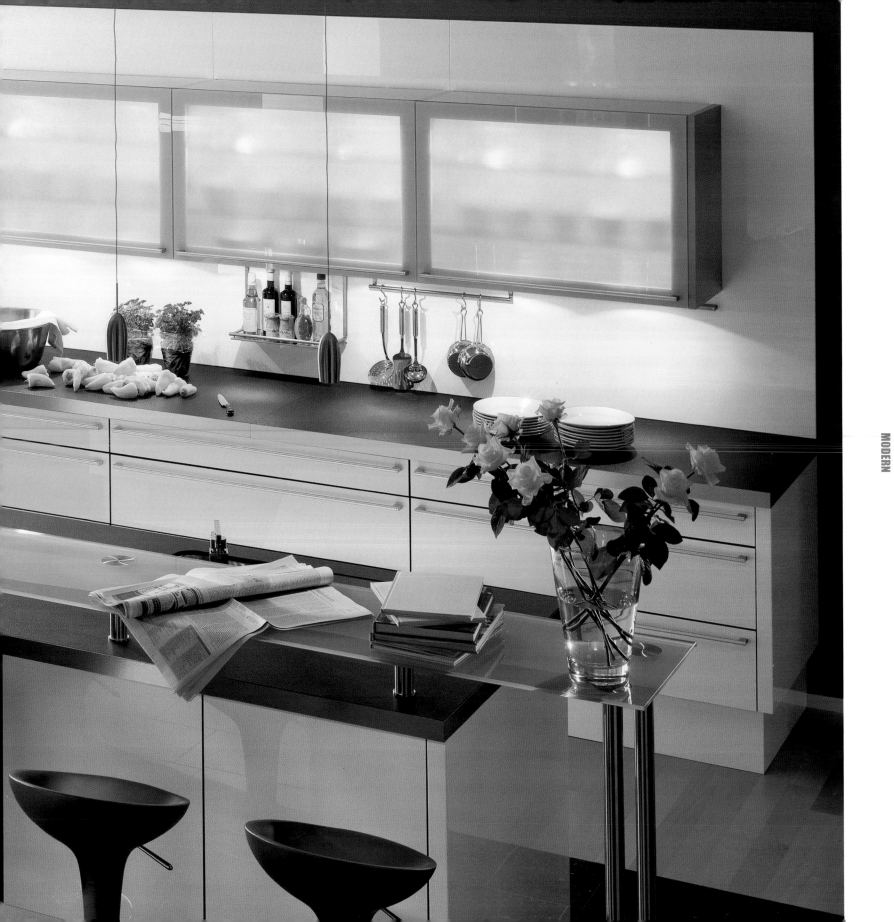

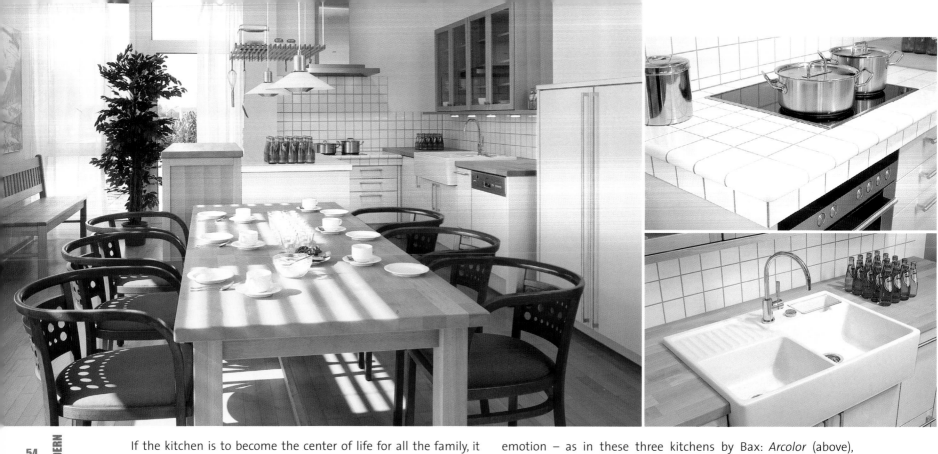

If the kitchen is to become the center of life for all the family, it needs to combine function with charm, and inventiveness with emotion — as in these three kitchens by Bax: *Arcolor* (above), *Cantare luce* (below), and *Tecno* (right).

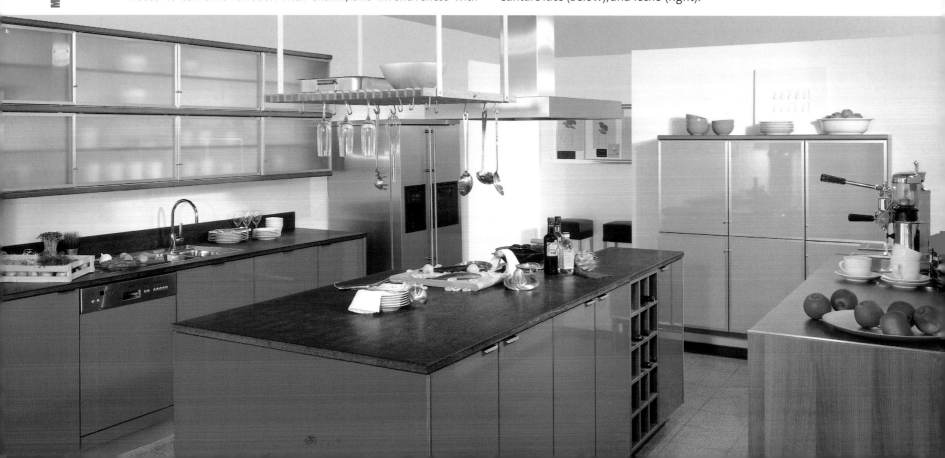

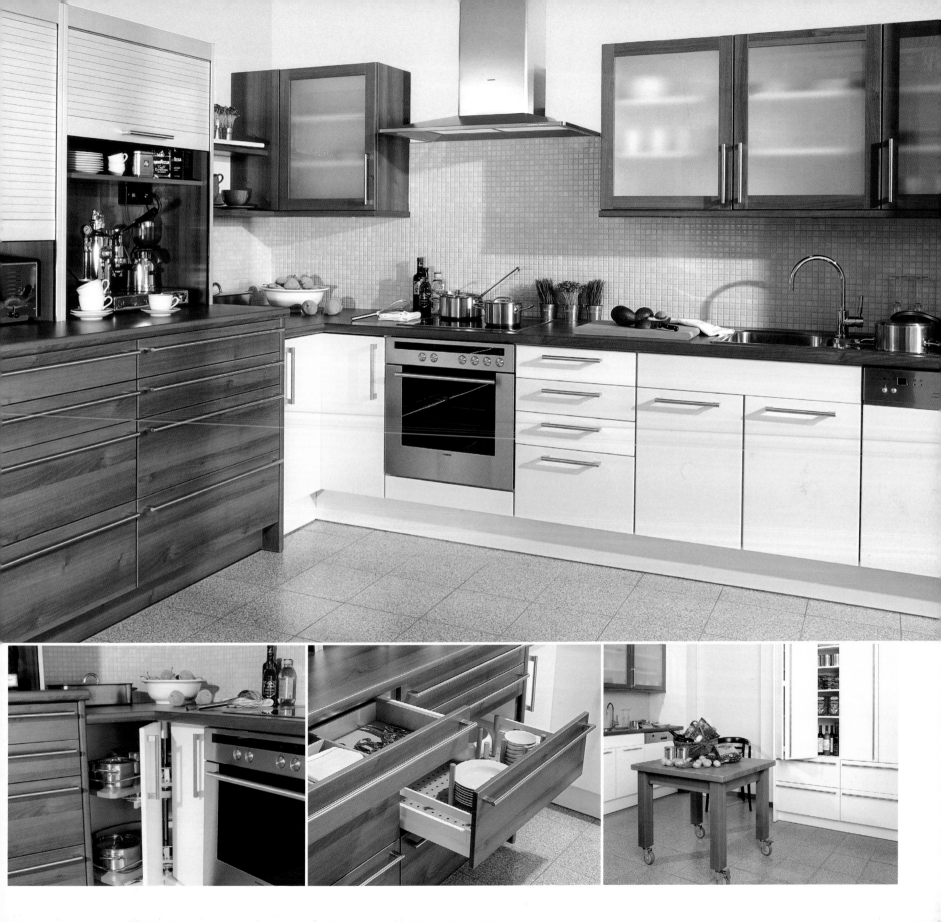

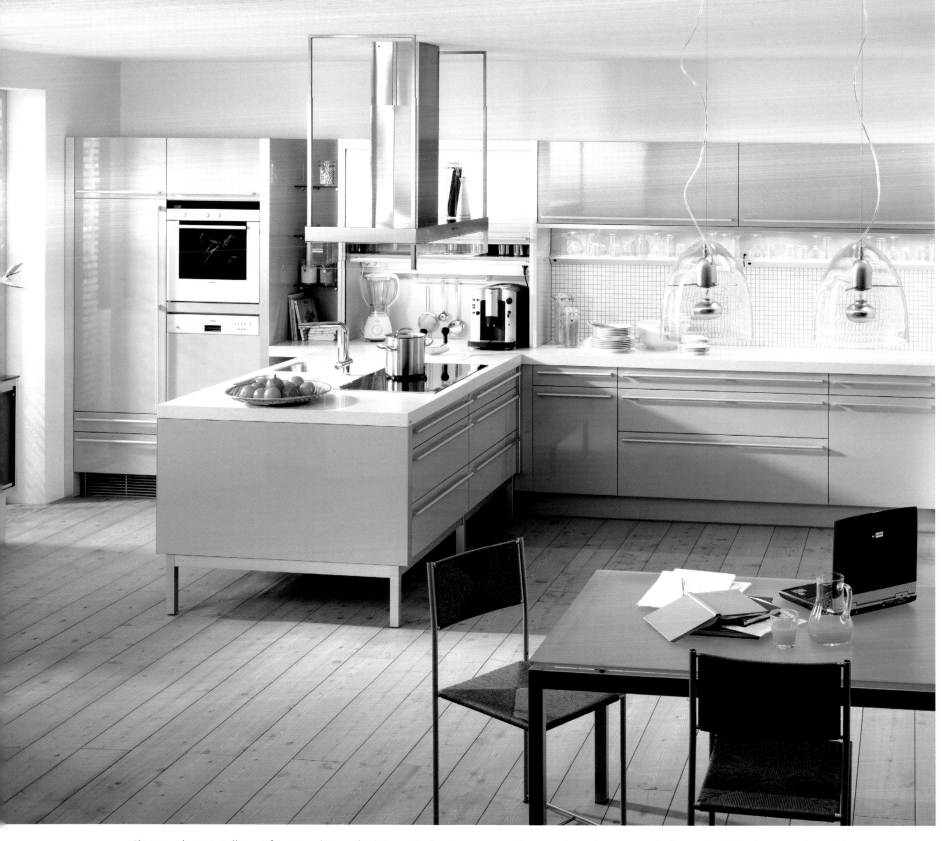

Clean outlines, intelligent functionality, and white with aluminum or gloss highlights – in the ewe range, even kitchen purists with a preference for urbane superiority can get their money's worth: compact storage space ensures a tidy kitchen.

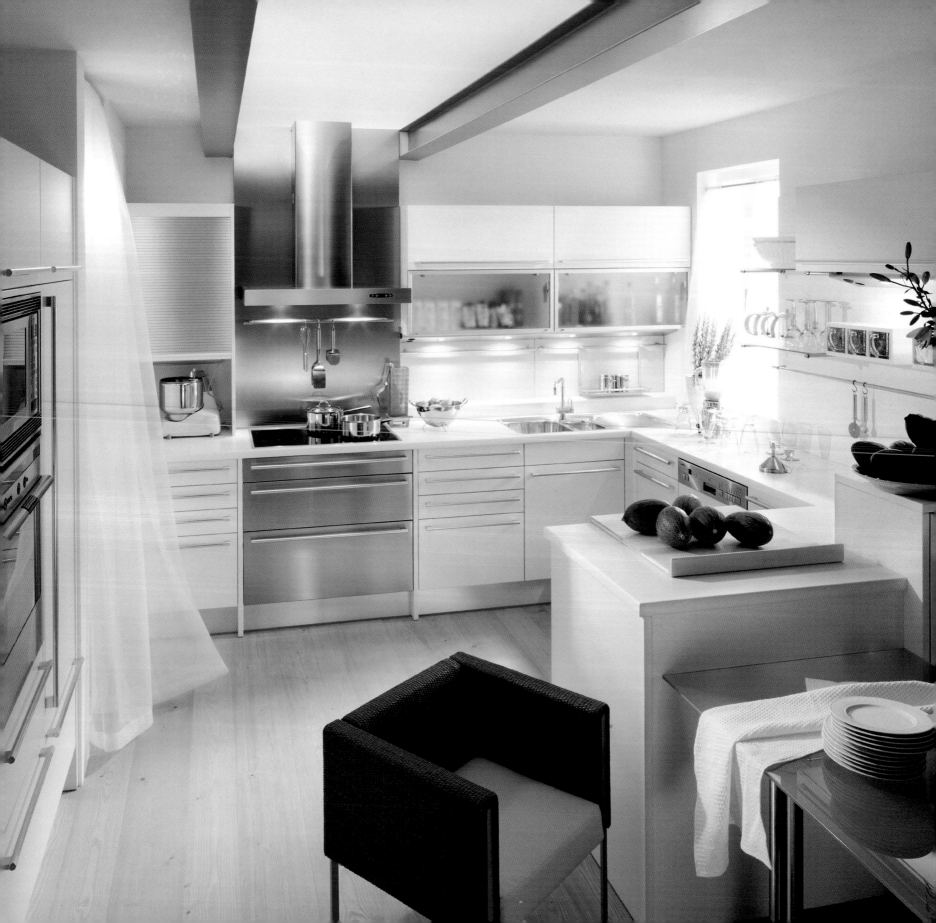

Functional or cozy, trendy or timeless, Mediterranean or Nordic: for contemporary kitchen designs with a promising future, quality and lasting value are in proportion to the versatility and adaptability of their aesthetic and functional solutions (ewe).

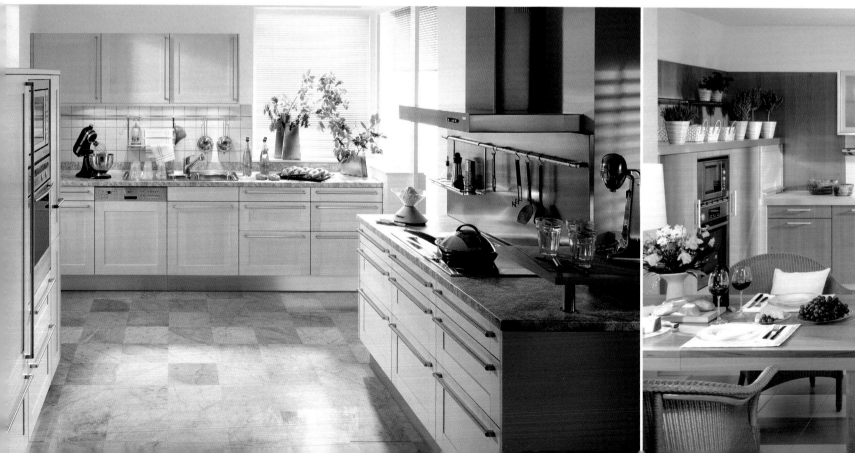

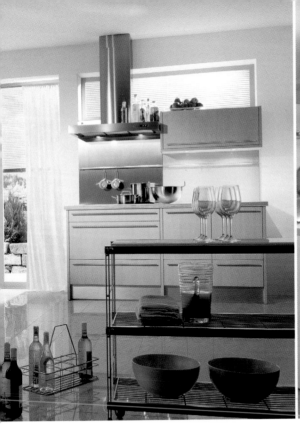

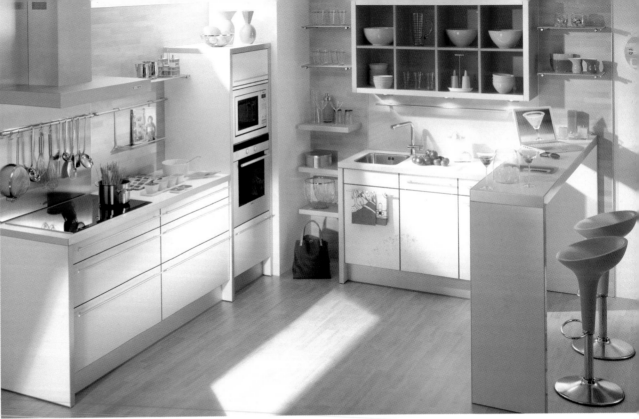

The kitchen as a living space: the company, ewe, gives creativity to the "warm heart of the house," and encourages users to arrange things in a way that bears their personal signature. Where else but in the kitchen do so many emotions come into play?

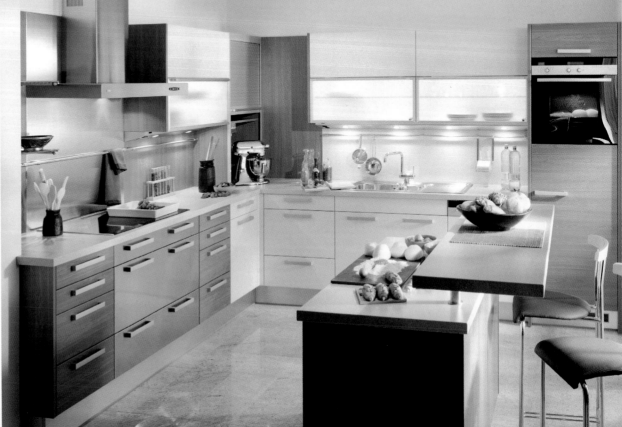

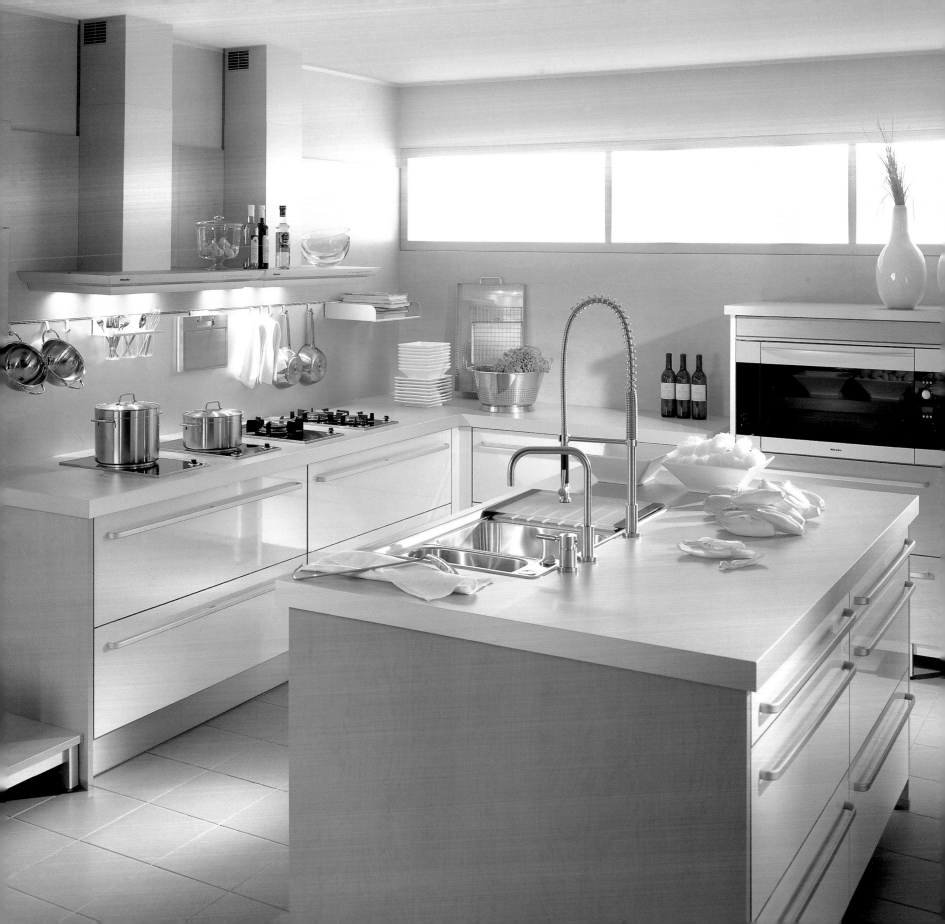

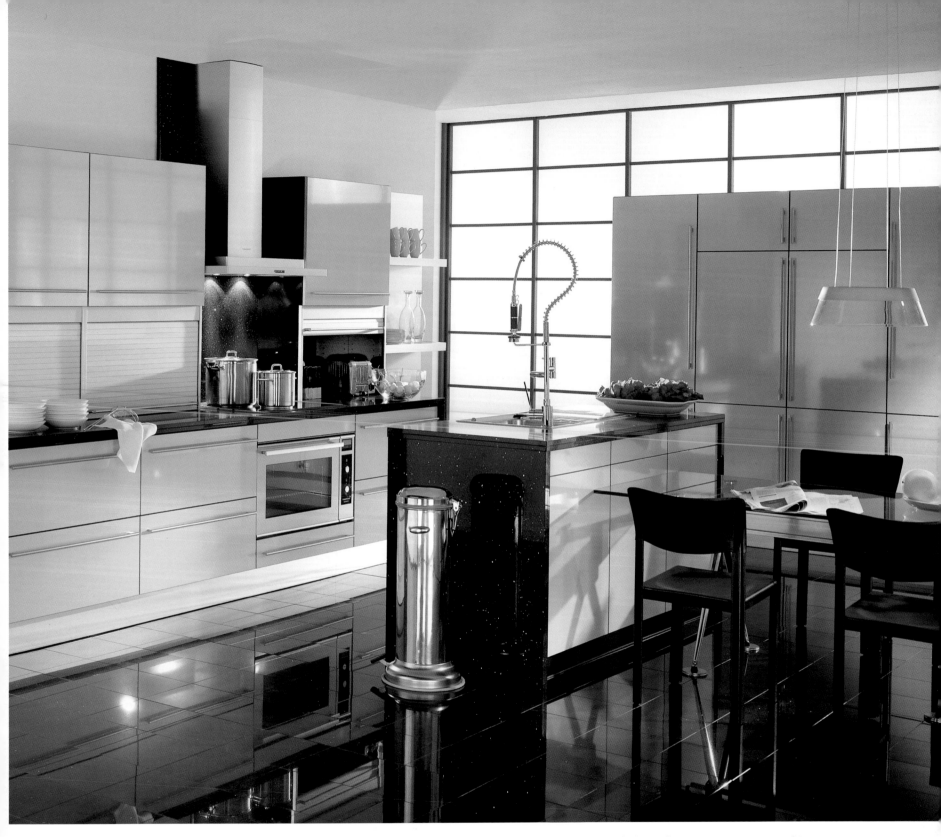

Linea and *Lucida*: these two glossy kitchens with their different color concepts (from manufacturer RWK) set the scene for the new enthusiasm for kitchens in a light and airy way, restoring cooking and eating to the light-hearted realm of pure enjoyment.

THE SMART REFRIGERATOR

Ringblomman 1 is a very special address in Stockholm. Here, the world's first high-tech apartments were built at the beginning of 2002. Thanks to the latest technology, the lives of their owners should be made very much easier. The heart of each apartment is its kitchen – and in it the refrigerator. Of course, this is not just any old refrigerator, but one that is way ahead of its predecessors in respect of information technology. The "cool box" has been developed by the Swedish Electrolux company, who first presented their smart Screenfridge to an amazed public at the *Domotechnica* exhibition in Cologne in 1999, and subsequently had it subjected to a practical test by several dozen families in Denmark.

The Screenfridge has a computer built into the door, and is connected to the Internet. Its touch screen makes it child's play to use, and it controls and manages all the tasks to be dealt with in a networked home. As a food manager, it keeps a watchful eye on the bar-coded products that are put in or taken out, signals what needs to be ordered, and sends the orders straight

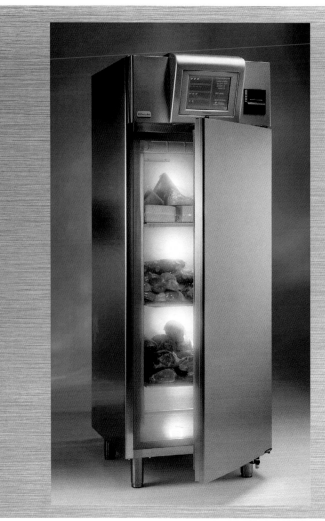

Cyber Fridge: the second generation Screenfridge, technologically more advanced and visually redesigned with a "cool" computer on top.

Temperature outside, weather, time, and the day's most important news: the Cyber Fridge computer is the perfect communications center for all the family.

SCREENF

off via the Internet. It warns about the use-by dates of fresh products, and makes suggestions as to what menus can be conjured up from the ingredients that are available.

The smart refrigerator computer also serves as a communications center for all the members of the family, as it can send them electronic messages in the form of e-mail or video mail. Additionally, it can let you send and receive e-mails, and search for information on the Web without having to exchange the cozy kitchen for the sober office one floor up or down. And because the kitchen is now well on the way to becoming the absolute center of life in the apartment, radio and television connections are also integrated, so the family can follow the morning news in peace over breakfast. A strange noise at the back door of the basement? Just press a button, and the refrigerator screen goes over to the pictures from the video camera that is keeping watch over the back of the building. Forgotten to put out the light in the basement? No problem; Screenfridge control will do the job quickly. Stressed with the family because they haven't tidied their rooms? Sorry, the fully automatic machine using Screenfridge remote control to pick up dirty washing and put away toys is still under development...

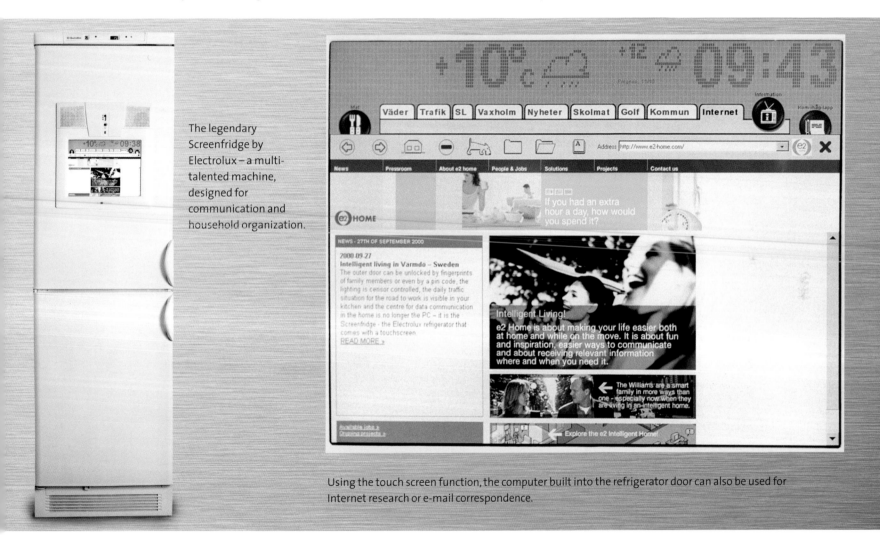

The legendary Screenfridge by Electrolux – a multi-talented machine, designed for communication and household organization.

Using the touch screen function, the computer built into the refrigerator door can also be used for Internet research or e-mail correspondence.

R I D G E

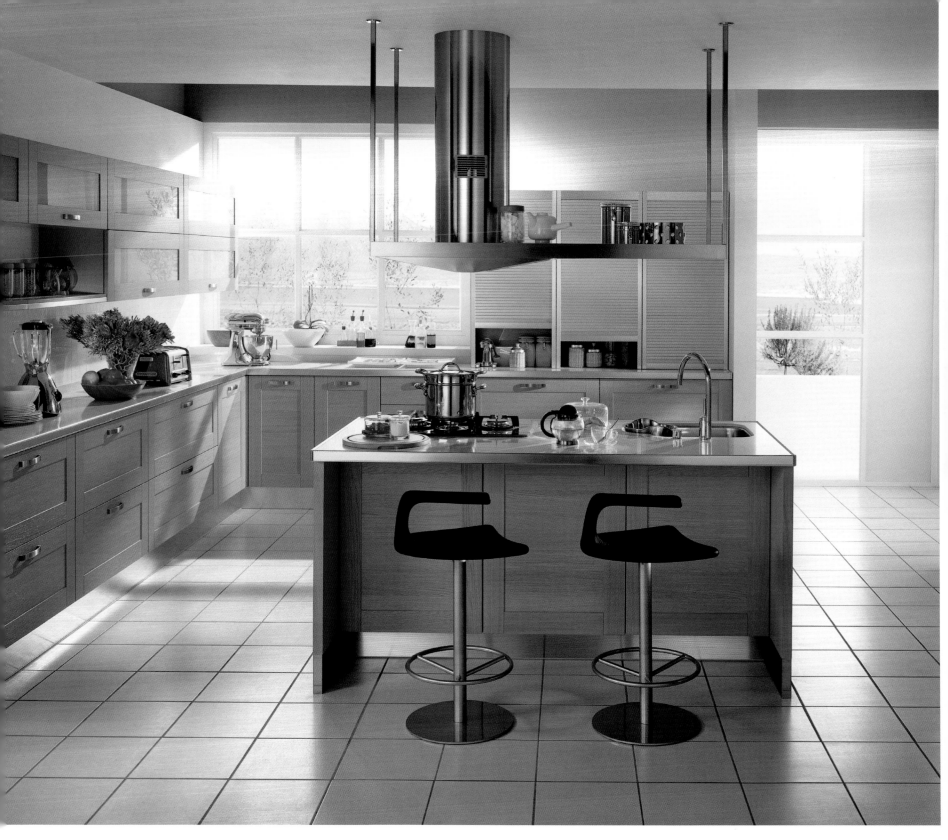

The first rays of the morning sun wake the kitchen from its nighttime sleep. For a light-hearted start to the day, *Play* by Scavolini shows its happy, scrubbed, light-oak face and sends the world an Italian *dolce far niente* greeting.

Life by Scavolini has everything needed to be the perfect kitchen for the passionate professional cook, and yet its design is so airy and spacious that there is still plenty of room for users to arrange things in their own individual way.

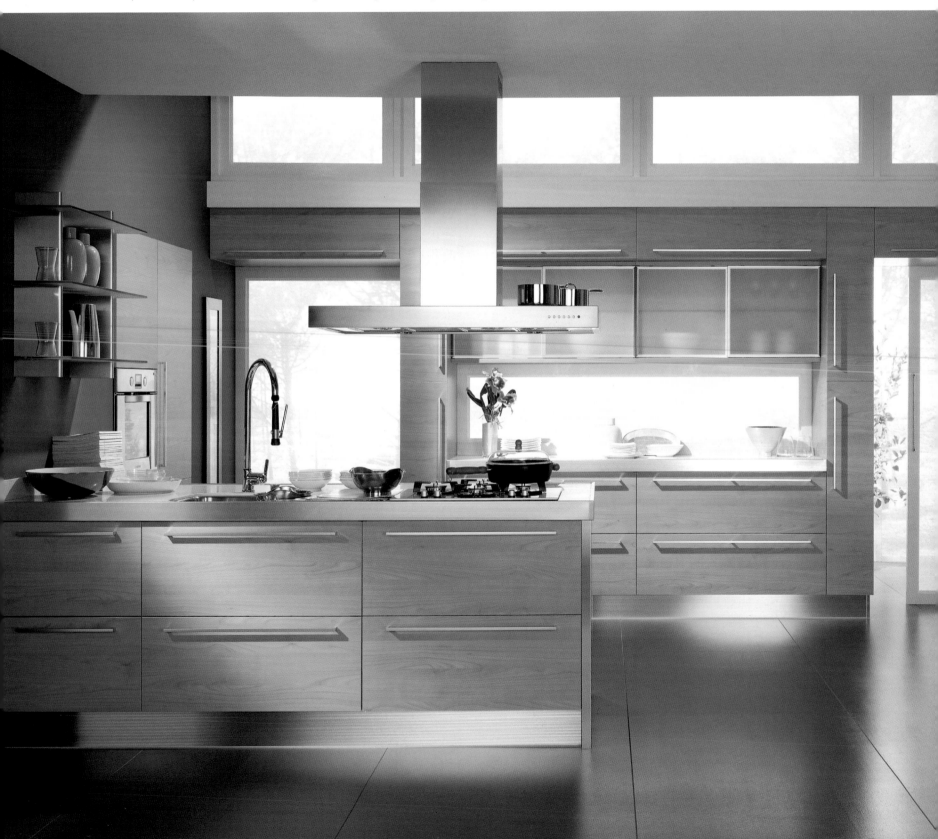

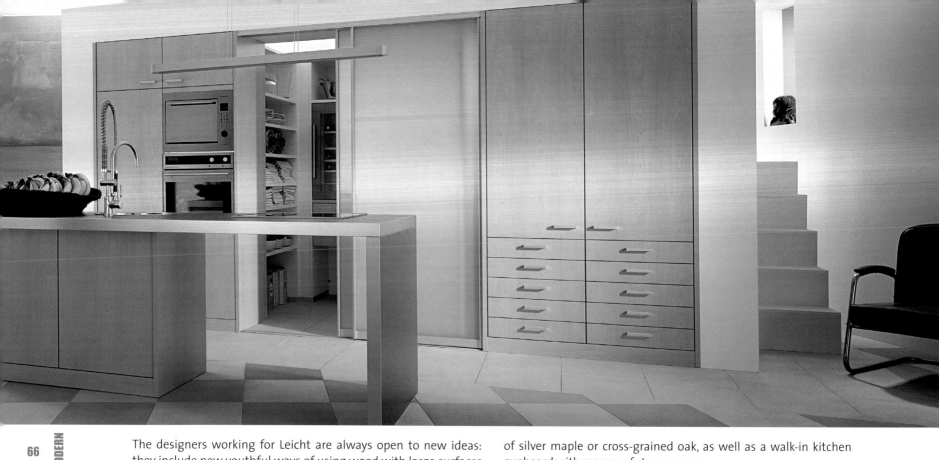

The designers working for Leicht are always open to new ideas: they include new youthful ways of using wood with large surfaces of silver maple or cross-grained oak, as well as a walk-in kitchen cupboard with masses of storage space.

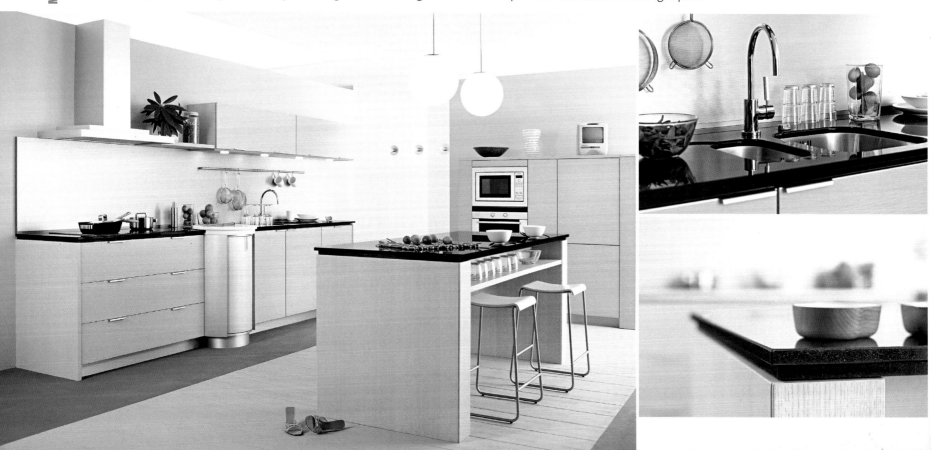

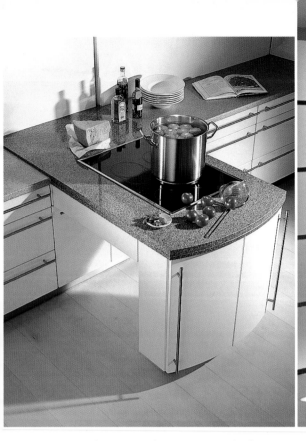

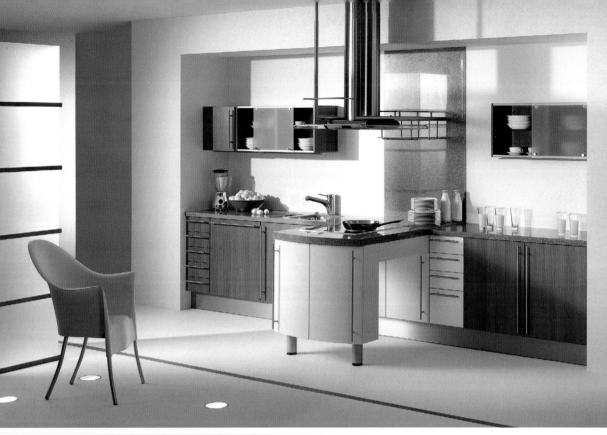

The open-plan room and the most varied combinations of materials give added dynamics to the way the kitchen space is used (*Avance HI*, below). "Dialogue centers," with work surfaces that can be used by several people at once, are typical of Leicht (above).

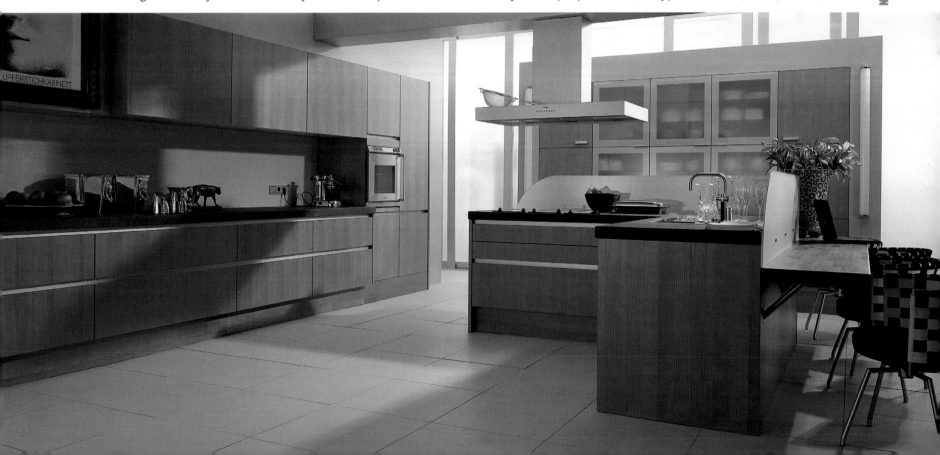

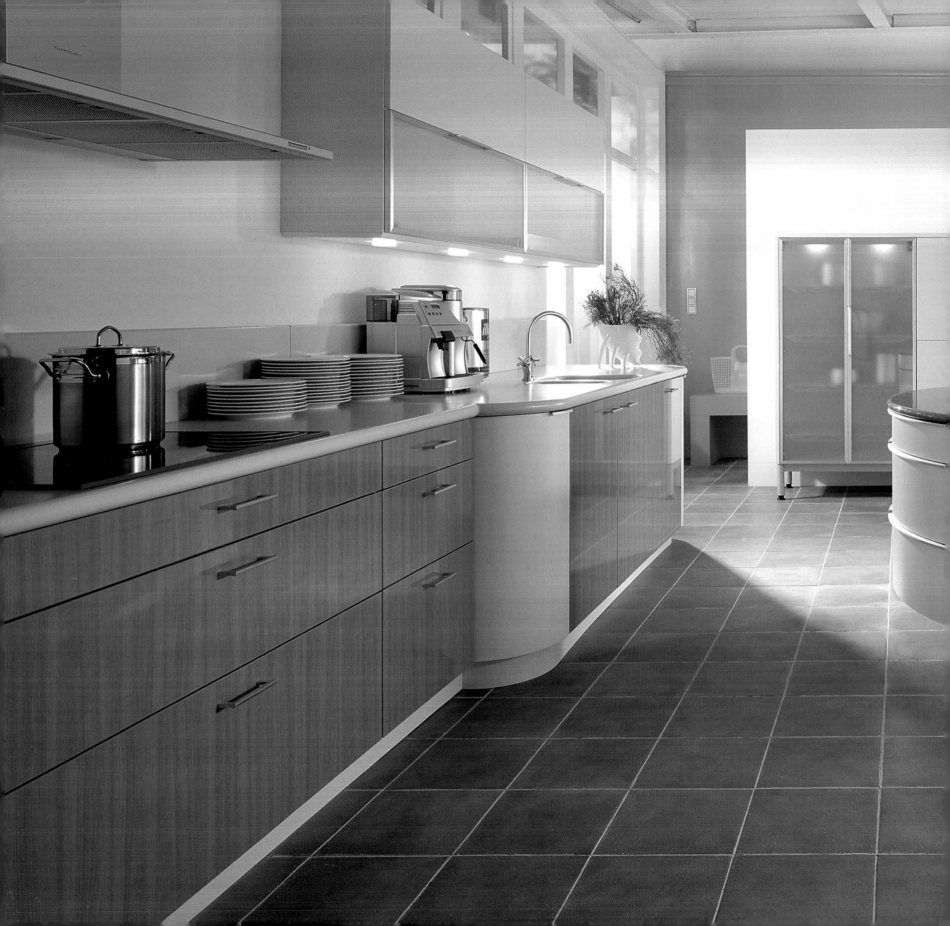

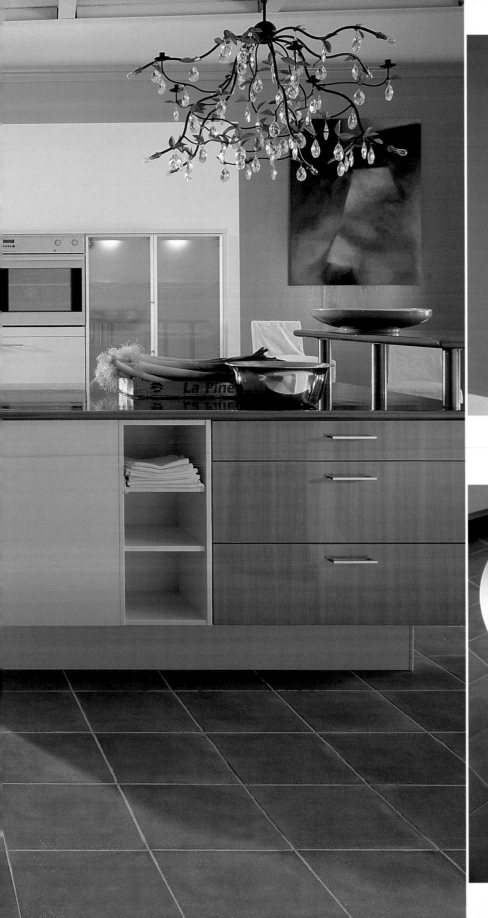

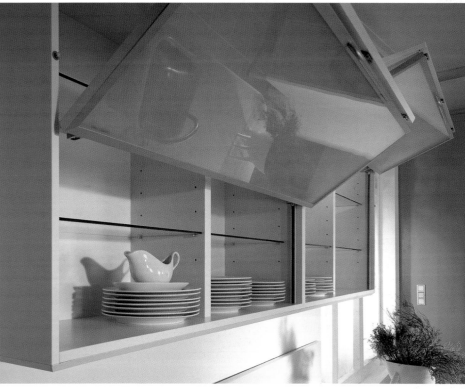

Brilliant and elegant: *Memory* by Leicht with its rounded forms, stylish colors, and an "inner life" that is planned down to the smallest detail.

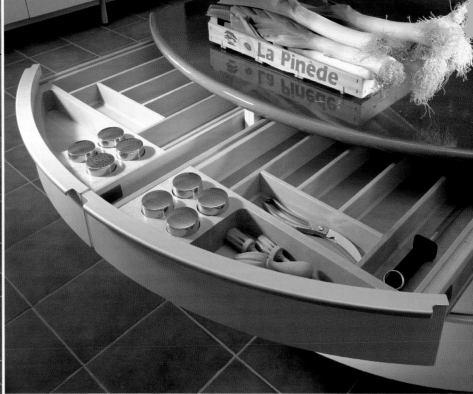

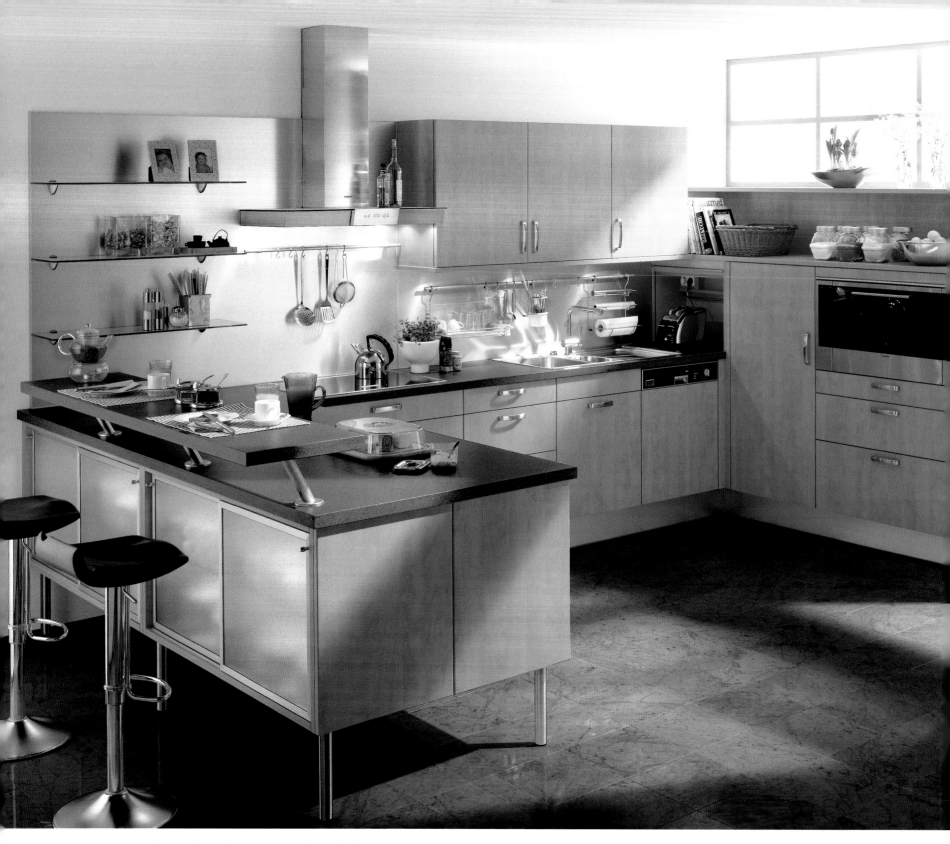

In this kitchen, the apricot birchwood decor radiates a unique warmth, and glass doors and strong work surfaces add a stylish counterpoint. *Scena* by FM helps to put the art of living in the kitchen on permanent show.

Everything neat and tidy, because the *Viale Pro* by FM offers indestructible copper surfaces and ample storage space, partly through unusual cabinet and shelving solutions. Even tidying up becomes a pleasure.

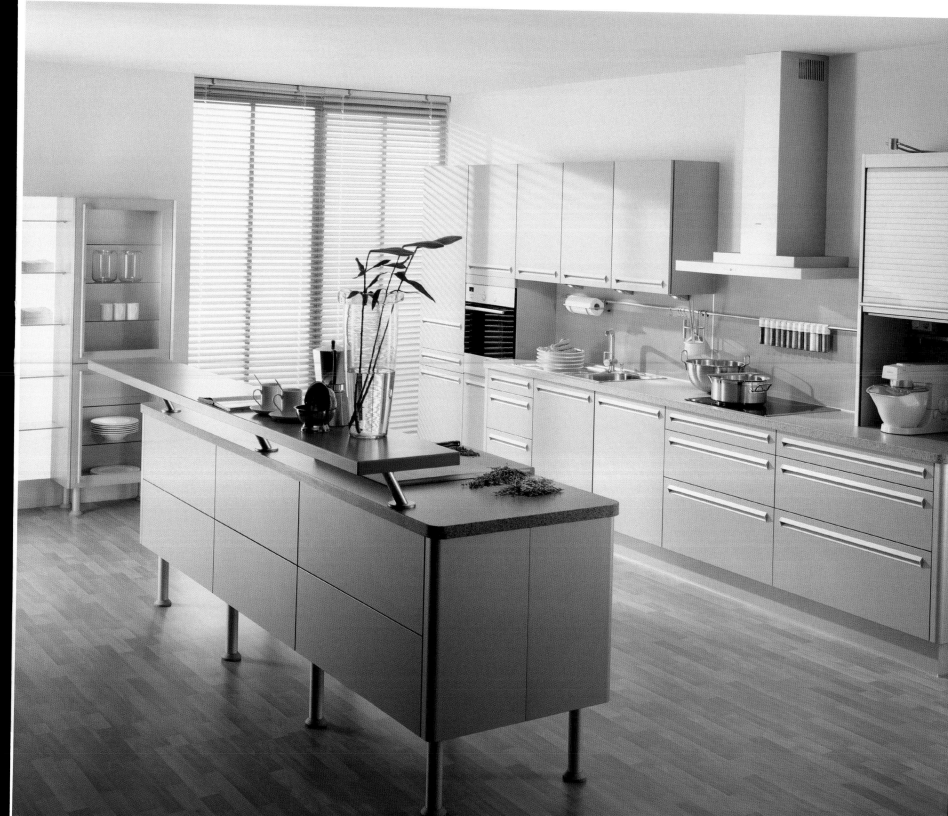

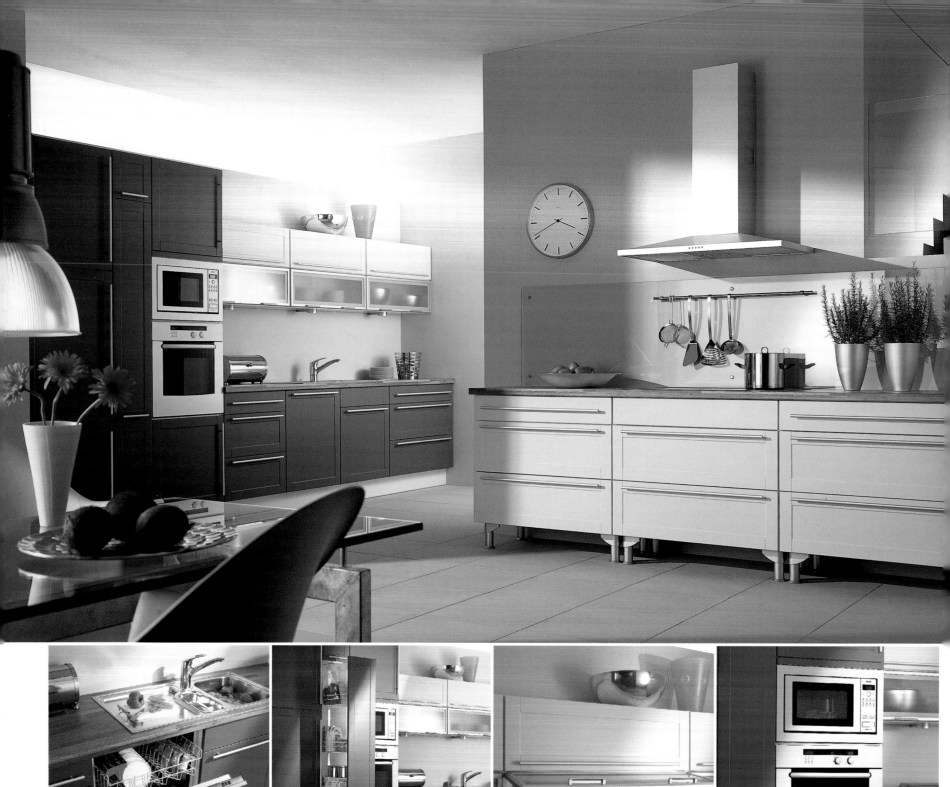

The kitchen as powerhouse: stoke up with energy for the day, and relax for the night. With their matter-of-course luxury and clean outlines, kitchens by Impuls offer a slice of indispensable quality of life to powerful women and strong men.

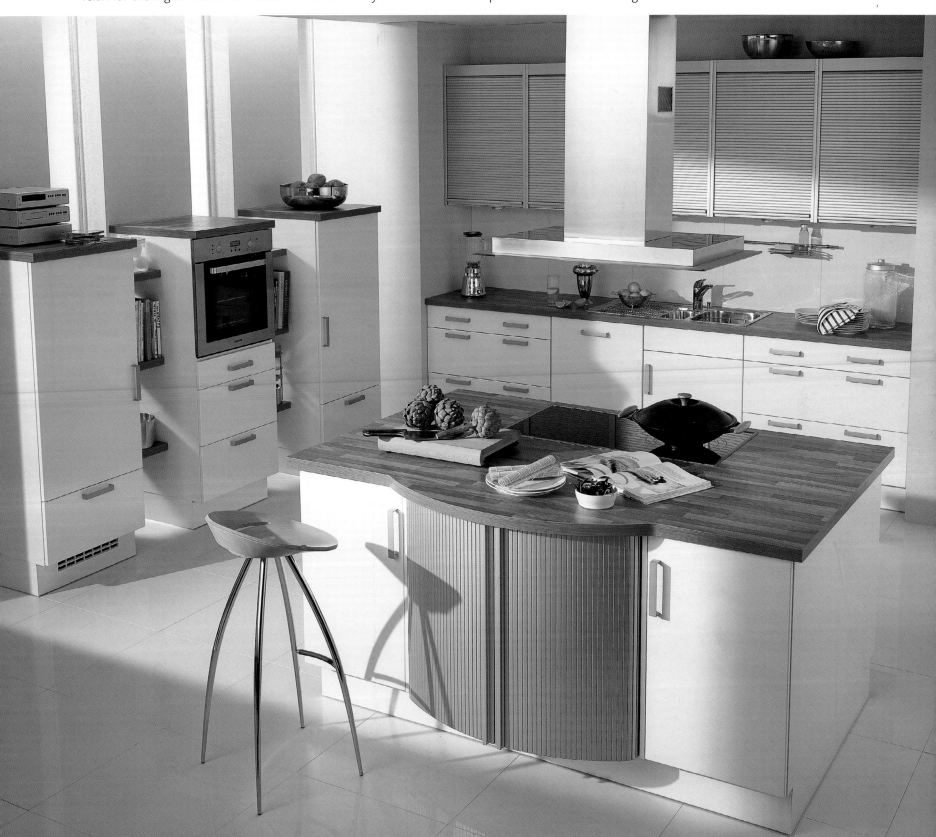

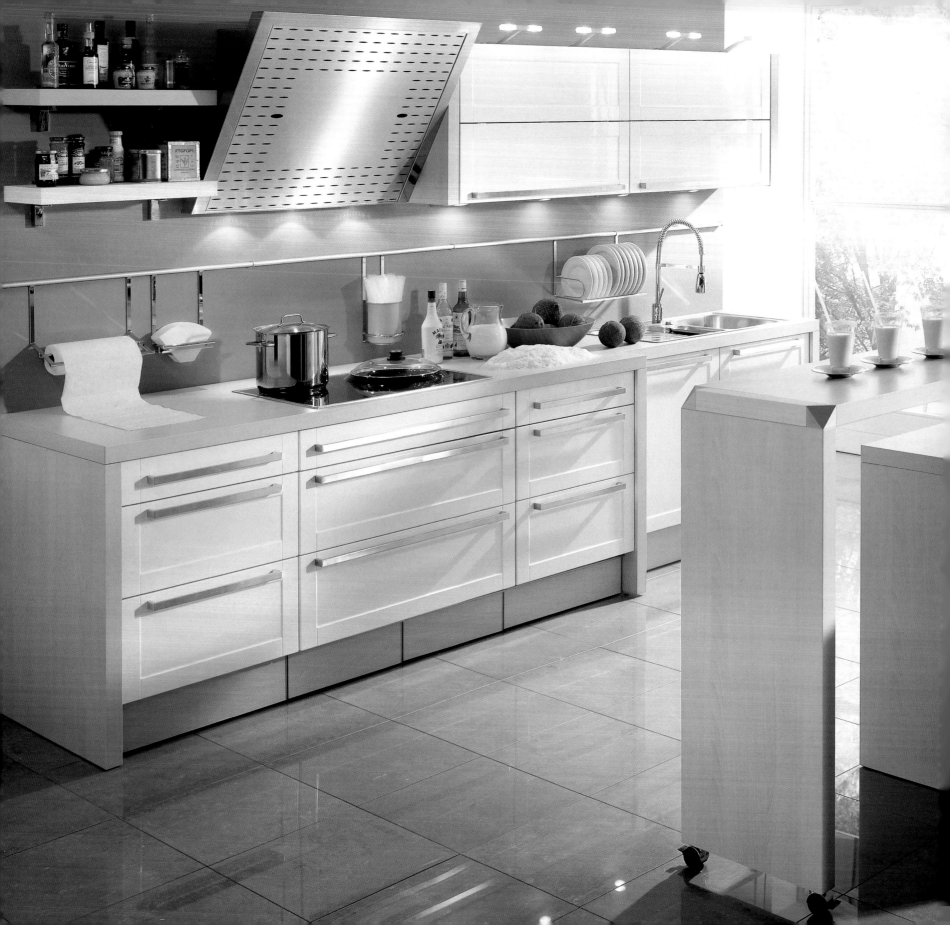

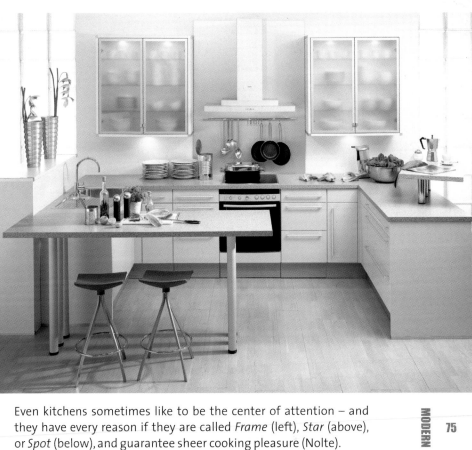

Even kitchens sometimes like to be the center of attention – and they have every reason if they are called *Frame* (left), *Star* (above), or *Spot* (below), and guarantee sheer cooking pleasure (Nolte).

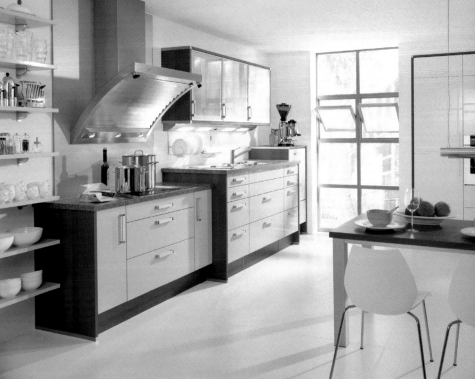

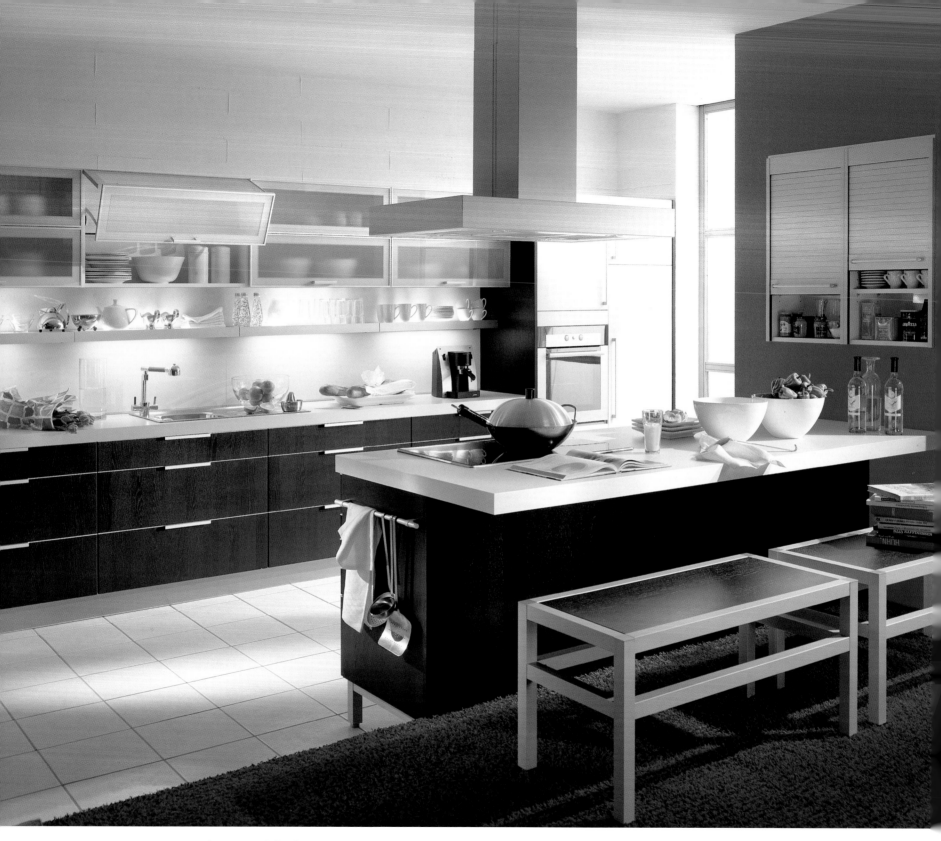

Open space solutions and fluid transitions to the living area are the expression of a contemporary kitchen culture, in which beauty and functionality have formed a creative liaison. Striking color contrasts create exciting dynamics (Geba).

A slightly Mediterranean look, with a lot of storage space behind glass and on the floor, and a pragmatic division of the working areas. This is how we might imagine the new "lightness of being" in the kitchen – unconventional yet functional (Geba).

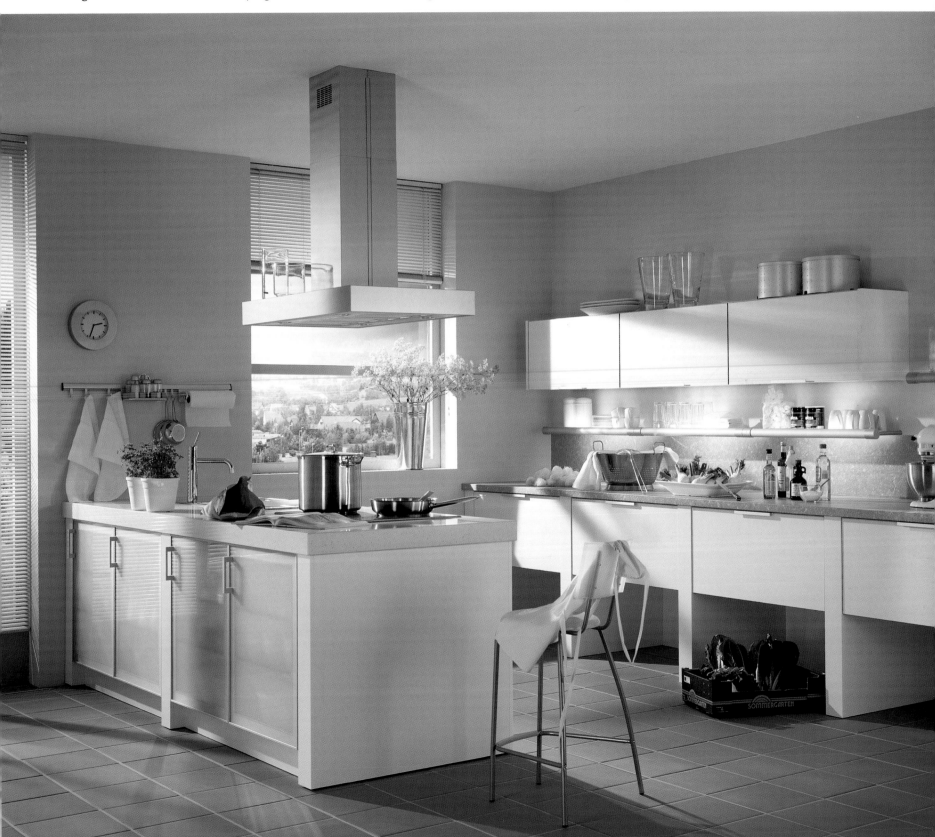

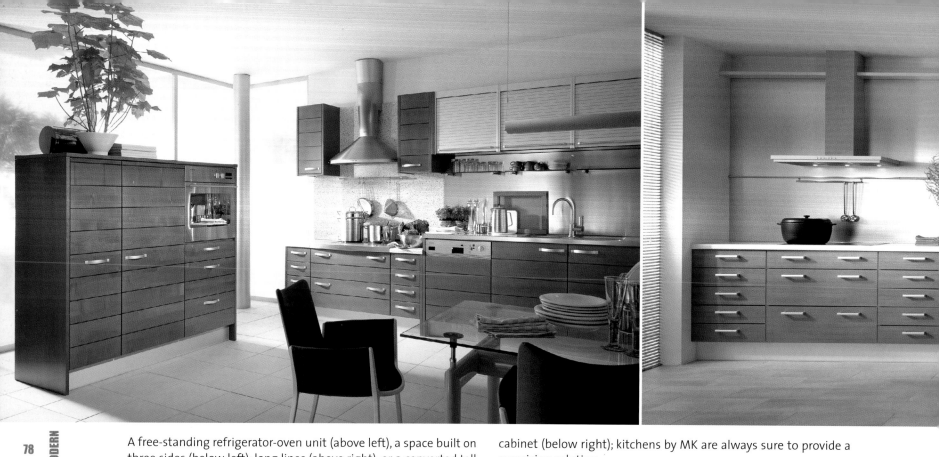

A free-standing refrigerator-oven unit (above left), a space built on three sides (below left); long lines (above right), or a converted tall cabinet (below right); kitchens by MK are always sure to provide a surprising solution.

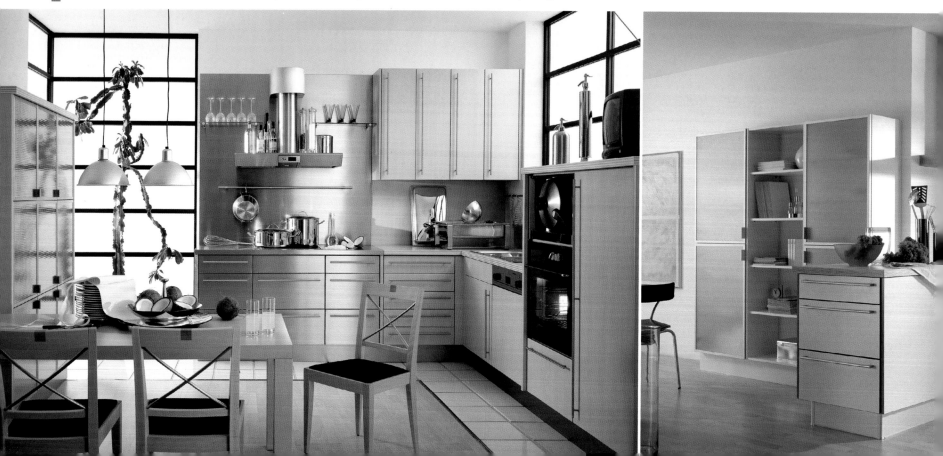

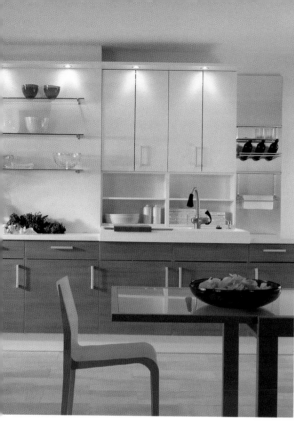

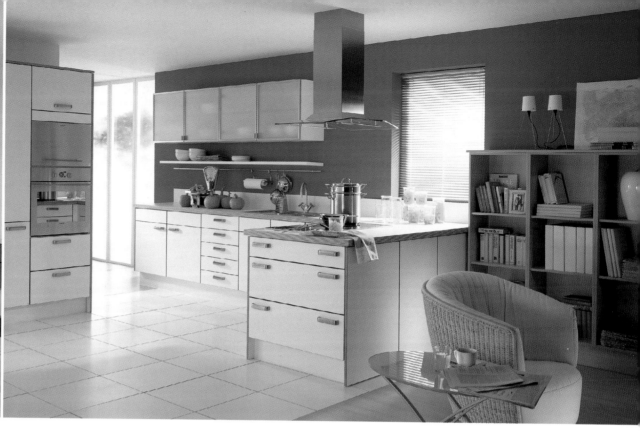

Decorative highlights and the daring way aluminum, stainless steel, glass, and wood are integrated give these kitchens an aura of modernity that still manages to be cozy. New concepts of space create amazing looks.

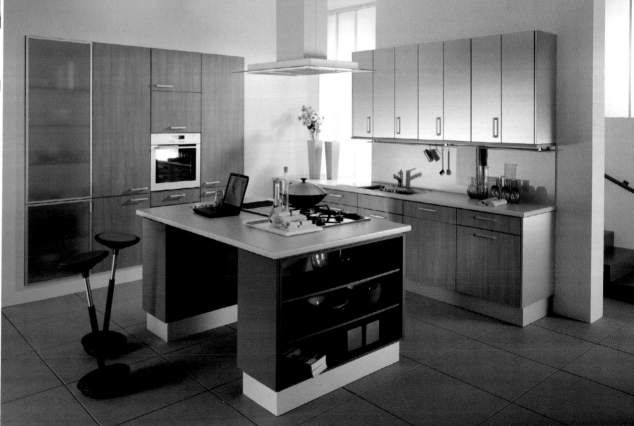

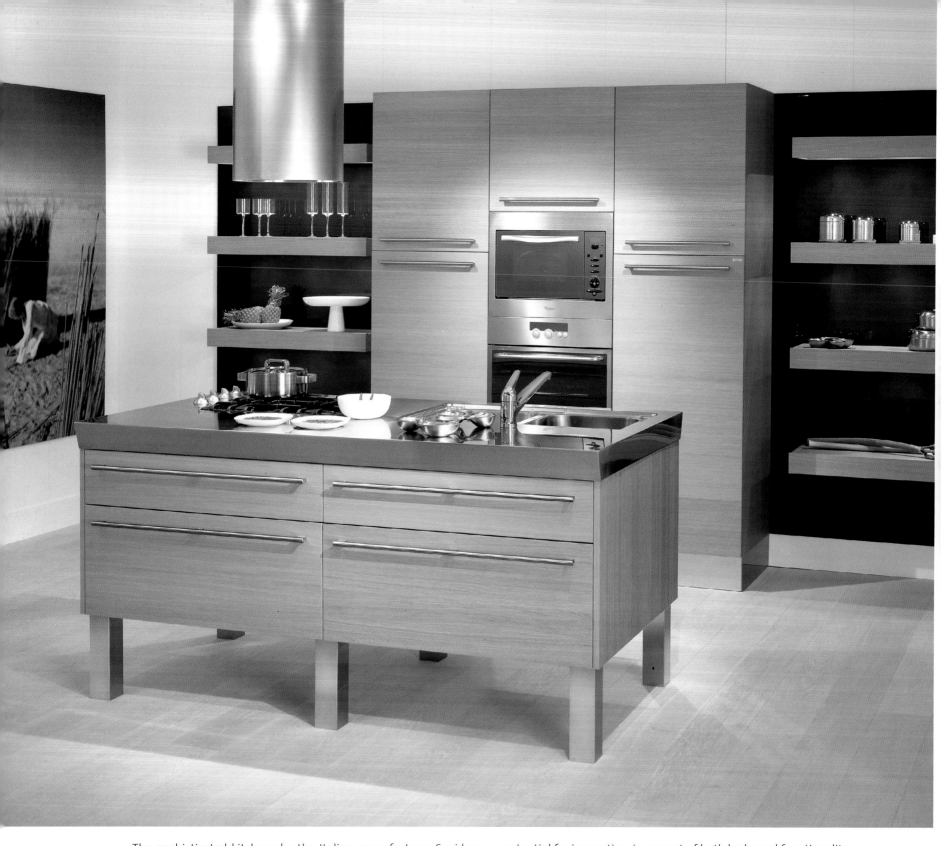

The sophisticated kitchens by the Italian manufacturer Snaidero are distinguished by a reduced language of forms and a high potential for innovation, in respect of both looks and functionality: *Sistema Zeta* (left), *Time* (right).

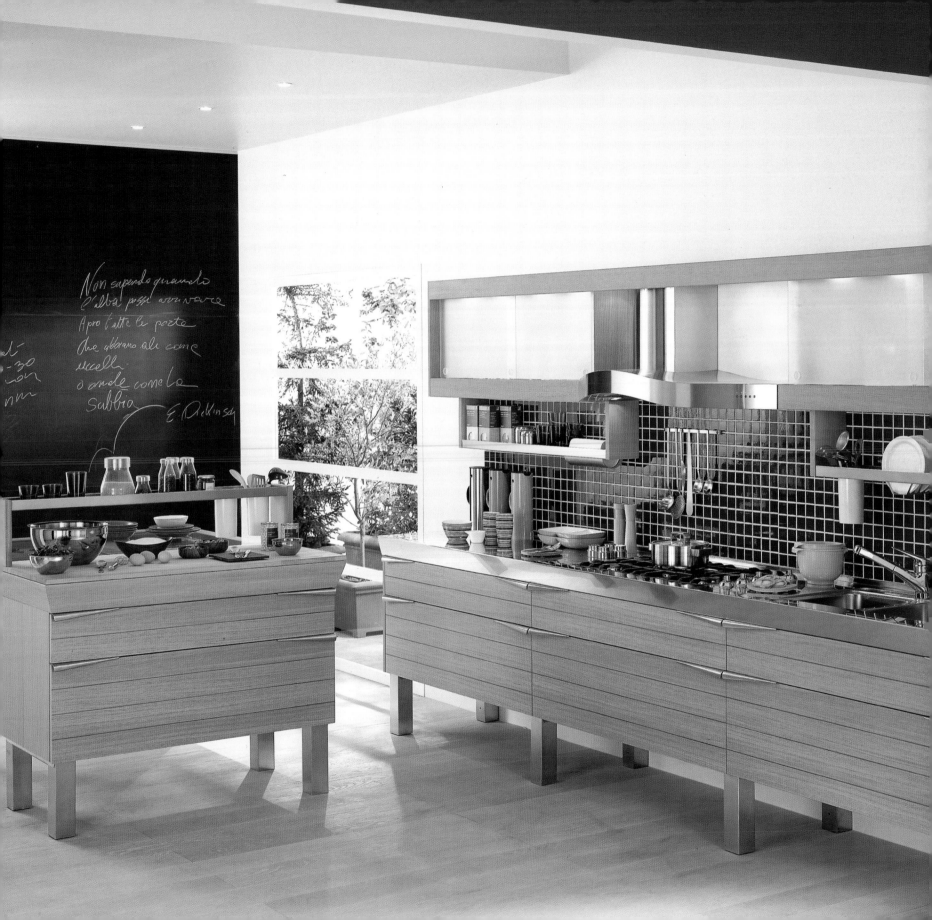

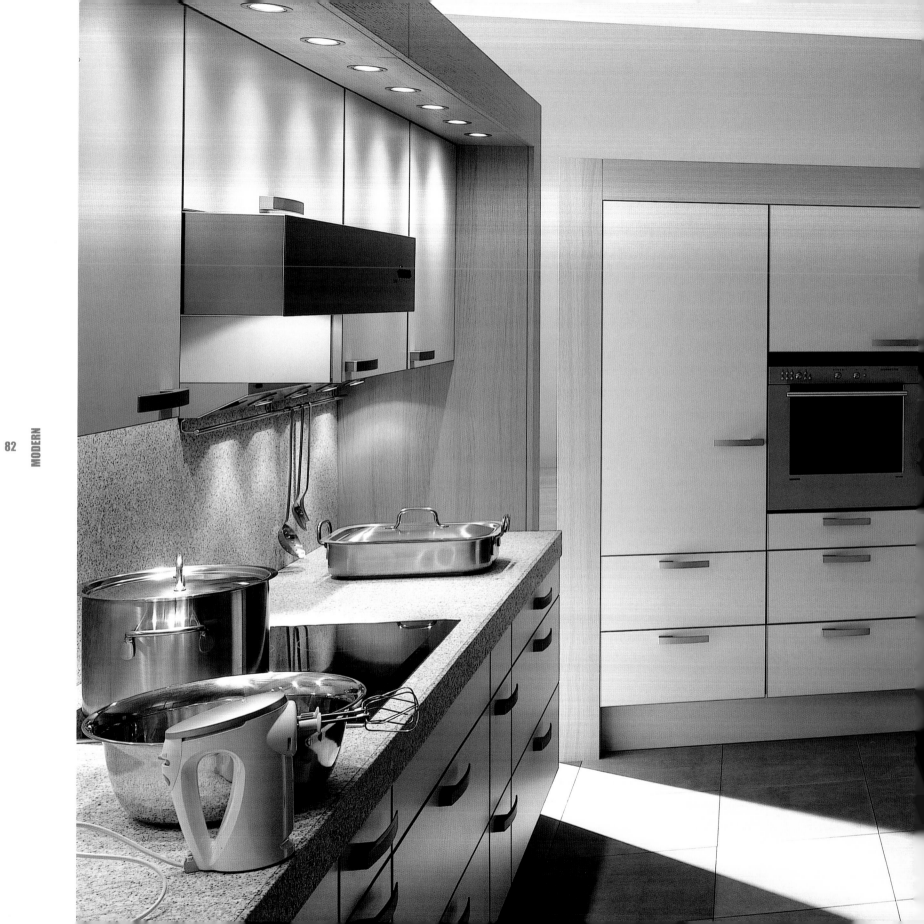

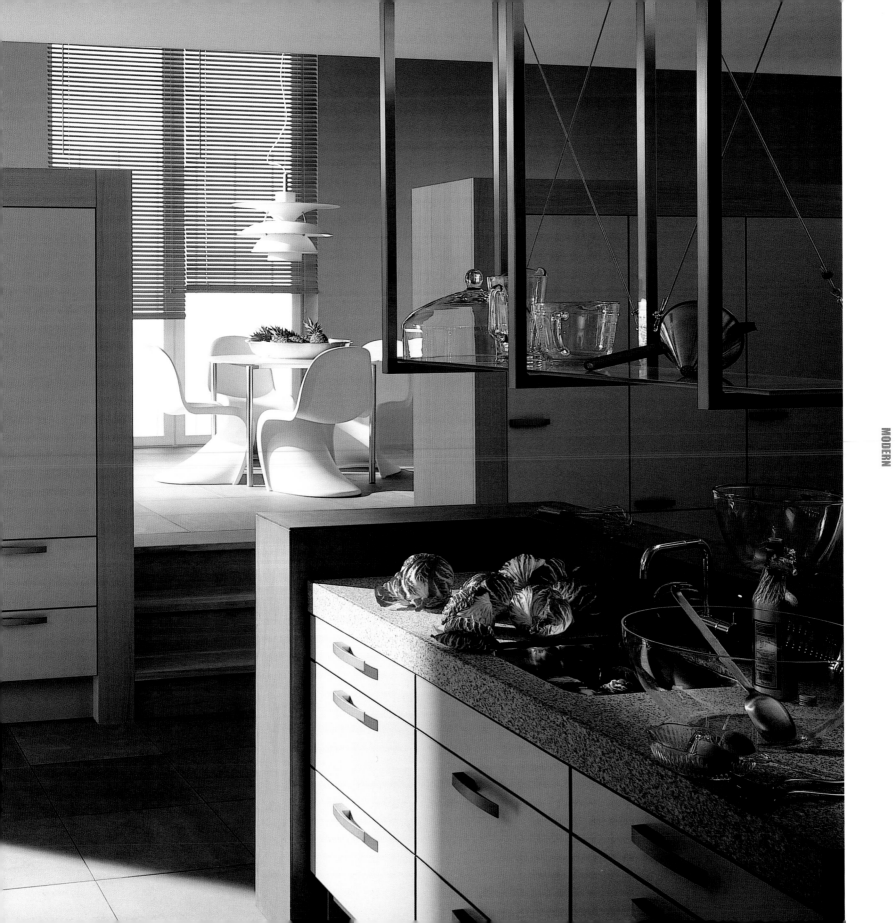

With their balanced dimensions (previous pages), also suitable for small spaces (below), the innovative solutions offered by SieMatic can adapt to any conditions, without losing sight of their elegant baselines and sense of luxury.

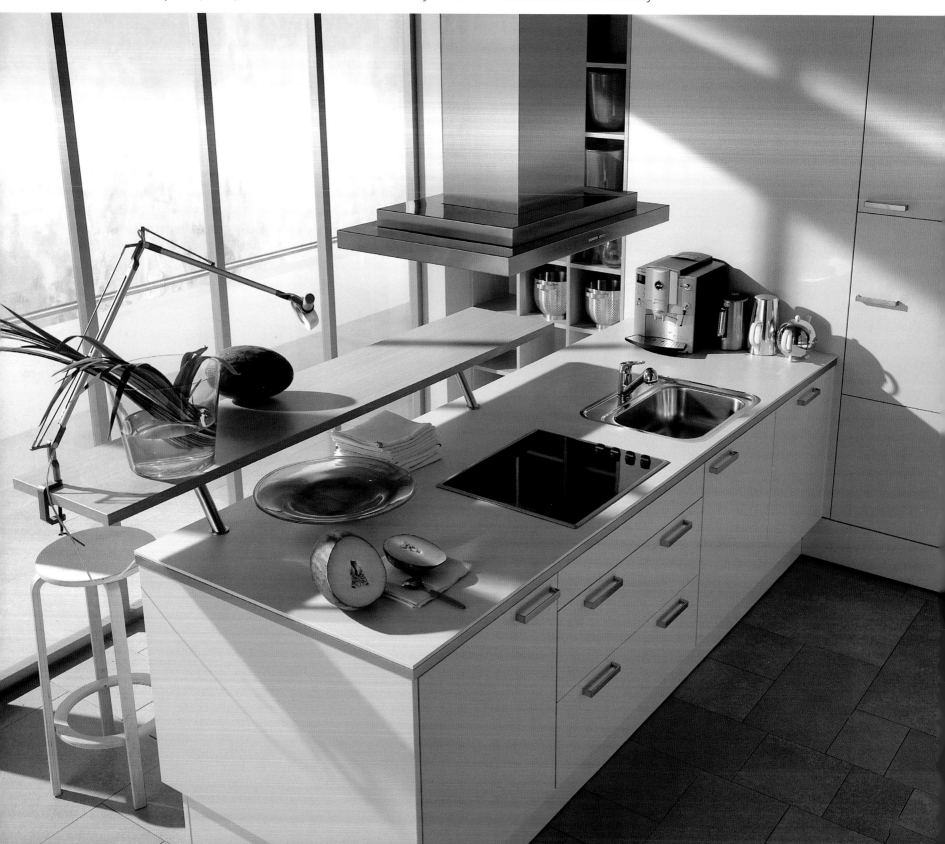

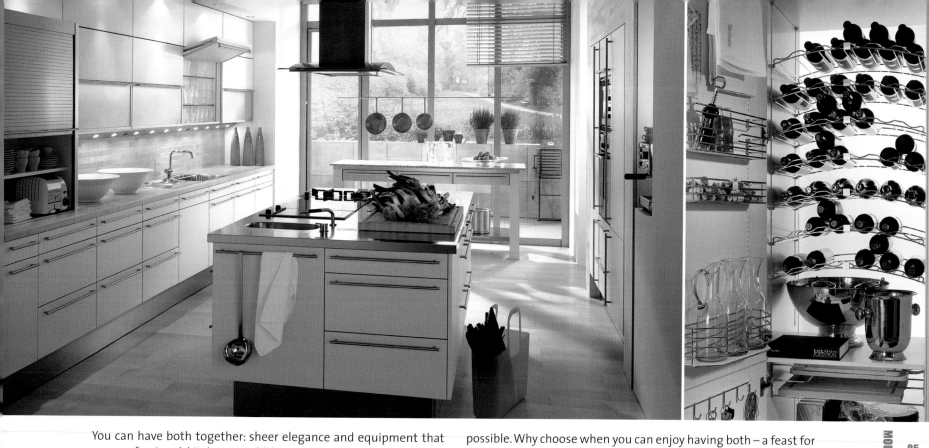

You can have both together: sheer elegance and equipment that any professional kitchen would be proud of. SieMatic makes it possible. Why choose when you can enjoy having both – a feast for the palate and for the eye? (See also following pages).

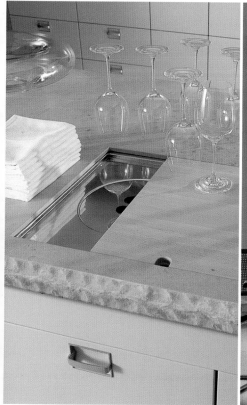

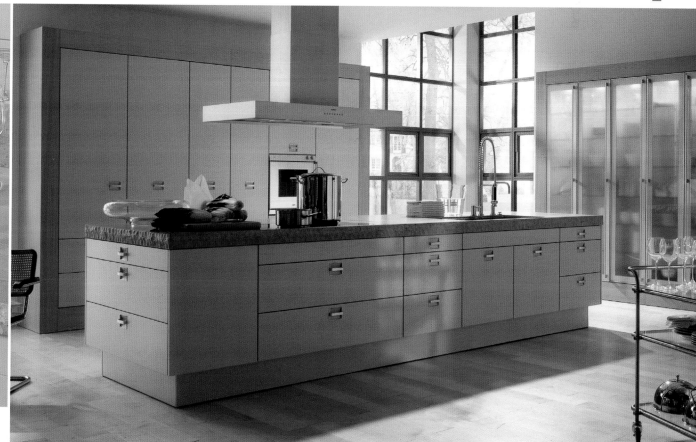

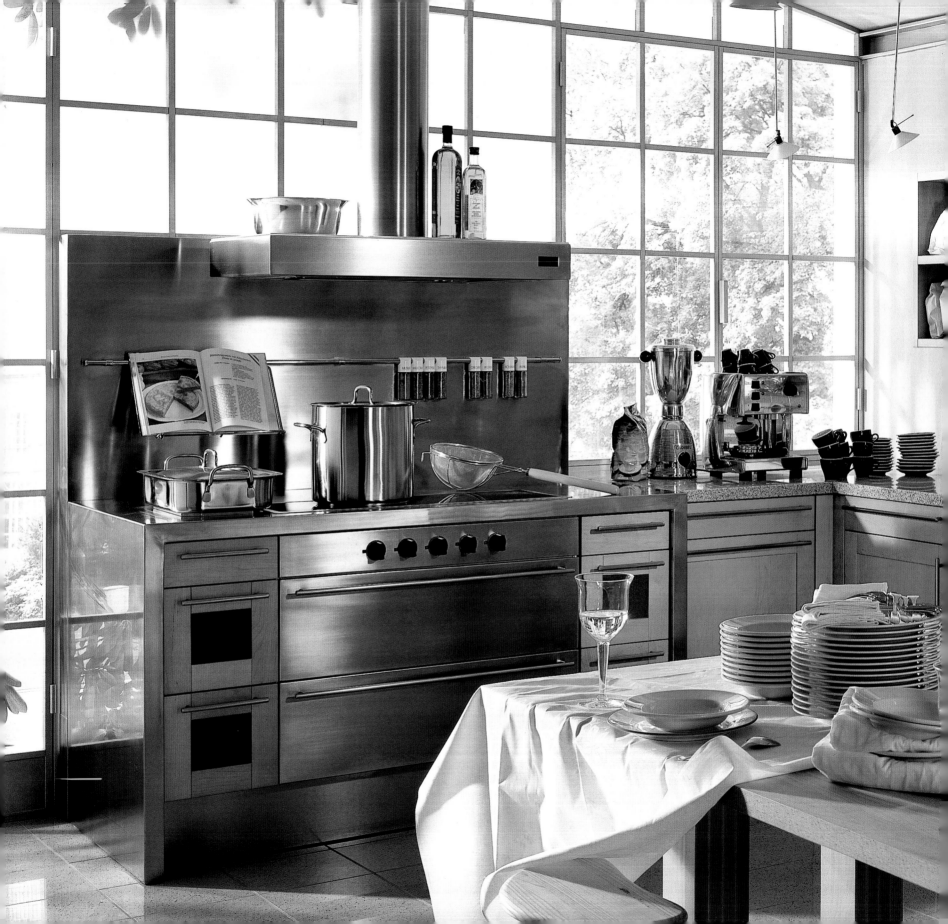

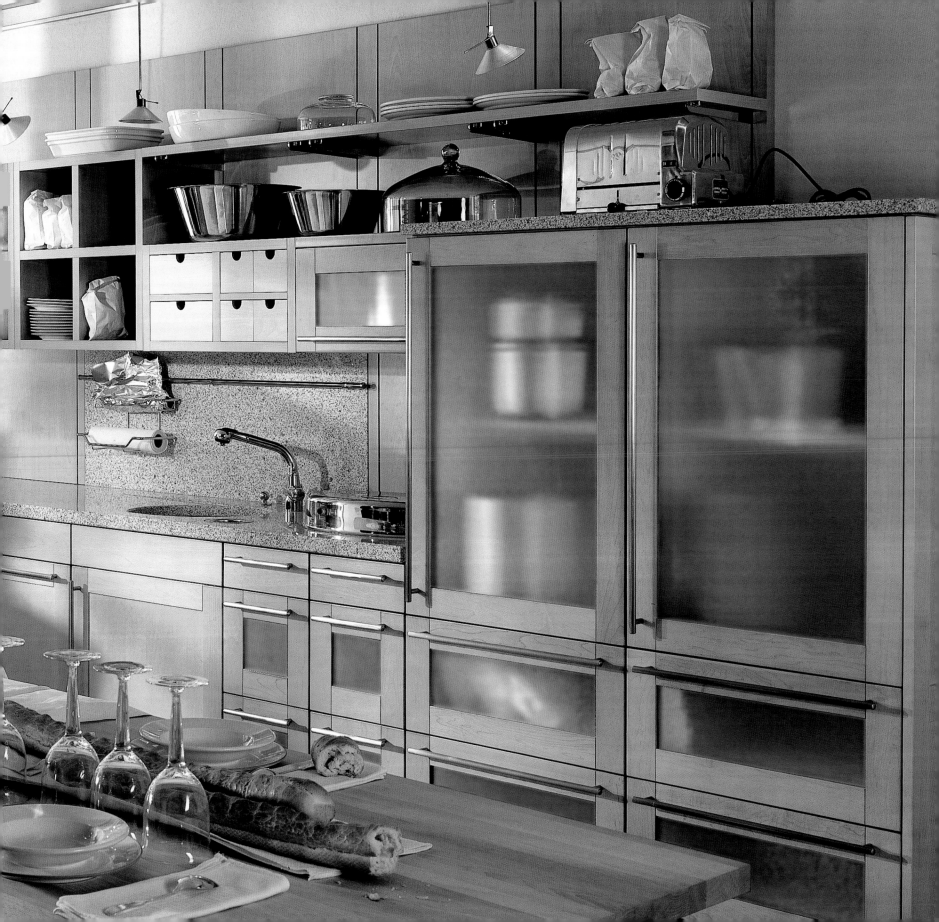

T U P P E R

The father of Tupperware:
Earl S. Tupper with one of his sets of
prizewinning bowls.

Tupperware parties have become a cult – no
longer just for ladies' circles but also for
enthusiastic amateur cooks.

Here color is the thing –
whether for bowls (above) or
the 10-egg storer *Kolumbus*.

Storing food – for a short time in the
Twin Set double snack box, or for
longer in the *Expressions Ovals* series
of food containers (below).

HAVE YOU TUPPERED TODAY?

There is a German proverb that says you save yourself work if you keep things in good order. Maybe Earl Silas Tupper had heard something similar repeated throughout his childhood and taken it to heart. That at least would explain why, immediately after the end of World War Two, the American chemist began to develop household products made from the new wonder plastic polyethylene. It all started with a cheap, indestructible plastic tooth mug, available in many colors. This was followed immediately by the *Wonder Bowl* with its sealable lid, which was the ancestor of all subsequent Tupperware articles. Gentle pressure on the lid squeezes the air out from inside the container, creating a vacuum inside, so that perishable foods can be kept water- and airtight. After these, everything that could help to bring order out of the chaos of kitchen cabinets was produced by Tupper's newly founded company – plastic boxes and containers of every shape and size for a thousand-and-one purposes.

The company's marketing strategy was just as smart as its products, as Tupperware was not sold over the counter in department stores, but by well-trained saleswomen in the cozy atmosphere of the living room, accompanied by crackers and lemonade. Three years after the introduction of Tupperware parties in 1951, there were already 9,000 advisers busy working very successfully for the company all over the USA. Today there are around a million women – and more and more men as well – in a hundred countries in the world, working to make kitchens and their owners happy with Tupperware products. Every year around forty new products are launched on the market, increasing the available selection. As always, functionality has top priority. The items that make the preparation, keeping or freezing of food easier for housewives or househusbands must be practical and without frills, but attractive and fit to put on the dinner table. Attention is paid to regional differences – color preferences, for example – and also to size. For instance, it turned out during the development of the Far Eastern market that the standard sizes were simply too big and clumsy for the delicate hands of Japanese women.

The fact that, because the material is very stable, Tupperware products are not easily broken – even in the most chaotic kitchen – goes against the

Famous prize winners for design are the tried-and-tested fridge storage containers and the *Garlic Wonder* garlic press (below).

A handy sieve and a multi-talented mixing bowl .

Cooking or baking – Tupperware helps with an elegant range for kitchen professionals and flexible silicon pastry mould series.

Small but beautiful: the small storage container for herbs and the *Swing Box* keep stored foods tidy.

throwaway mentality that is built into many other contemporary products. Earl Tupper went a step further by giving all his products a thirty-year guarantee. The fact that the success story continues – and the market has apparently still not reached saturation point – is shown by the company's ever-increasing profits, which were over 1.1 billion dollars in 2000. Serious competition from contemporary kitchen furniture manufacturers – who also like to keep things in order – might be a long-term threat to the colorful plastic boxes, because fixed systems for keeping things tidy are better than a lot of boxes piled up in cabinets and drawers. However, it will not be so easy for them to destroy Tupperware's cult status. What kitchen cabinet could compete with products with such delightful-sounding names as *CrystalWave*, *Stuffables*, or *Shelfsmart*?

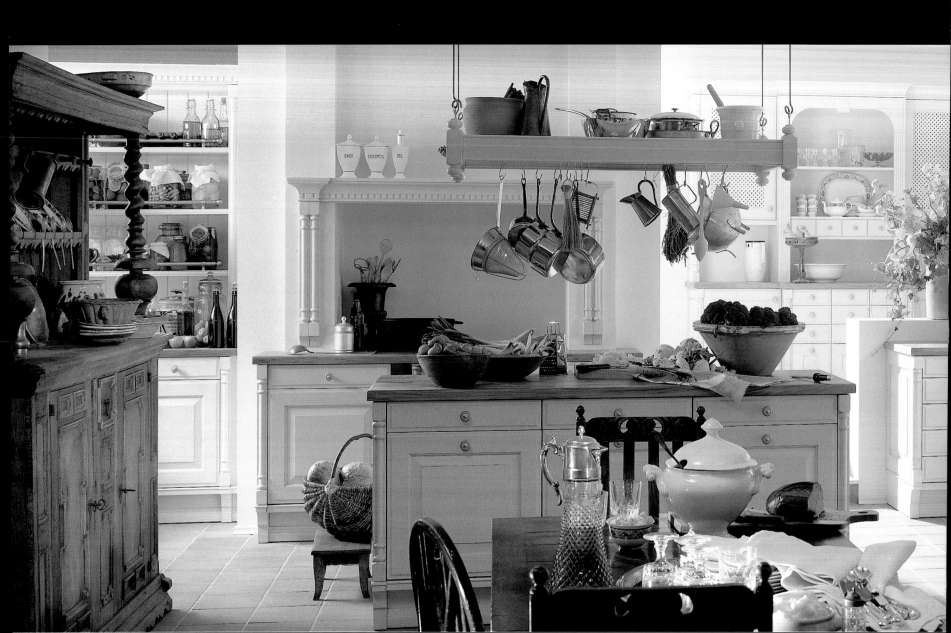

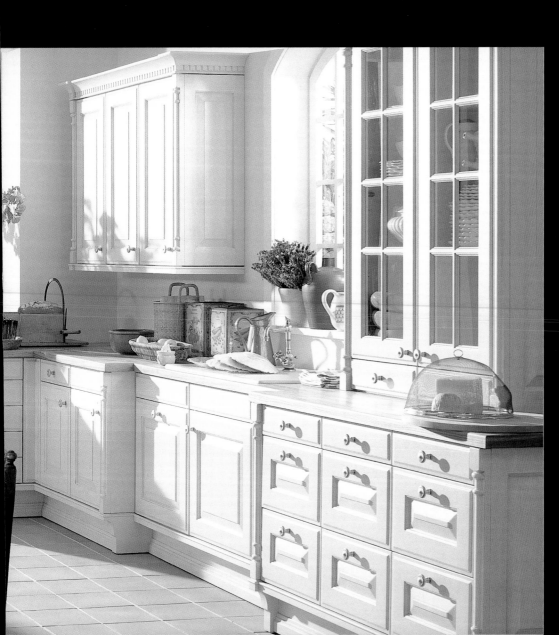

TRADITIONAL CHARM AND MODERN CONVENIENCE

Everybody suffers from it at some time – the nostalgic memory of the good old days. A country childhood, holidays at grandmother's house or the security of mother's kitchen, surrounded by the smell of roasting meat and the singing of the kettle – we use a country-style kitchen to bring a little bit of all those things back into our everyday lives. Curved arches, decorative edgings and trims, recessed surfaces and ledges, old-fashioned ovens, and huge stone sinks spread a feeling of warmth and comfort, enabling us to reminisce about traditional lifestyles. Wood in every shade and color is one of the most important features from this point of view, because it radiates natural coziness and conjures up associations with the quality of craftsmanship of the individual master carpenter, as it used to be, before the days of mass-produced kitchens.

Moreover, country-style kitchens are by no means confined to the pretty cottage or the holiday home, but also grace big-city apartments and neat suburban houses. They are distinguished by a high degree of individuality – which often distinguishes their owners as well, who use their great enthusiasm for decorating and ideas for unconventional combinations to give their cooking area a distinctive ambience. The choice of Scandinavian or Mediterranean, rustic or colonial, or echoes of the natural simplicity of the earlier Shaker or Amish styles, is a matter of the shape and size of the room, but also an expression of personal preferences. Either way, country-style kitchens everywhere are always extremely cozy.

Furniture and appliance manufacturers have long been making progress in the matter of producing kitchens with traditional flair that also match up with contemporary demands for convenience and functionality. Today, fans of old-style kitchens certainly do not have to sacrifice cutting edge technology and well-planned systems. Old and new, antique kitchen furniture and high-tech appliances, a nostalgic exterior and an interior in the modern spirit live together in perfect harmony, and build unconventional bridges between all ages and styles.

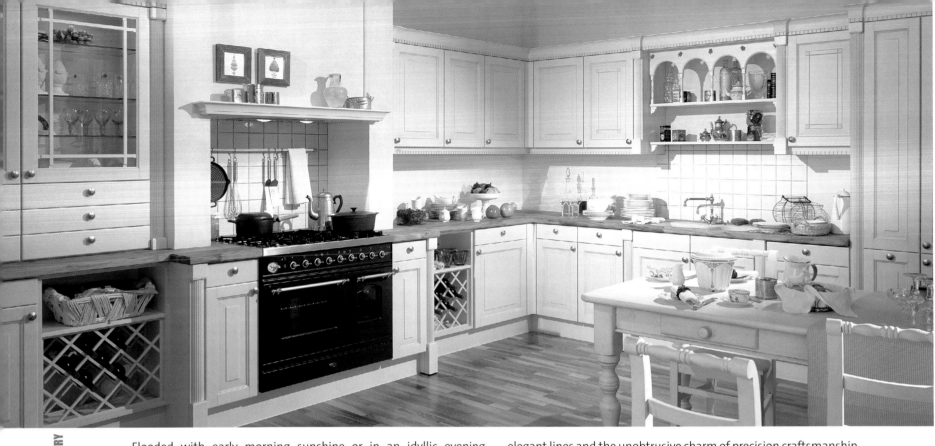

Flooded with early morning sunshine or in an idyllic evening atmosphere: *Finca* and *Fjord* by Rational are fascinating with their elegant lines and the unobtrusive charm of precision craftsmanship. These are kitchens for demanding exponents of the art of living.

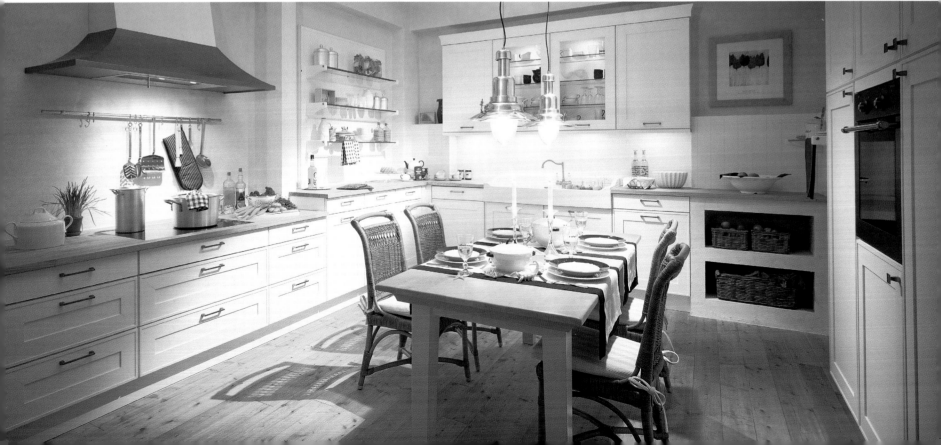

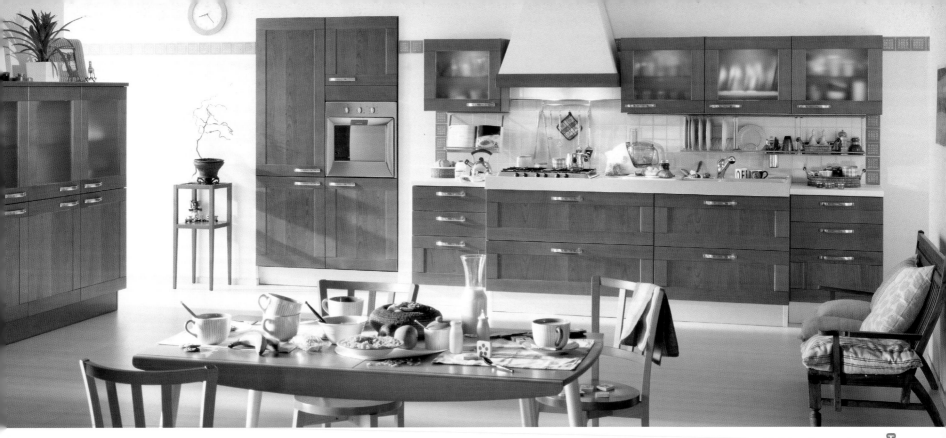

A kitchen for life – or at least for many restful or exciting hours. A feast for both the palate and the eye are combined here in obvious agreement. *Smeraldo* (above), *Decor* (below), and *Gioconda* (following pages), all by Snaidero.

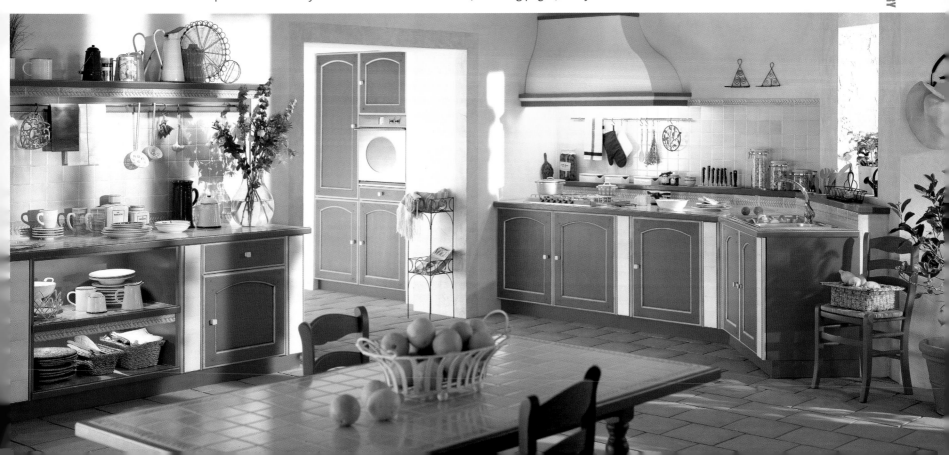

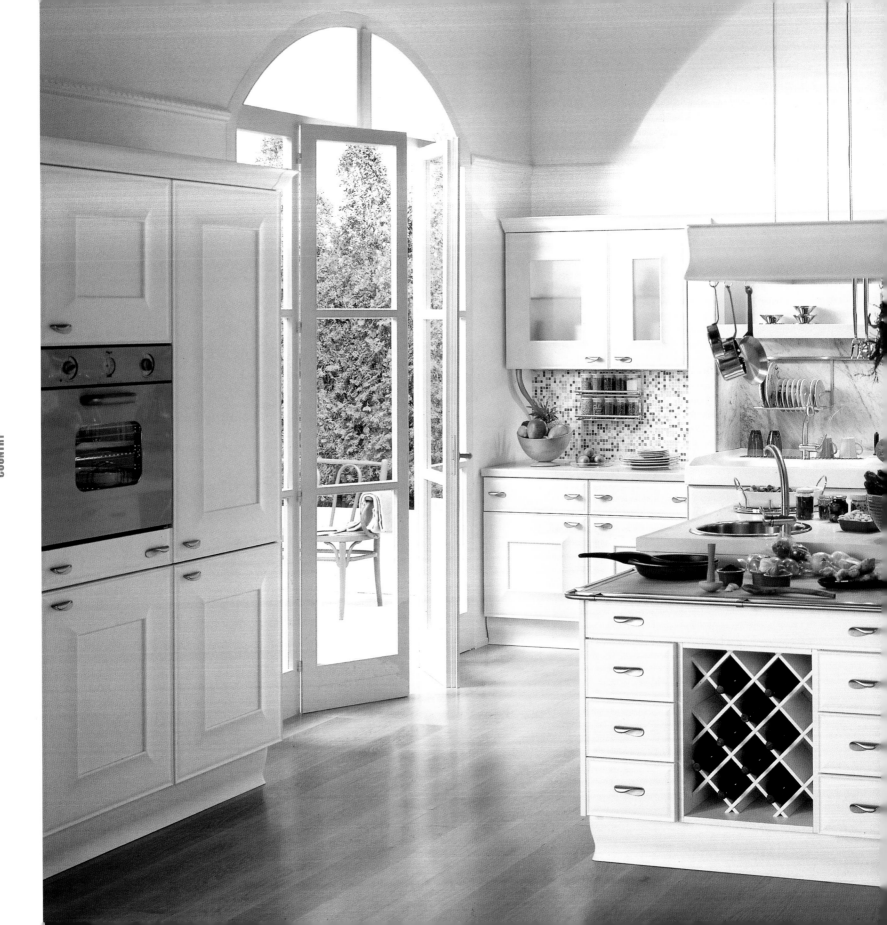

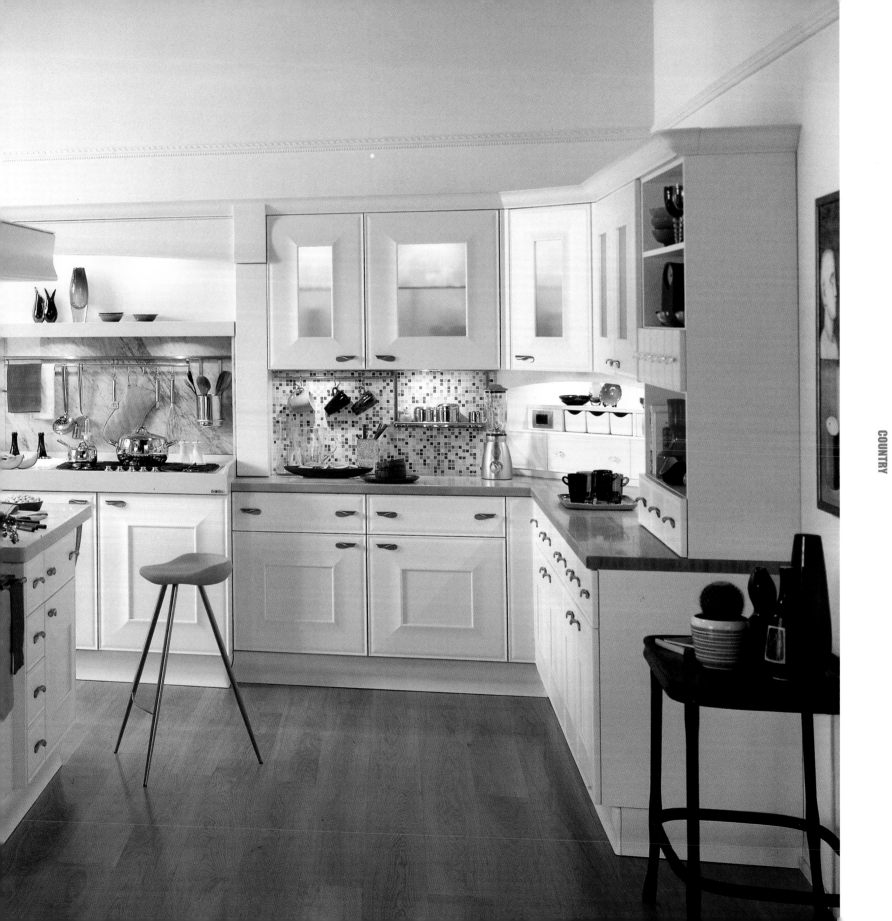

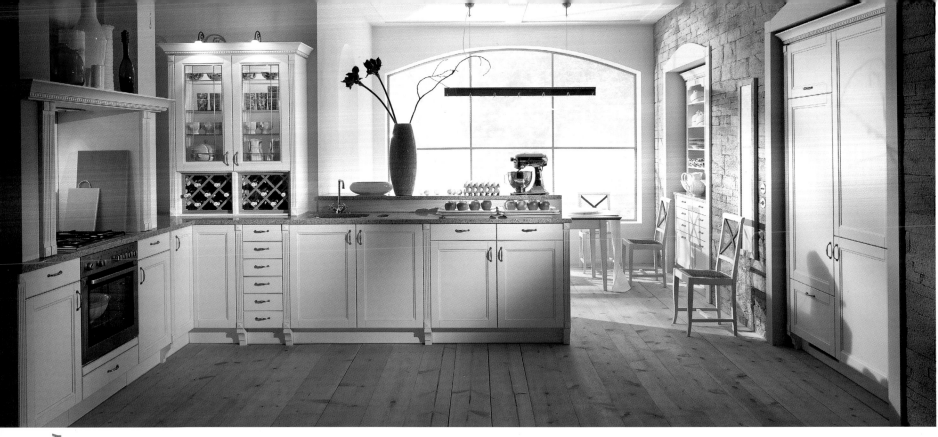

96 COUNTRY

Escape from the hectic world of everyday life, plunge into the cozy atmosphere of a kitchen that will lovingly offer you functionality and decorative detail. The antique vanilla lacquer gives *Alnoclair* by Alno a special rustic charm.

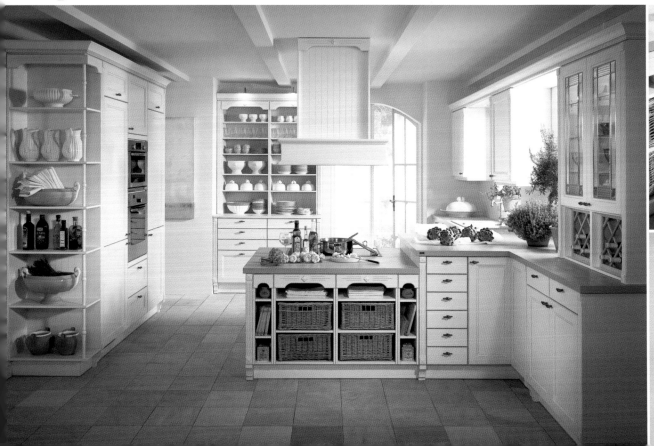

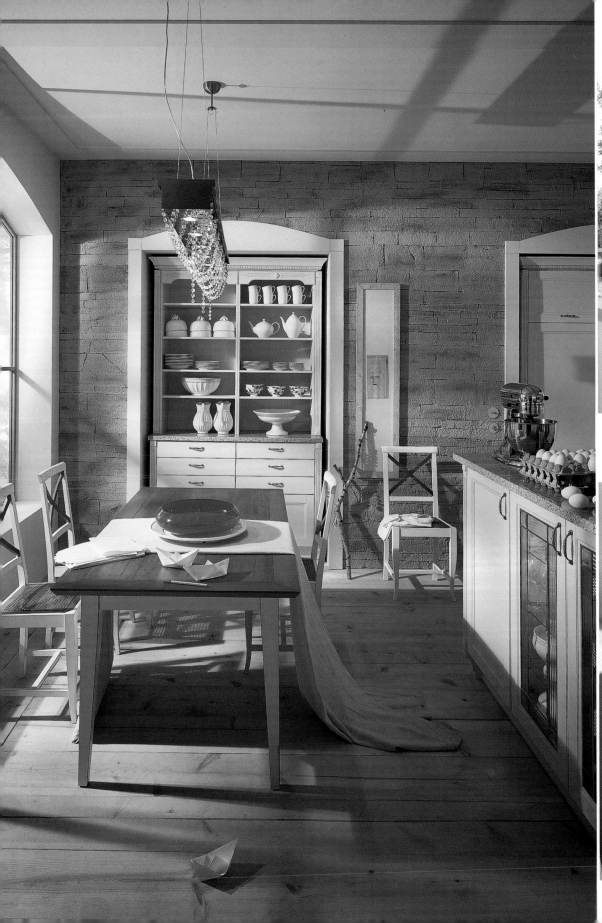

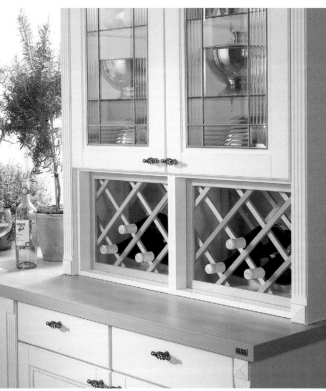

There is a place for everything here – in the top cabinet behind high-quality glass doors, in the open wine-rack, or the open shelf-unit.

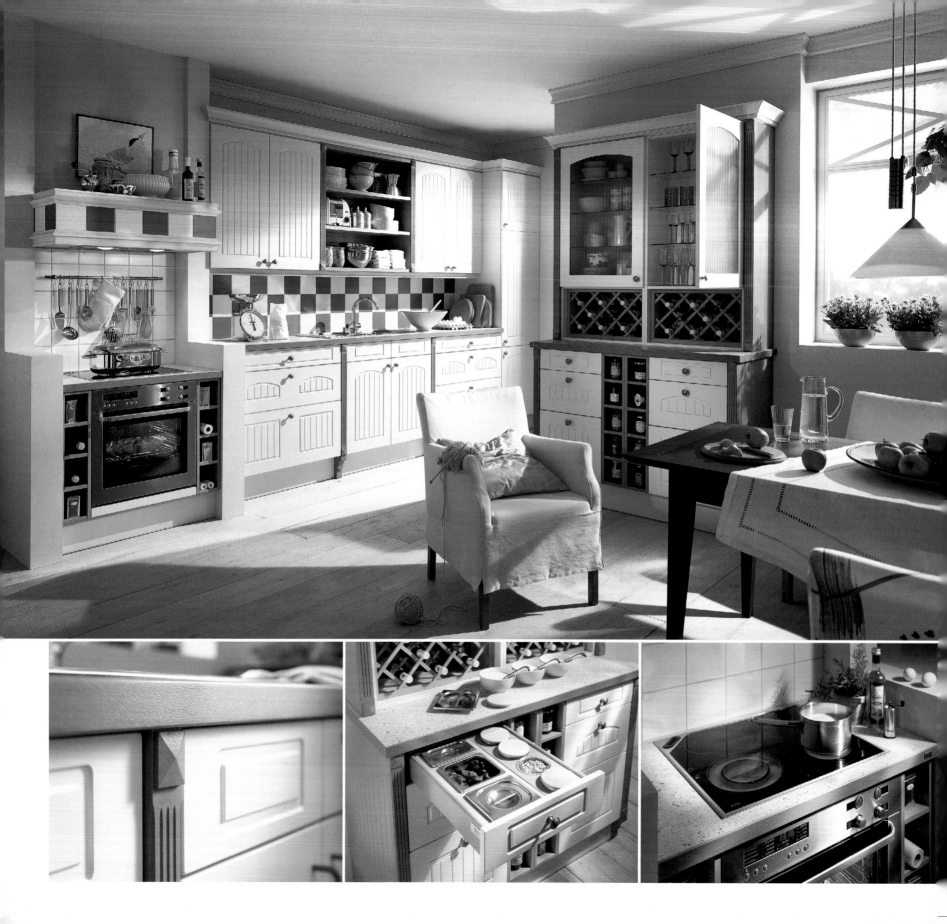

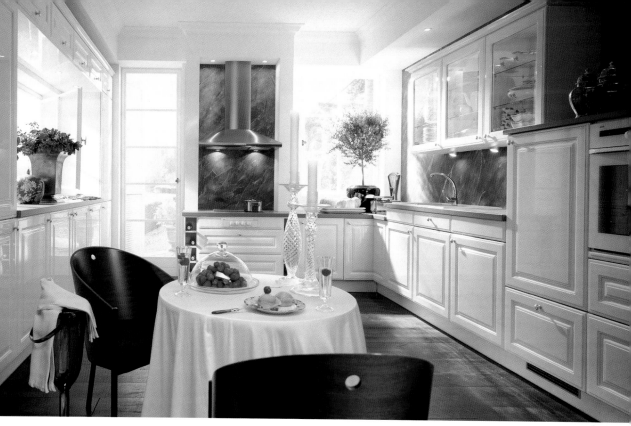

Cooking, eating, feeling good, living – the rest is a matter of taste. Glossy or matte silk, or with striking arches: *Alnoranch* (left), *Alnopol* (above), and *Alnoscout* (below) comfortably cater for all country desires (Alno).

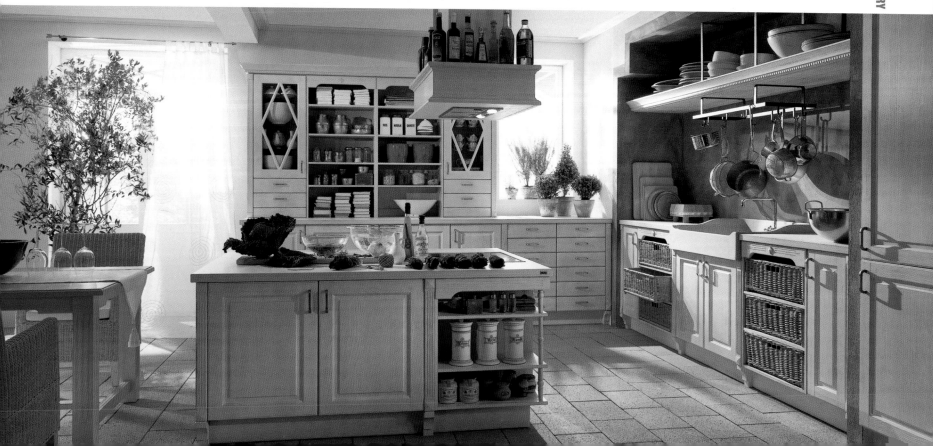

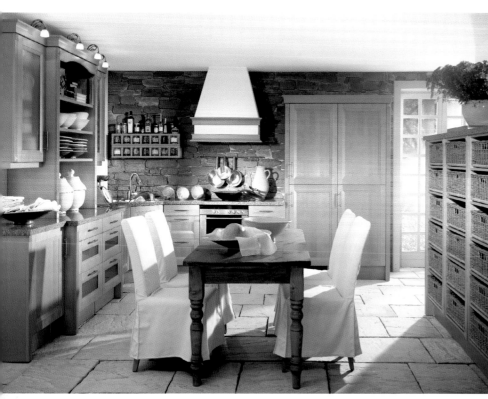

There is a hint of fresh basil and ripe olives in the air, and every detail of *Toscana* and *Cottage* (right) reminds you of the southern light and feeling of well-being (Nolte).

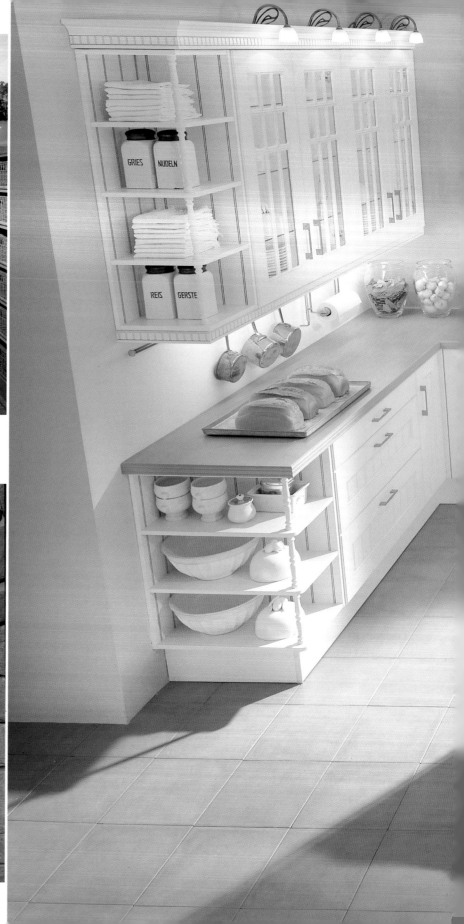

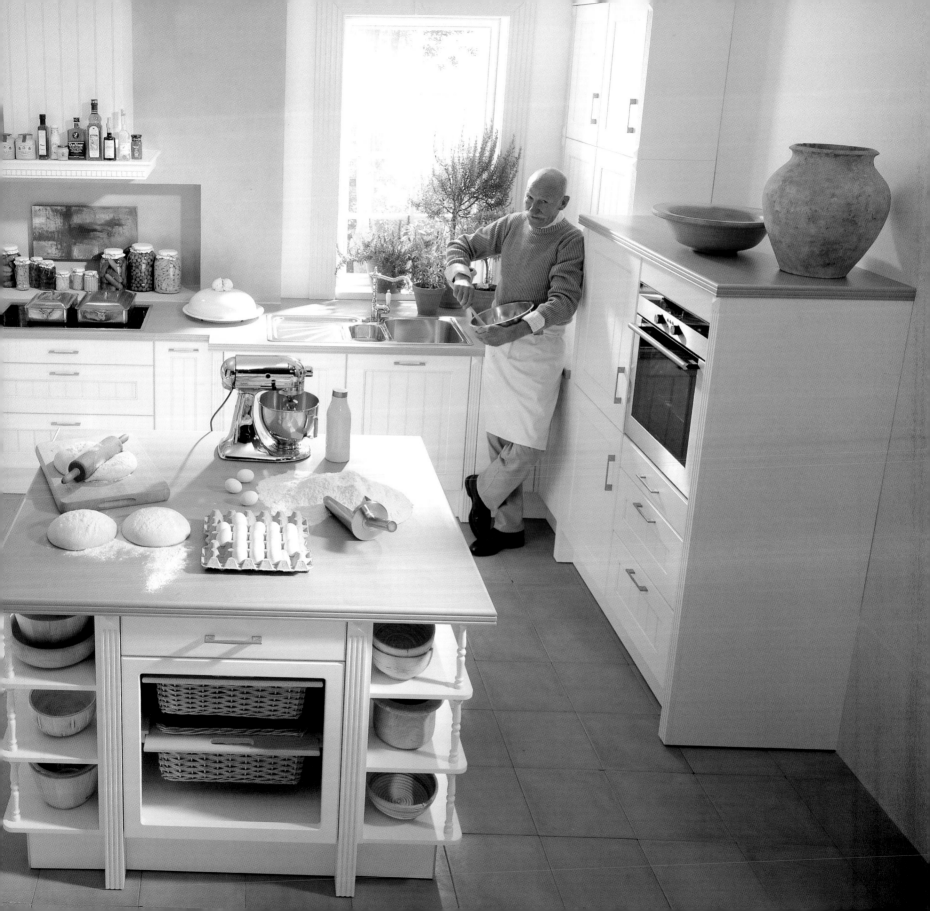

A coffee in the cozy dining area, preparing for the evening meal with friends round the big cooking island: *Gelderland* and *Casa* (right) by Bax offer a high level of comfort in a stylish arrangement that skillfully plays on traditional elements.

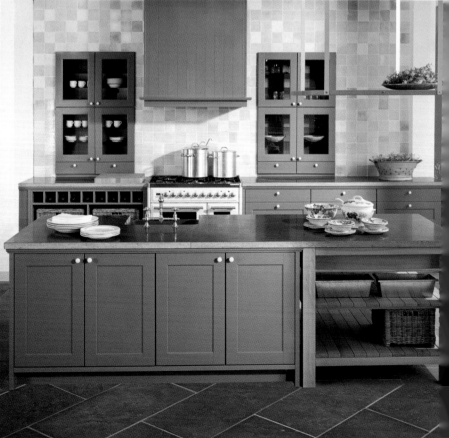

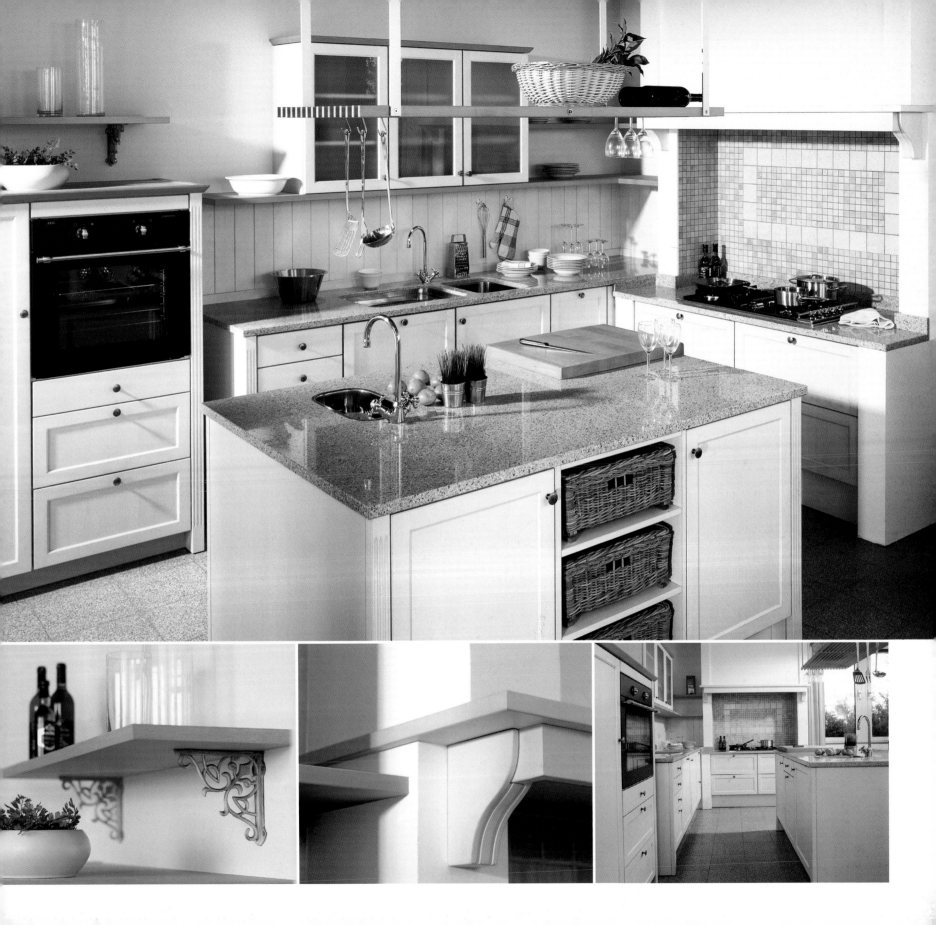

It might have started like this – the kitchen refuge of our childhood dreams. *Castella* by FM, with its antique wood finish and luxurious hand-made craftsmanship, provides the perfect atmosphere for all devotees of country kitchens.

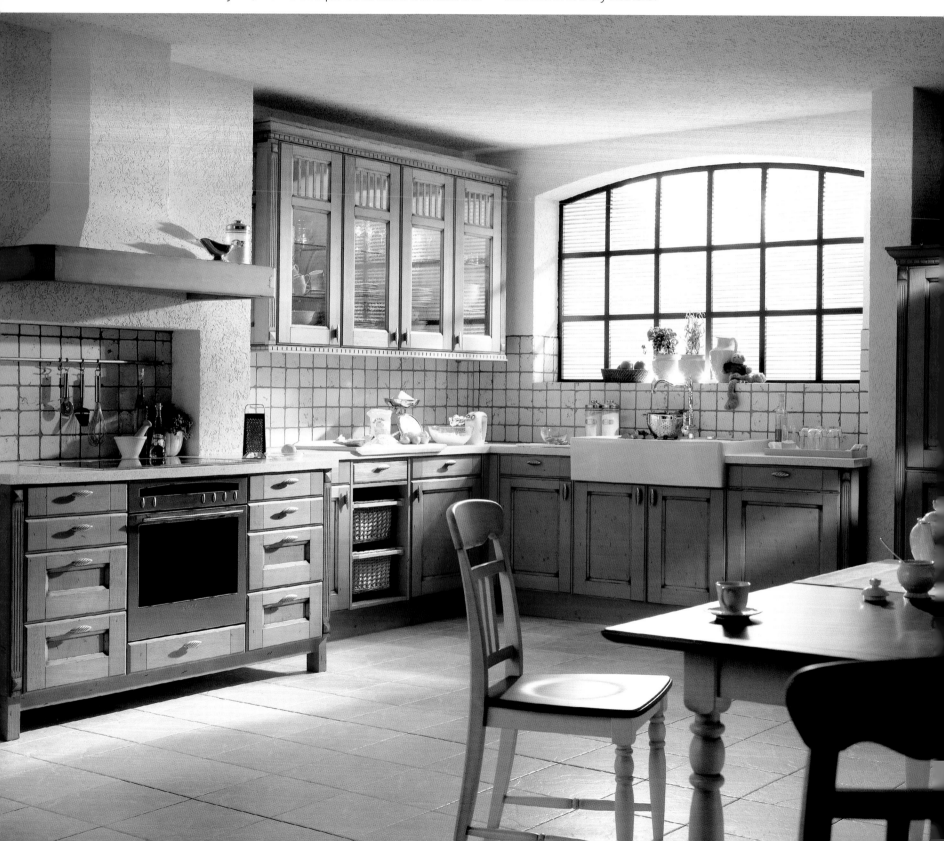

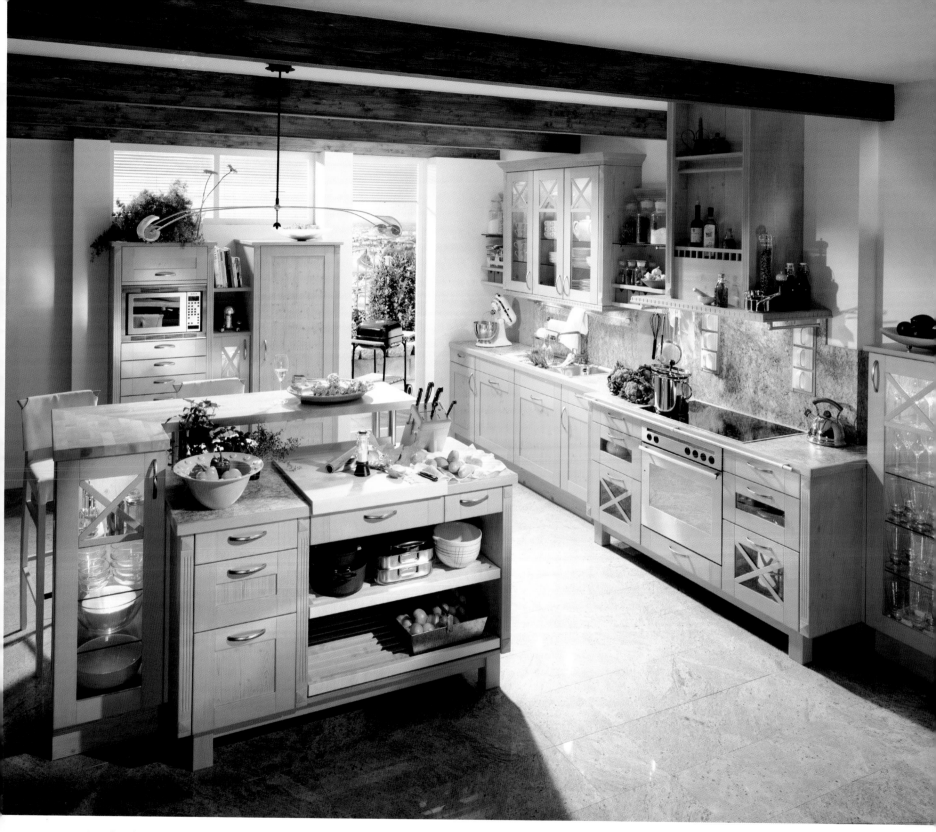

People who love their kitchens decorate them with all their favorite things. Country-style kitchens like the *Amara* by ewe or the *Classic* by Häcker (following pages) are ideally suited to provide the comfort and luxury to match the desire for nostalgic decor.

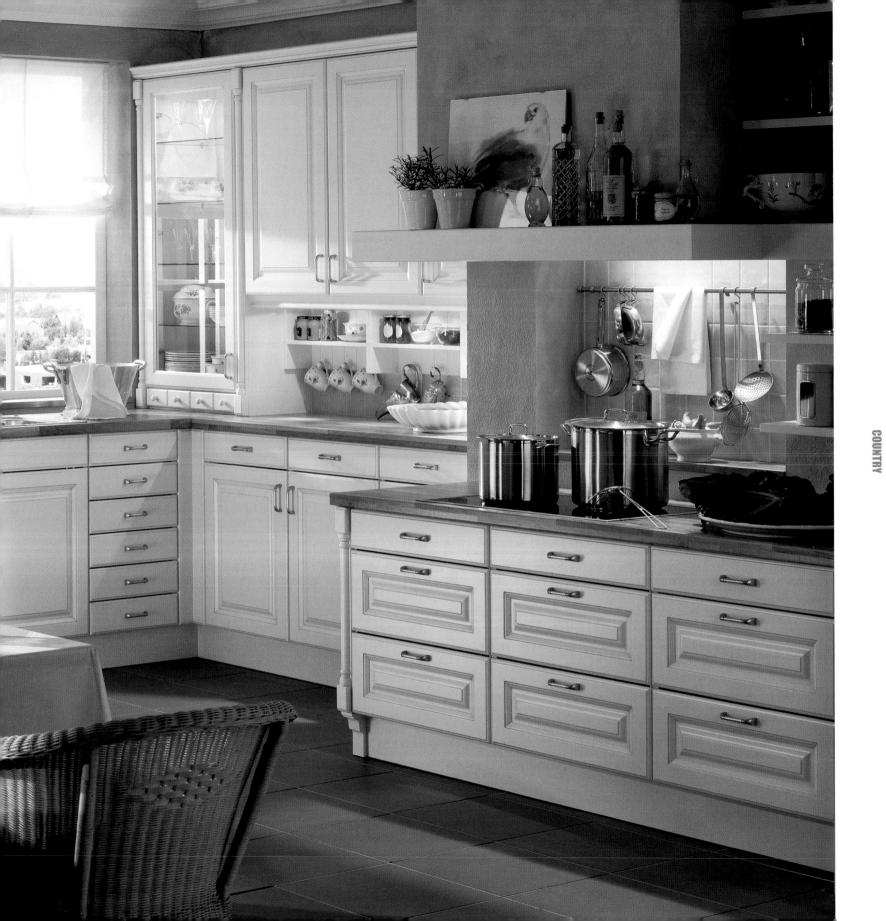

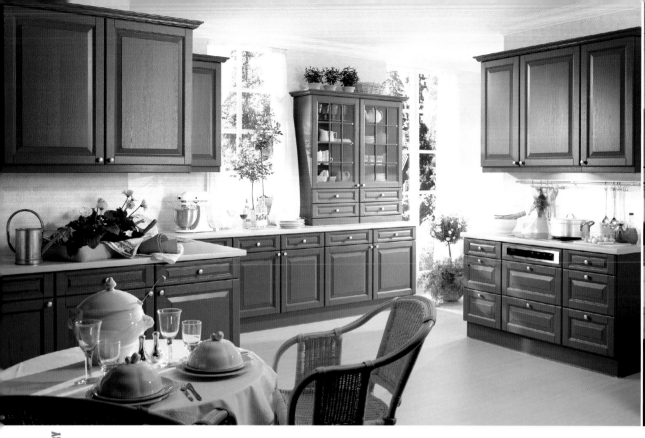

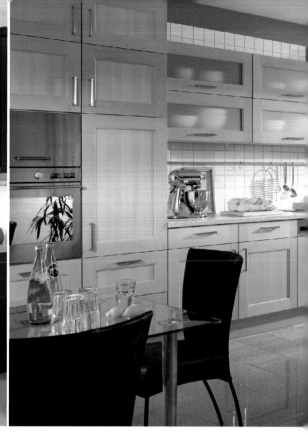

Striking outlines, plenty of wood, warm, natural colors and lots of traditional features give an impressive look to the many variations of MK's country classics.

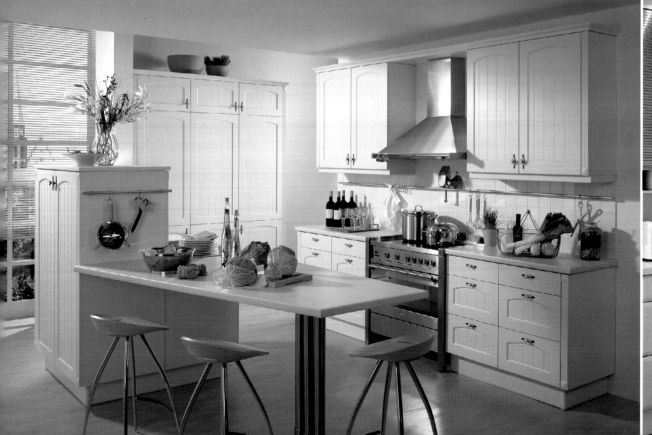

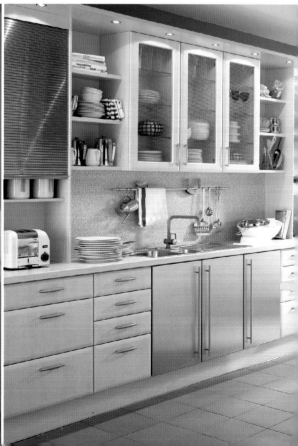

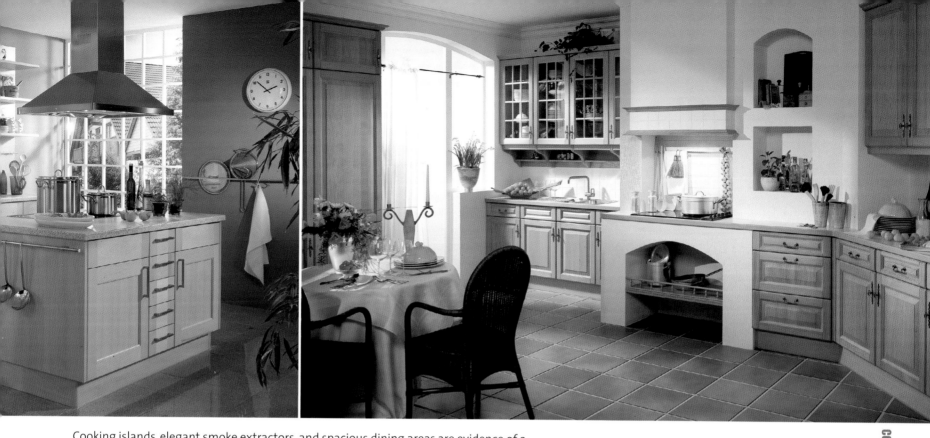

Cooking islands, elegant smoke extractors, and spacious dining areas are evidence of a
kitchen culture that satisfies aesthetic criteria and the need for communication.

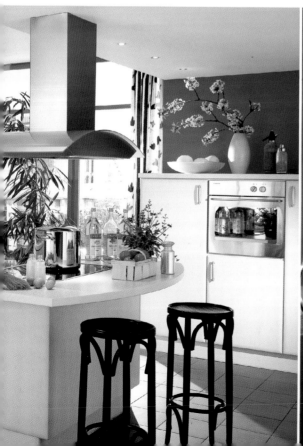

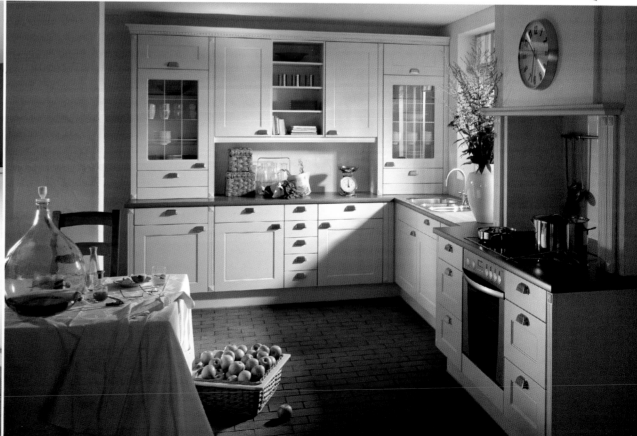

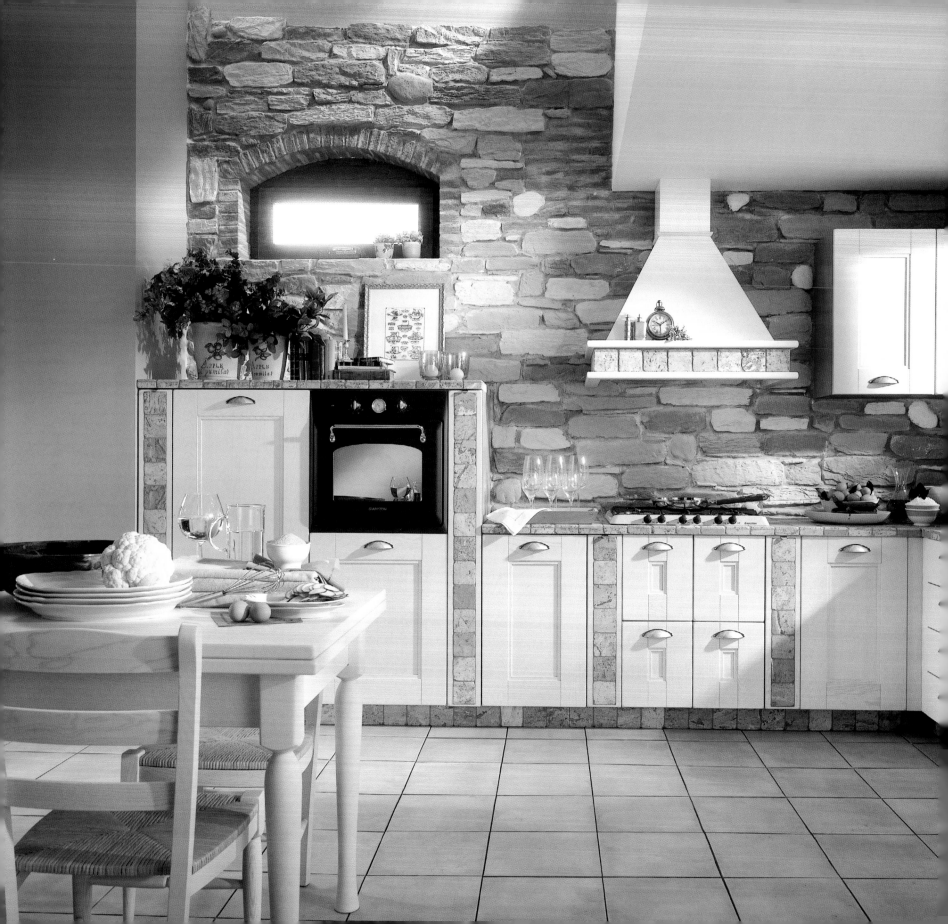

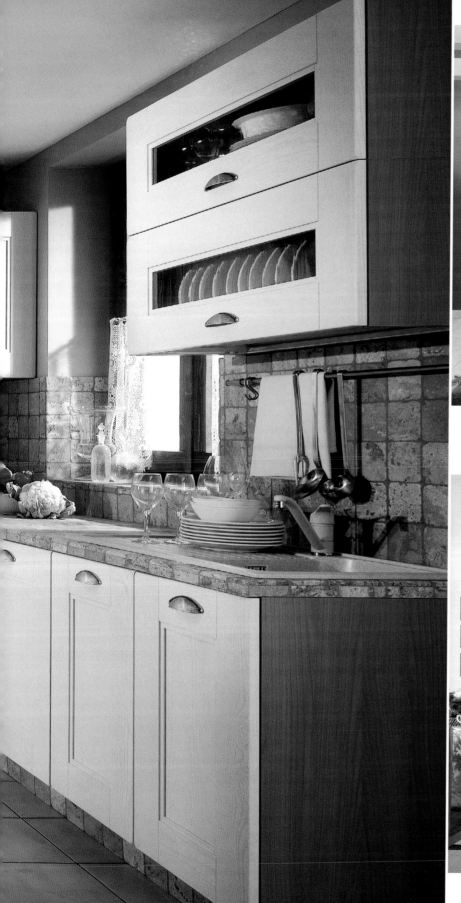

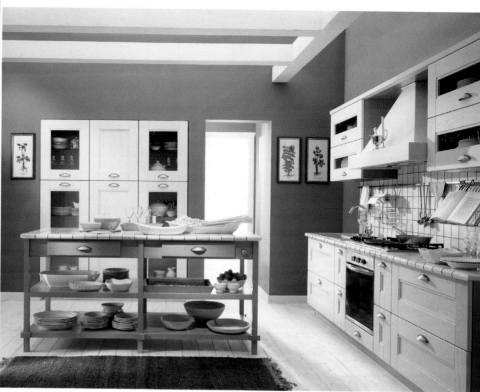

New creativity for kitchens with a feel for tradition and Italian stylishness: Sira's *Emma* model combines rustic flair and modern technology with unmistakable individual accents.

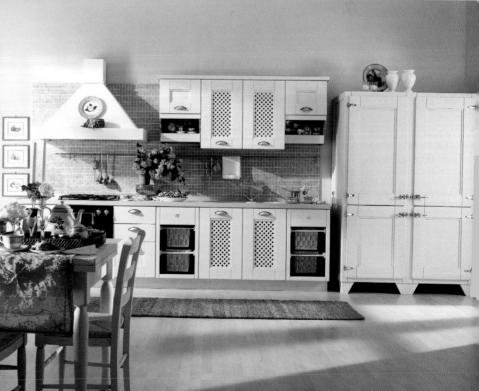

PRESSURE

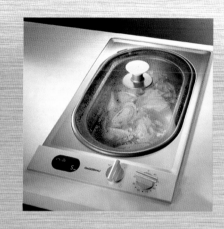

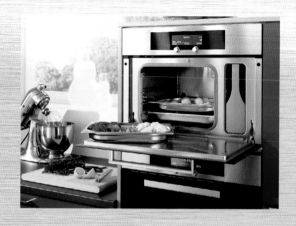

If you have the choice: pressure steamer (above), or Vetro Design pressureless steamer by Imperial.

For the gourmet: the *VK230* steamer by Gaggenau, and the *Mami* pressure cooker from Alessi (below).

Insight into the "open-plan" *DG4000* steamer by Miele (above), and the pressureless steamer by Imperial.

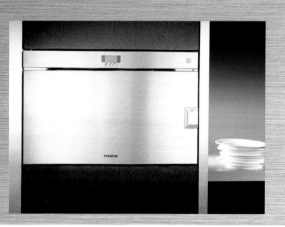

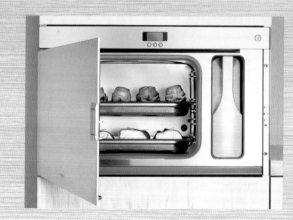

COOKING LIKE THE PROFESSIONALS – WITH STEAM

It is enough to drive any housewife wild. You take all that trouble at home to make the food as healthy and appetizing as possible. Then you go out to eat in a restaurant and you have to face up to the fact that the fish has the kind of consistency you never achieve at home, and the beans and peas have a fresh green color that, with the best will in the world, home-cooked vegetables just cannot compete with.

Amateur cooks were slow to discover the secret of the professional chefs – it only happened some twenty years ago, when the first electric steamers came on the market for private homes. Now they are well-established as the all-time favorites of diet-conscious mothers as well as gourmets with fastidious tastes. This is because steamed foods, especially vegetables and fish, but also starchy and sweet foods, are low in fat and calories. They offer a complete, unadulterated taste experience, plus everything they contain in the way of vitamins, minerals, and trace elements. When you blanch, braise, or steam

them at 212 or 248°F (100 or 120°C) almost nothing is lost – not even color or consistency. There is no healthier way of cooking.

Steamer fans now have the choice of two different types of appliance – pressureless and pressure-steamers. While pressureless steamers are easy to install in a kitchen – even later on – because they only need electricity and a power point, a pressure-steamer needs to be plumbed in so that the machine is permanently supplied with fresh water. With pressureless steamers, where the water is stored in a removable tank, the food is surrounded by steam at 212°F (100°C); in pressure-steamers the temperature in the hermetically sealed inner compartment can be as high as 248°F (120°C). Multi-steamers offer another variation, combining a steamer, a fan oven, and an ordinary oven with top and bottom heat in one appliance.

If you cook at full steam like the professionals, many dishes – even convenience and frozen foods – can be prepared quickly and punctually when guests arrive unexpectedly, a feast to delight the palate and the eye. And if your guests turn up late again, that is no problem either, as the steamer can also be used for warming up. As well as being convenient in this way, the steamer reheats meals without the food showing any trace of it.

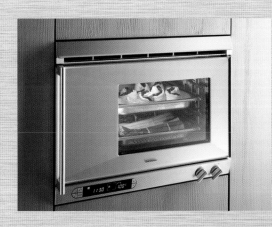

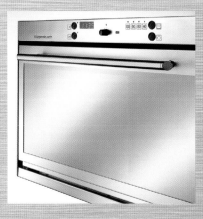

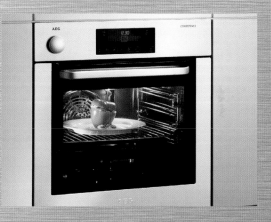

Very smart: the *ED 220* combi steamer-oven by Gaggenau (above) and the WMF quick cooker.

Gentle cooking – with variable baking and steaming systems by Küppersbusch (above) and Neff.

For all occasions: the *Competence* multi-steamer-oven by AEG (above) and the microwave oven from the *Design Line* range by Bauknecht with broiler, hot air, and steamer functions.

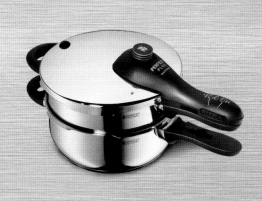

COOKER

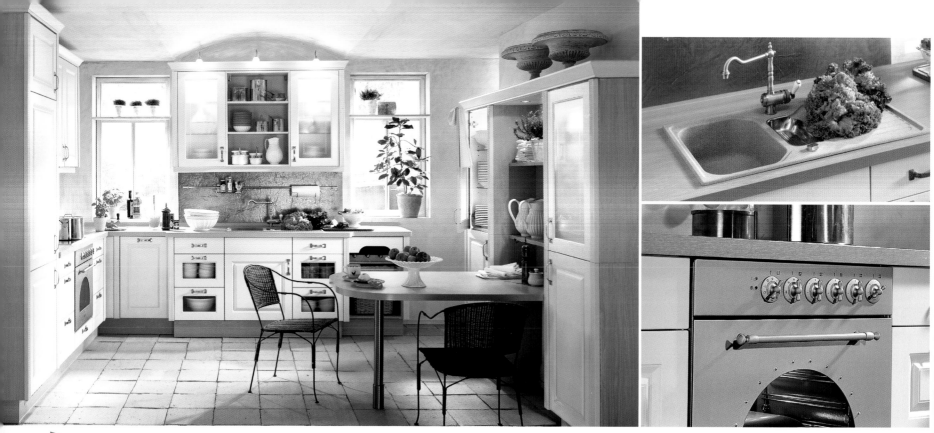

Kitchen range, built-in hob or classic cooker hood: nostalgia is an important feature of these kitchens by Impuls (above) and Pino (below) that can brighten up even the sad winter days with their Mediterranean flair, and warm maize yellow or velvet green colors.

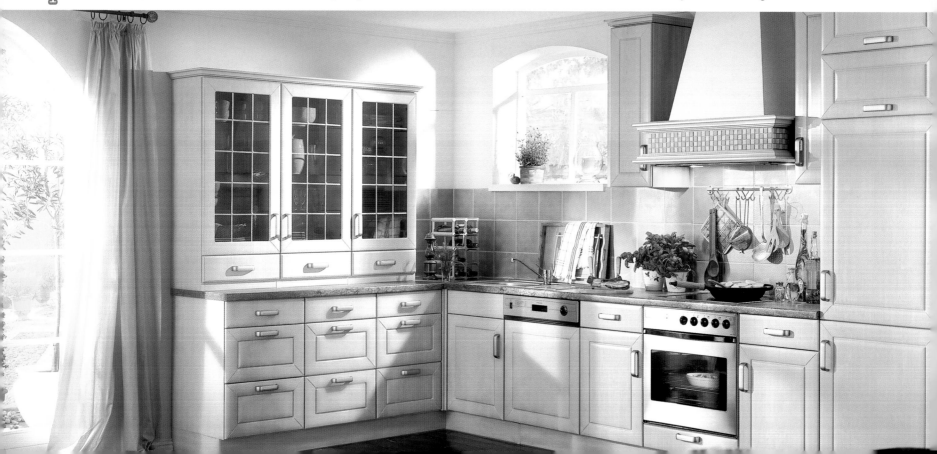

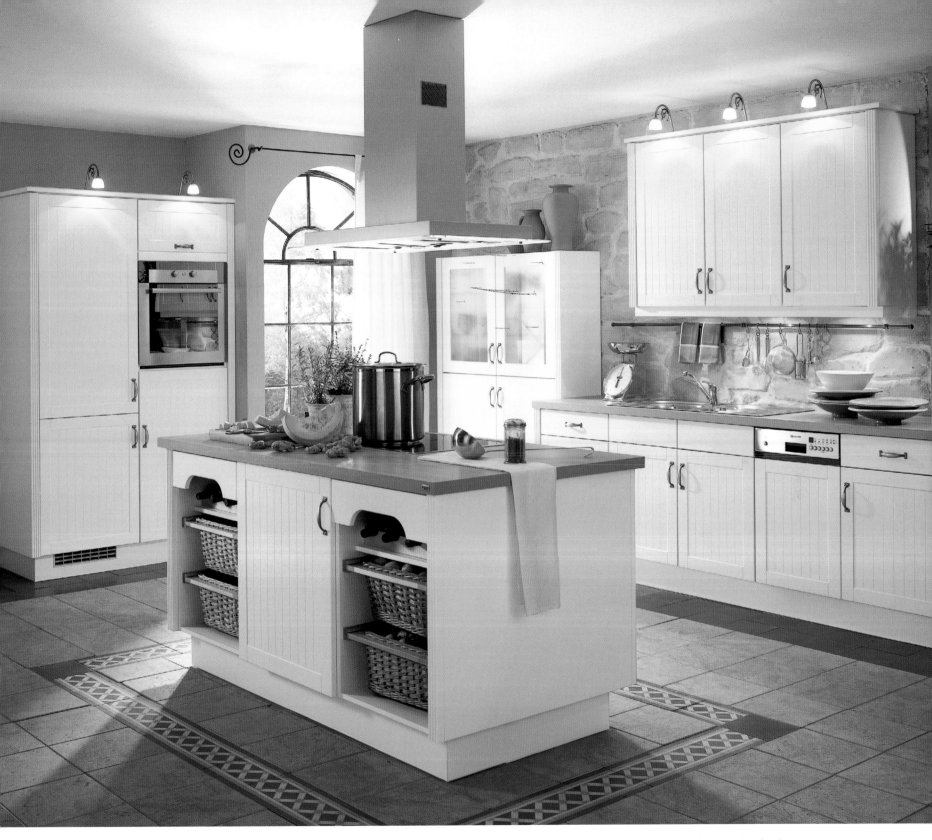

This kitchen is like an old country estate reawakening to new life. Tradition and innovation, classical and modern elements come together in harmony in the *Impuls 4600*. Working in this kitchen is fun and offers pure relaxation.

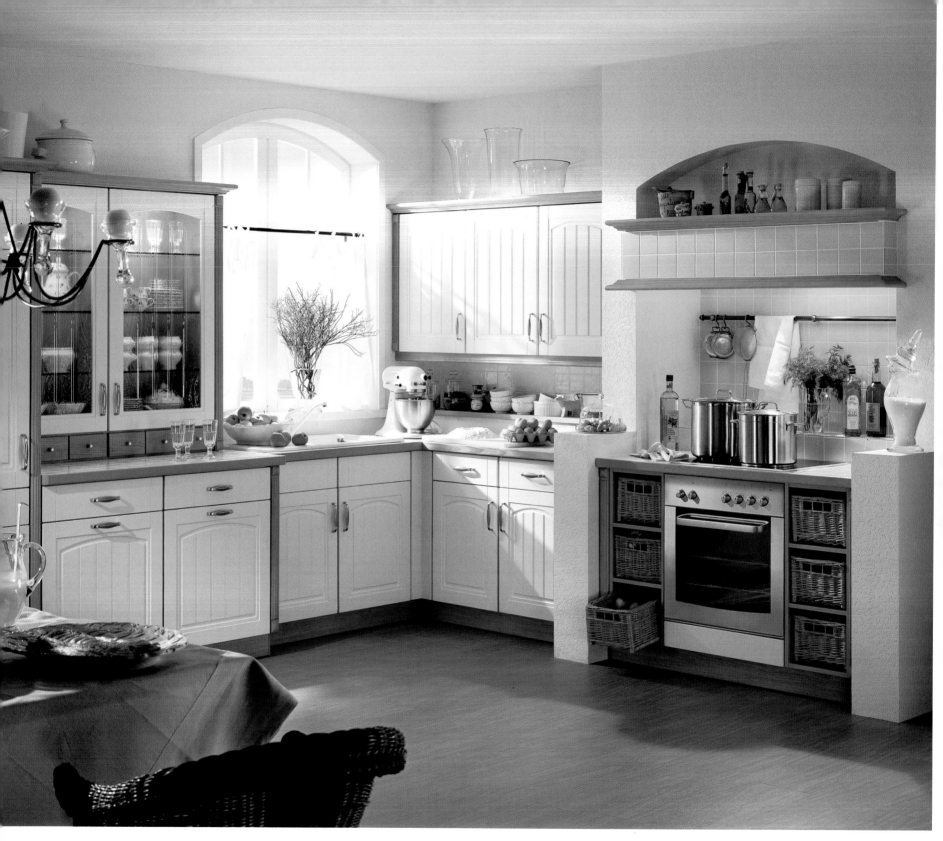

Rustic willow baskets celebrate a great comeback in Wellmann kitchens. They represent high-quality country house culture, leaving nothing to chance, and carefully adapting traditional shapes and styles to modern situations.

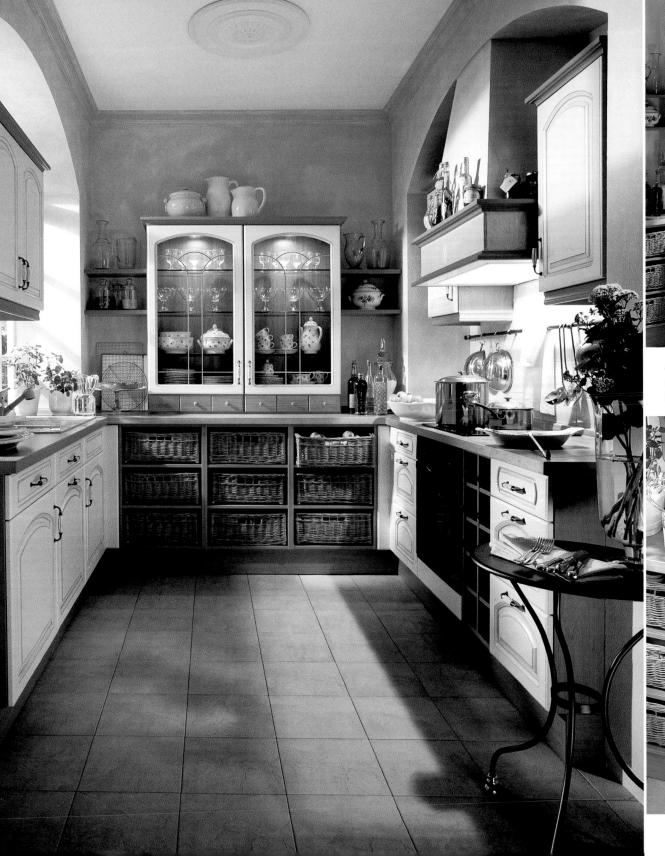

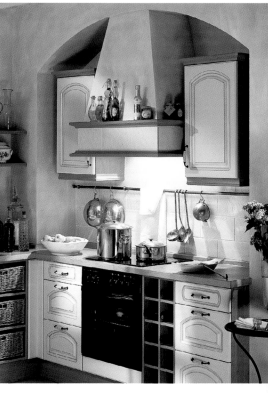

A chimney over the range, just as in the good old days – but it hides a good deal of technology.

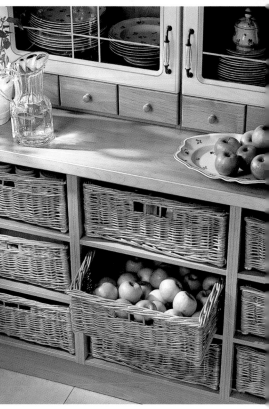

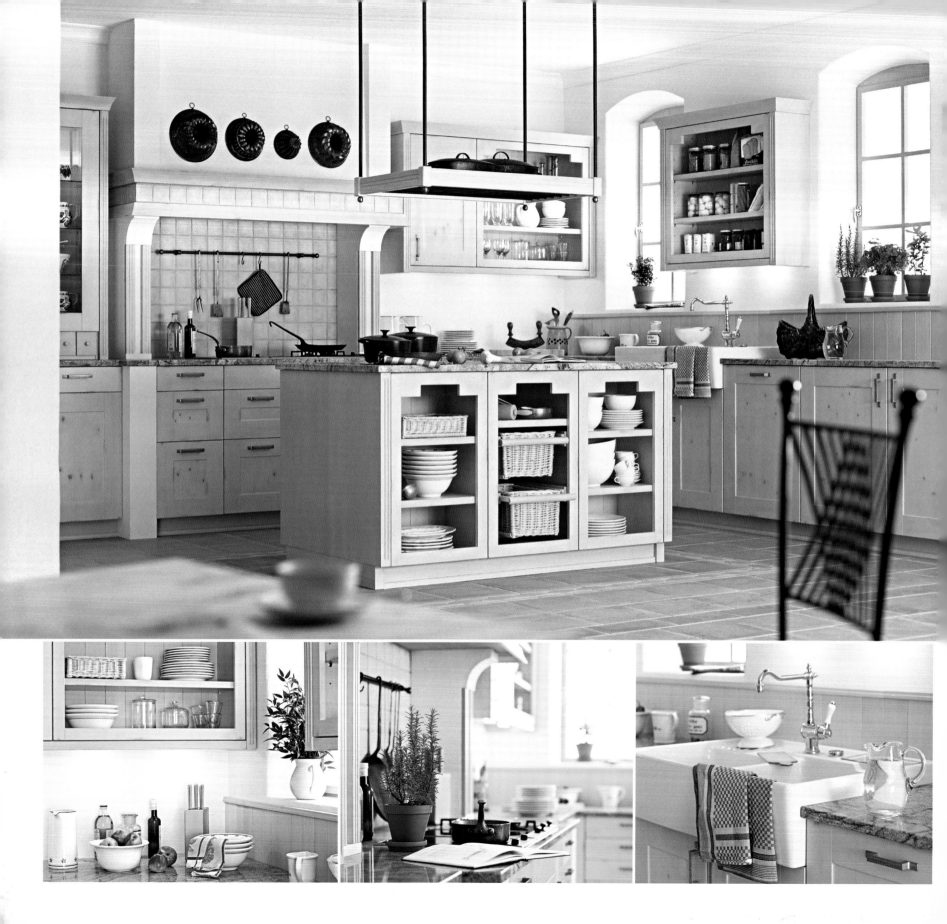

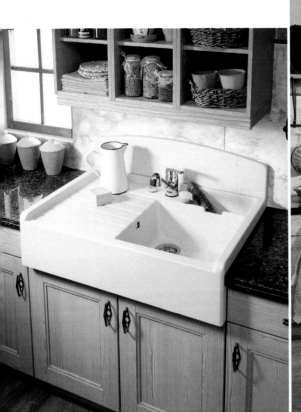

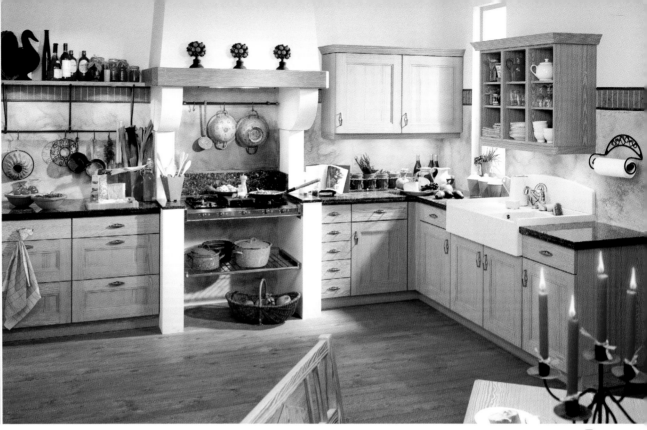

Each one of Leicht's *Handcraft* kitchens is created and signed by a master craftsman, giving the owner a feeling of pride in possessing something unique. *Casa* (above) and *Como* (below) both exhibit as much emphasis on aesthetic effect as on functional intelligence.

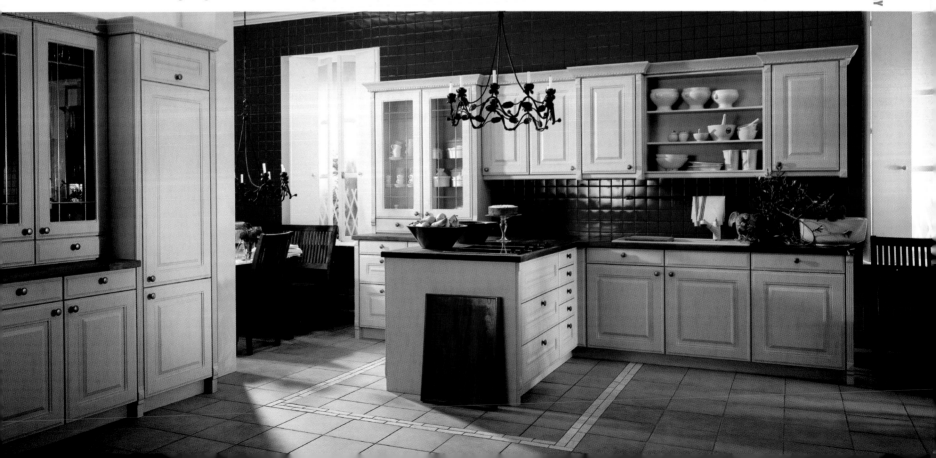

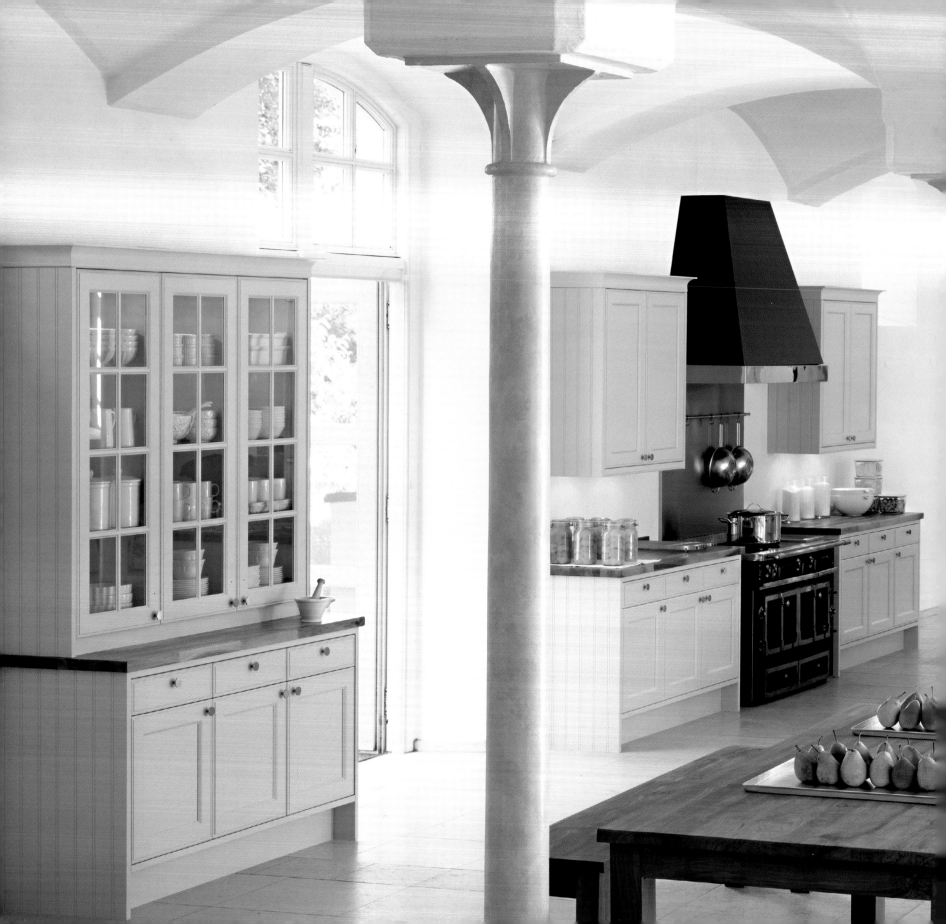

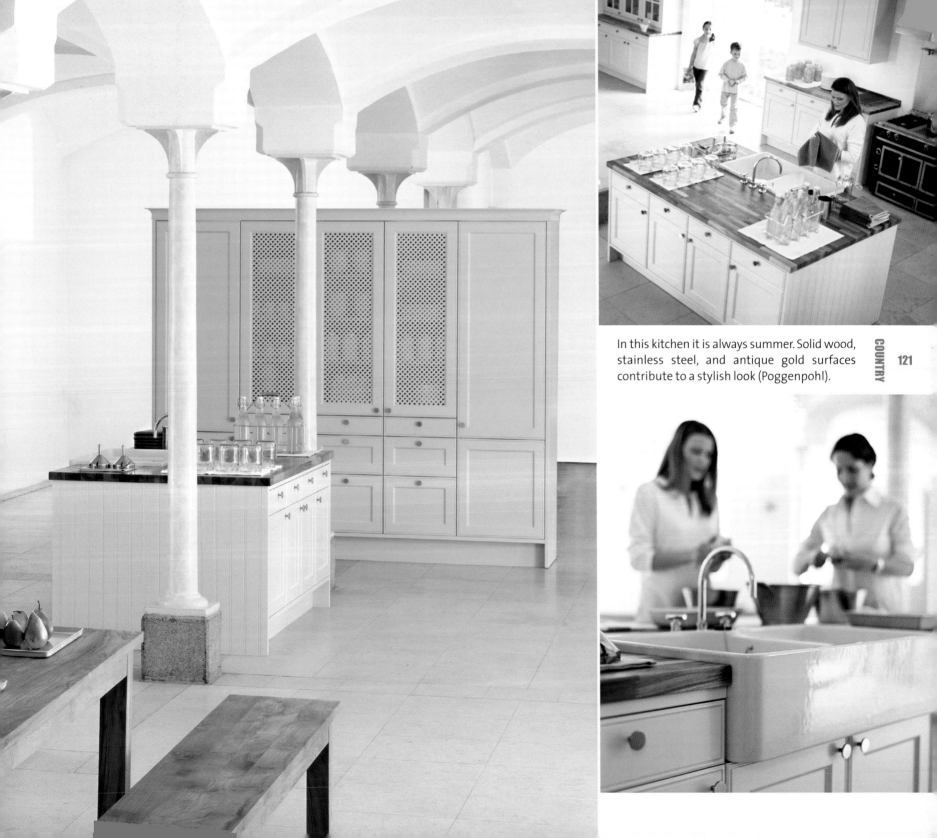

In this kitchen it is always summer. Solid wood, stainless steel, and antique gold surfaces contribute to a stylish look (Poggenpohl).

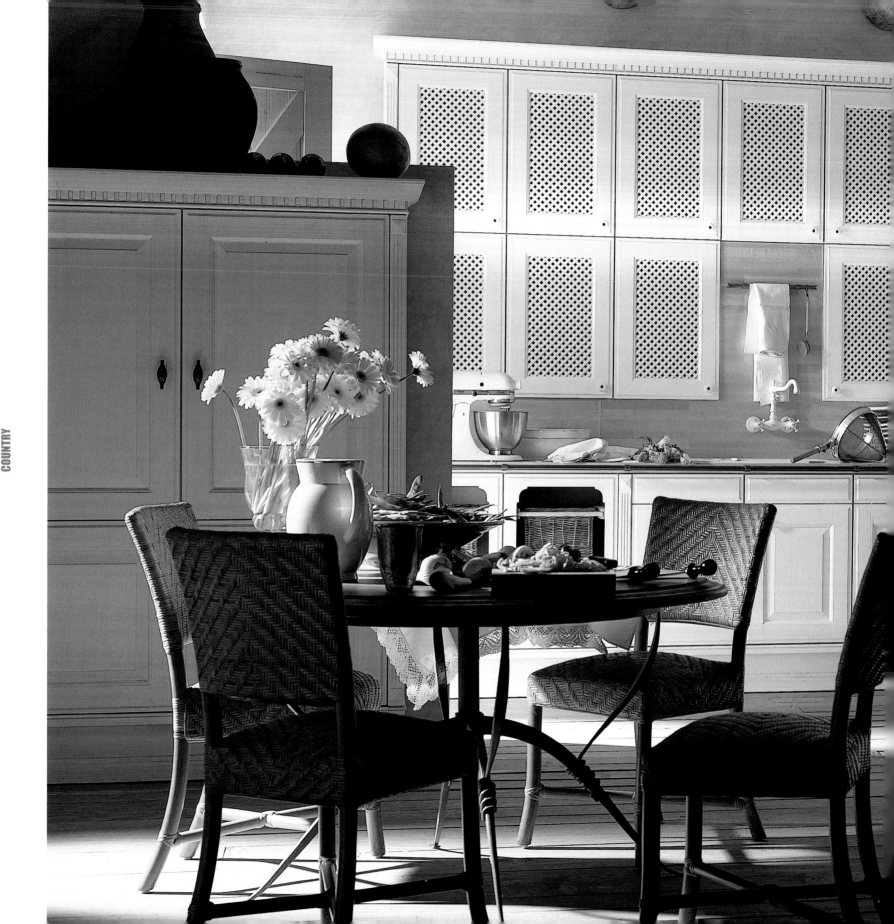

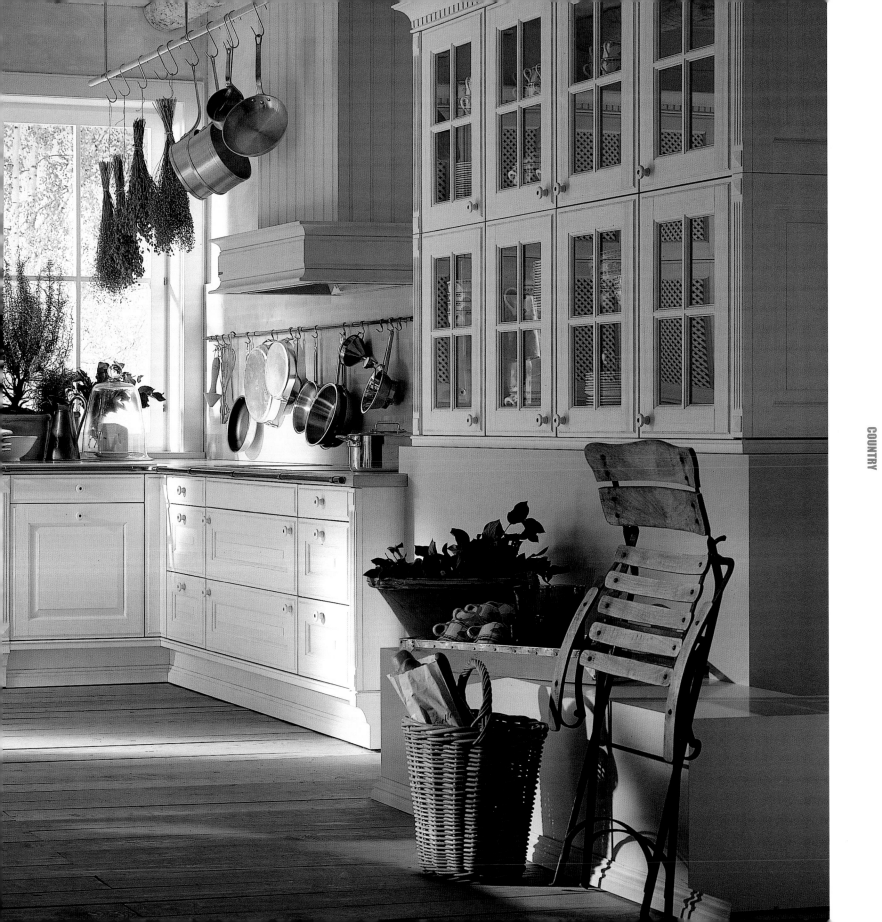

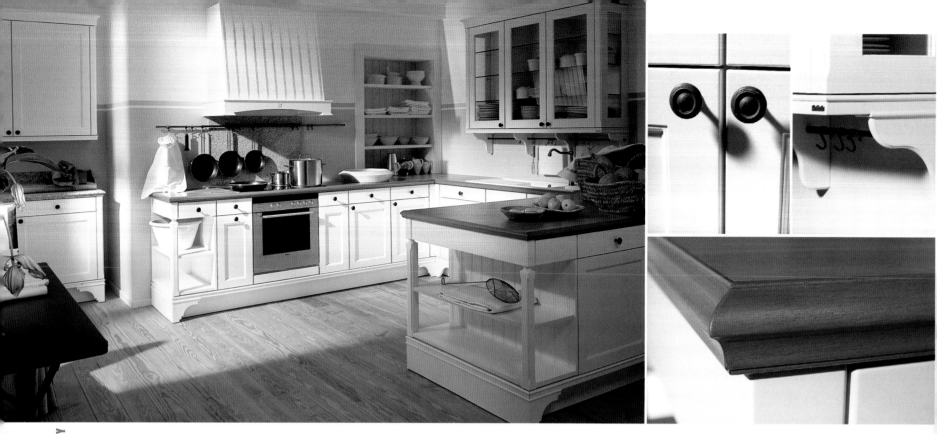

The kitchen is still asleep, but when the day begins it will be filled with bustling life, as everybody feels good in a SieMatic kitchen (see also previous pages). The handcrafted precision and quality that make kitchen life a pleasure cannot fail to have an effect.

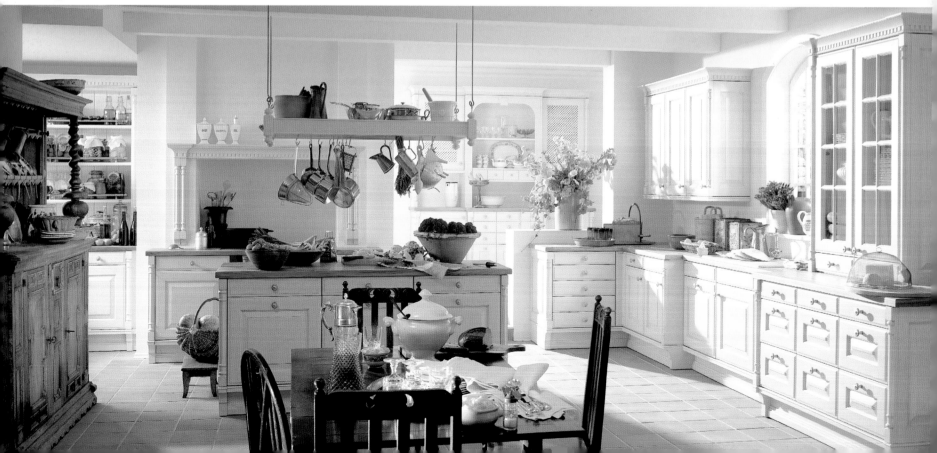

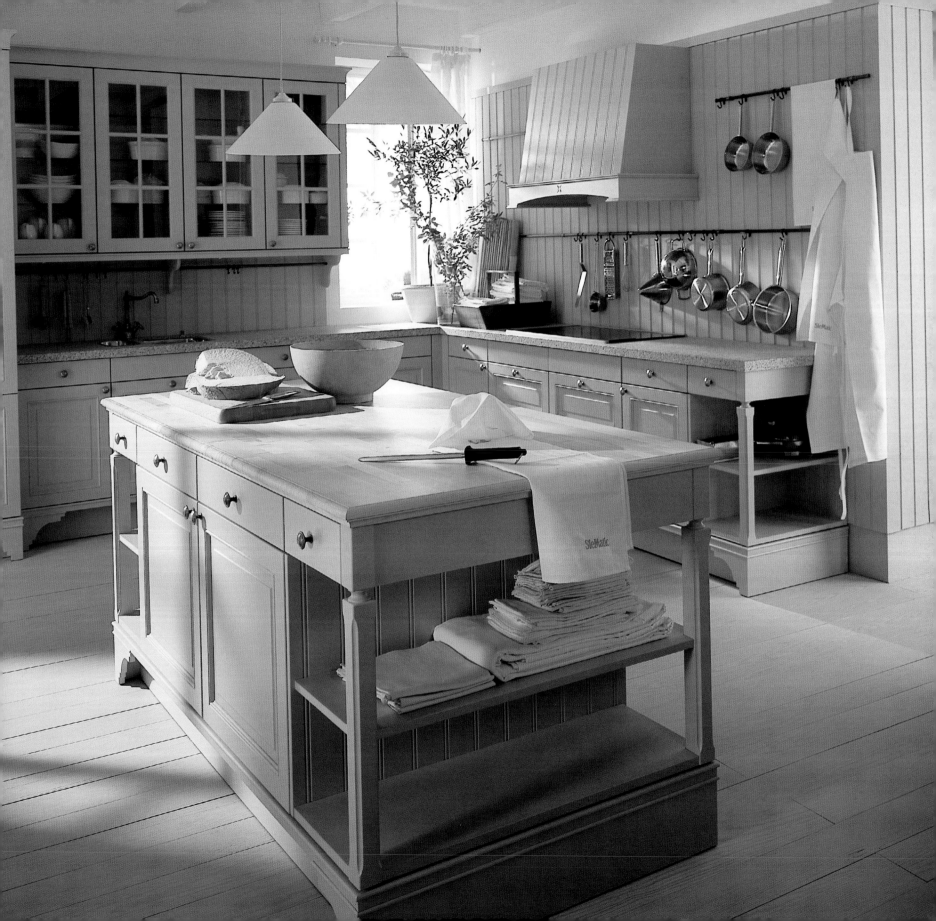

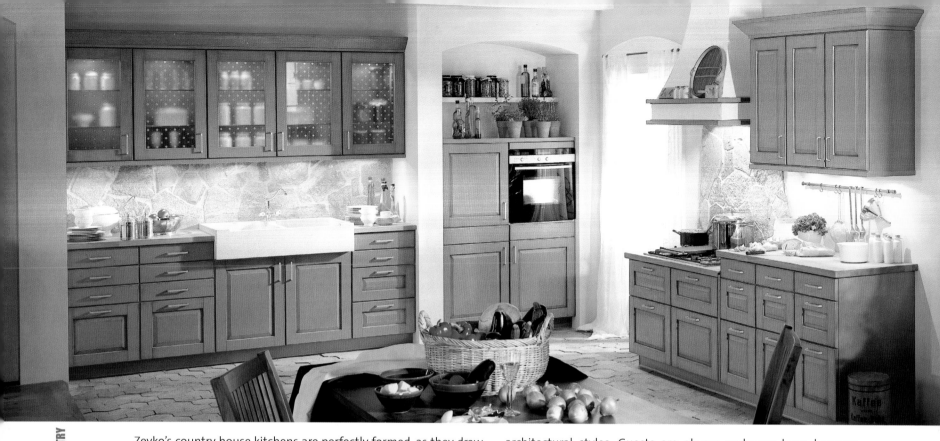

Zeyko's country house kitchens are perfectly formed, as they draw their inspiration from the classical tenets of great artistic and architectural styles. Guests are always welcome here, because prestige and comfort are a part of the range.

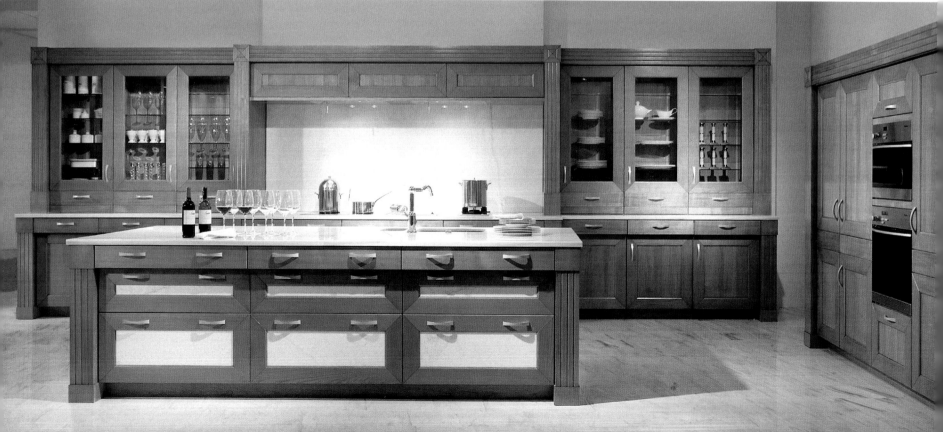

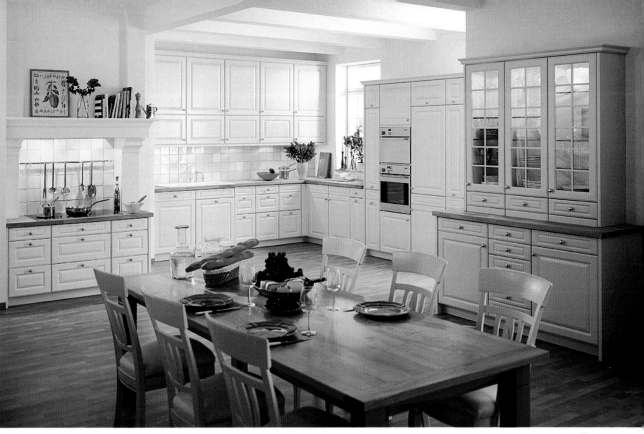

Where better could you enjoy a lovingly prepared meal with close friends than in a kitchen like this? The names *Chalet Camé* and *Vienna Veneto* (Zeyko) betray the origins of their stylish harmony. Inspiration is everything.

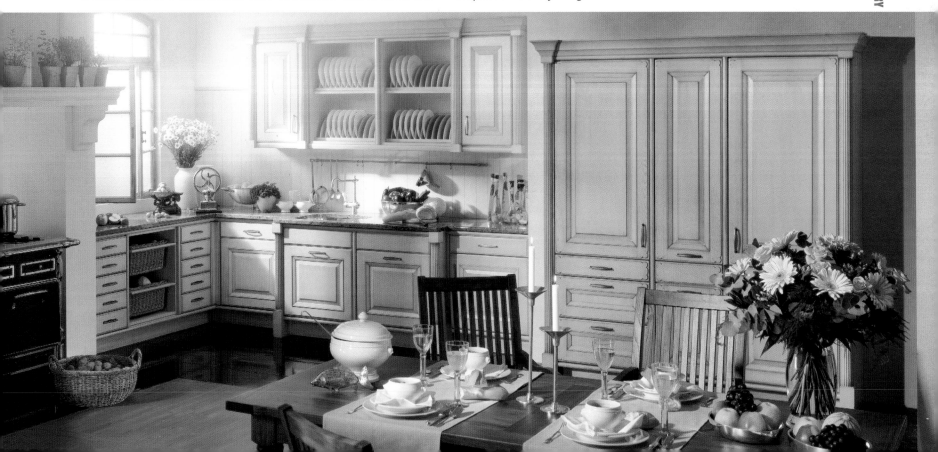

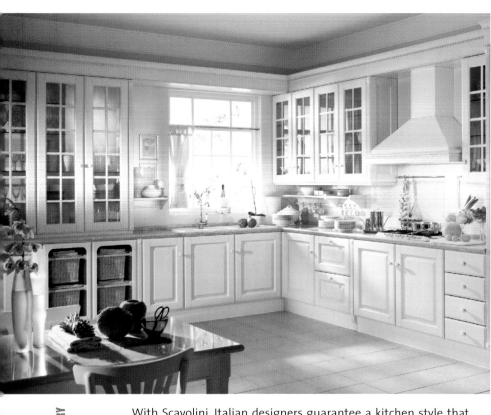

With Scavolini, Italian designers guarantee a kitchen style that links timeless classic elegance with a contemporary look. Time can safely stand still for once during a cozy meal.

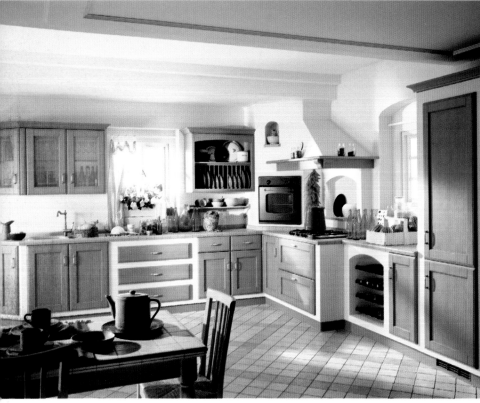

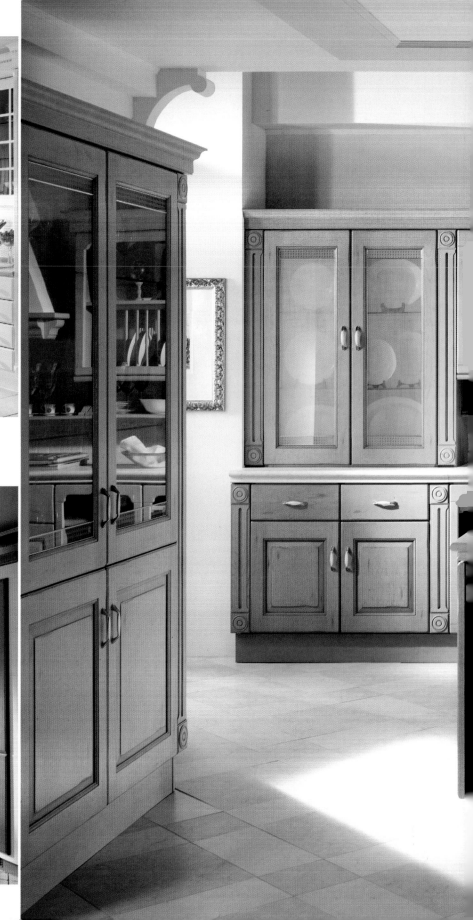

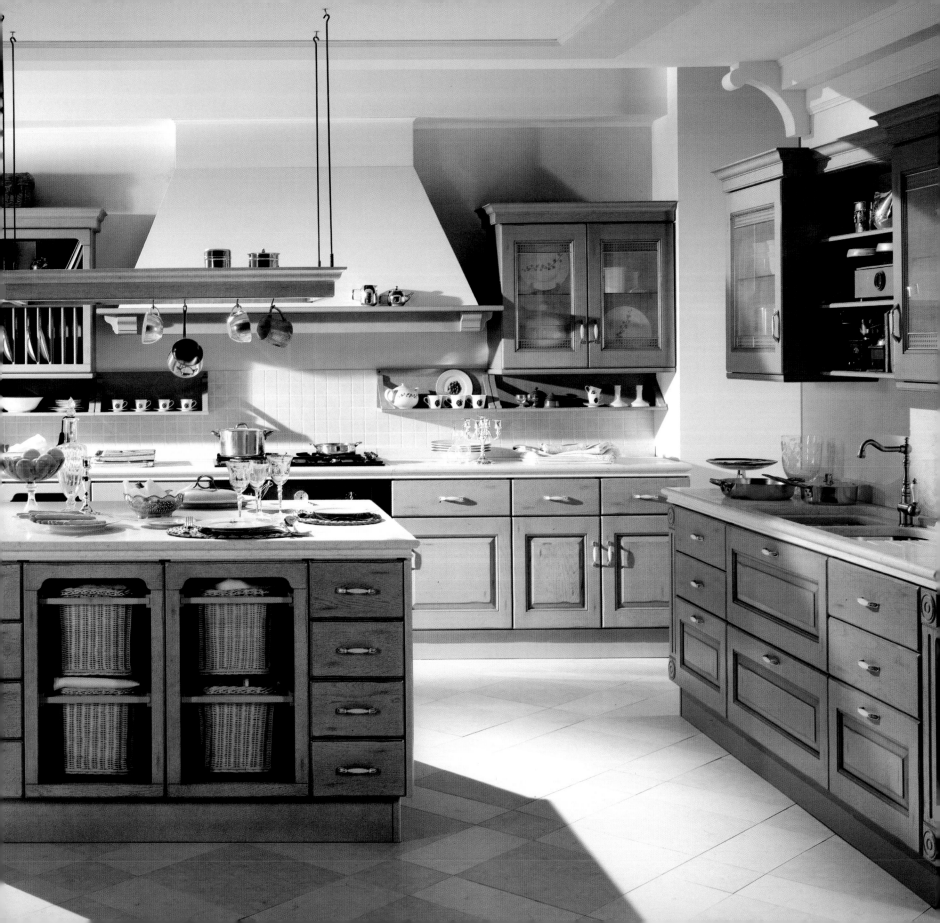

COFFEE

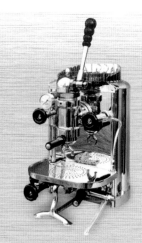

Already ancient history: coffee maker by Siemens (1925, above) and the Melitta *Aroma Art* from the 1980s.

Sought after: electric coffee and tea makers, 1925 (above). On the direct brewing principle, *Café Gourmet* by Phillips.

The first big coffee machine from 1927 by WMF (above), and the thermo-coffee machine from the *F. A. Porsche* design range by Siemens (below).

Electric coffee grinder by Siemens, 1940 (above). *Senseo* by Phillips with a special brewing system.

Futuristic espresso machine from 1951 by Saeco (above). Built-in espresso machine by AEG (below).

COFFEE MACHINES – COFFEE CULT IN THE KITCHEN

Tea may be the drink of philosophers, but when it comes to preparing their favorite drink, coffee drinkers also quickly become philosophical. They make profound statements in an attempt to explain why coffee should be prepared in one way and not another in order for it to show its best, aromatic side. Great chasms open up between the champions of the various coffee camps and machinery.

The argument begins right away with the difficult question of whether you should have your coffee ground in the warehouse, coarse or fine, for filter or coffee maker, or whether it is better to do it yourself – and maybe grind the beans a portion at a time in grandmother's indestructible coffee mill.

Grandmother's coffee was the best ever, according to the traditionalists, who prefer to put the ground coffee straight into the pot and fill it up with boiling water. Coffee grounds in the cup are detrimental to true enjoyment, say the others, who swear by the filter method using paper filters and boiling water

from the kettle, and stubbornly defend it against the general trend toward coffee makers. However, they have been in a clear minority for a long time, as the vast majority of coffee drinkers have been brewing it in machines for ages. Coffee makers are an indispensable part of the equipment in almost all kitchens. And since an incredibly enthusiastic new coffee cult has recently grown up around them, the agony of choice is greater than ever. The 300 or so different models of coffee maker currently on the market are only the basic stock. True coffee connoisseurs, on the other hand, move in quite different circles of flavor and aroma. Fully automatic coffee makers are the Rolls-Royce of coffee making. These all-rounders can do everything from grinding the beans in portions, via preparing the coffee, espresso, or cappuccino if required, to disposing of the used coffee grounds in a special drawer, and at a small extra cost they can also be fitted with a milk frother. Espresso machines differ from their bigger cousins in that they cannot grind their own coffee, but have to be filled by hand with ground coffee. As an alternative to these – also available for use in the home – there are Nespresso systems, in which the ground coffee is loaded into the machines in packs containing individual portions, and hot water is passed through them under pressure.

Genuine Italian: the *Macchina tipo esportazione 3 gruppi* by Gaggia, and *La Pavoni* by Saeco (below).

For individualists: the good old coffee filter by Melitta, and the handy espresso travel set by Alessi (below).

1970s' coffee cult: the Braun coffee grinder (above). Today's cult object – *Jules* by Saeco (below).

Coffee from the *Aromaster* by Braun (1976), and smart accessories by WMF (below).

There are about 20 years between them: the Braun *Aromaster* of 1984 (above), and the Saeco *Front Magic Comfort*.

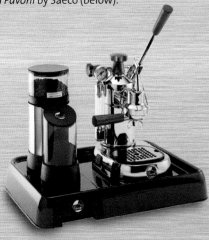

There is absolutely no complicated technology in the stove-top espresso makers that can be found in every Italian kitchen and many other European homes. They are quick and easy to use, especially for a quick espresso in between times or at the end of an Italian meal.

It is also a factor in the never-ending story of coffee's success that it is simply a part of any good meal, in whatever variation, whether you are in a classy five-star restaurant or having a cozy evening at home in your own kitchen. Anyone who has ended their evening meal with a coffee and maybe taken a long time to get to sleep as a result will do well to take time the next morning for at least one reviving cup of coffee with their breakfast, no matter what kind of machine it has been made in. No other drink can compete with its omnipresence at all times of the day and night, and with every meal. No wonder just as much money is spent on many coffee makers as on a new washing machine or a new oven.

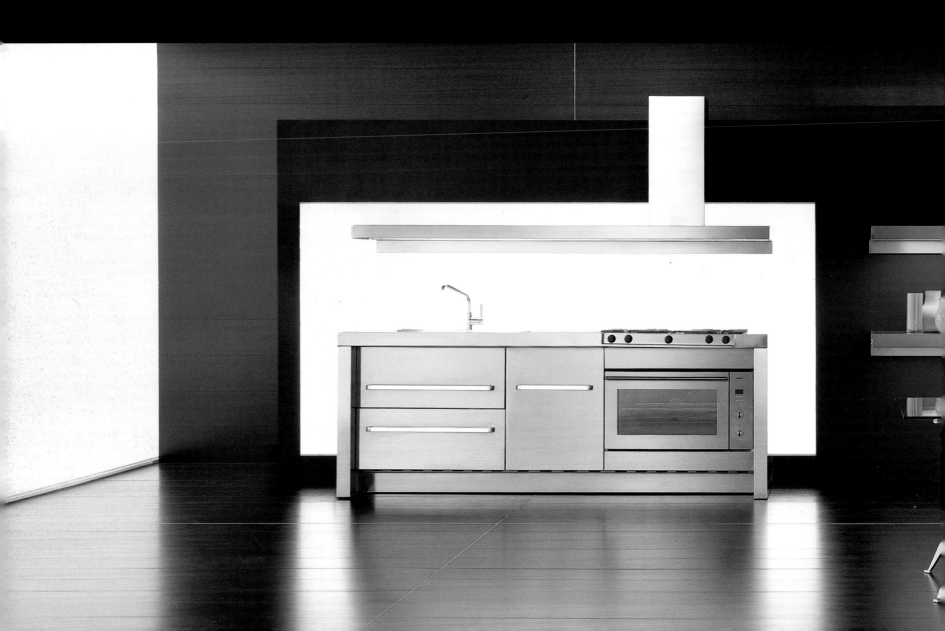

M inimalist, purist, elemental: there are many words to describe what distinguishes the trend-setters among modern kitchens – a reduction to essentials, a new simplicity, and an uncompromising rejection of unnecessary frills. These kitchens are masters of the art of understatement. They do not create a sensation in order to become the focus of attention, nor do they forget what the kitchen is, or should be, all about – that is, the art of cooking and living. But anyone working in them and with them soon realizes that this is down to professionalism. Everything is thought through right down to the smallest detail; everything is organized so as to achieve the highest degree of efficiency and functionality; everything bears witness to the fact that perfection is taken for granted.

It is the clean lines, the skilful deployment of forms and colors, and the sensitive use of materials that the admirers of beautiful kitchens find so fascinating about the sophisticated designer interiors of their favorite rooms. Head and heart and stomach all have a say in it, because this kind of kitchen will not be won over by love at the first fleeting glance, but systematically, piece by piece. Quite often it is the beginning of the story of a wonderful, unshakable, indestructible relationship.

There is no question that this kind of kitchen makes – and fulfils – the highest demands when it comes to quality and workmanship. This kind of installation cannot be bought "off the peg." Planned down to the smallest detail, made with technical precision and master craftsmanship, using the very best materials, it guarantees something that has become very rare and precious these days: it will not date or lose its value – during its entire lifetime.

Nomis Dada

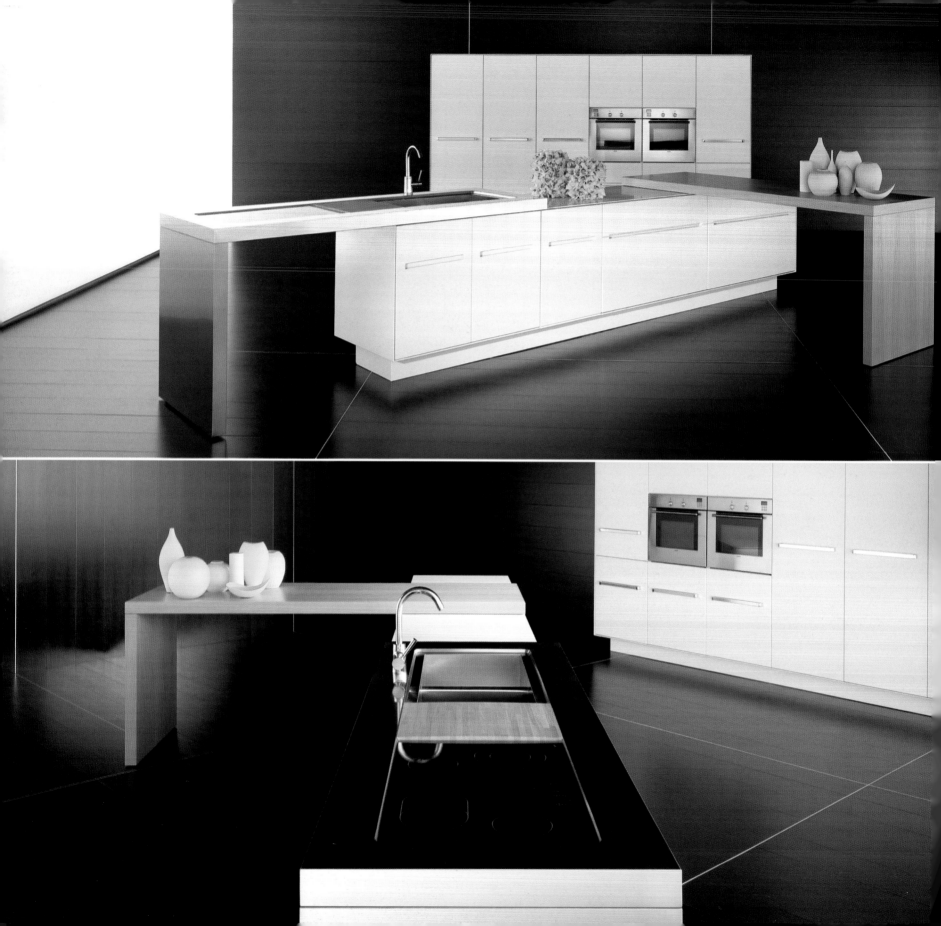

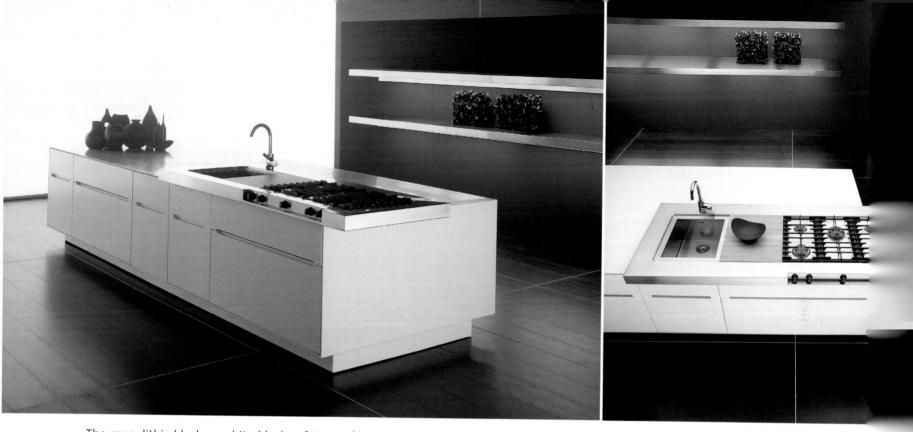

The monolithic black or white blocks of *Nomis* (design: Hannes Wettstein) dominate the room. The oak dining area, and the stainless steel cooker and sink area can be placed on the basic rectangular blocks in a variety of ways (Dada).

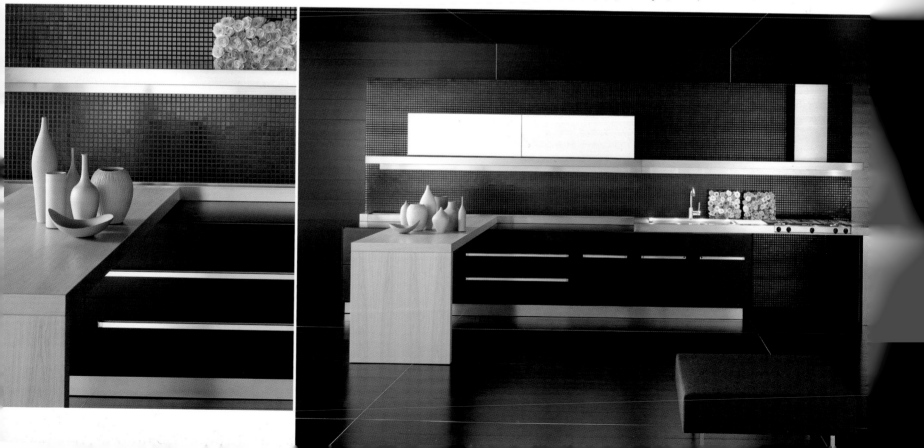

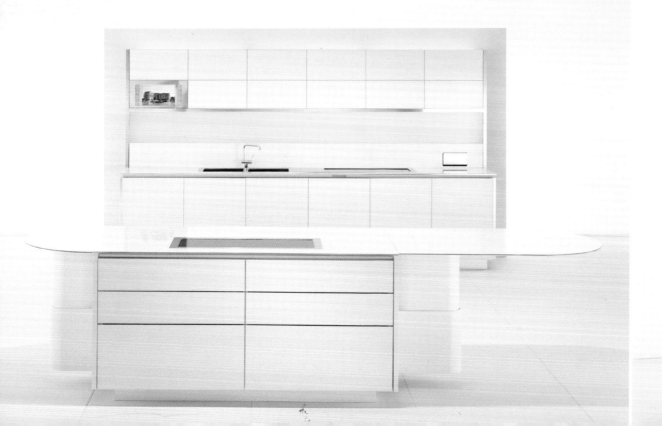

The *Tivali* walk-in kitchen (above) – a radical break with familiar kitchen habits. Only when the doors open do you get a view of the unusual workspace with its equipment that is technologically advanced (Dada).

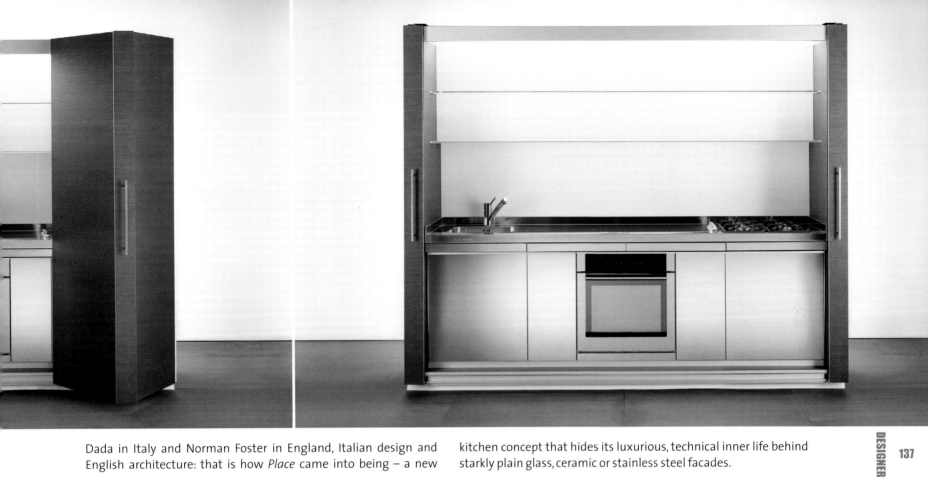

Dada in Italy and Norman Foster in England, Italian design and English architecture: that is how *Place* came into being – a new kitchen concept that hides its luxurious, technical inner life behind starkly plain glass, ceramic or stainless steel facades.

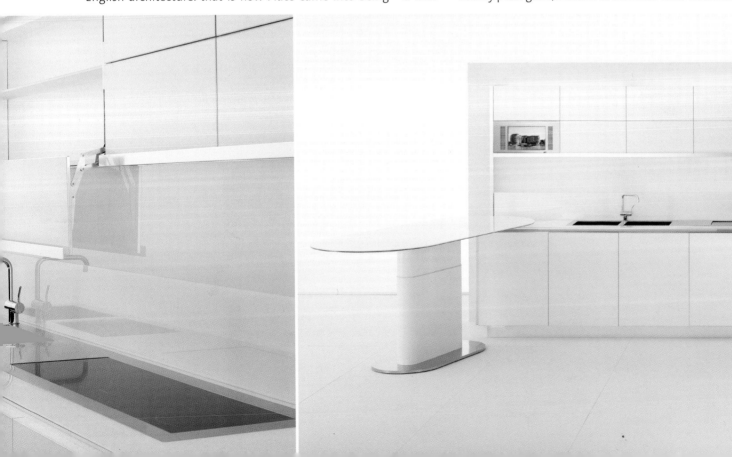

Nuvola, designed by Luca Meda for the kitchen manufacturer Dada, releases the kitchen from the force of gravity. All the wall units appear to float above the ground, and the cooking island on its tapered base rests lightly amidst the everyday life of the kitchen.

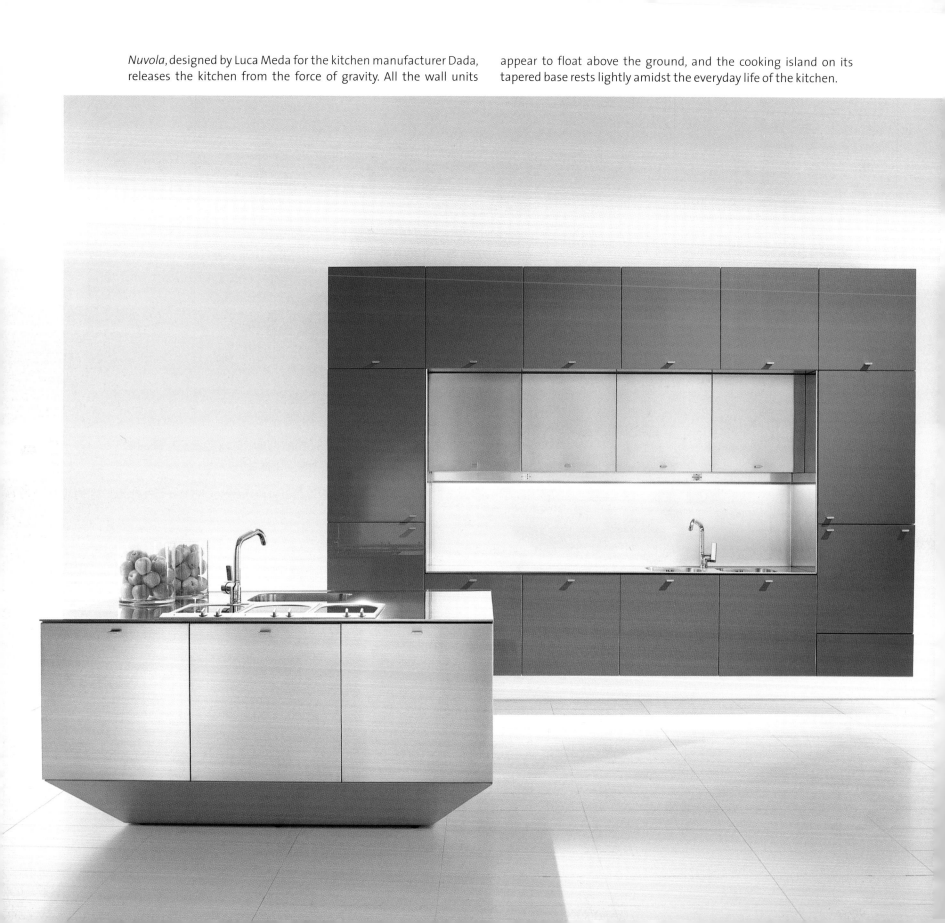

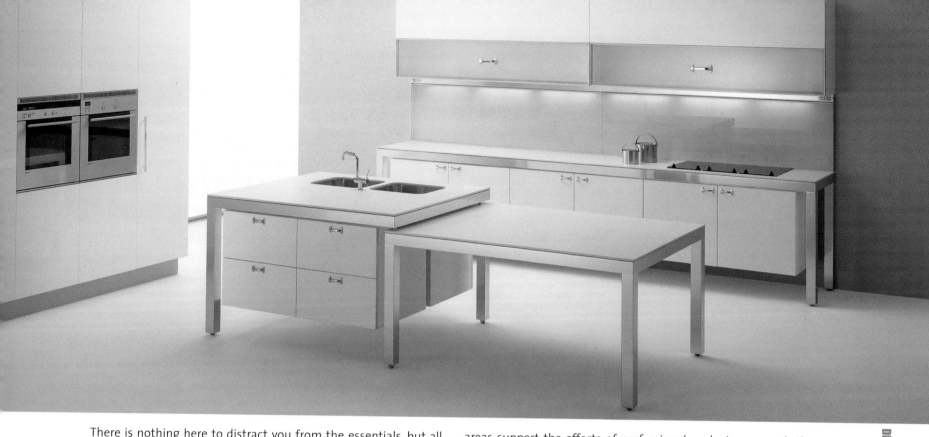

There is nothing here to distract you from the essentials, but all the carefully planned details and the large, separated working areas support the efforts of professional cooks to approach the fundamentals of life in cooking (*Banco* by Dada).

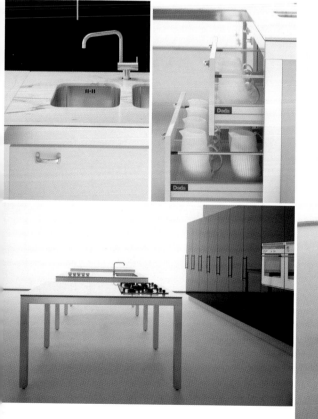

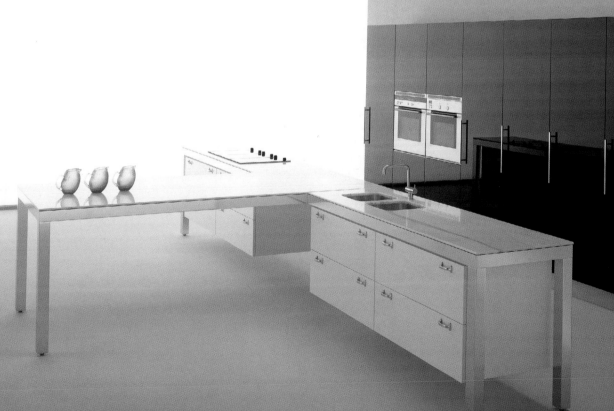

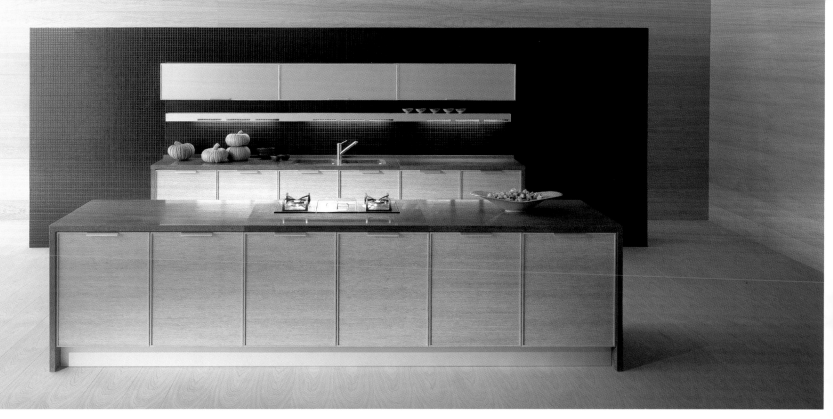

Slim horizontal lines, refined wall units and, at the still center, a meticulously constructed preparation and cooking area that makes it easy for you to forget all the stresses of your hectic daily life (*Quadrante* by Dada).

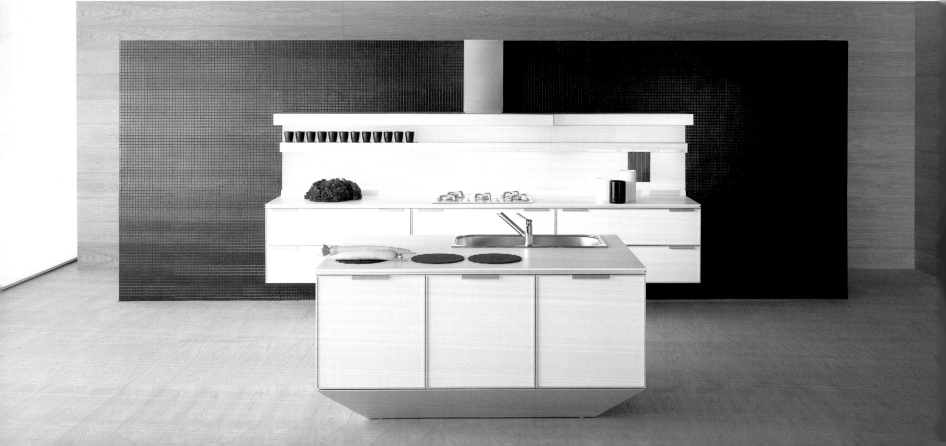

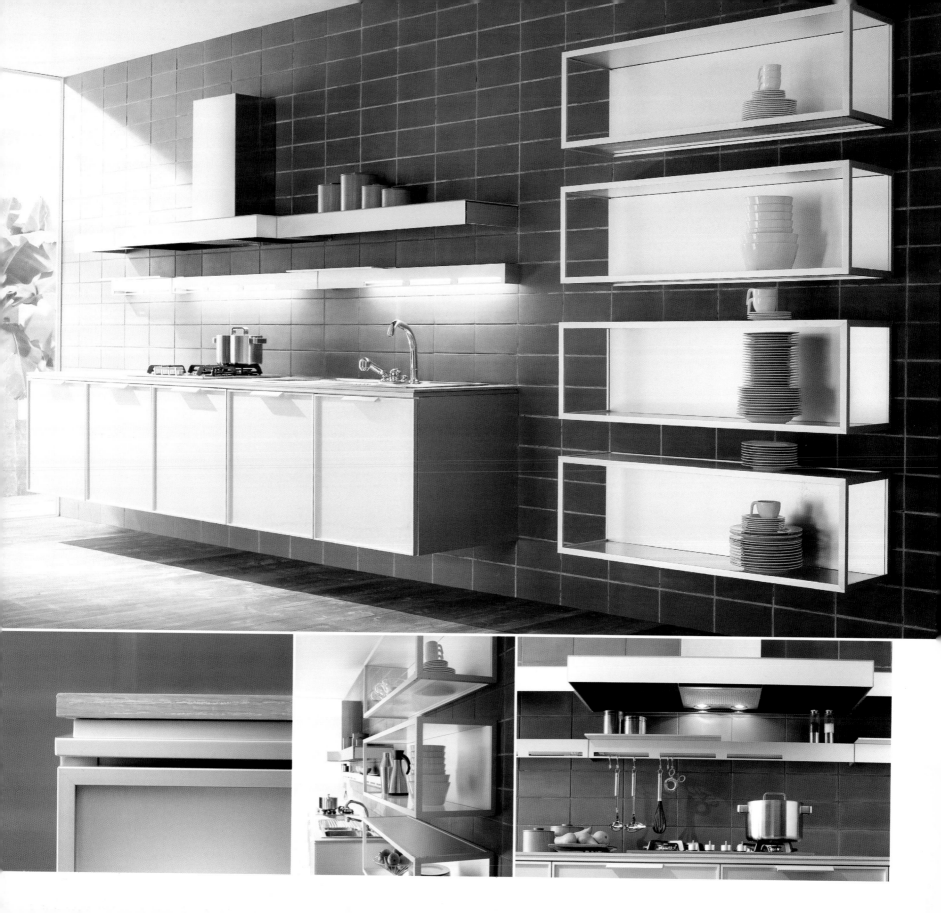

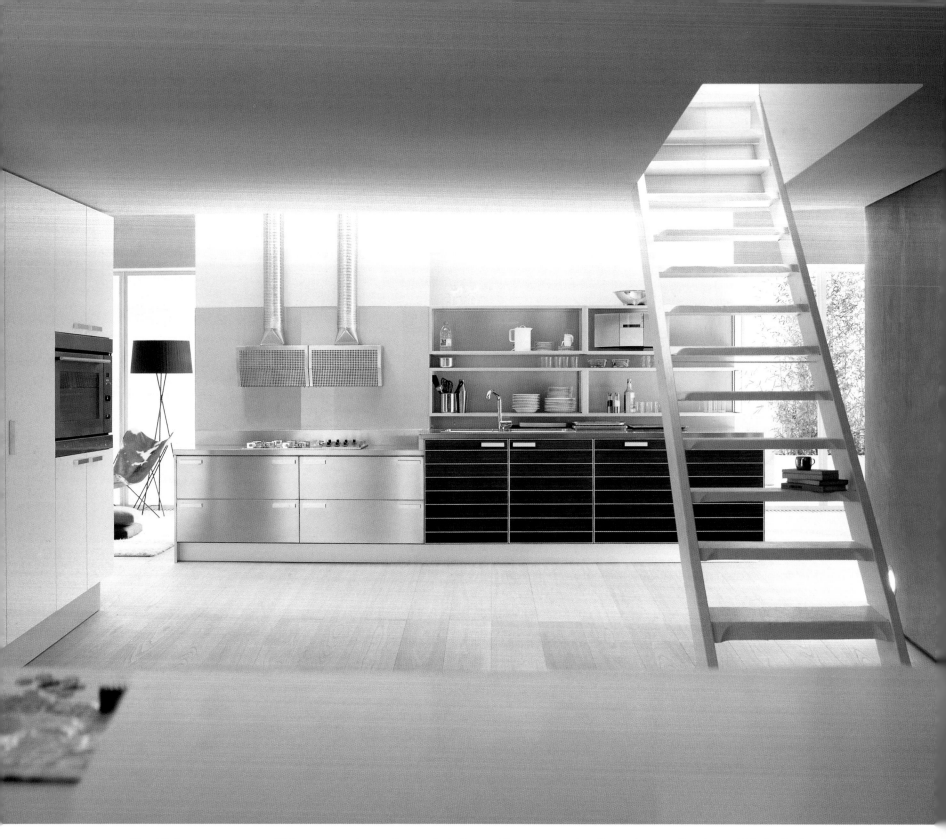

The kitchen as a room within a room. Innovative wall design with modular elements. Professional stainless steel equipment.

There are contrasting colors on the doors. *Vela* by Dada creates unconventional solutions for unusual rooms.

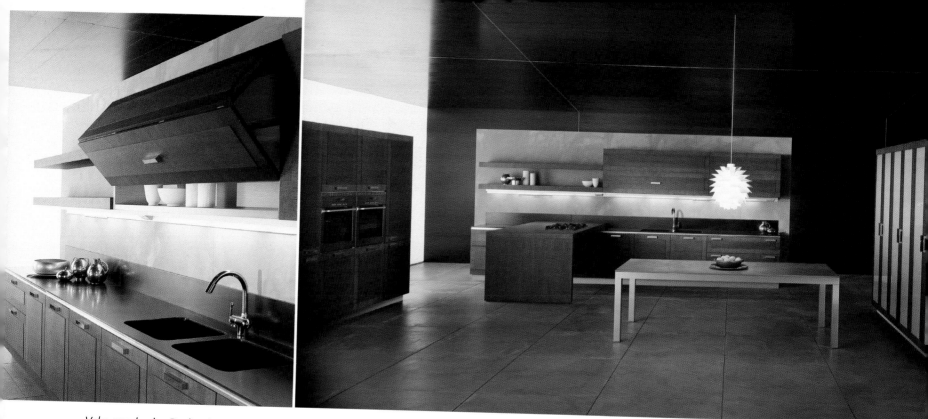

Vela quadra by Dada shows that wood can be used in the same elegant, avant-garde way as stainless steel or glass. Dark or gray stained oak dominates the picture, and the basic simplicity of the outlines creates space for sophisticated details.

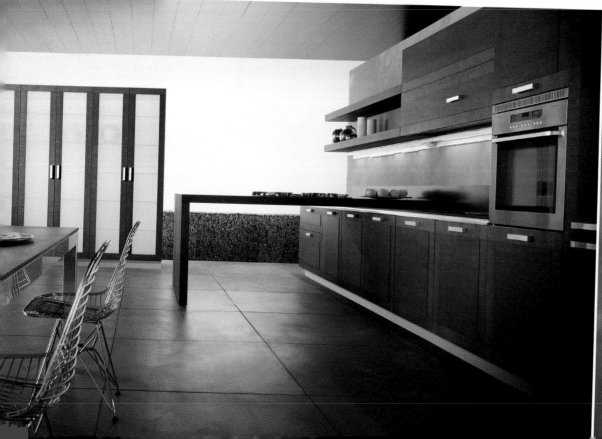

Modern design loves warm wood. The strongly marked grain of zebra wood fits well with the dark worktops and gives the kitchen a hint of the exotic (*Elegance* by Sanitas Troesch).

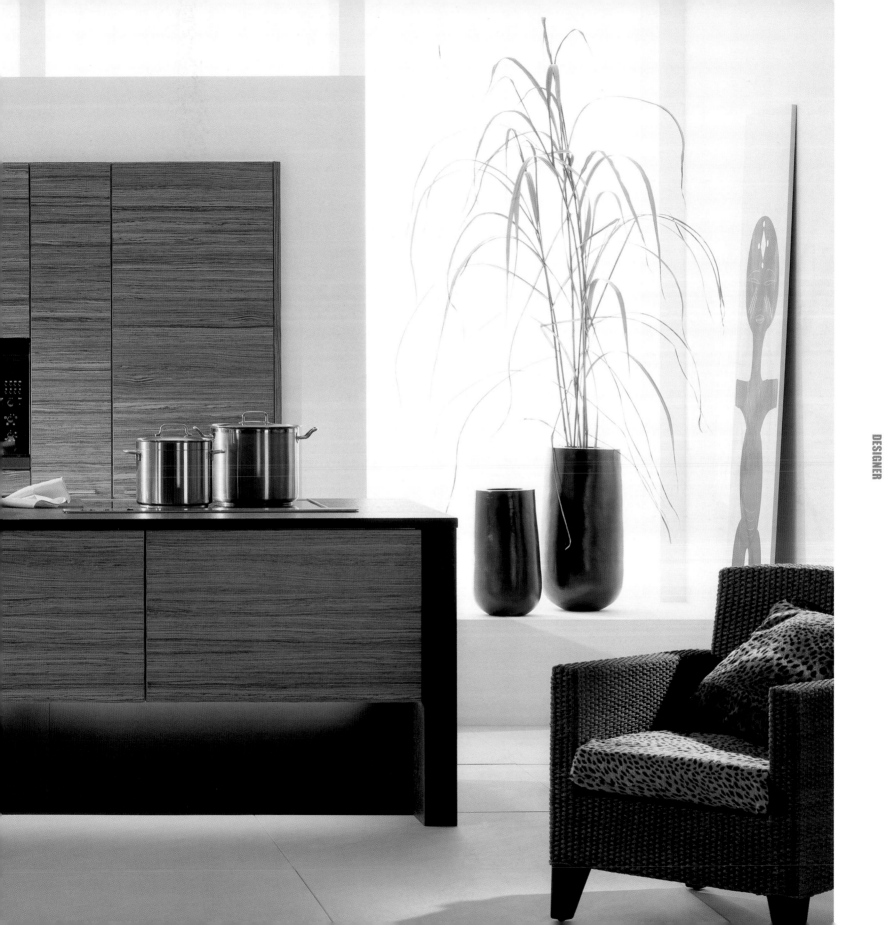

Velvety matte or glossy lacquer surfaces, or a sturdy granite worktop: *Graphics* (above) and *Largo FG* (below) by Leicht stand for the kind of elegant kitchen that combines modern designer units with timeless charm.

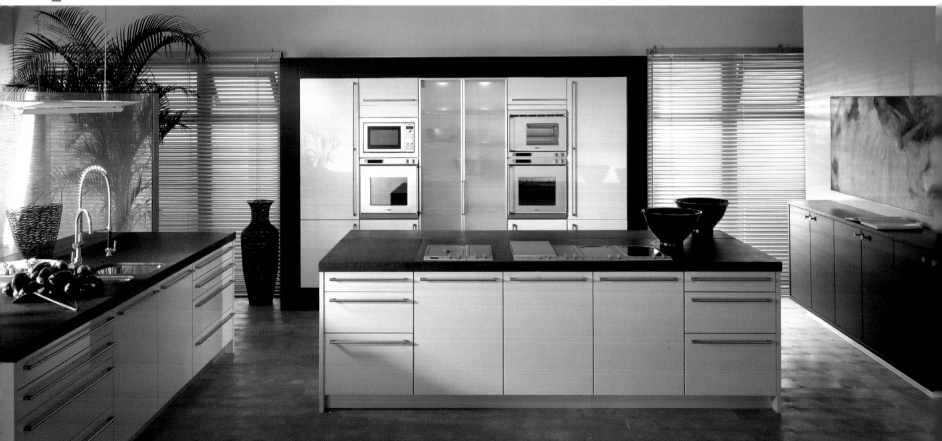

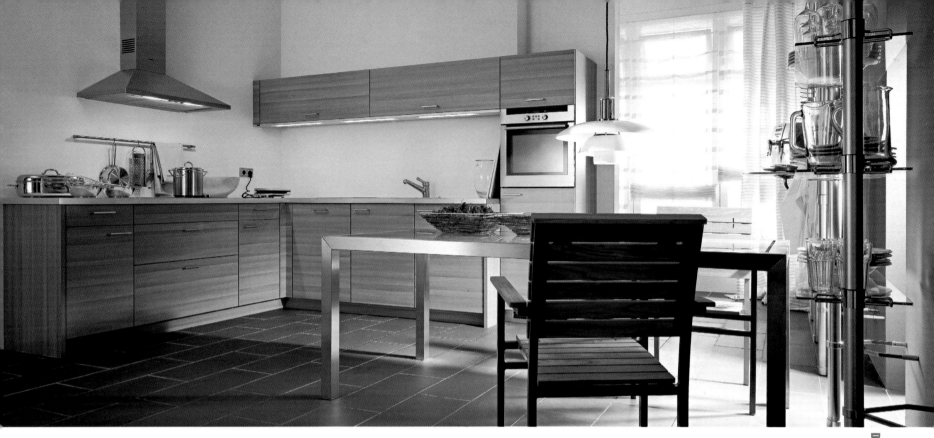

Orlando (above) and *Amara* (below) are characterized by the expressive grain of walnut imitation or ash doors. The broad lines create a restful effect that goes well with the spacious look of these kitchens (Leicht).

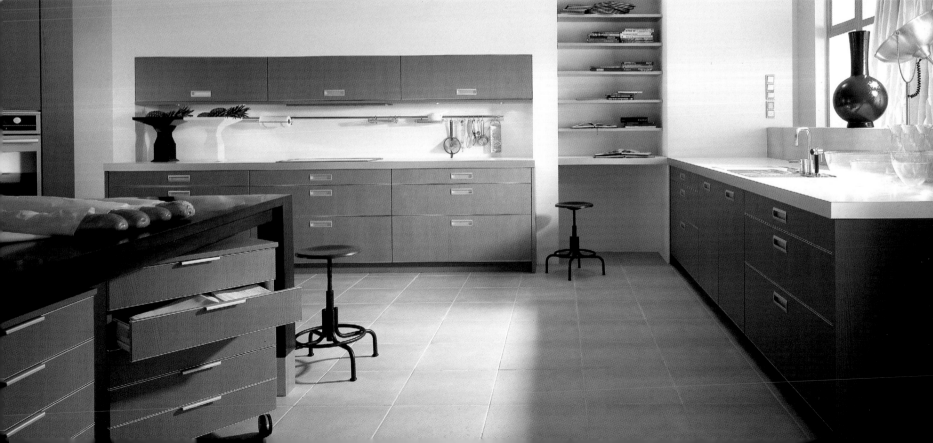

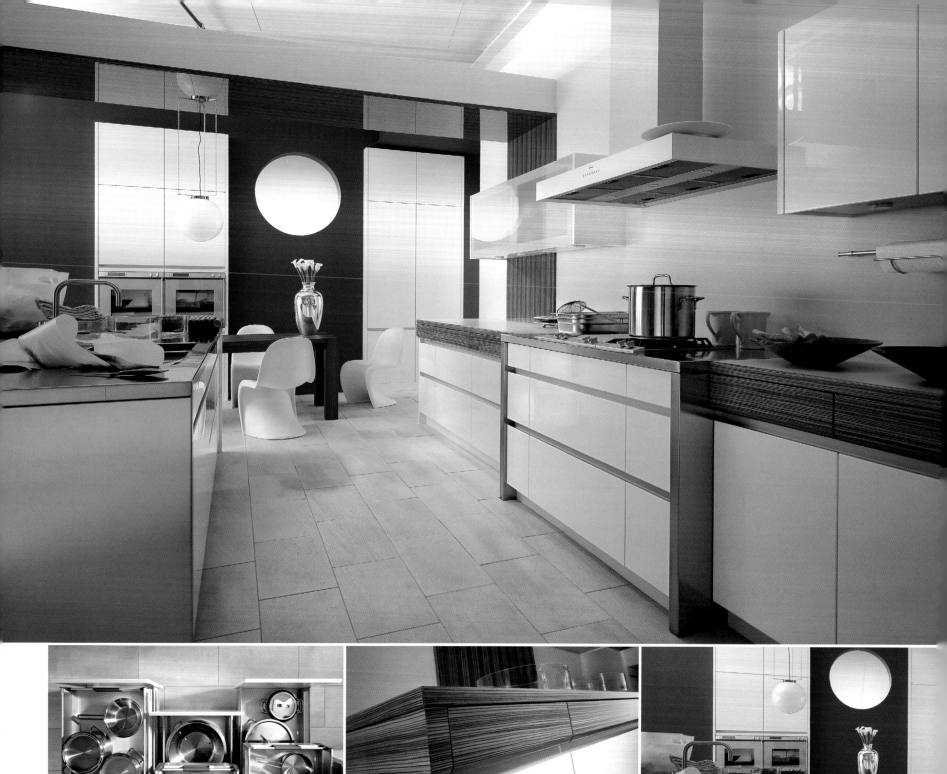

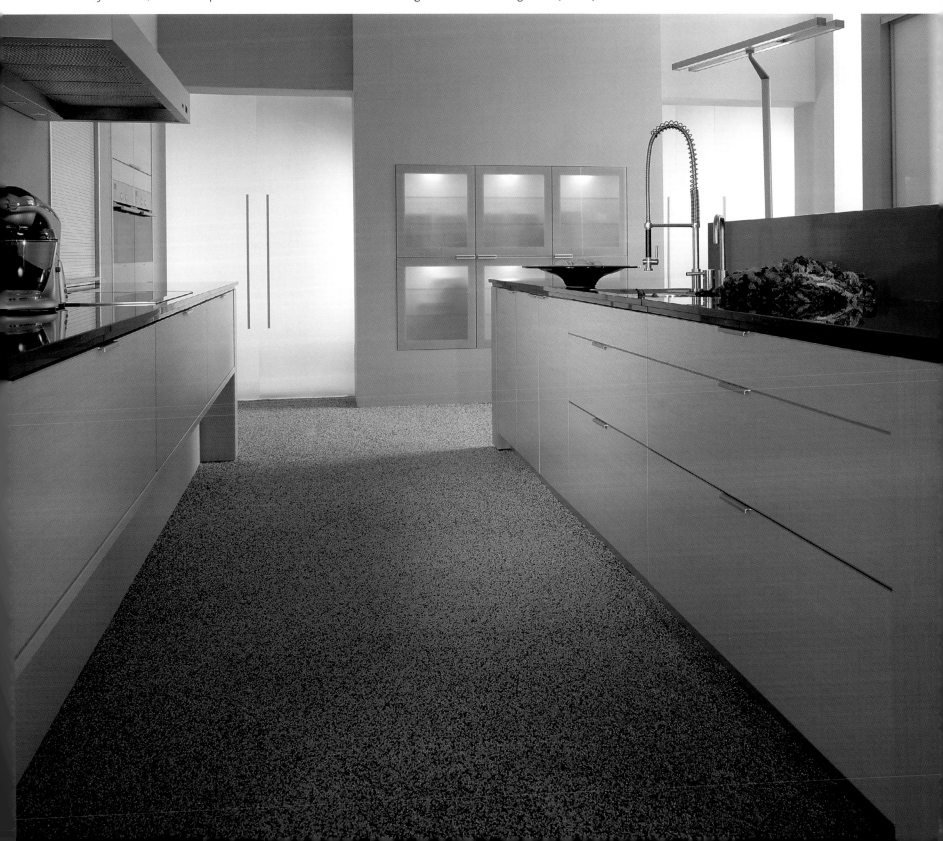

Avance FG (left) is distinguished by its plain fronts, uninterrupted by handles, and an emphasis on the horizontal lines. *Ontario* goes for the youthful charm of light, strongly grained oak, combined with black granite (Leicht).

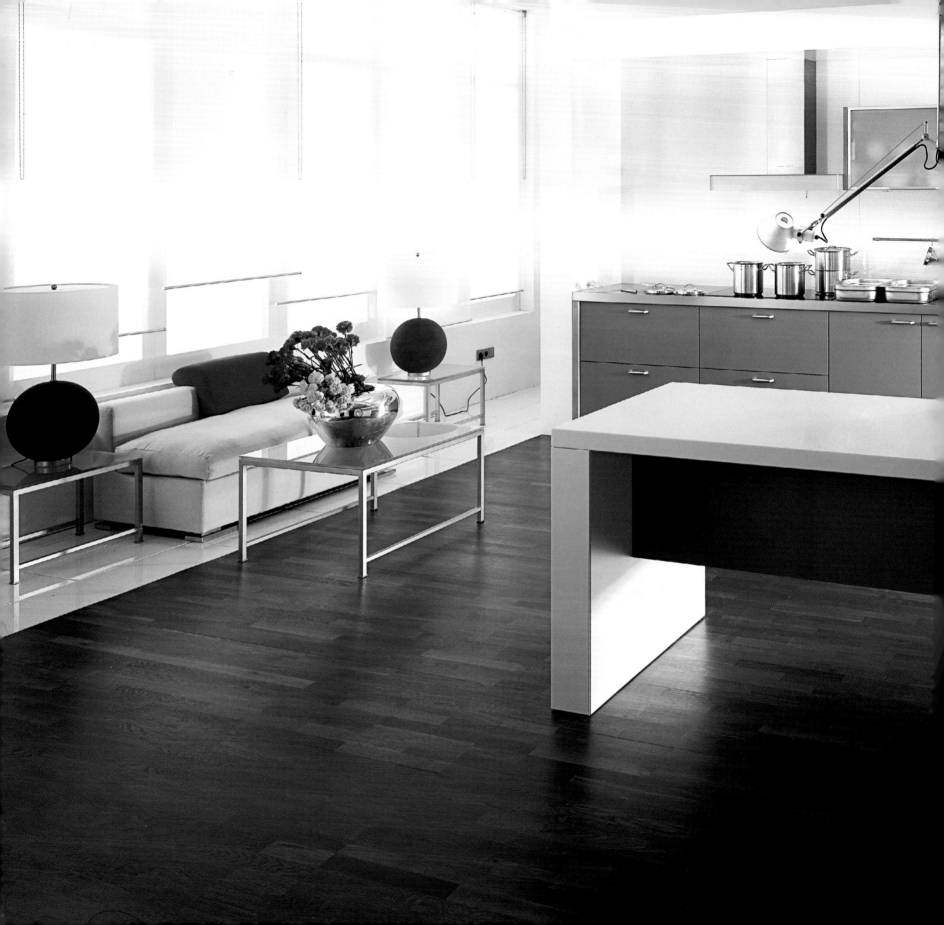

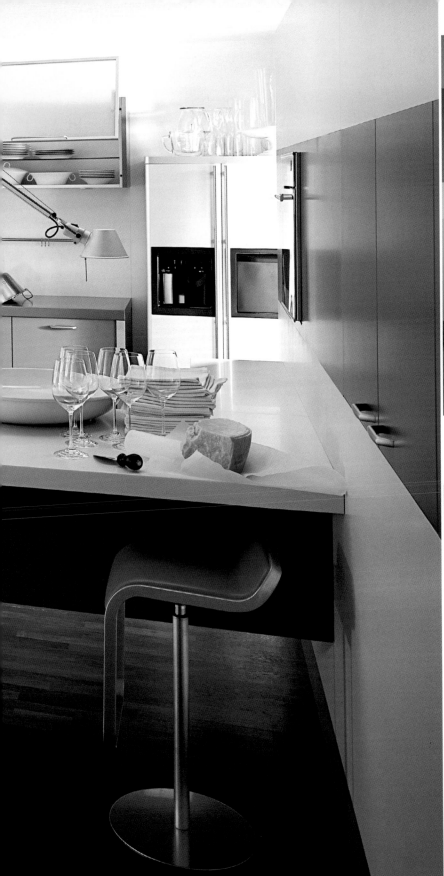

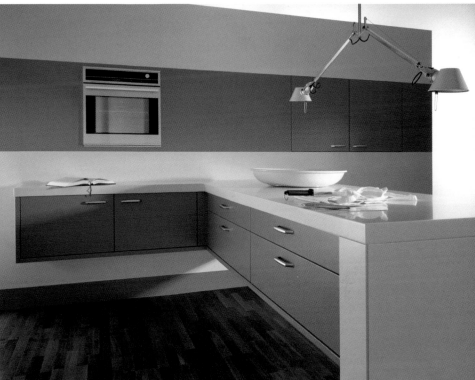

To be savored slowly: cappuccino and vanilla are the names of the fashionable colors of the *Largo FS* by Leicht. They harmonize perfectly with one another, radiating warmth and comfort in large measure.

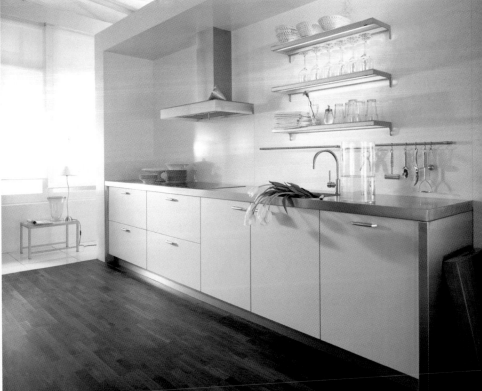

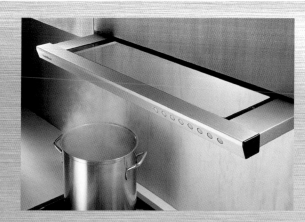

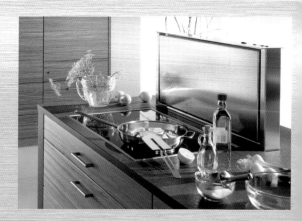

Meteoric development – from the early models (Siemens 1976), to the new class of contemporary designs by AEG (below).

Small and neat, but providing great ventilation: the *AH 900* cooker hood from Gaggenau (above), and the stainless steel wall-mounted chimney from Neff.

Professionals at work create a wind of change: the fold-down cooker hood by Sanitas Troesch/ Merial, and the aluminum/stainless steel version from Gaggenau (below).

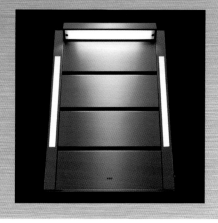

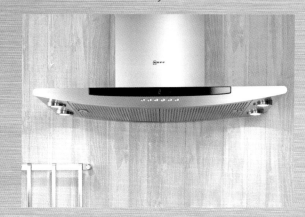

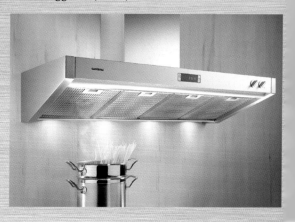

GENTLE SUCTION – EXTRACTOR HOODS

A stuffy atmosphere in the kitchen hampers creativity and communication. If the stale smell of the day before yesterday's fish and yesterday's cabbage are still hanging in the air, the kitchen is not exactly conducive to comfort. So, before the age of cooker hoods, housewives had good reason to want to keep the kitchen behind closed doors, in order to prevent cooking smells from spreading through the entire house. Conversely, the new trend for open living-room/kitchens would be quite unthinkable without high performance extractor fans. Since the late 1960s, cooker hoods have been taking hold in the kitchen. Unlike the early versions, which were successful in combating smoke and smells but significantly increased the noise level, great importance is now being placed on minimal noise levels during the development of new models. Their elegant, eccentric, futuristic, or sometimes even deliberately old-fashioned designs are one more way of ensuring that these appliances – which may be in the form of stainless steel columns with glass umbrellas, gently

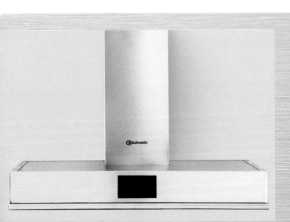

Versatile and full of new ideas: the flat-hood model with touch control from Bauknecht (above), and the Miele model with a railing round it.

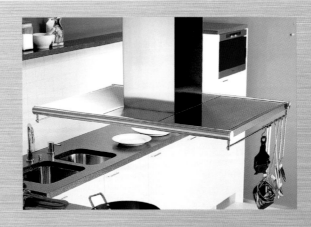

Visual highlights for designer kitchen fans: the cooking island extractor hood from Miele, and the wall-mounted version by Imperial (below).

Innovative concepts: the trough ventilator from Gaggenau (above), and the wall-mounted system by Küppersbusch.

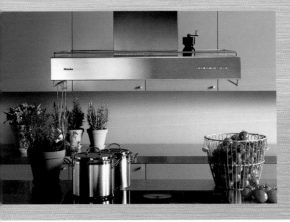

floating chimneys or modular elements freely suspended from the ceiling above the cooking island – have the visual place of honor in the kitchen. Anyone who dislikes such an obvious reference to smells can fall back on concealed solutions, if the extraction mechanism is installed in hollows next to the cooking area and the smell is sucked downwards, or if it is mounted not above but in segments behind the cooking area.

Of course, innovative technology is also involved in the matter of clean air. The latest sensor hoods manage ventilation automatically. Any smells and heat being generated are captured by intelligent electronics via the cooking surface, and the fan speed is regulated accordingly. Freed in this way from all the irritating side effects of cooking, nothing more stands in the way of the civilized cooking and communication culture in the living room/kitchen.

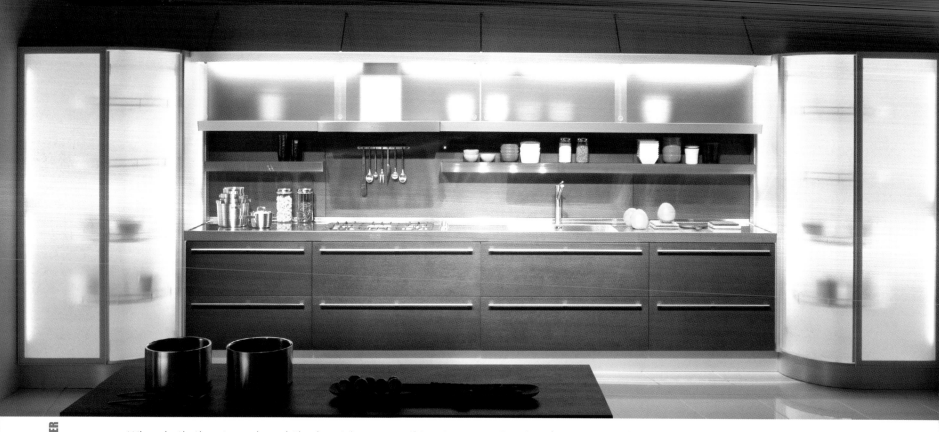

When both the stomach and the heart have something to say, decisions about kitchens should be easy, as these models from Snaidero (*Panoramica*, above, *Fluida*, below) put the emphasis on emotional appeal and leave nobody feeling indifferent.

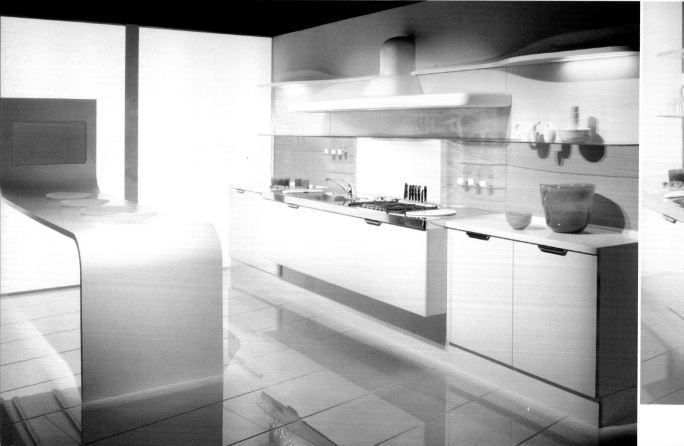

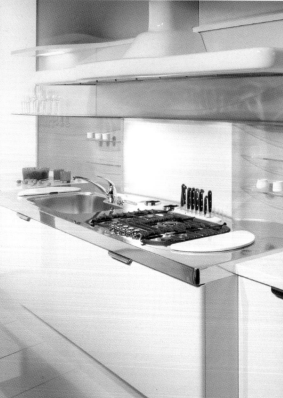

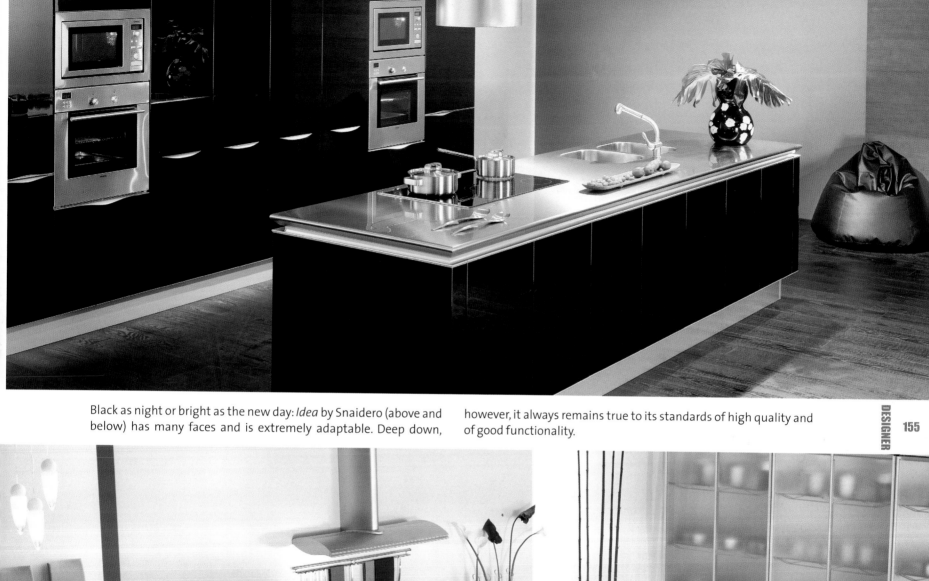

Black as night or bright as the new day: *Idea* by Snaidero (above and below) has many faces and is extremely adaptable. Deep down, however, it always remains true to its standards of high quality and of good functionality.

Acropolis – a great name for a spectacular kitchen that is the result of the collaboration between the Italian manufacturer Snaidero and the Pininfarina design studio. The Acropolis kitchen is the nucleus around which family life is organized.

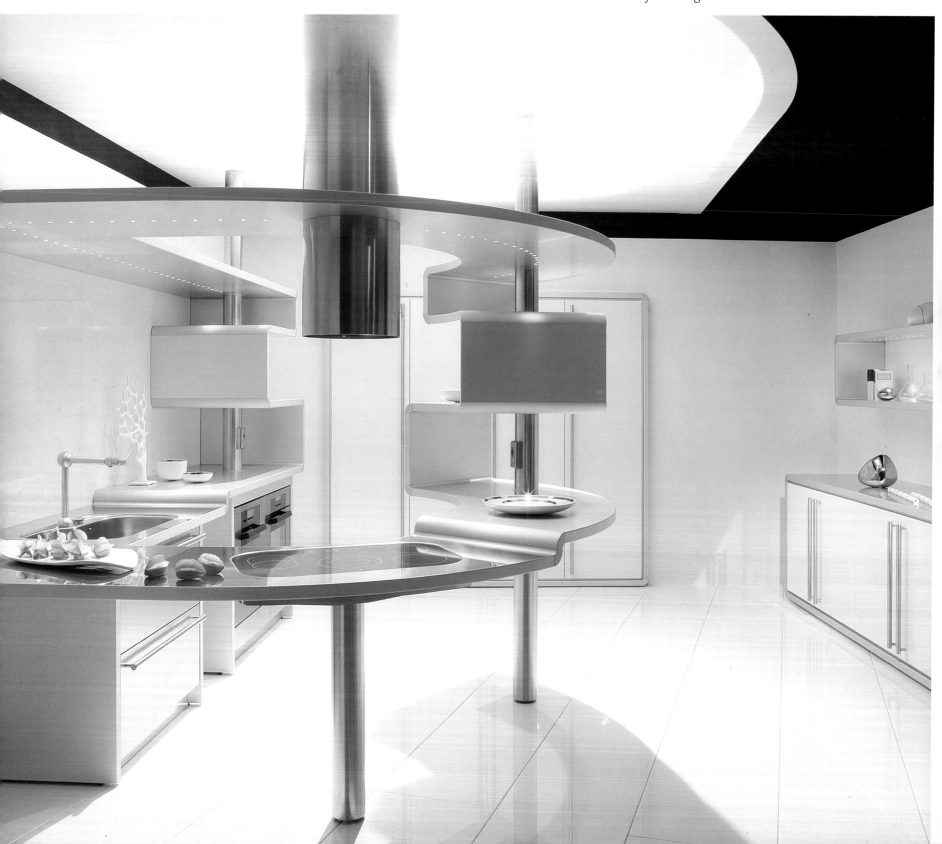

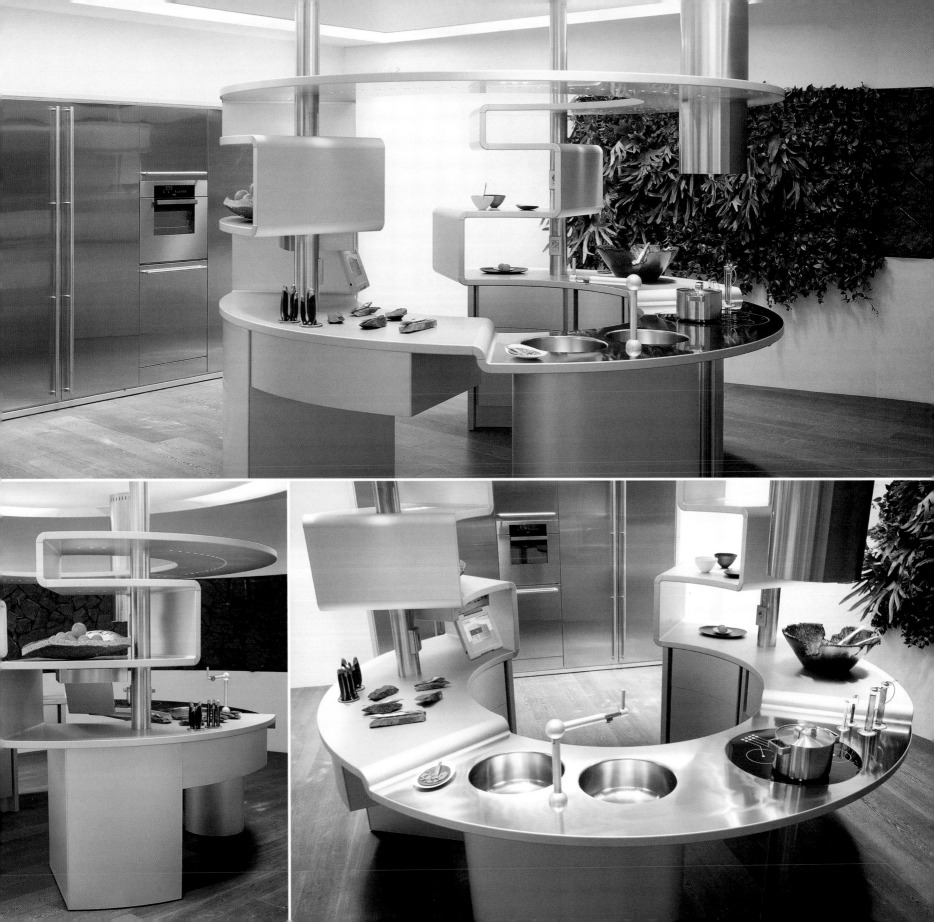

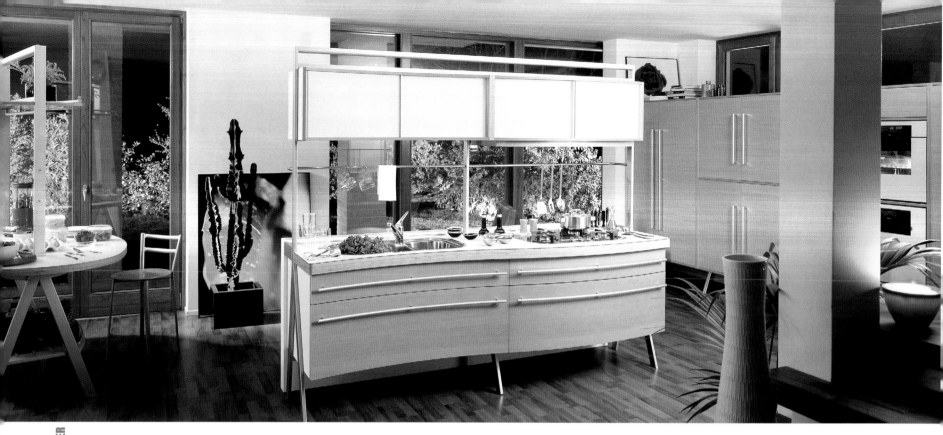

Perfect for global players are the *Sistema ES* (above), with its hint of an S-shape, and the *Sistema Zeta* (above right) as its linear counterpart (Snaidero). Light and flexible, made up of freestanding units, they can adapt to life at any level.

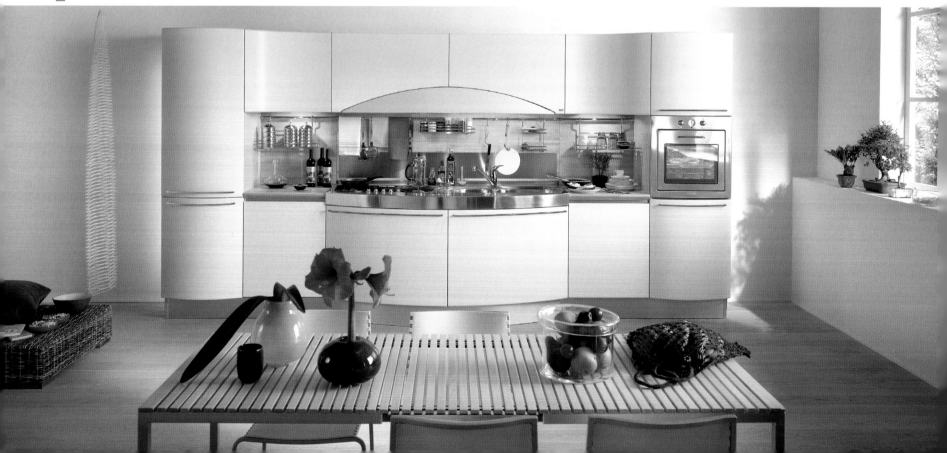

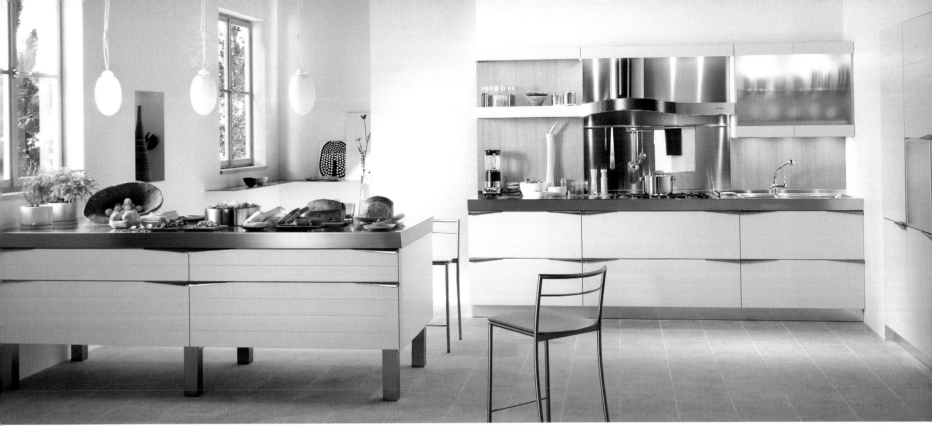

Ola (below left) and *Viva* (below) bear the hallmarks of Pininfarina design and the innovative hand-made quality of Snaidero. Both of these kitchens show that they are really at ease in quite exceptional surroundings.

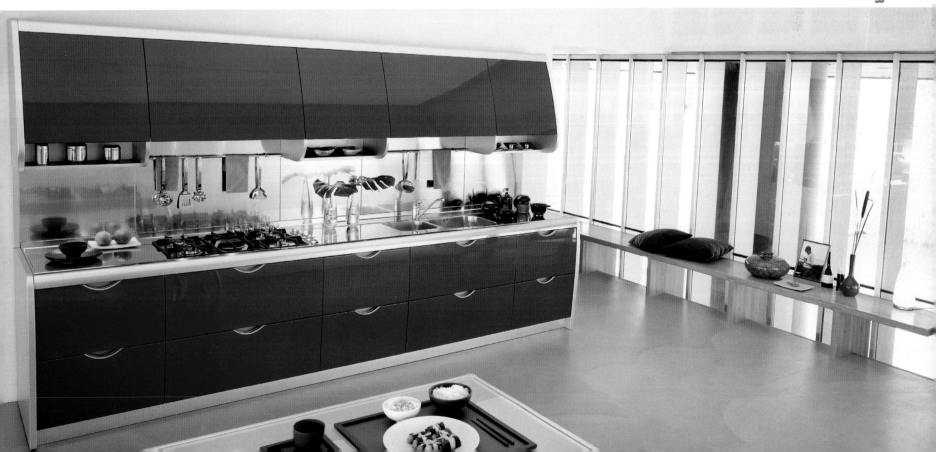

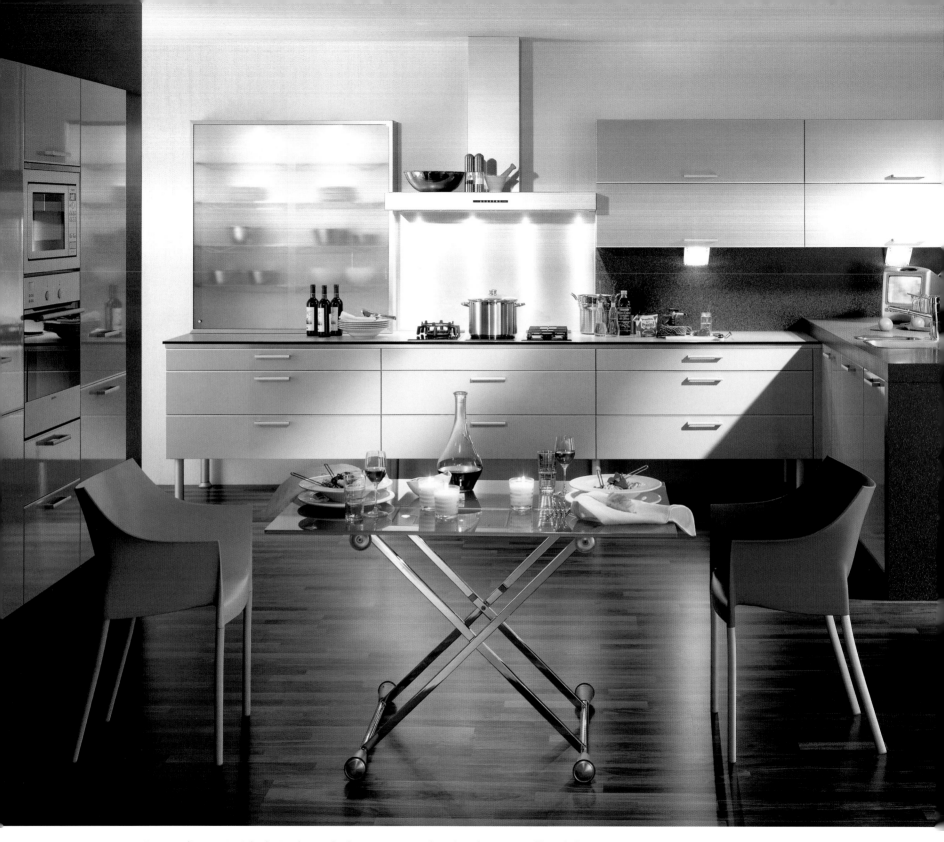

Using quality materials, lovingly worked out in every detail and never losing sight of the demand for comfort: every FM kitchen is a one-off. And if it is a *Ventura Platin*, it comes with an emphasis on lightness and buoyancy.

Serviceberry is one of the less commonly used woods. In *Cosma* by FM, the beautiful grain of this wood, which alternates with satinized glass and the sturdy worktops and end boards, really comes into its own.

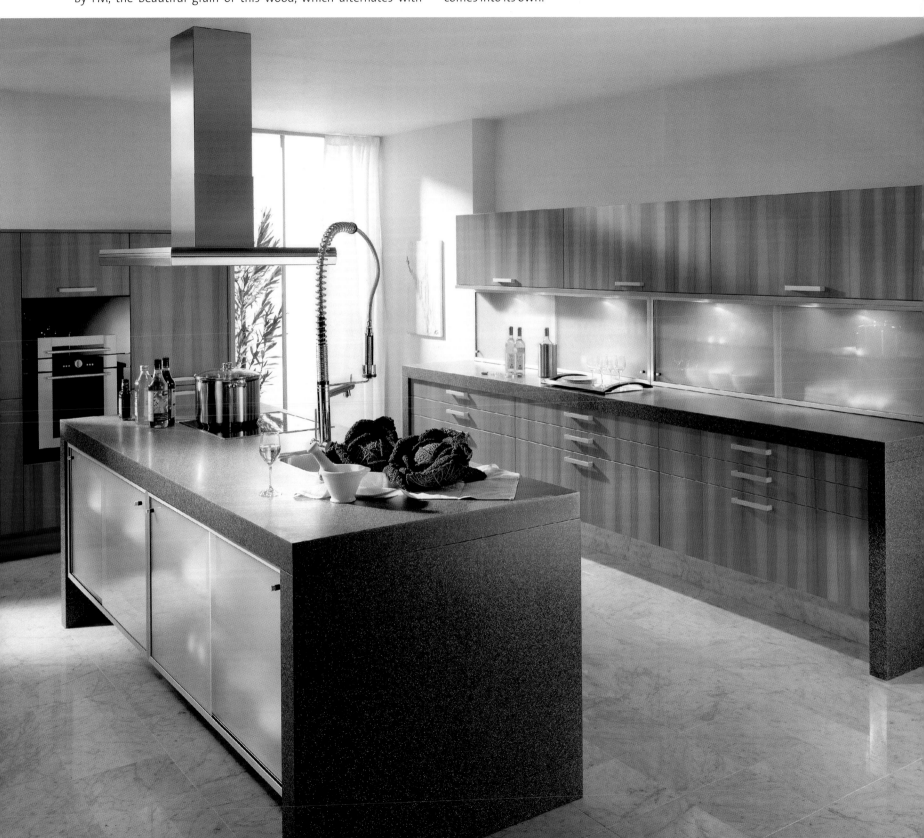

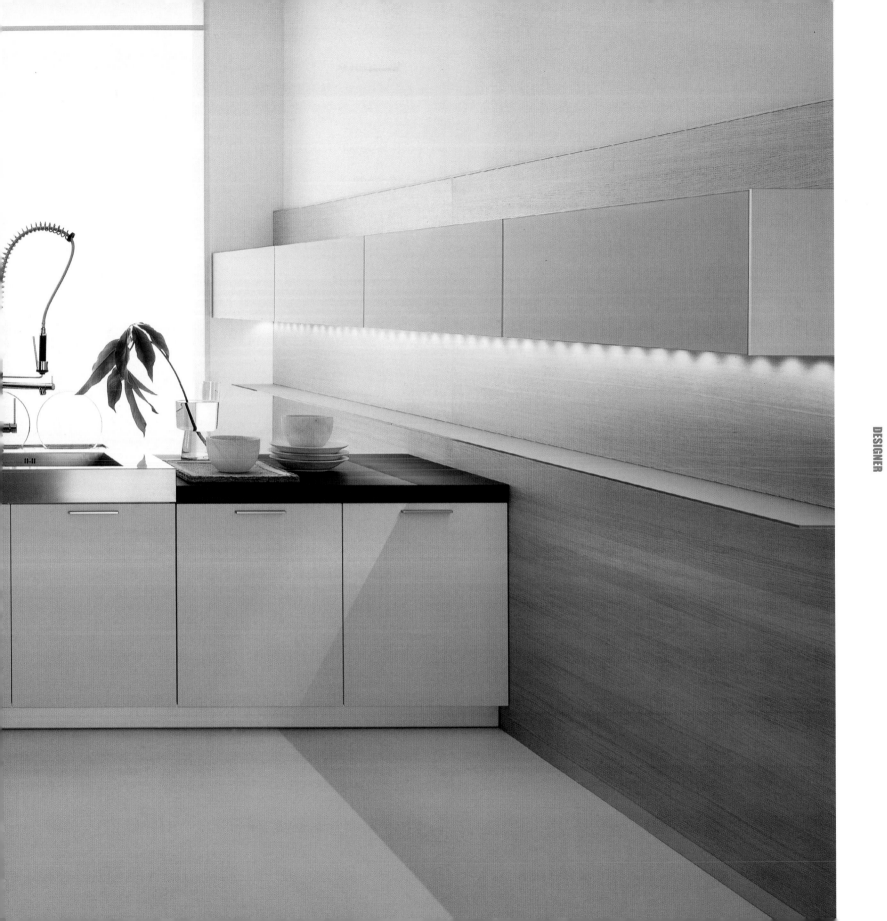

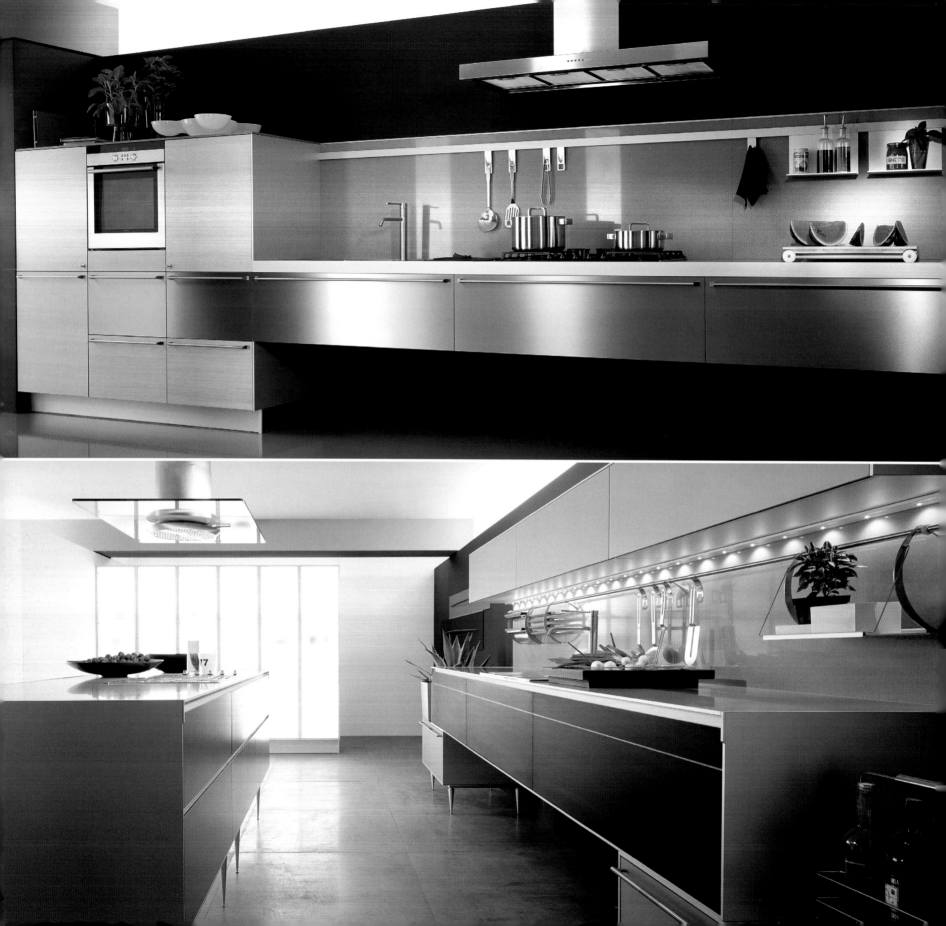

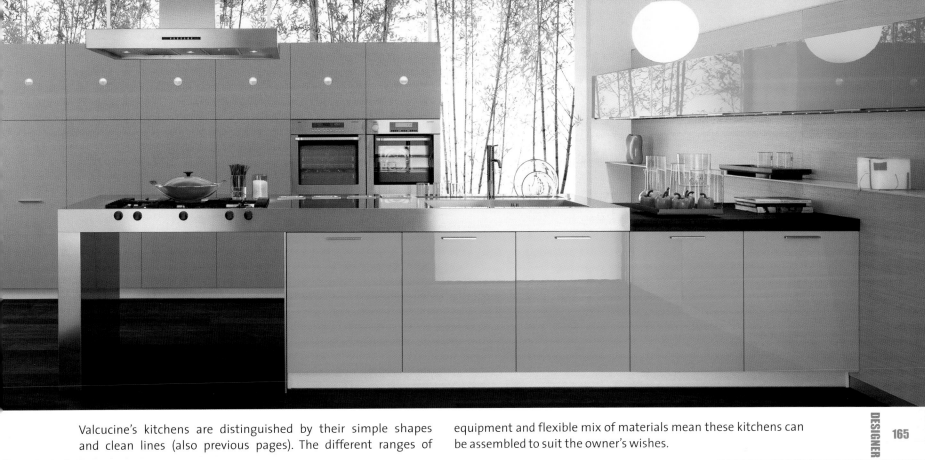

Valcucine's kitchens are distinguished by their simple shapes and clean lines (also previous pages). The different ranges of equipment and flexible mix of materials mean these kitchens can be assembled to suit the owner's wishes.

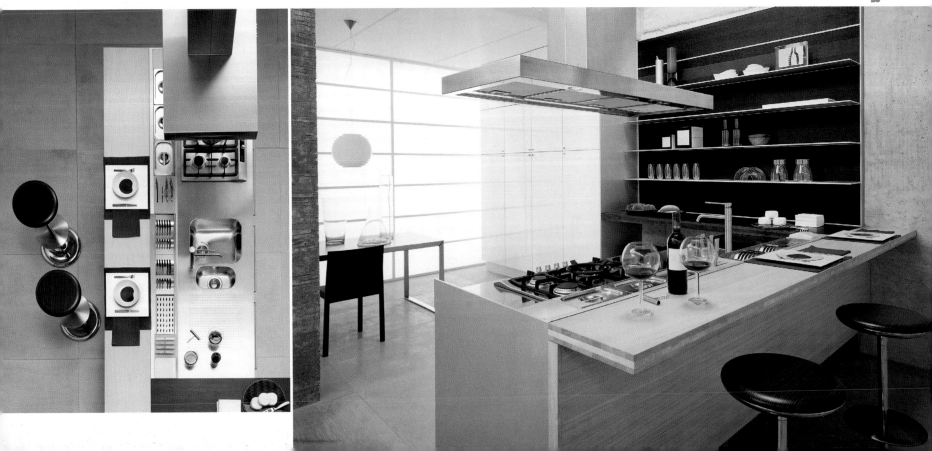

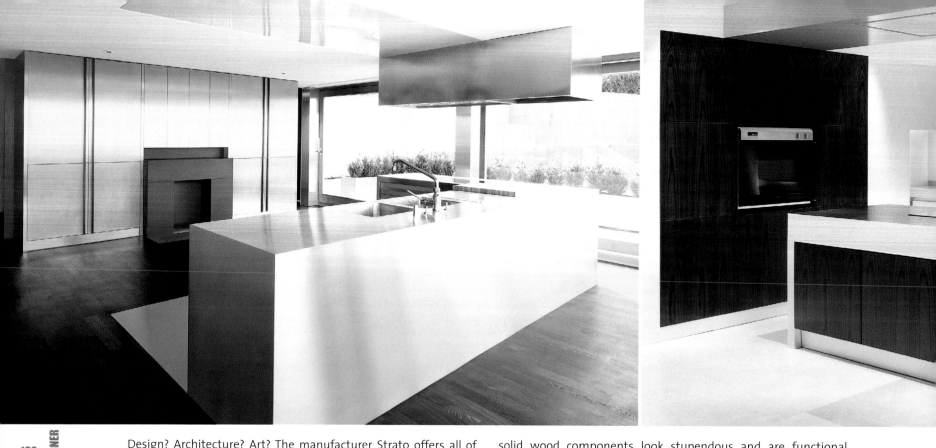

Design? Architecture? Art? The manufacturer Strato offers all of these and more. The individual stainless steel, Carrara marble, or solid wood components look stupendous and are functional. A must for lovers of good design with a passion for cooking.

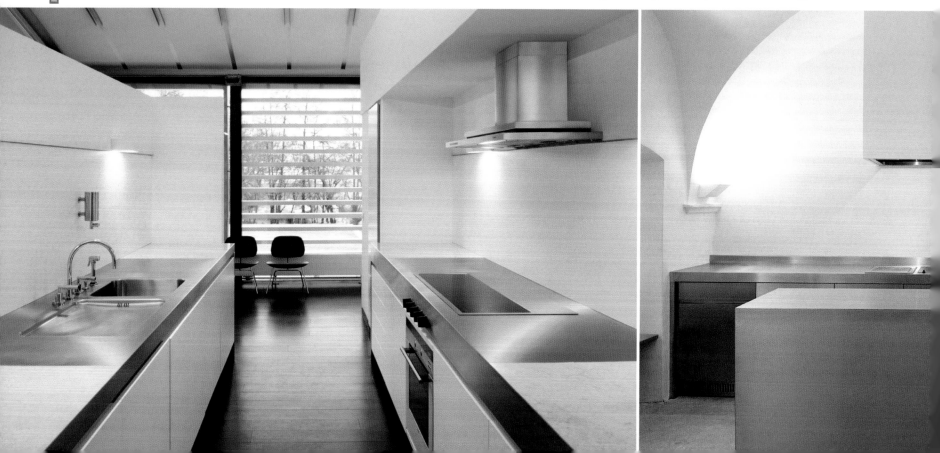

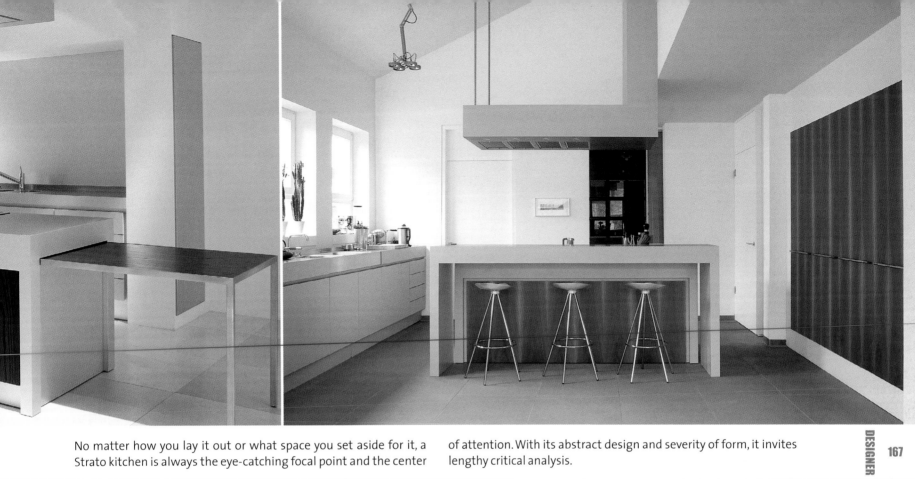

No matter how you lay it out or what space you set aside for it, a Strato kitchen is always the eye-catching focal point and the center of attention. With its abstract design and severity of form, it invites lengthy critical analysis.

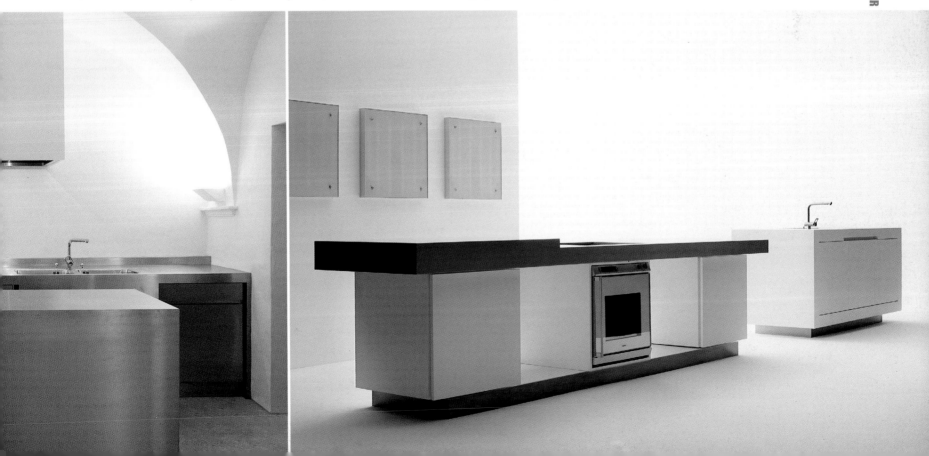

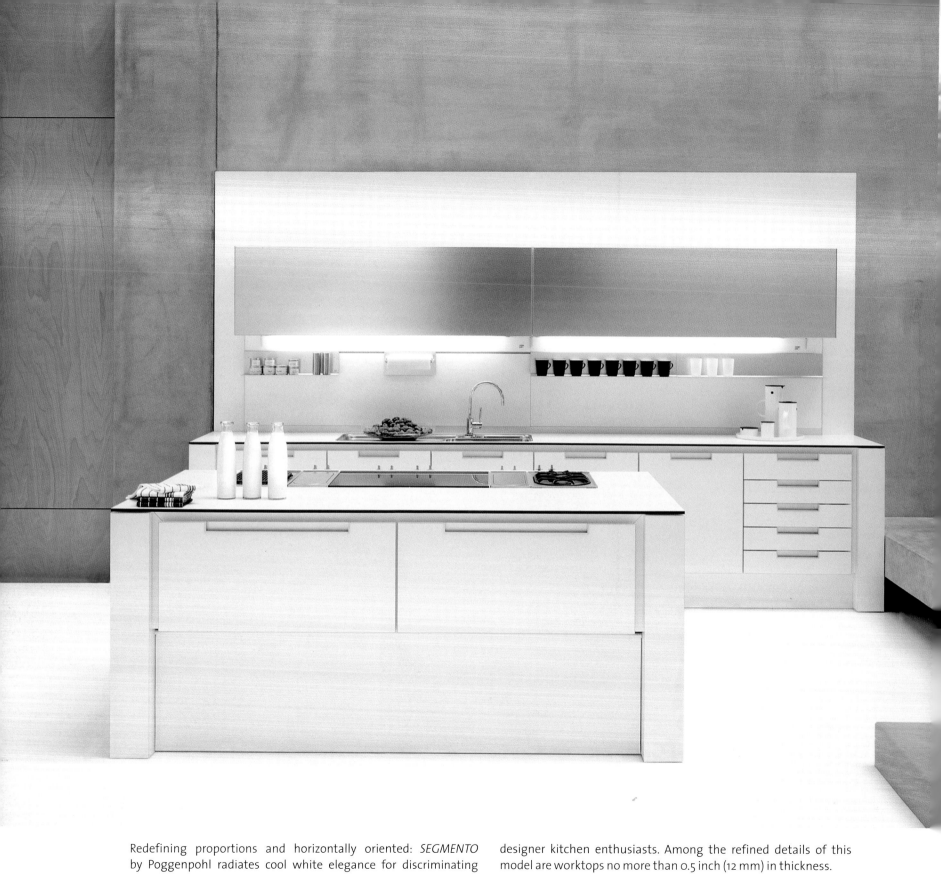

Redefining proportions and horizontally oriented: *SEGMENTO* by Poggenpohl radiates cool white elegance for discriminating designer kitchen enthusiasts. Among the refined details of this model are worktops no more than 0.5 inch (12 mm) in thickness.

White satinized glass with spectacular light effects and a white Corian worktop make a delicate contrast to the interesting grain of the cherry wood. The walk-round preparation island looks light and slender, and leaves a lot of floor space free (Poggenpohl).

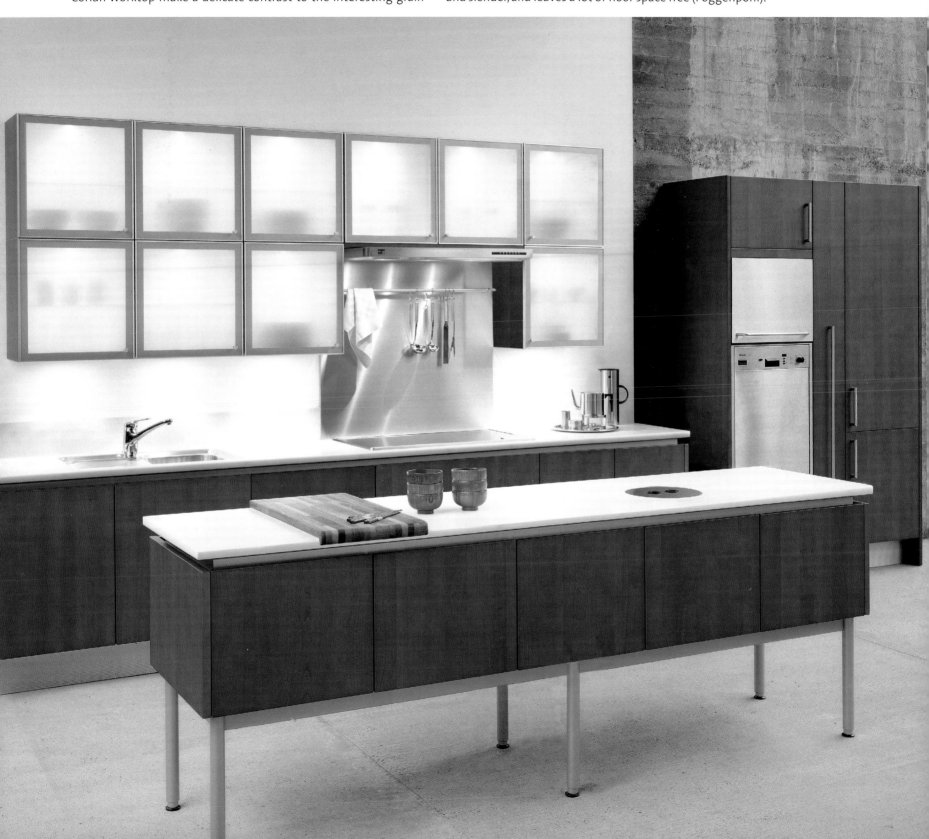

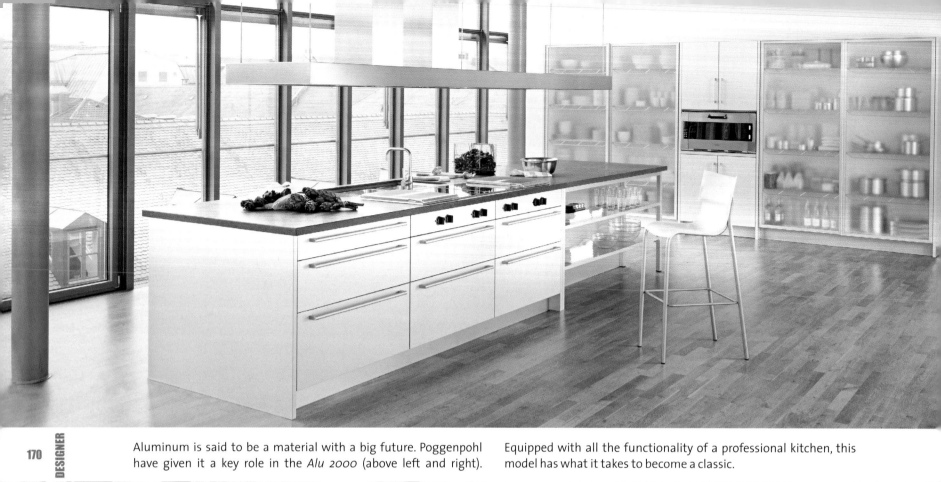

Aluminum is said to be a material with a big future. Poggenpohl have given it a key role in the *Alu 2000* (above left and right).

Equipped with all the functionality of a professional kitchen, this model has what it takes to become a classic.

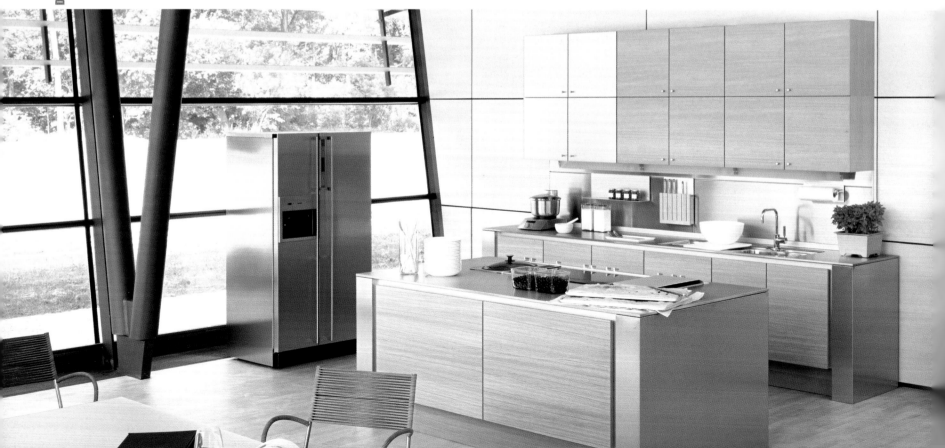

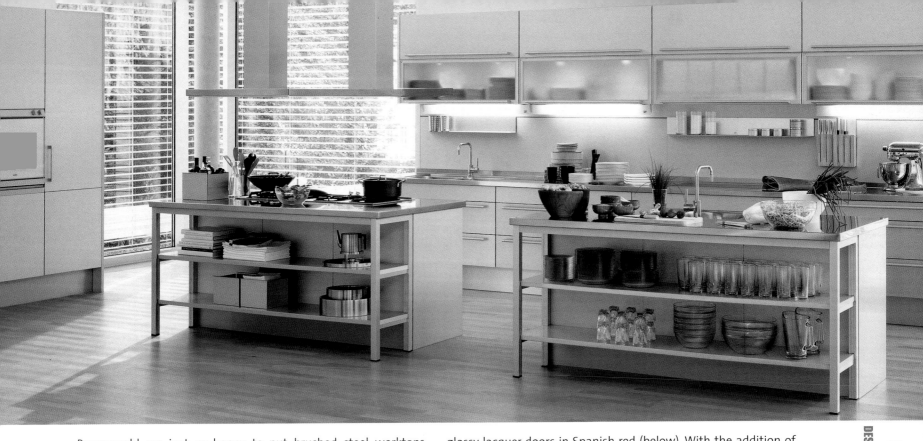

Poggenpohl are just as happy to put brushed steel worktops together with light, horizontally veneered oak (below left) as with glossy lacquer doors in Spanish red (below). With the addition of high-quality appliances, the effect in both cases is stunning.

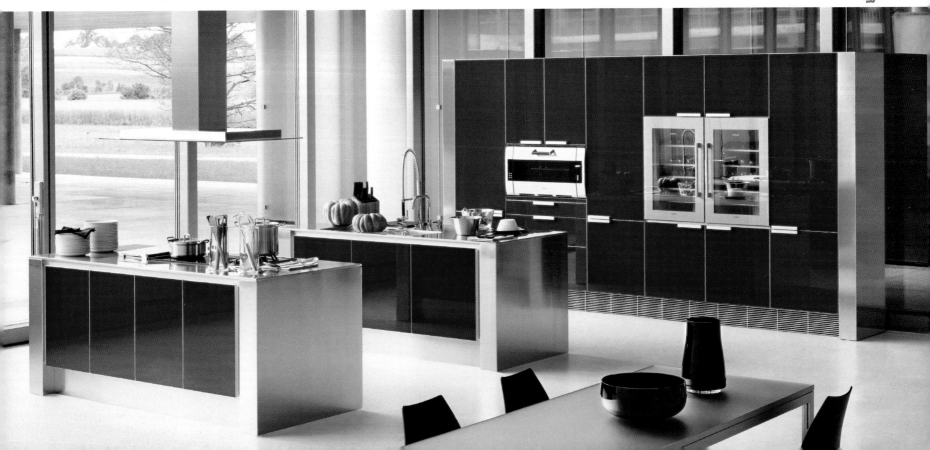

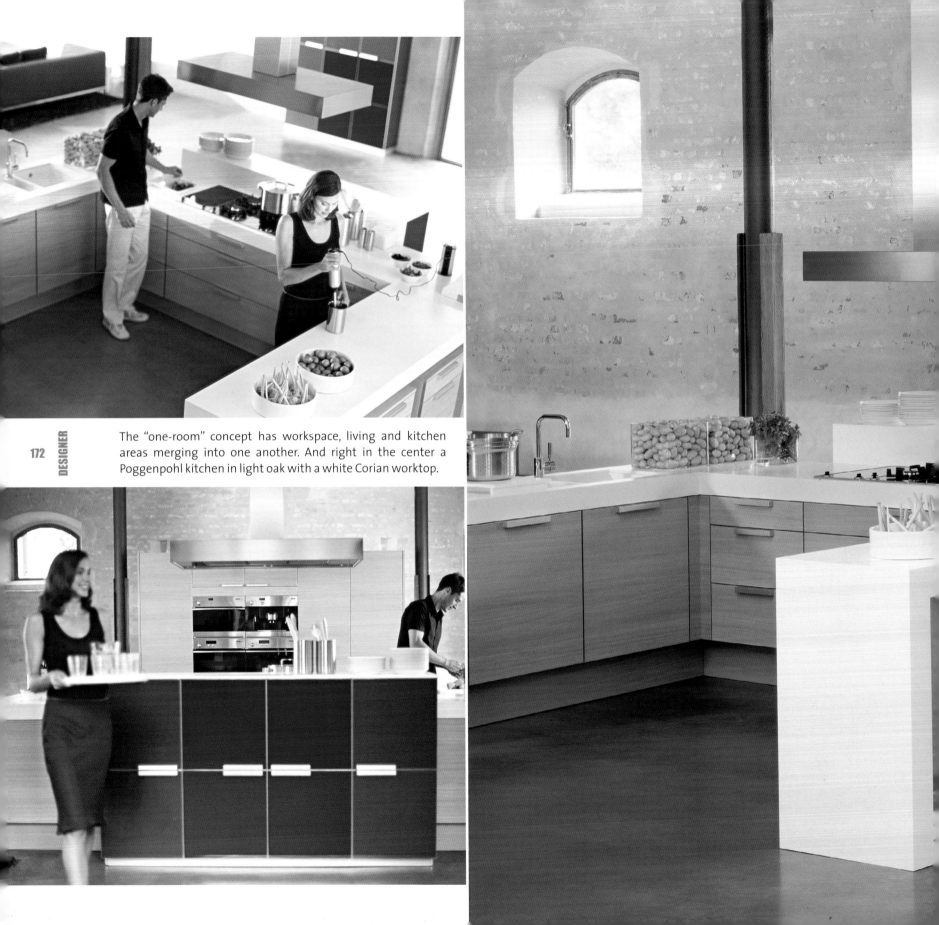

The "one-room" concept has workspace, living and kitchen areas merging into one another. And right in the center a Poggenpohl kitchen in light oak with a white Corian worktop.

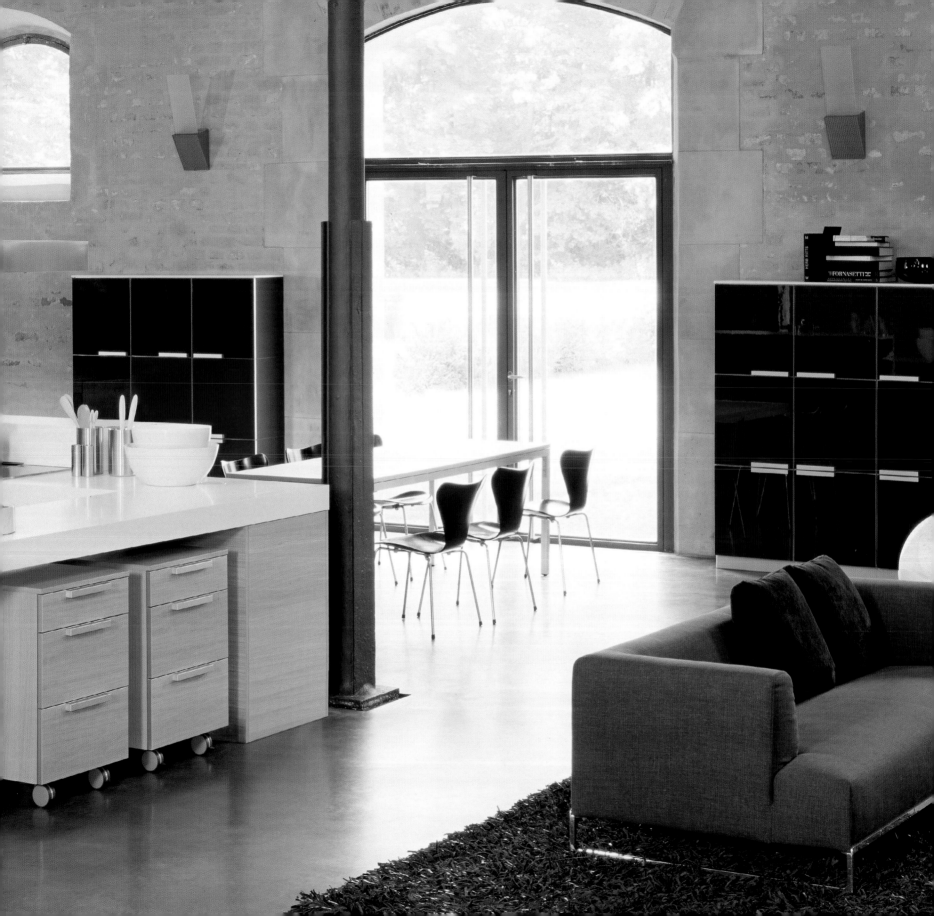

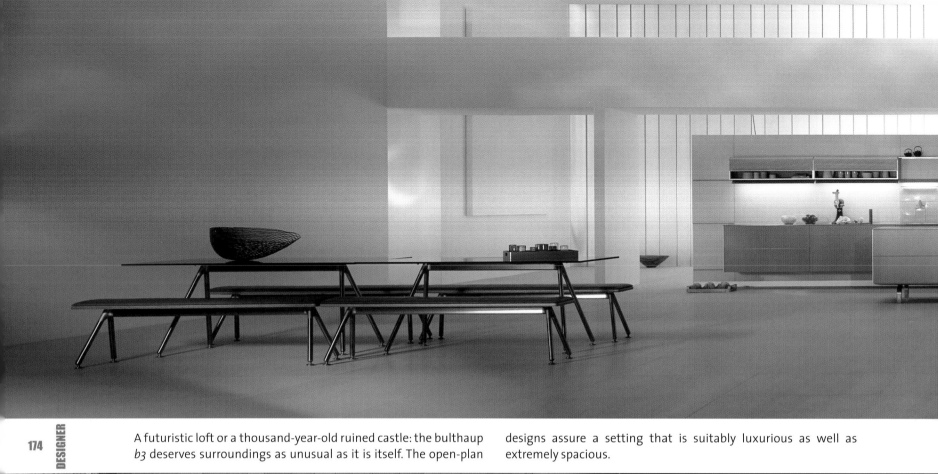

A futuristic loft or a thousand-year-old ruined castle: the bulthaup *b3* deserves surroundings as unusual as it is itself. The open-plan designs assure a setting that is suitably luxurious as well as extremely spacious.

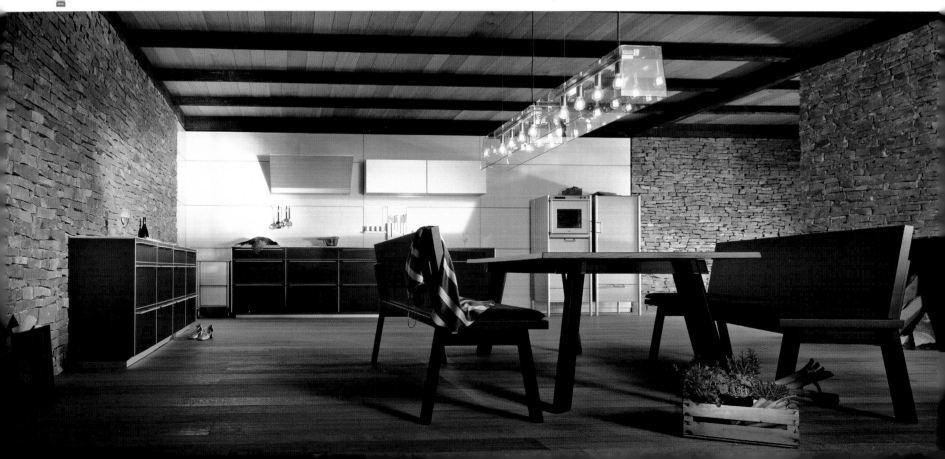

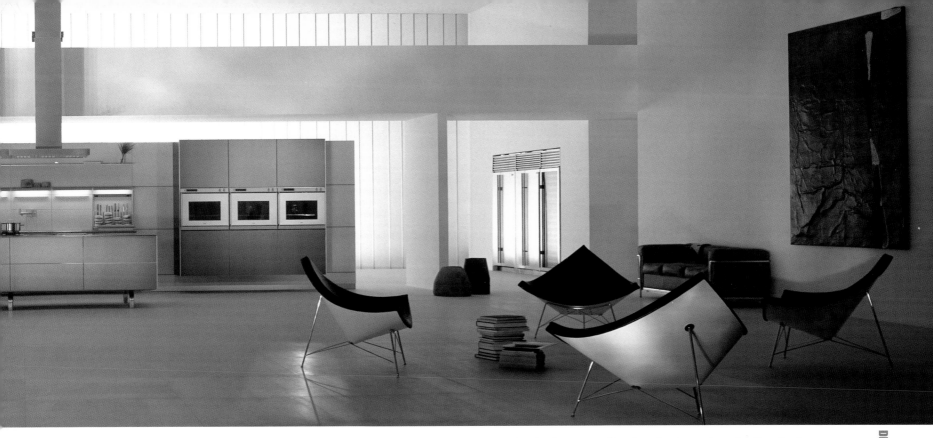

A function wall with "floating" cupboard units, doors and drawers with no handles, thanks to a cunningly devised touch system, and dark anodized aluminum for the fronts and ends: the *b3* by bulthaup sets new standards.

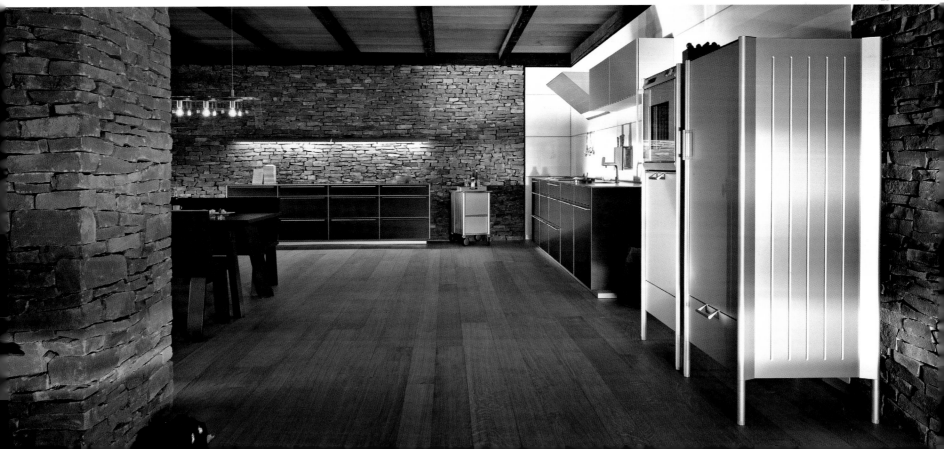

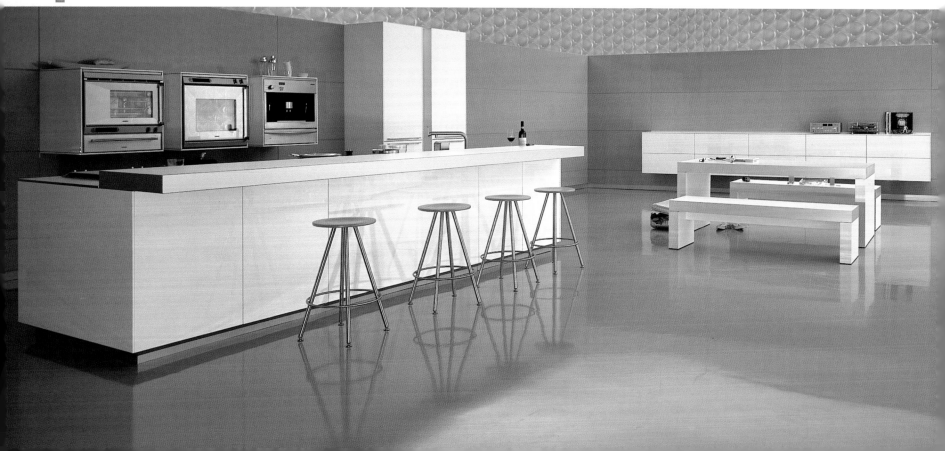

The new bulthaup *b3*: light, horizontal and floating – the product of intensive, perfectionist efforts to achieve precise, solid, lasting workmanship with high-quality design. The harmony between the cooking and living areas is particularly appealing.

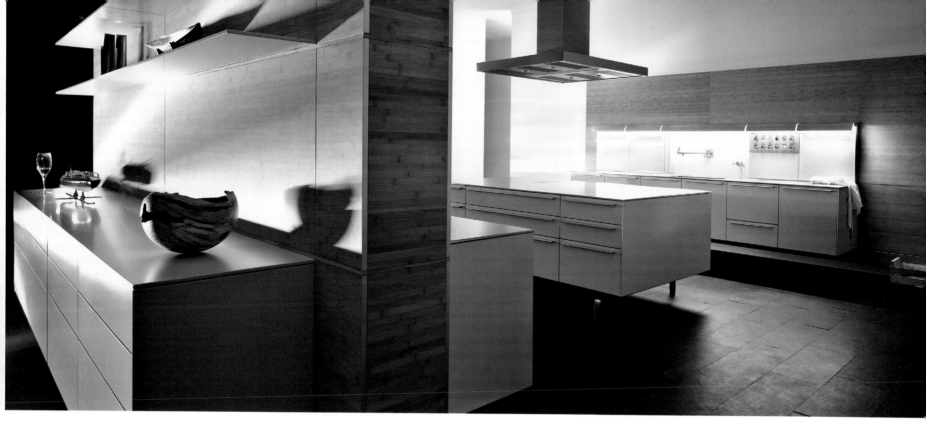

A brilliant solution: the glossy wall panels of the bulthaup *b3* (below) support separate, free-hanging appliances, top cabinets and a sideboard, completed by a floor-standing island with a bar. The bulthaup touch system makes handles unnecessary.

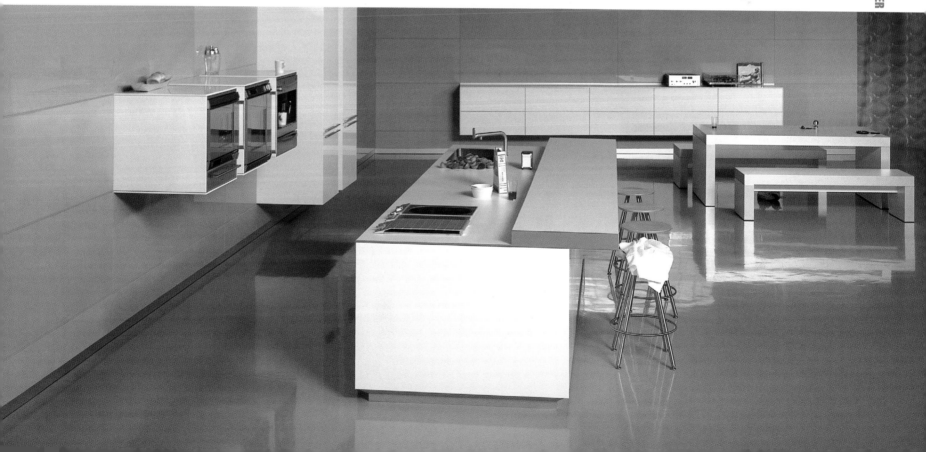

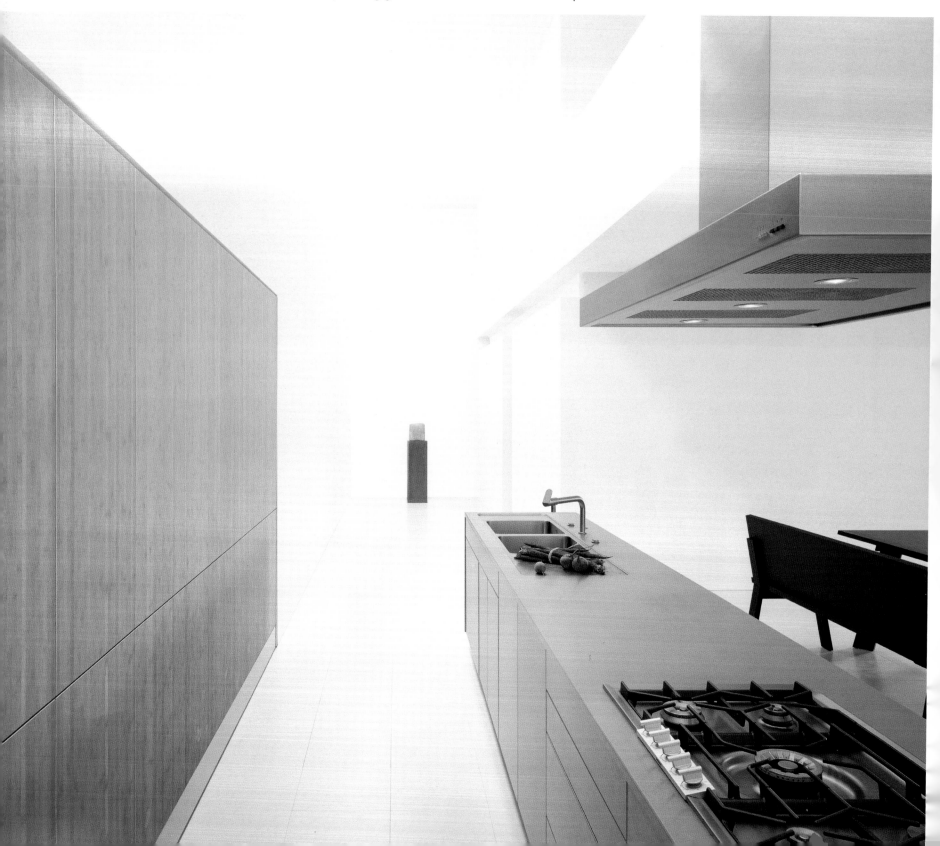

system 20 by bulthaup with its flexible units, and *system 25* (right), with its three-dimensional, one-inch planning grid, offer endless possible combinations for kitchens that can be tailor-made to individual requirements.

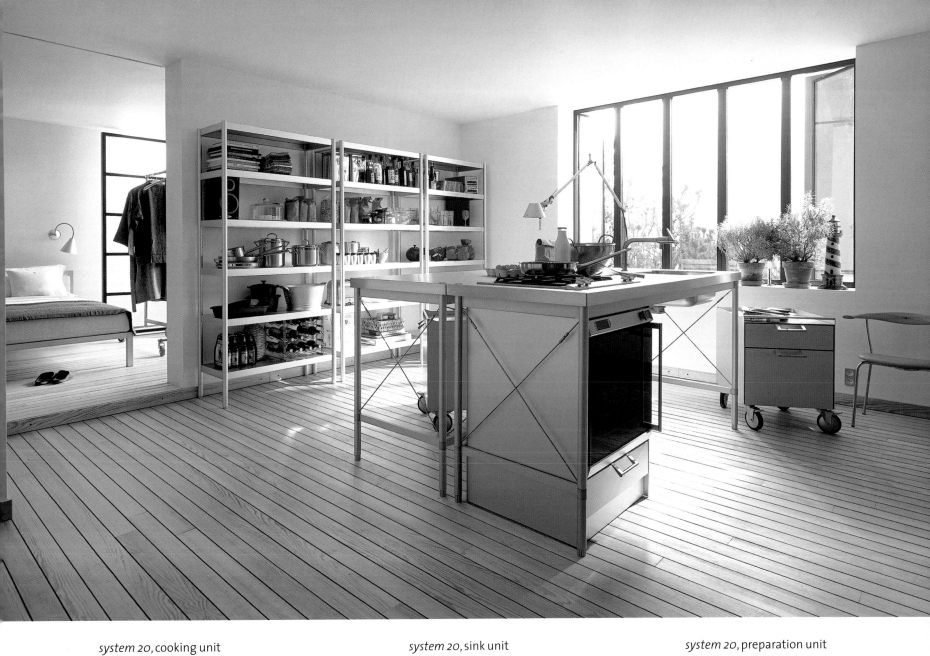

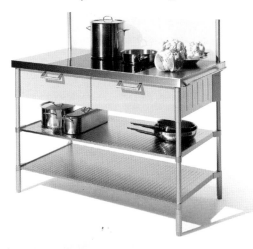

system 20, cooking unit

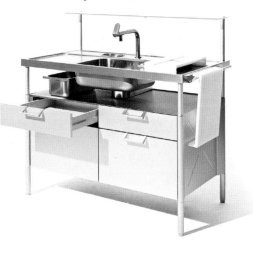

system 20, sink unit

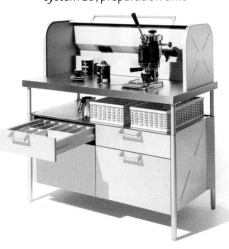

system 20, preparation unit

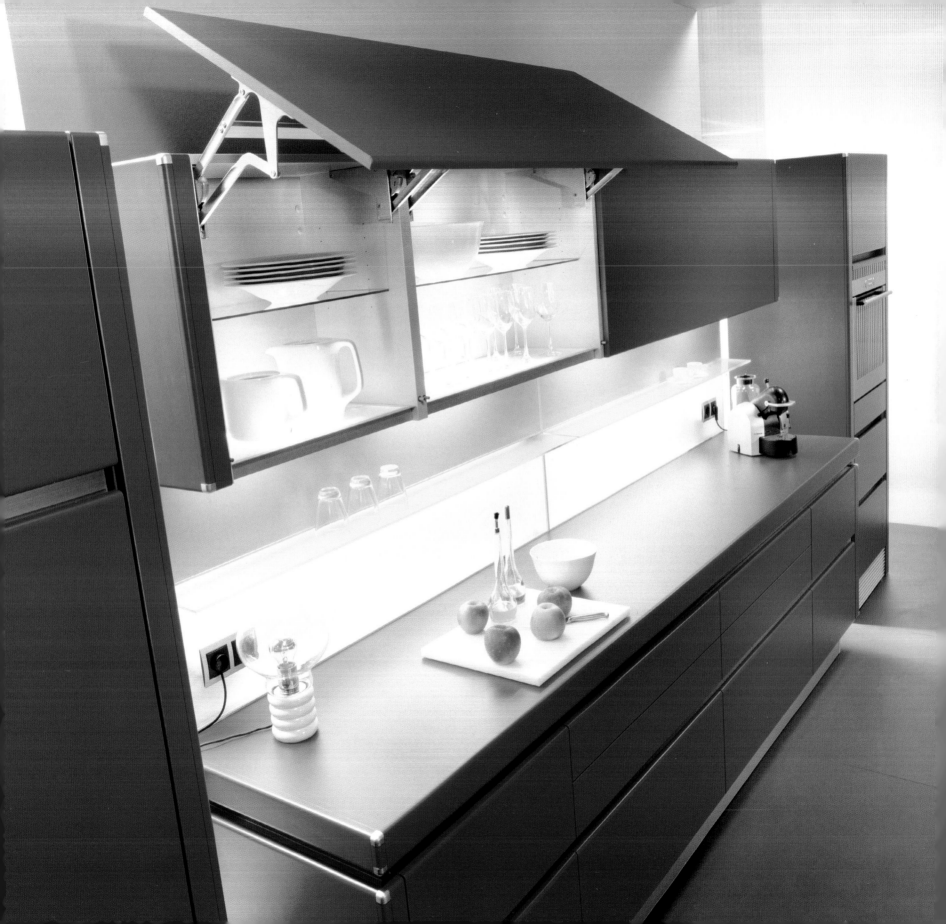

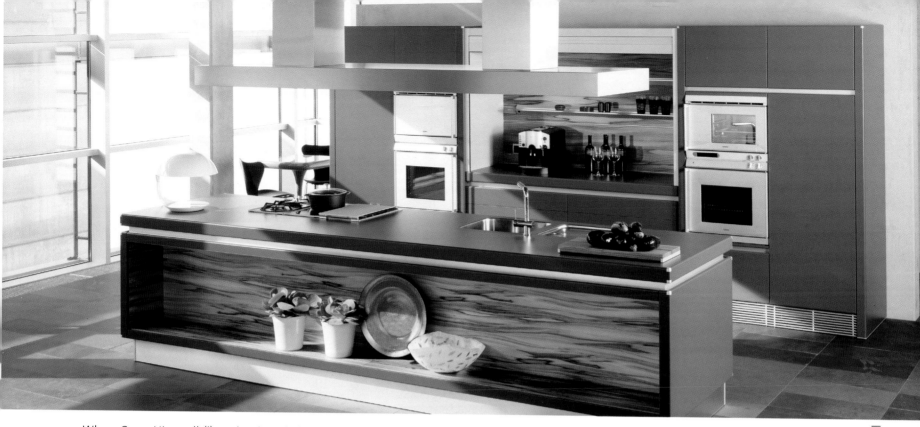

When Coop Himmelb(l)au developed the *Soft Mobil* design for ewe thirty years ago, the kitchen had not yet become a center of communication. The "remake" of this classic kitchen emphasizes the effects of open-plan design and moveable units.

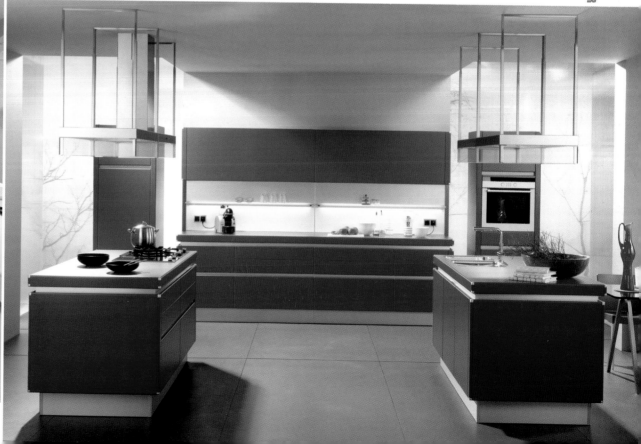

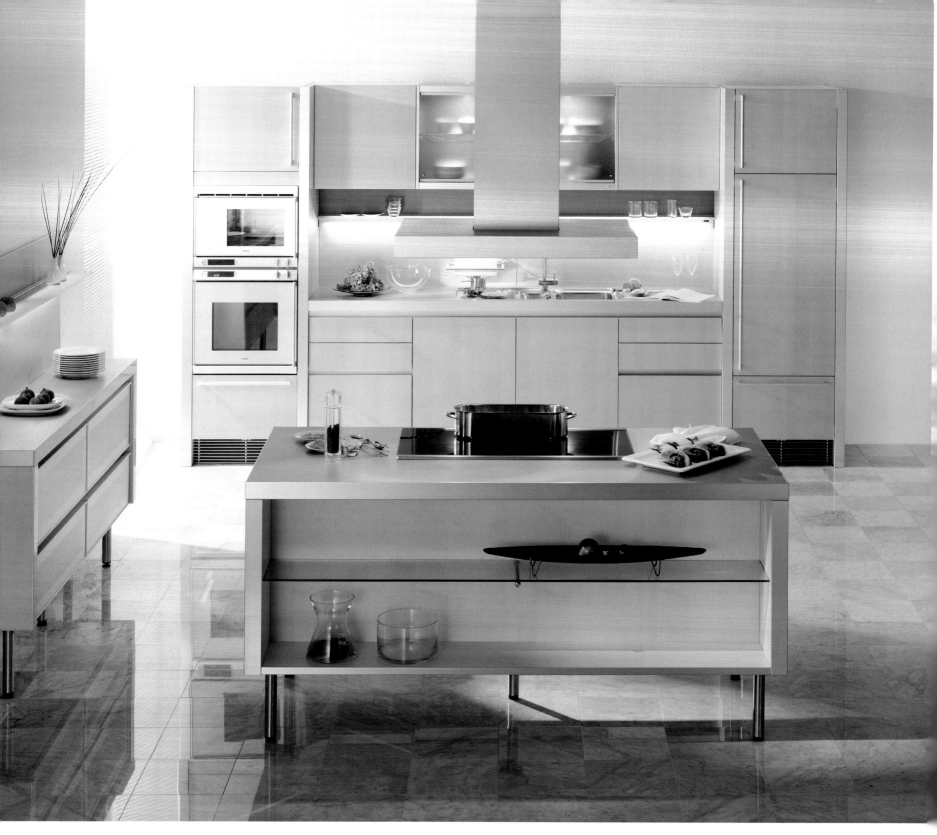

Sophisticated contemporary kitchen design should get the credit for the rediscovery of wood. The lively markings of walnut (following pages), maple (above), and oak (right) are celebrating a splendid comeback in the *ewedition* models by ewe.

In *ewedition* kitchens, elegant stand-alone pieces such as sideboards, glass-fronted cabinets, and dressers complement the functional units and create a fluid transition between the cooking and living areas. This is living space with individual comfort.

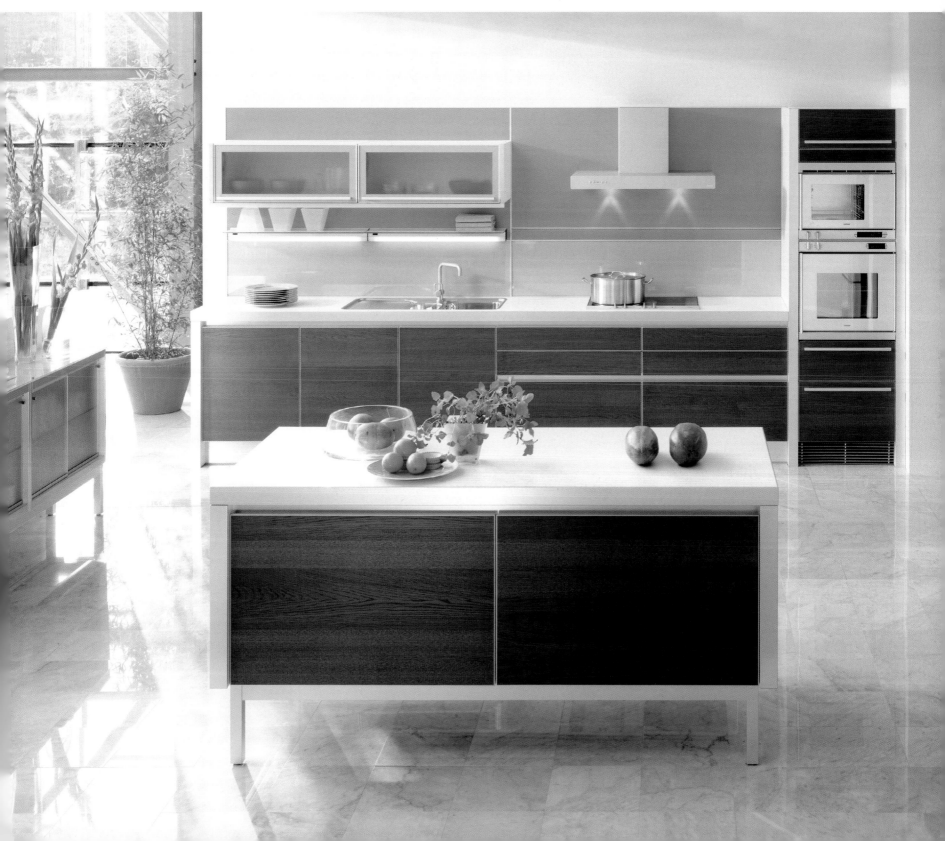

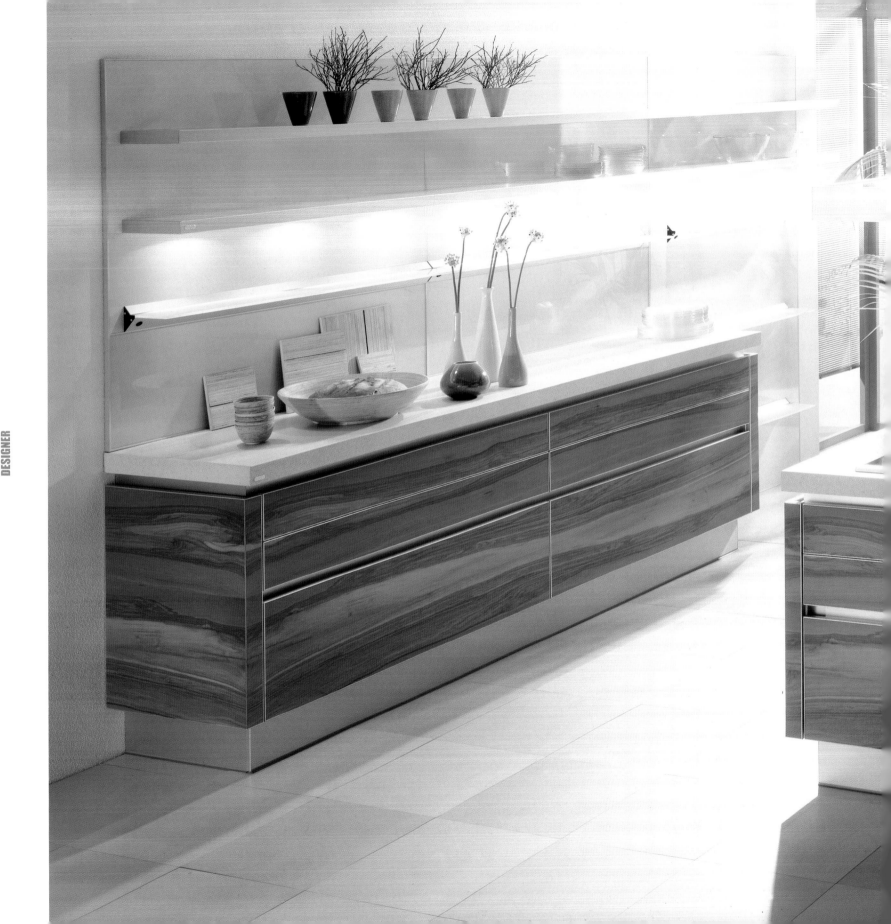

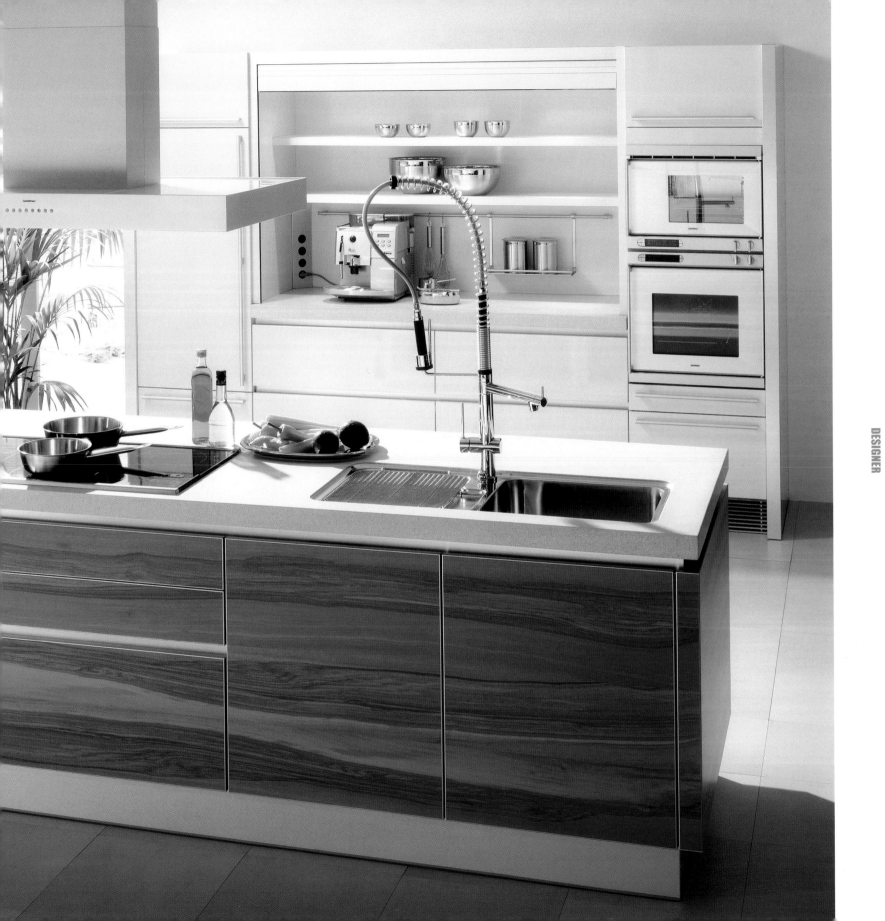

Culinary high-flyers will find the best possible starting-point here. An island that is accessible from all sides makes it easy for people to communicate and work together. Contrasting materials make it easy on the eye as well (*Alnotop,* below, and *Alnostar* by Alno).

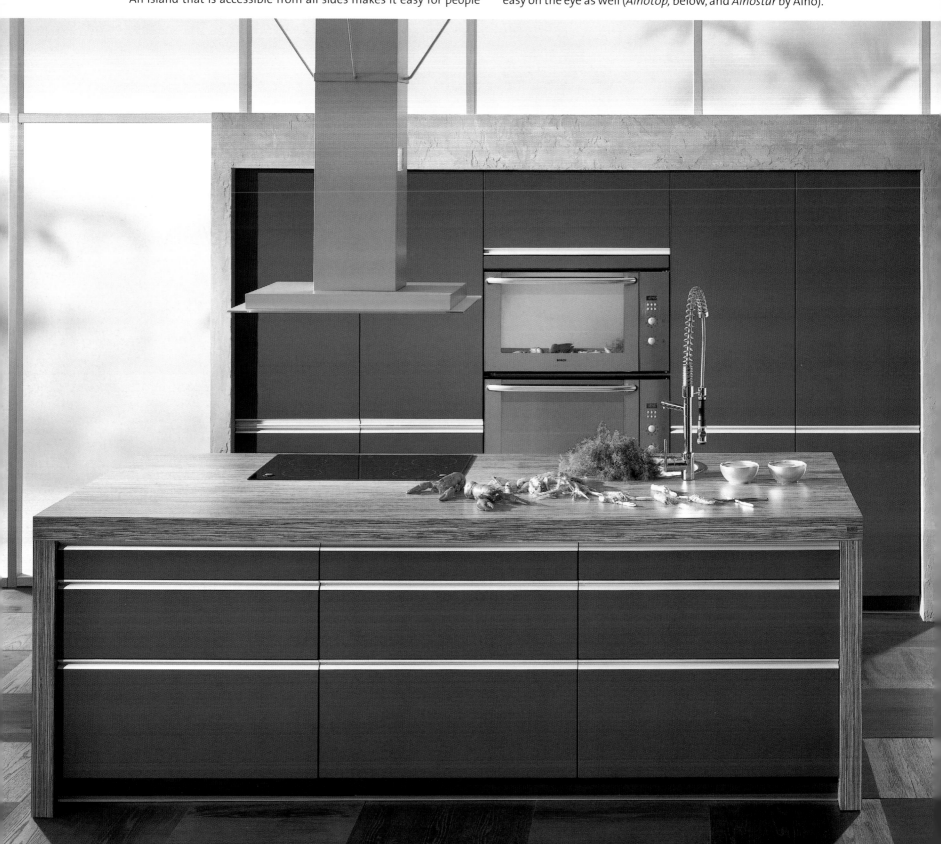

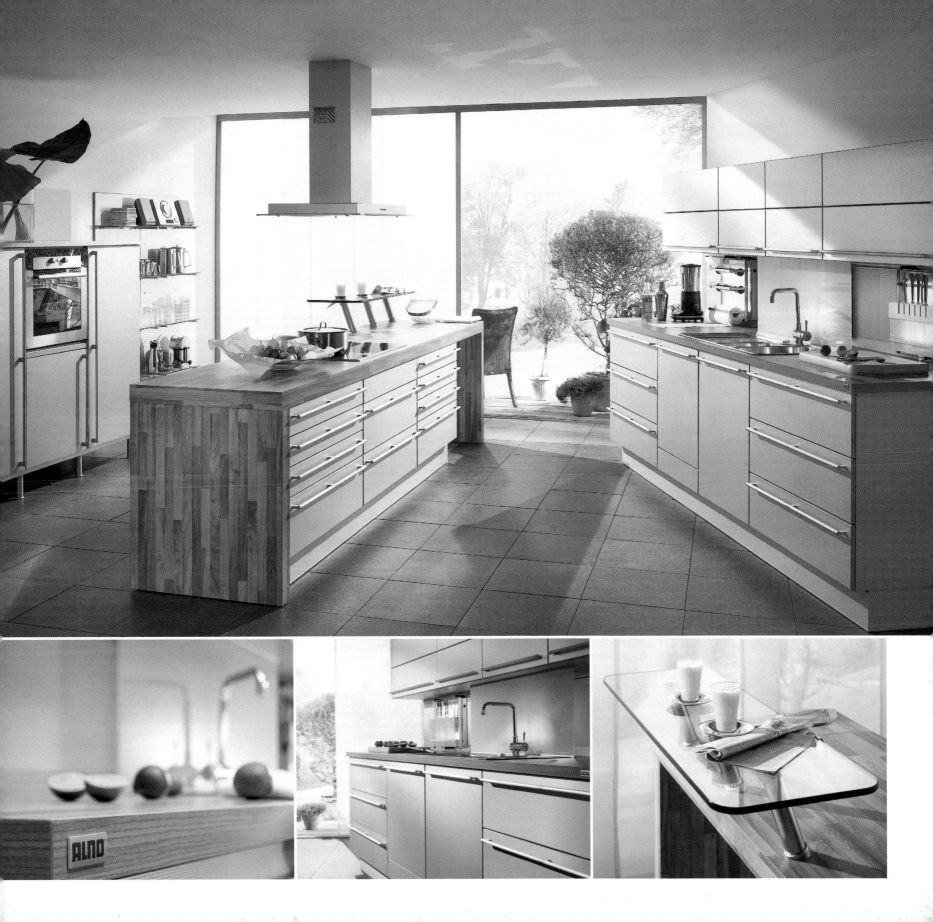

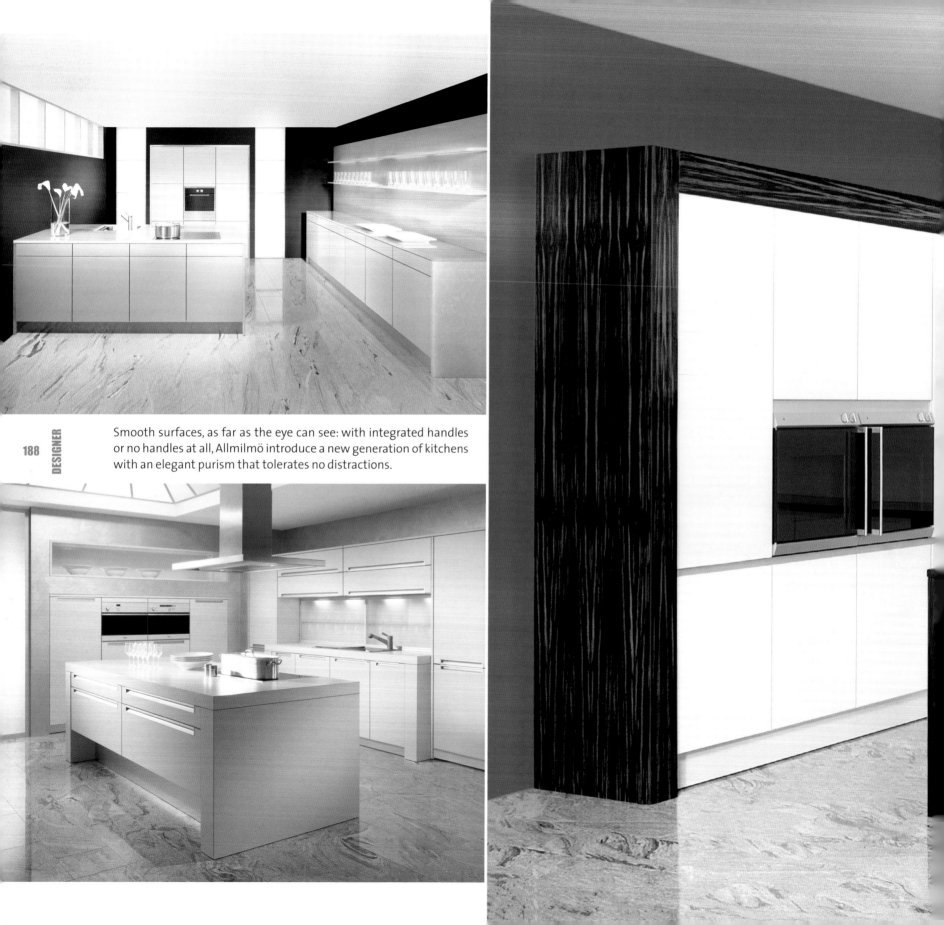

Smooth surfaces, as far as the eye can see: with integrated handles or no handles at all, Allmilmö introduce a new generation of kitchens with an elegant purism that tolerates no distractions.

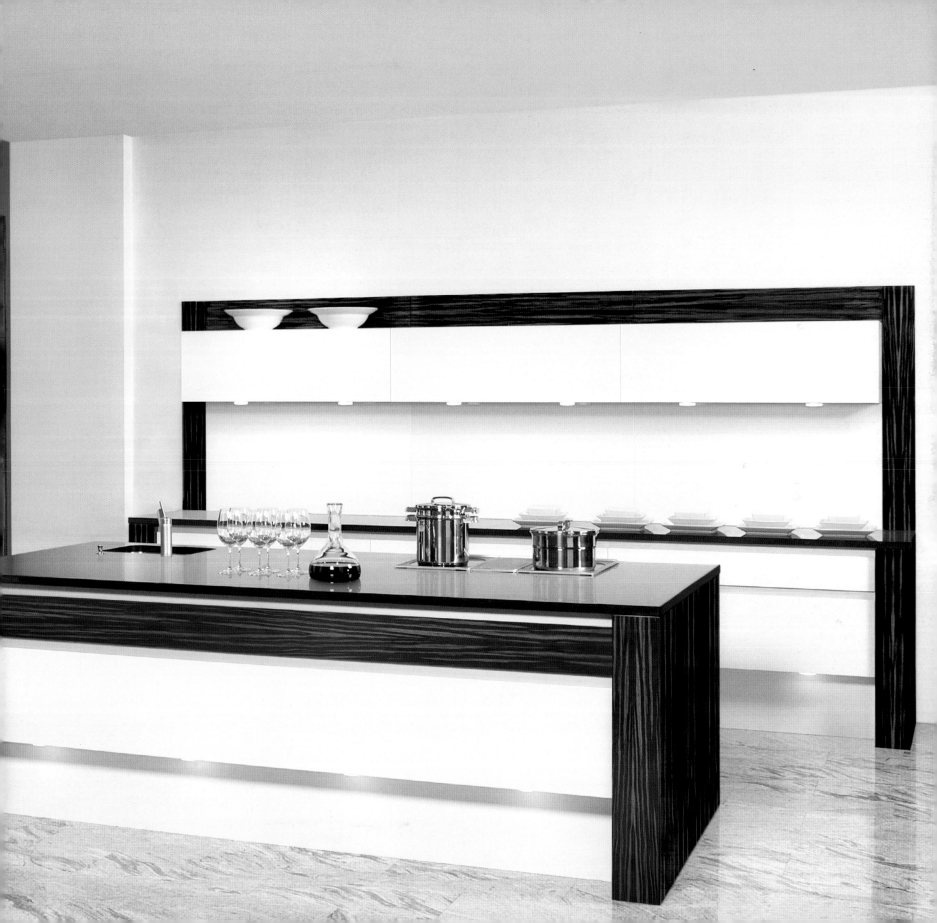

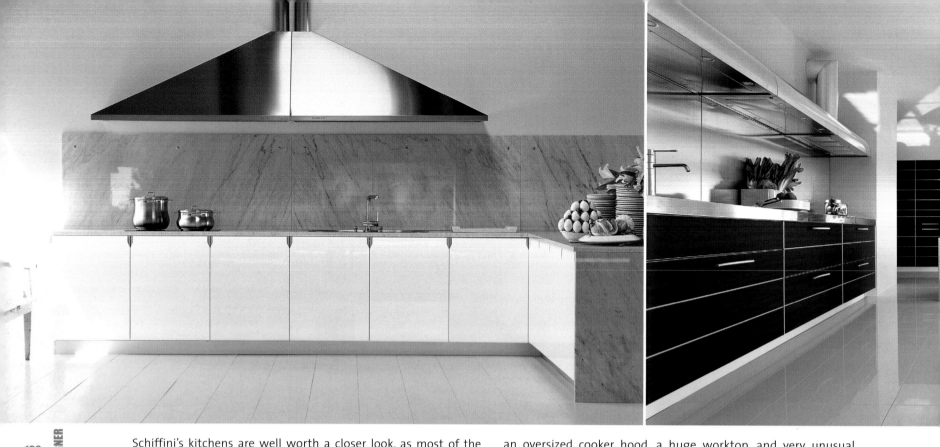

Schiffini's kitchens are well worth a closer look, as most of the refinements are hidden in the details – strikingly shaped handles, an oversized cooker hood, a huge worktop, and very unusual door surfaces.

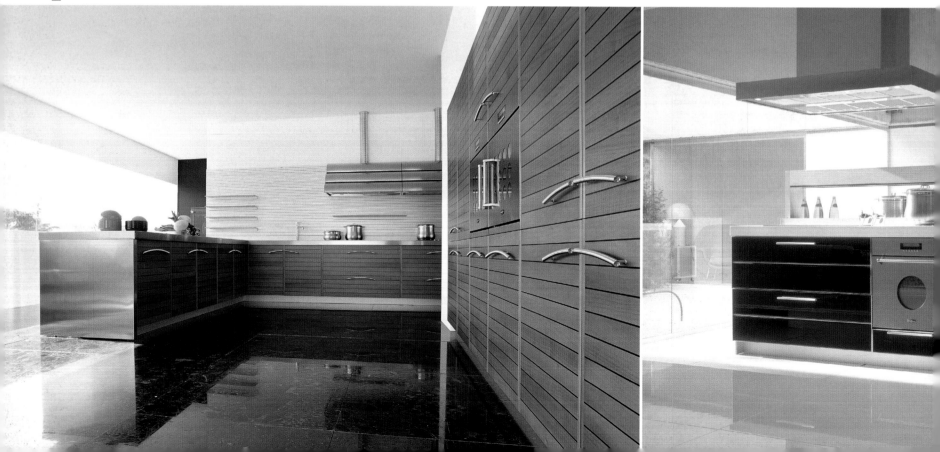

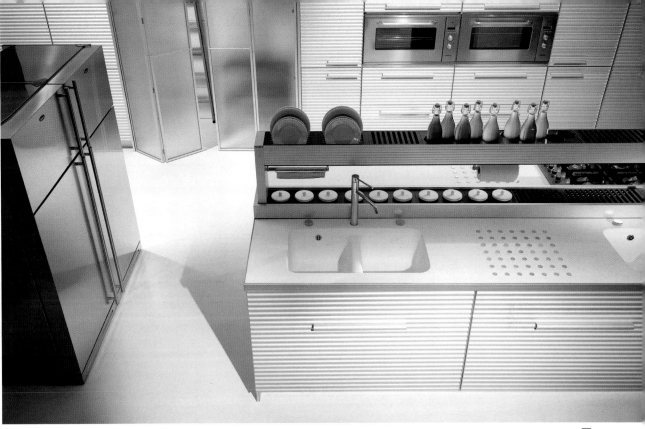

Kitchen as far as the eye can see: the linear construction gives Schiffini's Italian models a unique spaciousness. With their clean lines and lack of unnecessary features, they represent a contemporary elegance born of the art of understatement.

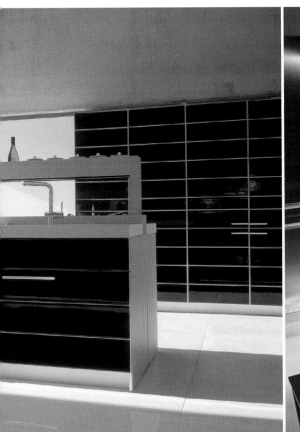
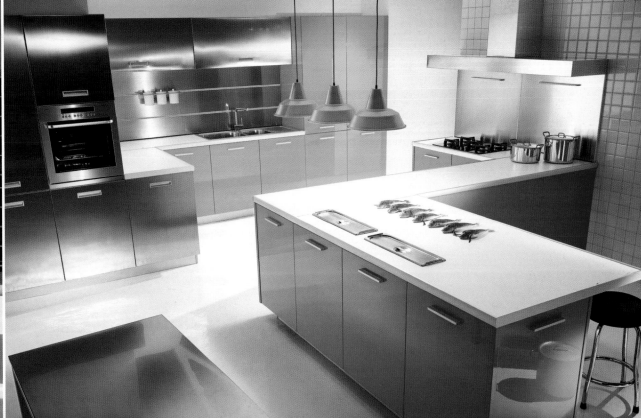

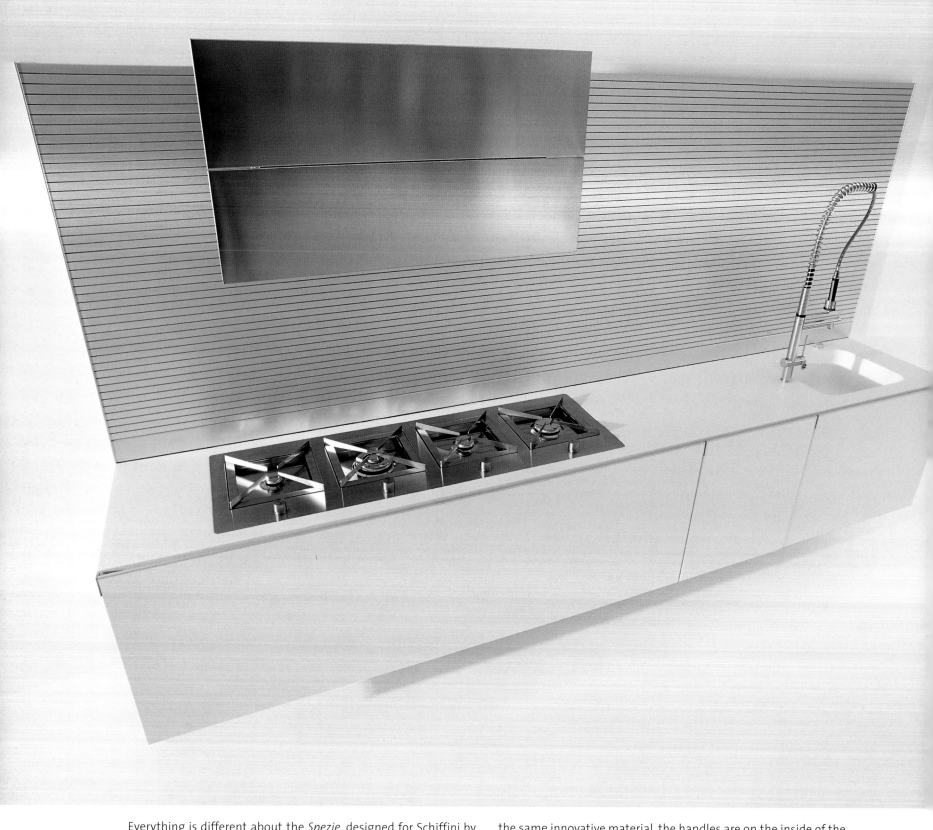

Everything is different about the *Spezie*, designed for Schiffini by Ludovica & Roberto Palomba. Worktops and doors are made from the same innovative material, the handles are on the inside of the doors, and cooking is done on a new kind of gas burner.

The daring design of the *G.Box* from the Schiffini range is characterized by the minimalism of a severely formal architectural language. Cooking is done on the large bridge-like table, the shape of which is emphasized by the central extractor hood.

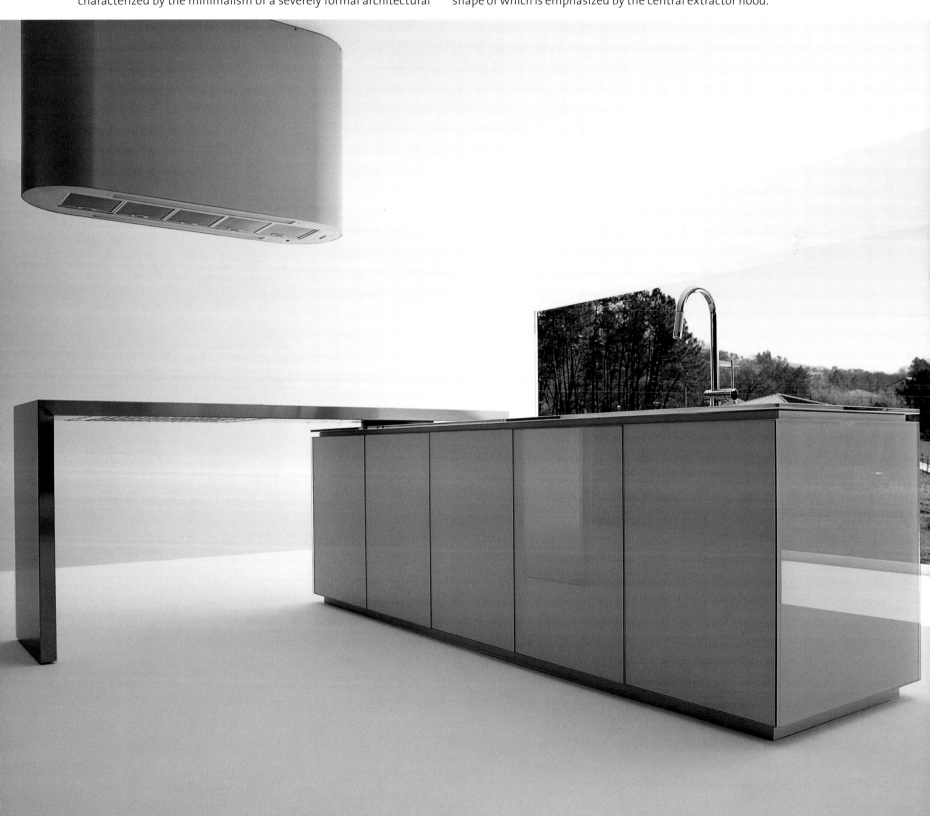

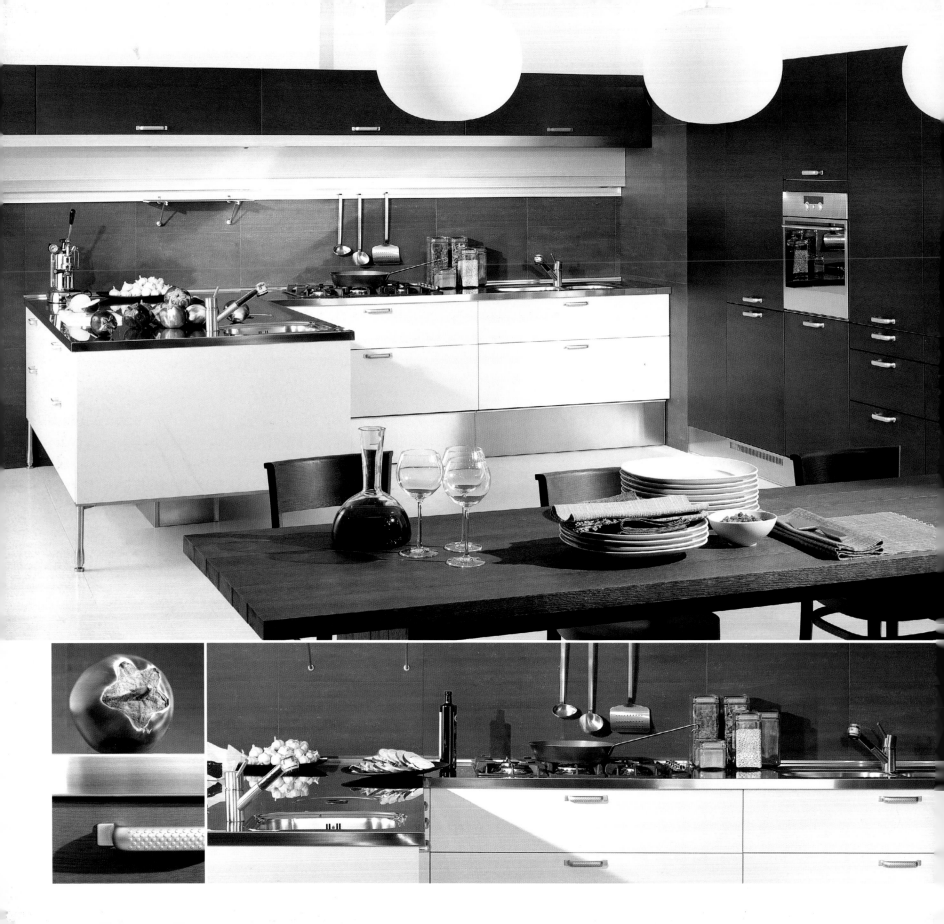

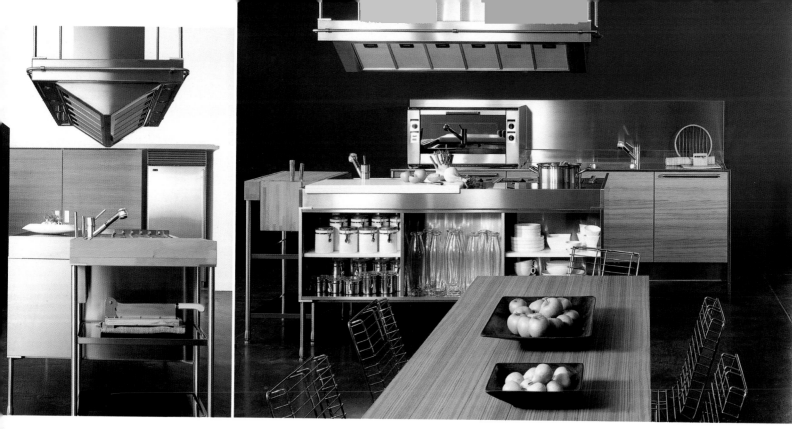

Rational architecture, a linear look, and high-quality materials: Italian kitchen design combines perfect functionality with comfort – for professional cooks with high aesthetic expectations. The flexibility of the units is in tune with the spirit of the age (Arclinea).

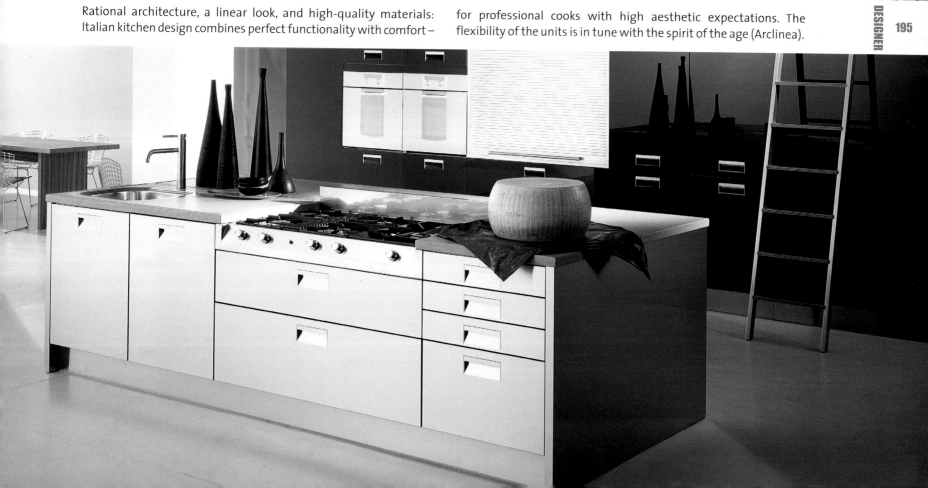

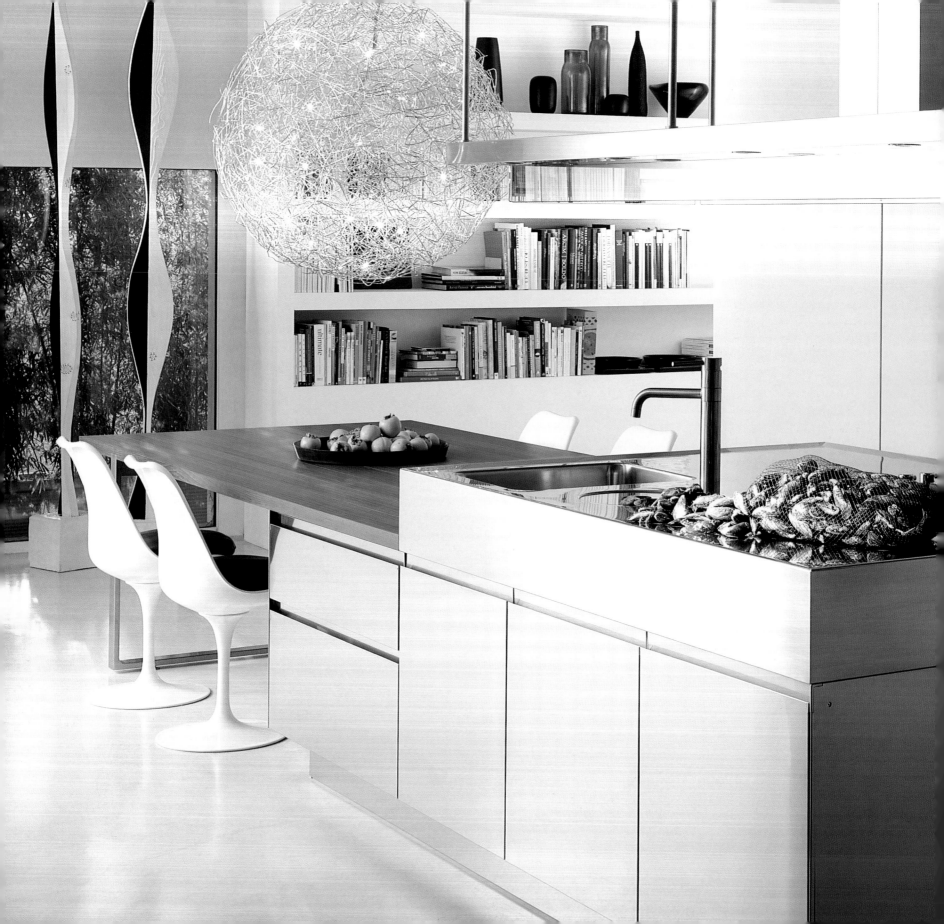

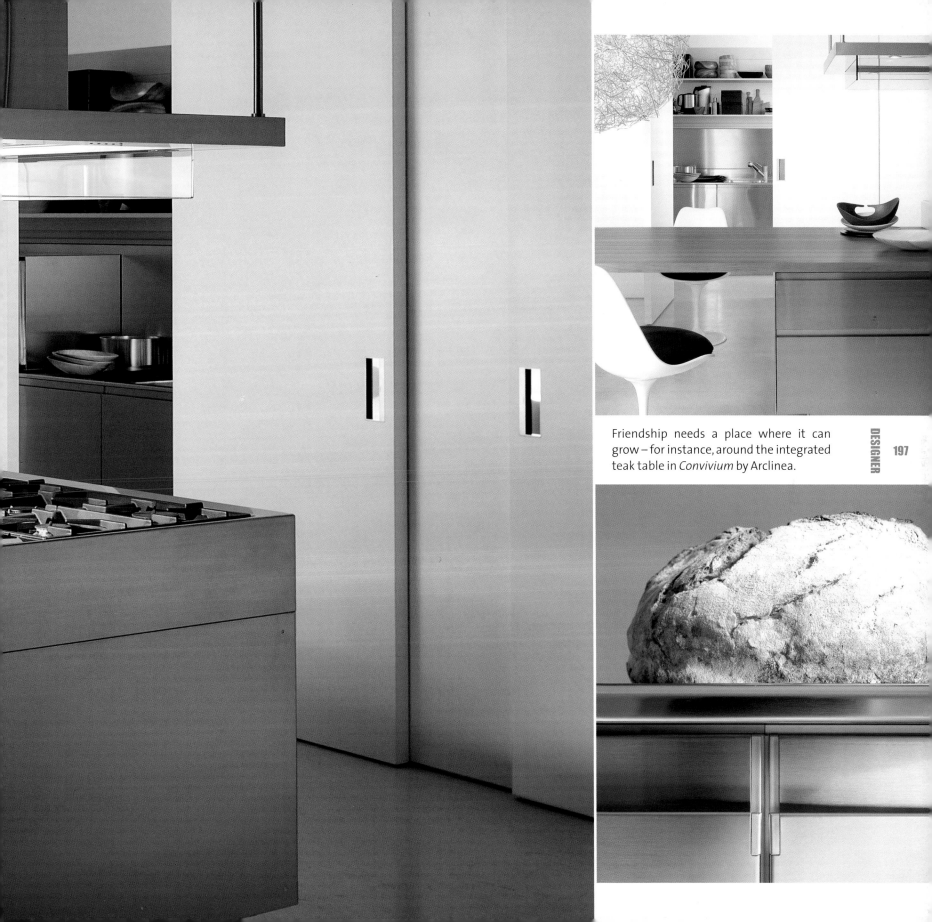

Friendship needs a place where it can grow – for instance, around the integrated teak table in *Convivium* by Arclinea.

GADGETS

The "little things" from Siemens that made life easier in 1935, and a modern garlic slicer from WMF (below).

Krups helping with the mixing: advertisement from 1950 (above). Siemens boiling eggs (*Edition Gerd Käfer*).

Versatility in the kitchen: *Affix* blender by Bauknecht, 1948, and the Braun hand blender (below).

Beautiful design, perfect functioning: the Rowenta toaster and the *Primavera* universal slicer/grater by WMF.

Work makes you inventive: the *Neuzeit* blender by Bosch, 1952, and the handy spaghetti measure from Roesle (below).

KITCHEN AIDS BOTH GREAT AND SMALL

What would the kitchen fire be without the cooking pot, and where would the freezer be without the little plastic containers that have no trouble withstanding the extreme changes of temperature? Alongside great achievements there have always been small ones that have made the work of the kitchen better and easier.

The ancestor of all these small aids is the cooking pot. Vessels made of stoneware, later iron, bronze and copper, and later still cast iron (an American company started producing the Saugus pot in 1642) belonged to the age of open fires. When the first enameled cookware was produced in Germany, it was a giant step forward, not only visually, but also in ease of use, as sheet steel could be used under the layer of enamel, which meant that even large kettles and casseroles were very much lighter than those made from any of

the materials used previously. Only a few decades later, aluminum cookware from the United States began to make its way in the kitchen. As well as being light in weight, it offered the advantages of being extremely easy to use (there was little danger of food getting burnt or baked on to it) and it was easier to clean.

The 20th century saw the triumphal entry of plastics in the kitchen. After a difficult start (with bowls, plates, and sieves that became distorted in hot water or melted out of shape in the sun), they provided an inexpensive substitute for natural substances that were becoming scarcer (for example

rubber and natural resins), and could be used for the handles of saucepans and fry pans (Bakelite), for wrapping food and keeping it fresh (cellophane), for washable tablecloths (vinyl), easy-care kitchen furniture (Formica, Resopal), and not least for coating non-stick pans (Teflon).

Finally, in the wake of electrification, the kitchen was invaded by small electrical goods. First shown in Chicago as early as 1893, the all-electric Schindler kitchen included such items as an egg-boiler and a coffee maker. In 1909 the General Electric Company brought out the first toaster, and in 1927 Siemens launched the *Protos* oven, which, among other things, was excellent

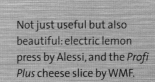

Irreplaceable household aids: the versatile blender by Braun (above), and the roasting pans – for Sunday joints and other roasts – from Roesle.

Many kitchen aids have long since become classics: whisk, sieve, all-purpose knife, can-opener, grater (Roesle). Also, of course, the Whirlpool *KitchenAid* (below).

Not just useful but also beautiful: electric lemon press by Alessi, and the *Profi Plus* cheese slice by WMF.

Everything close at hand with the Roesle kitchen foil cutter. Everything bite-sized with the Bosch (below) universal chopper.

for re-heating food or keeping it warm. An all-purpose kitchen cabinet presented by Bauknecht in 1950 had an electric motor in the bottom section, to which a great variety of extra appliances could be connected, from coffee grinders to mixers and meat grinders.

Nowadays, almost every kitchen activity can be done by an electrical gadget – cutting, beating, chopping, mashing, grating, pureeing, kneading, and whisking. But there is a reactionary movement. A surfeit of high-tech awakens

a yearning for the good old days. So grandmother's heavy old meat grinder and the almost hundred-year-old vegetable-slicer that is still in perfect working order are celebrating a comeback among enthusiastic amateur chefs and keen young housewives. Though they may require more effort to use, the results are convincing, and it is fun into the bargain!

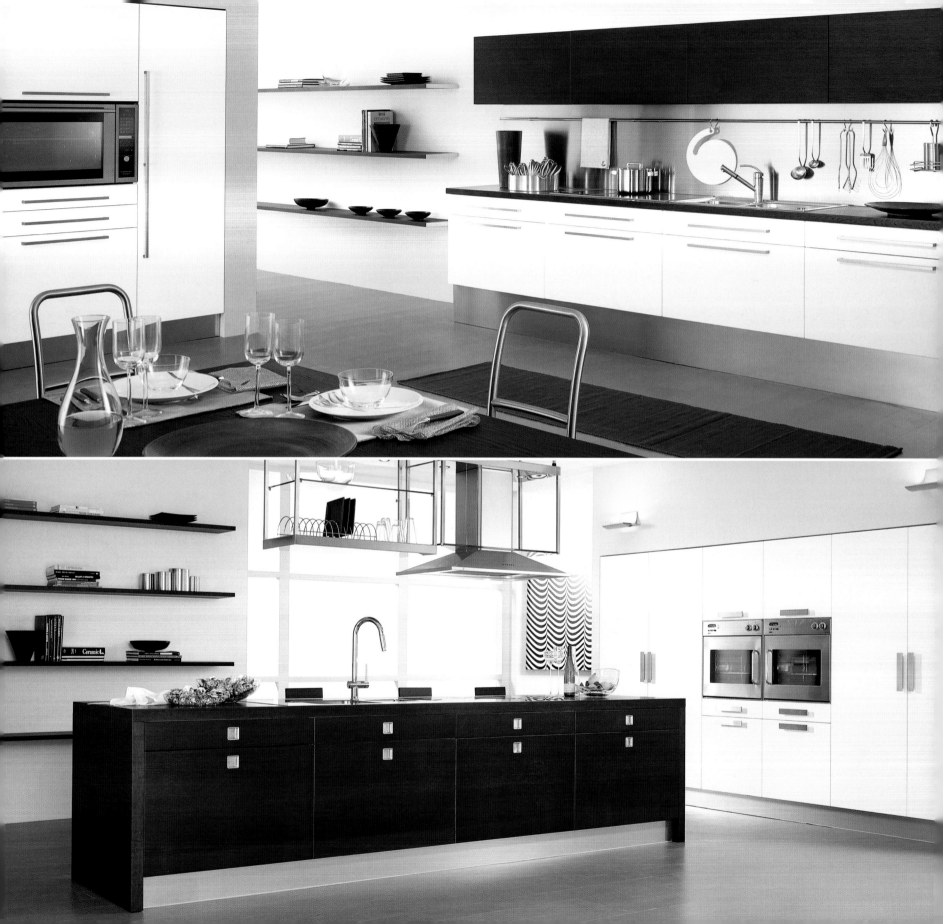

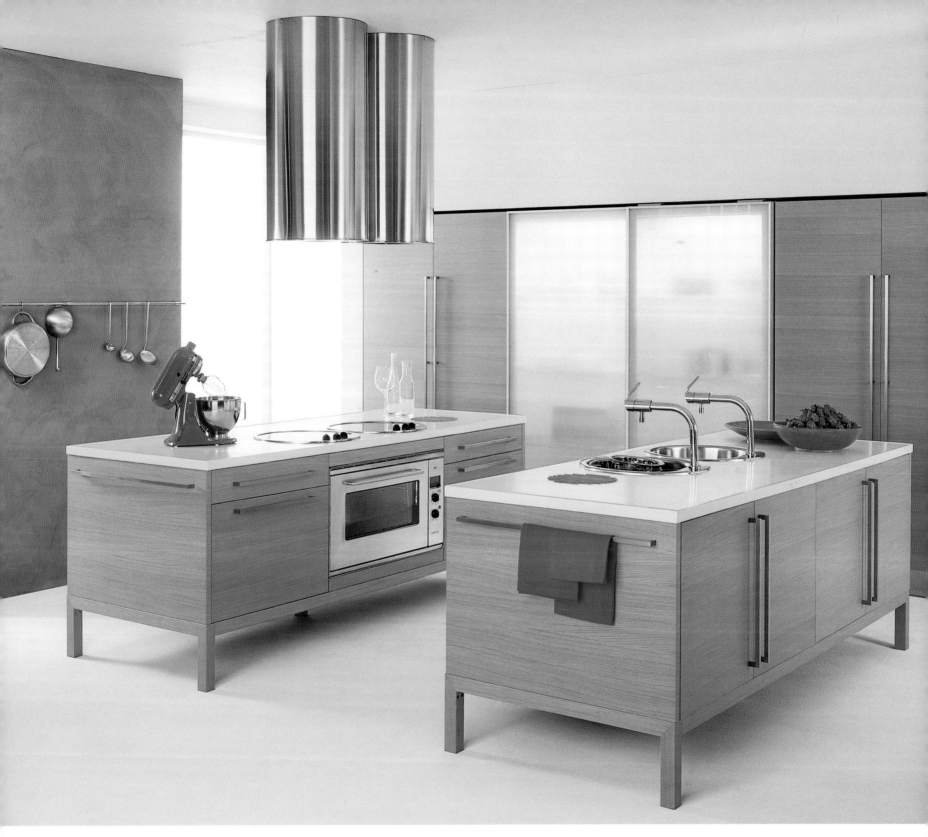

Open shelves, "floating" cupboard units and cooking islands on solid legs give Linea Quattro kitchens a style of their own. Besides the wood, glossy or embossed surfaces from a range of 12 series and 160 colorways give each one an individual accent.

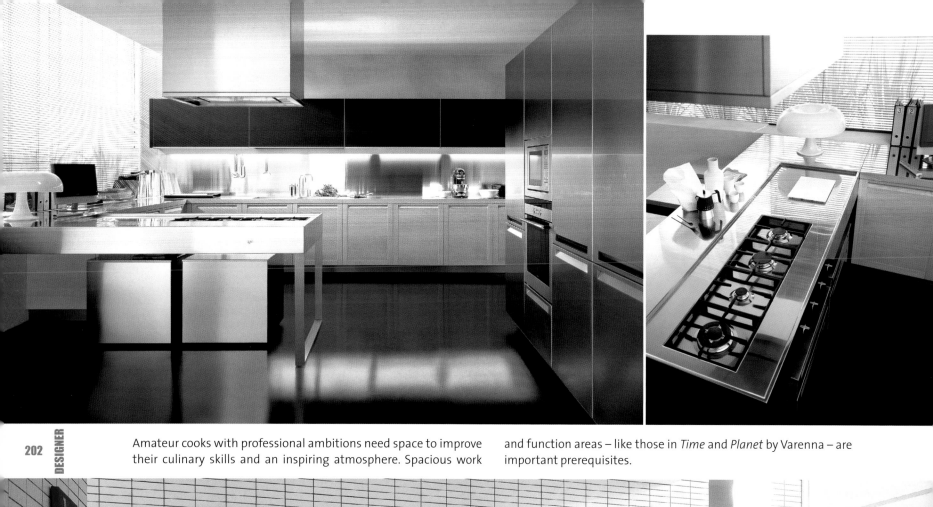

Amateur cooks with professional ambitions need space to improve their culinary skills and an inspiring atmosphere. Spacious work and function areas – like those in *Time* and *Planet* by Varenna – are important prerequisites.

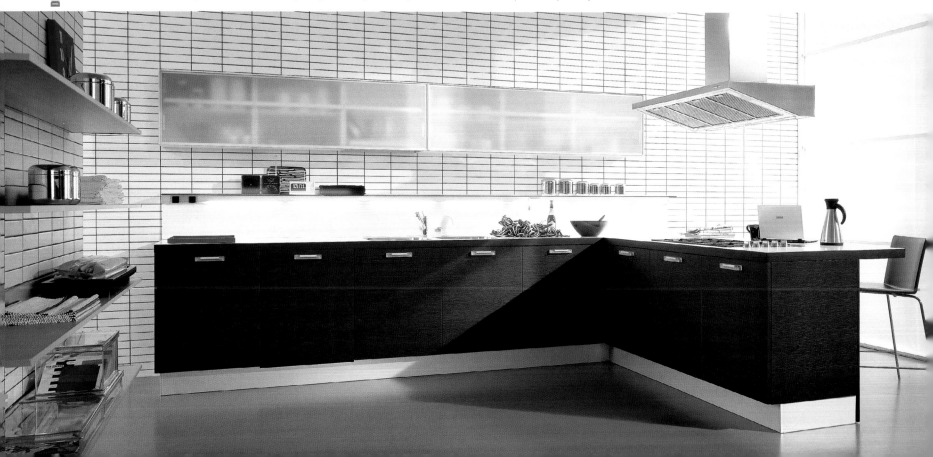

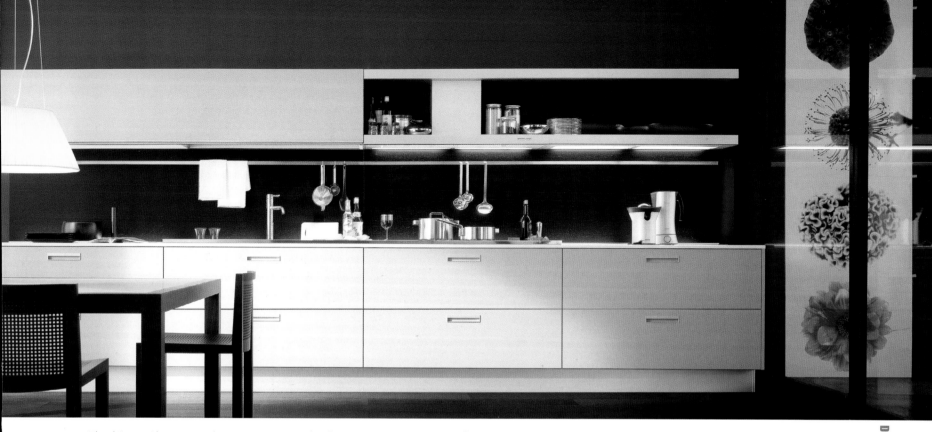

The bigger the room, the more Varenna kitchens appear to their advantage with their unusual cabinets made of stainless steel (*Time*, above left and below right), and the markedly linear layout of *Planet* (below left).

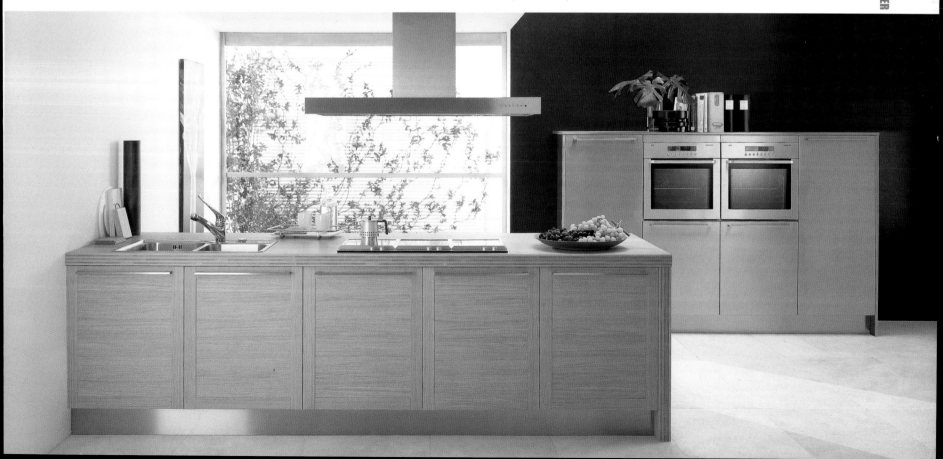

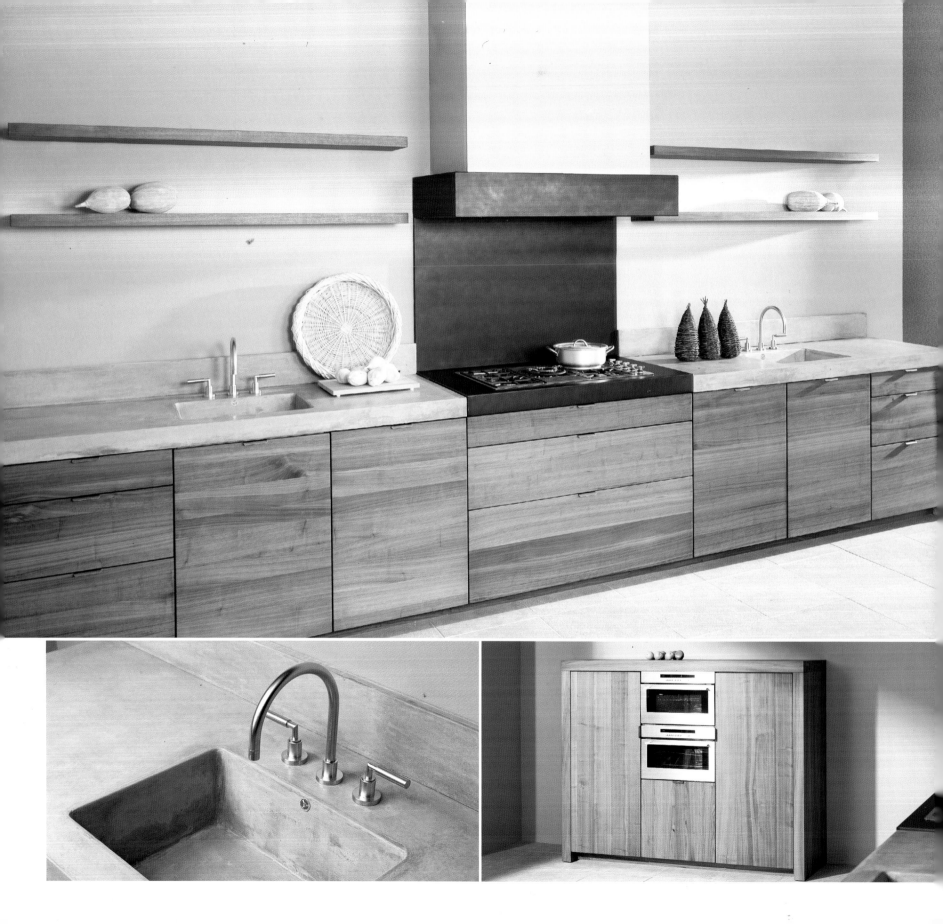

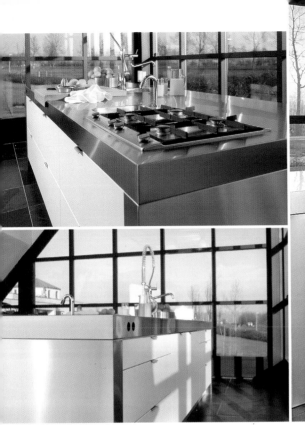

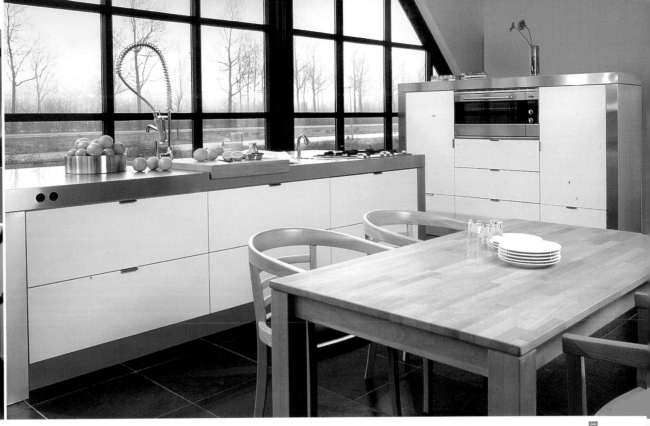

Bold and flamboyant? With Bax, there is no doubt about it. Worktops made of a special concrete (*Franca*, left), stainless steel with high-gloss white (*Tecno luce*, above), or black oak with a stainless steel hob (*Tetra II*, below) show innovative design concepts.

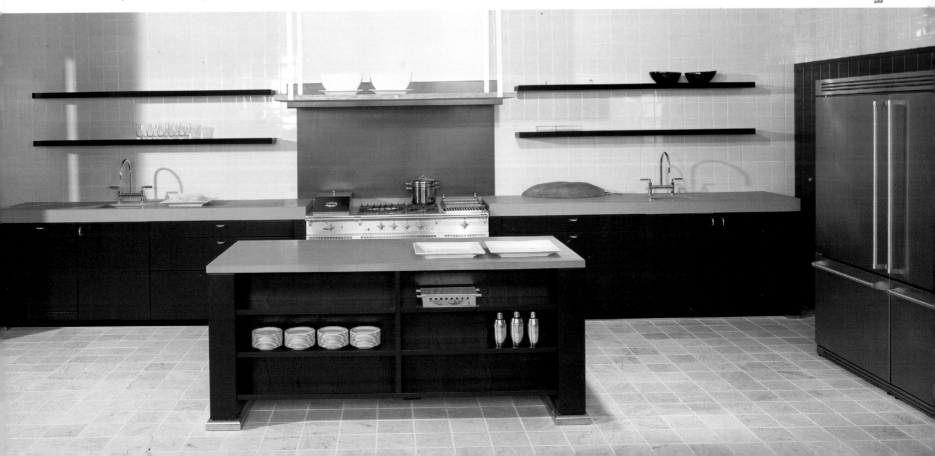

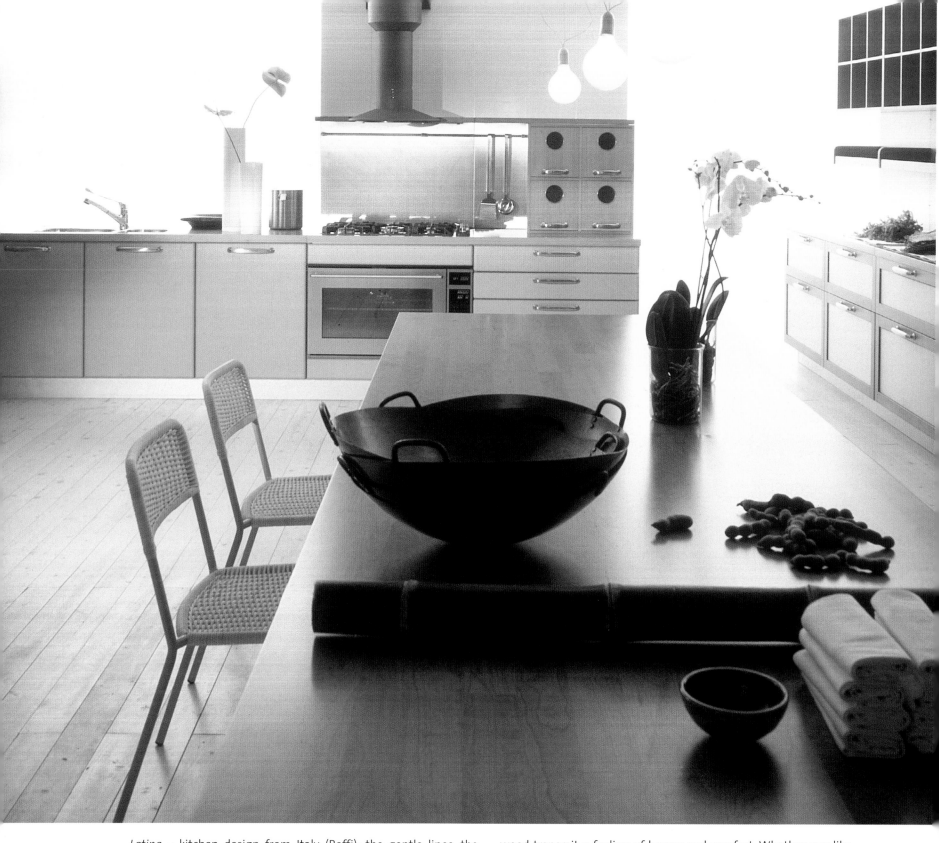

Latina – kitchen design from Italy (Boffi): the gentle lines, the curved handles and velvety surfaces in combination with cherry wood transmit a feeling of luxury and comfort. Whether you like sushi or pasta, this room is to everyone's taste.

Those who feel at home anywhere in the world can safely avoid adventurous experimental installations. The uncomplicated modernity of the *EFC* by Boffi is ideally suited to kitchen-lovers seeking practical solutions but not wishing to sacrifice beauty.

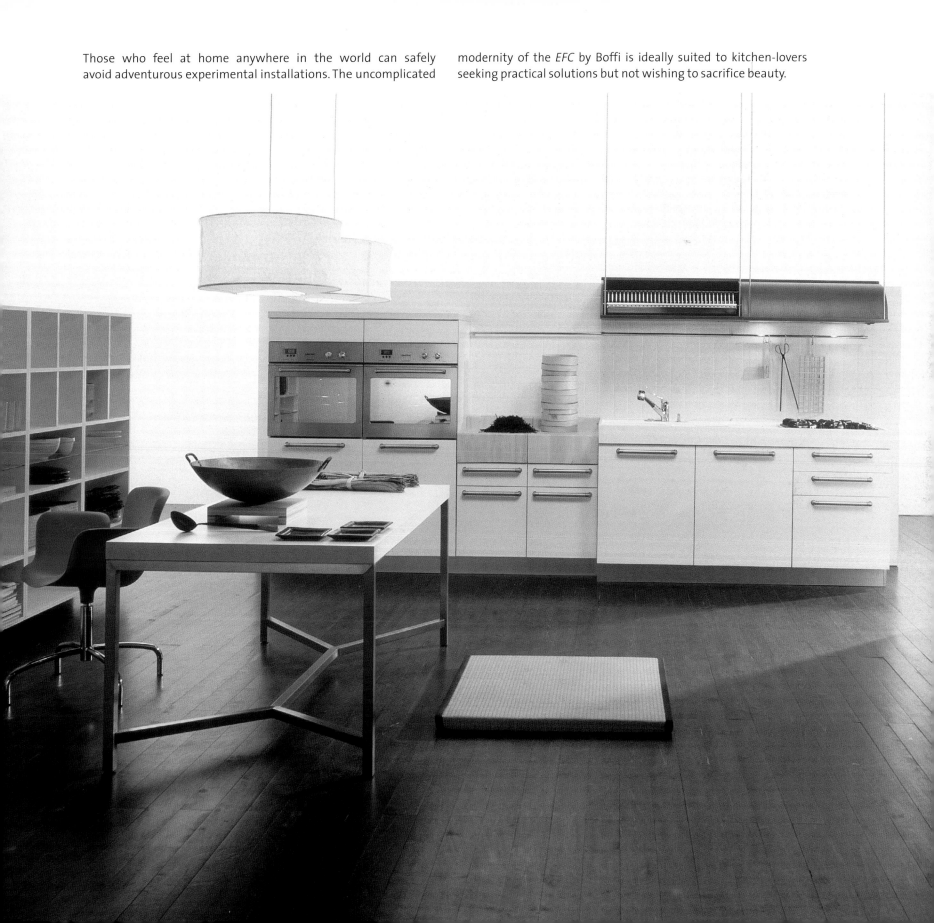

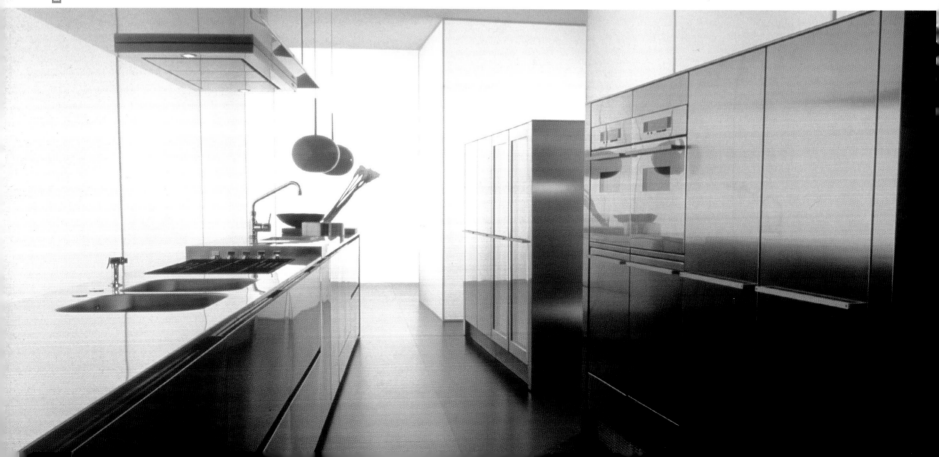

The formal language of *Case System 2.3* (right) and *Case System 5.0* by Boffi is based on pure minimalism. The art of visual concentration on the essential is brought to perfection here, and the actual sensual experience takes place between the worktop and the oven.

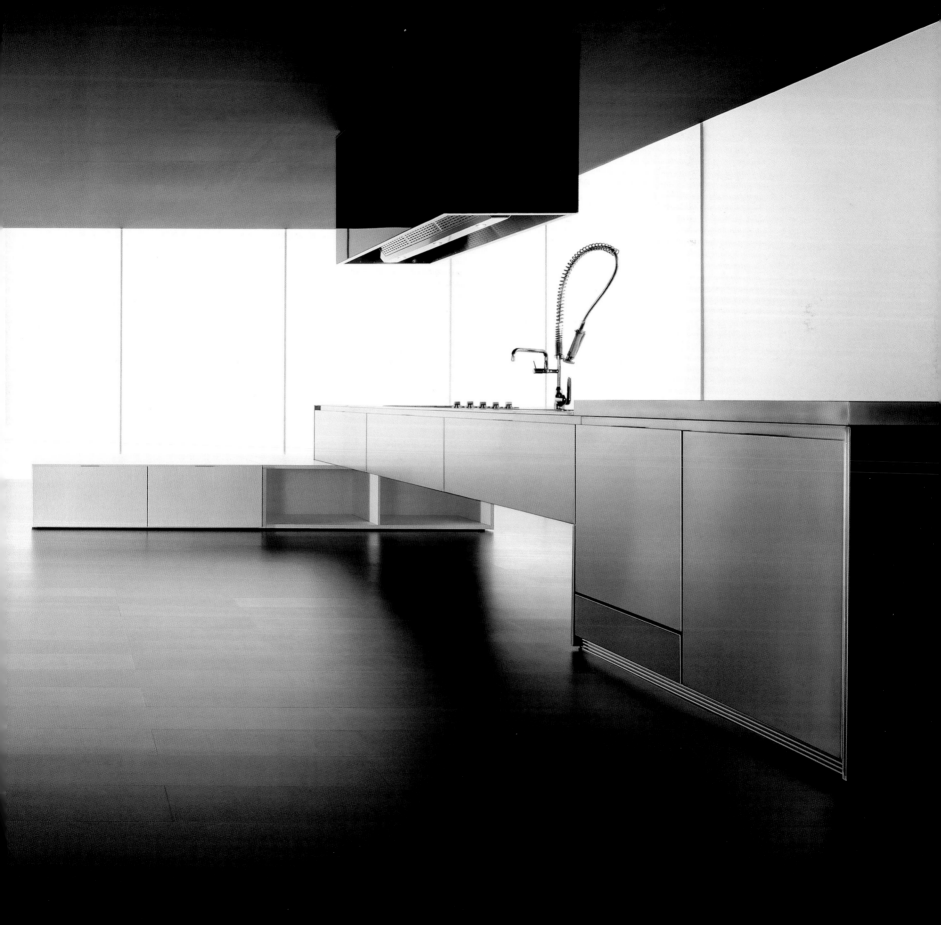

Who can tell today how they will arrange their kitchen tomorrow? In *Works* by Boffi, freestanding units and appliances, drawers, and storage units in the form of mobile containers are the answer to the flexibility demanded by today's global players.

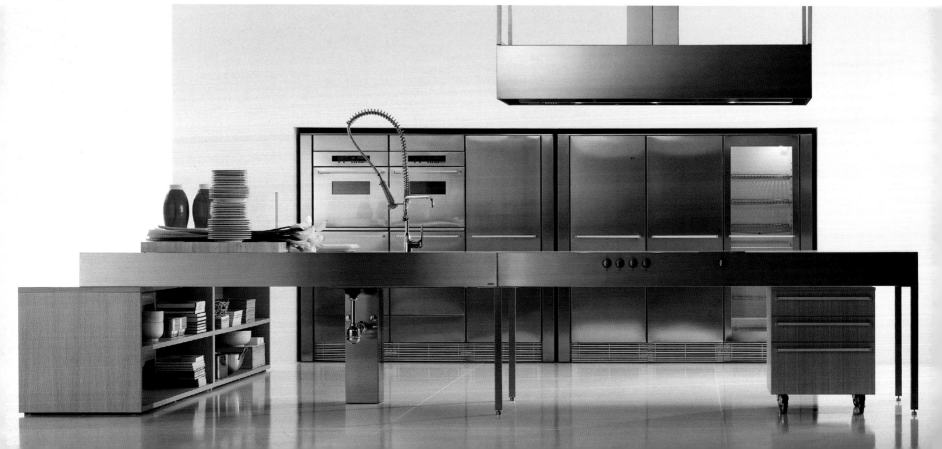

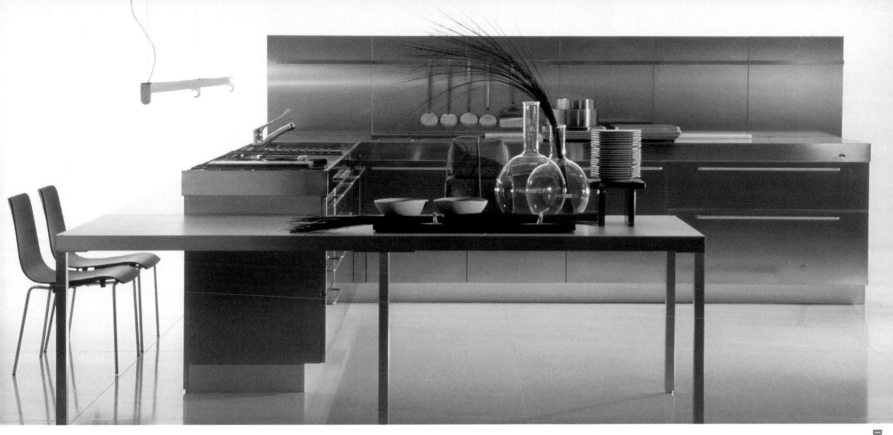

Timeless, plain and consistently functional: *Grand Chef* (above) and *Factory* (below) build the stage on which passionate professionals show off their cooking skills. All you need are the spectators to applaud the show by eating and drinking (Boffi).

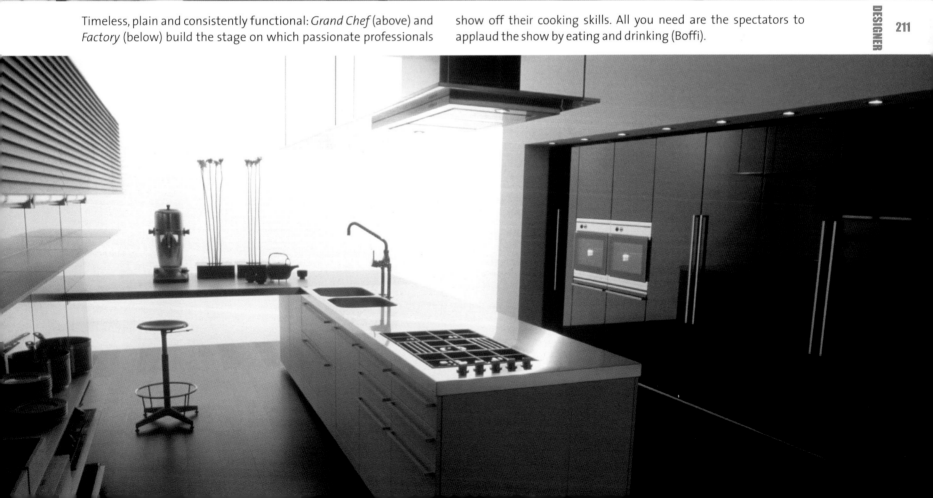

You have to look at it closely in order to understand its infectious elegance. Veneered in warm cherry wood, the SieMatic *SE 3003* is surrounded by a worktop that is made of real slate, and has decorative handles.

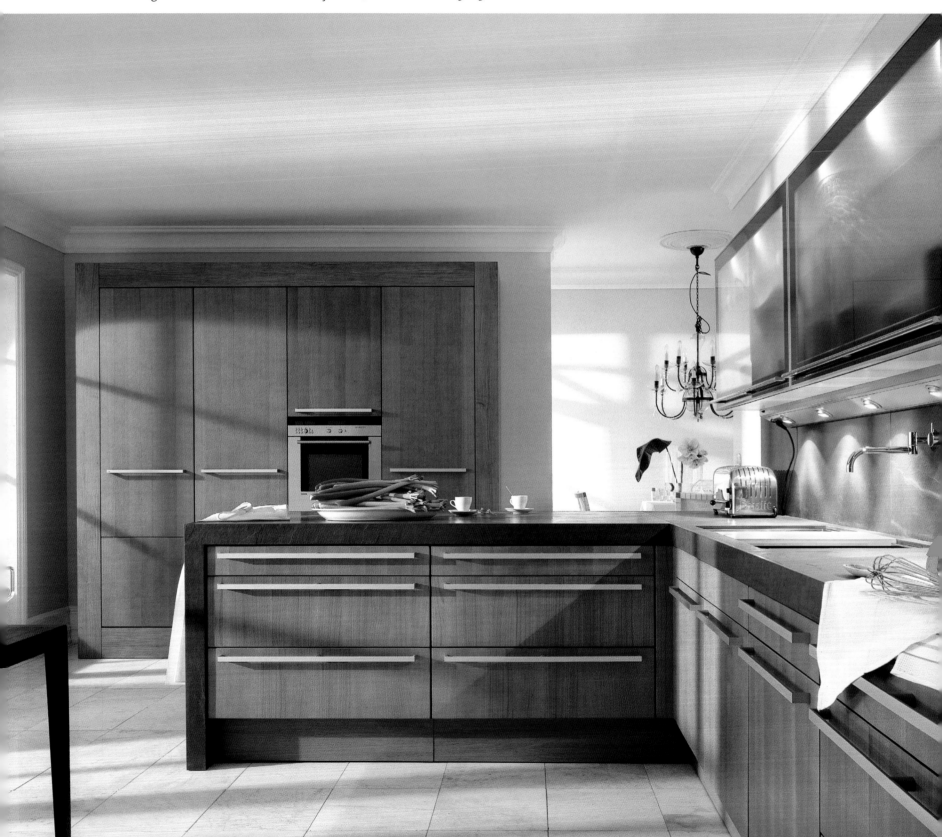

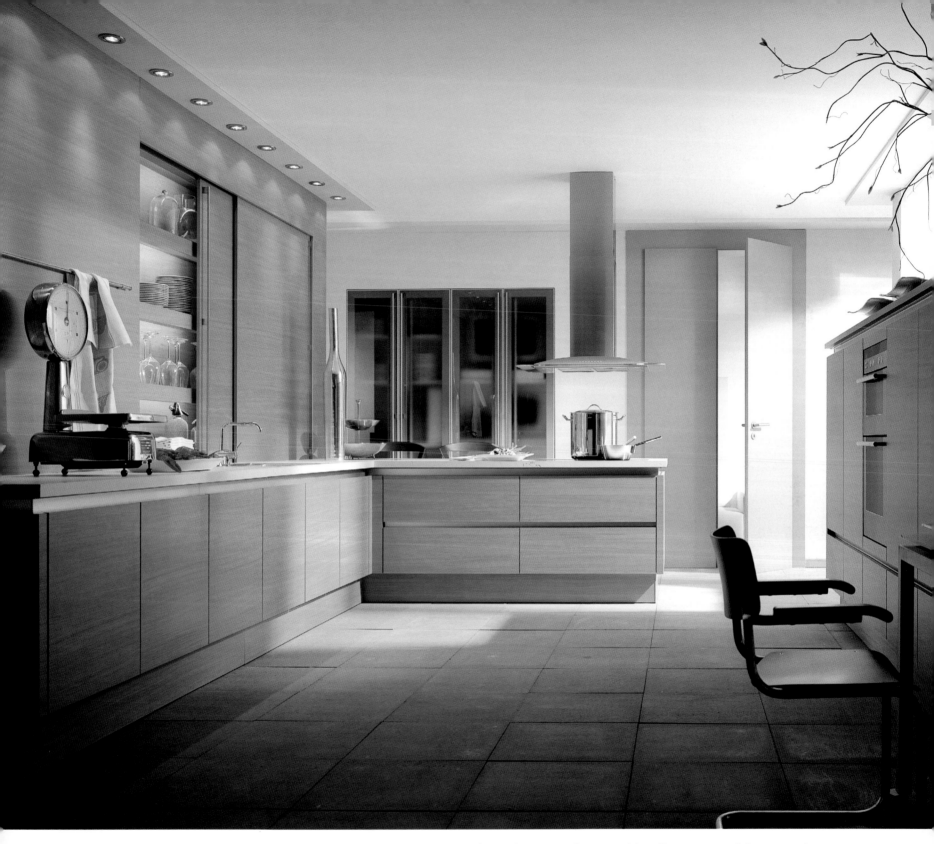

Kitchens from the SieMatic *SL* series offer a solution to many problems of space with smooth-running sliding doors above the worktop. The practical, recessed handles are one of the unusual features of the bottom cabinets.

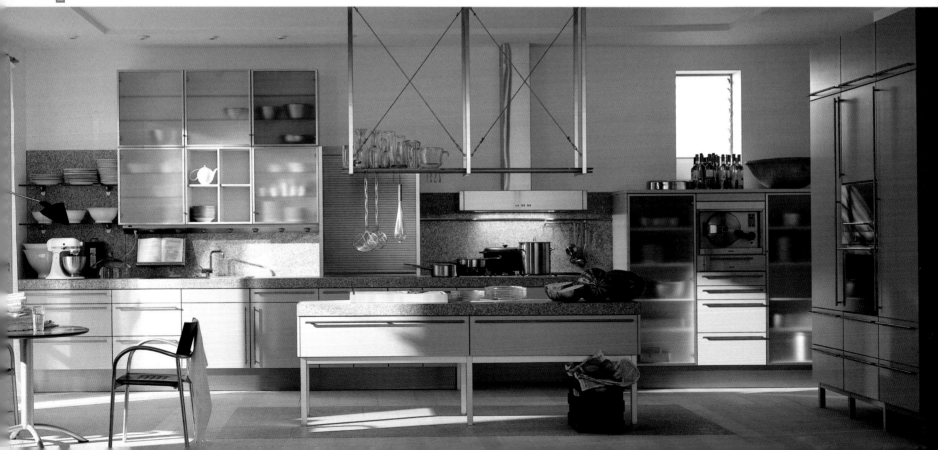

Would you like a couple of bars of piano accompaniment? If you want to cook really well, you need some powerful inspiration. In SieMatic kitchens it is easy to be infected by the professionalism of their design and execution.

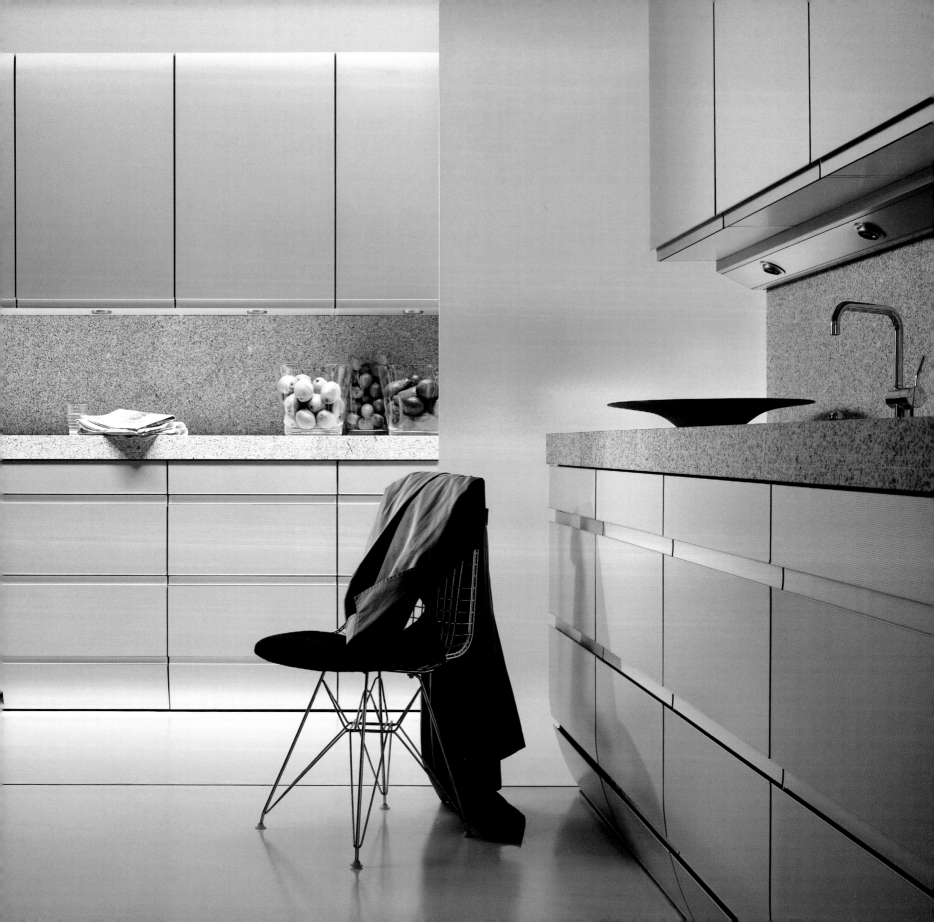

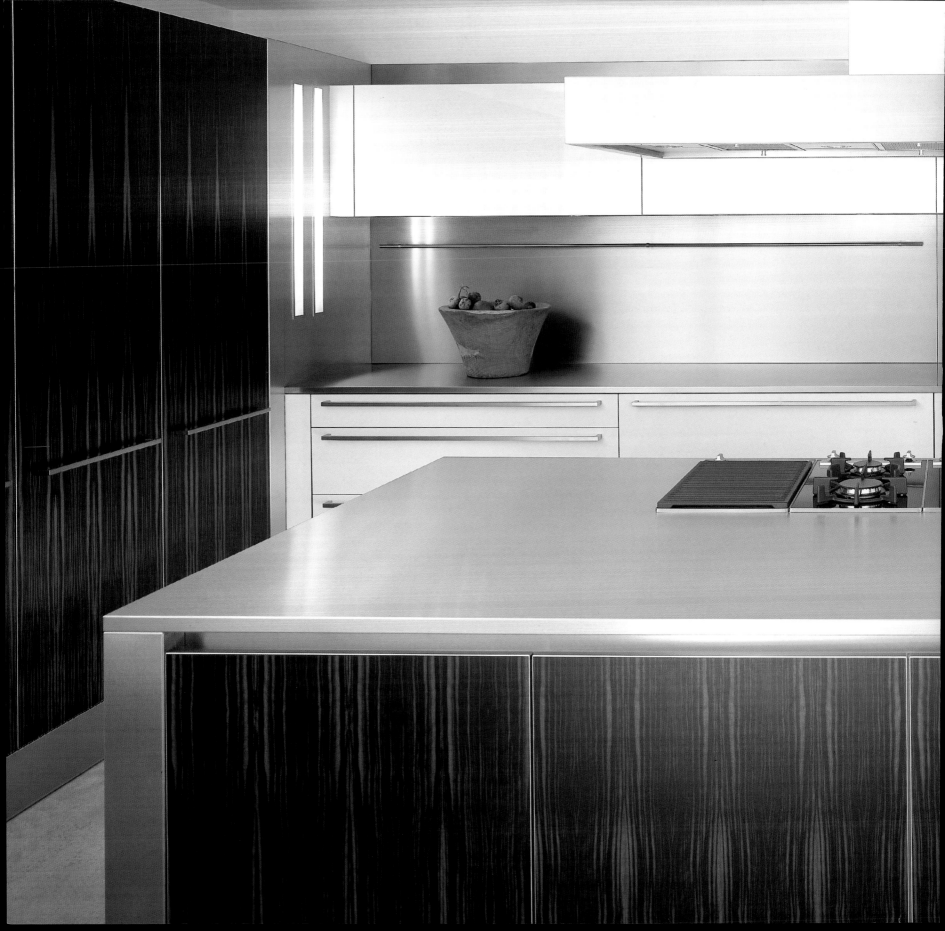

Simple elegance, quality materials, and polished solutions for details guarantee cultivated kitchen design (Eggersmann).

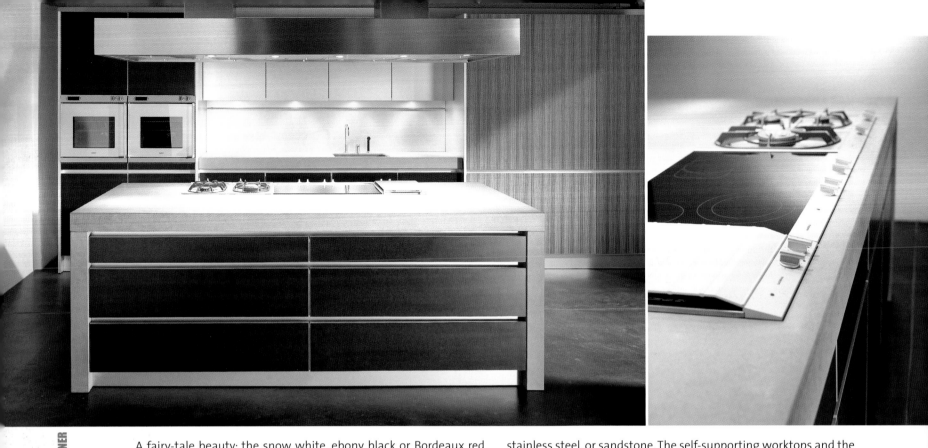

A fairy-tale beauty: the snow white, ebony black or Bordeaux red doors of Eggersmann kitchens are combined with aluminum, stainless steel, or sandstone. The self-supporting worktops and the stainless steel plinth system assure visual transparency (below).

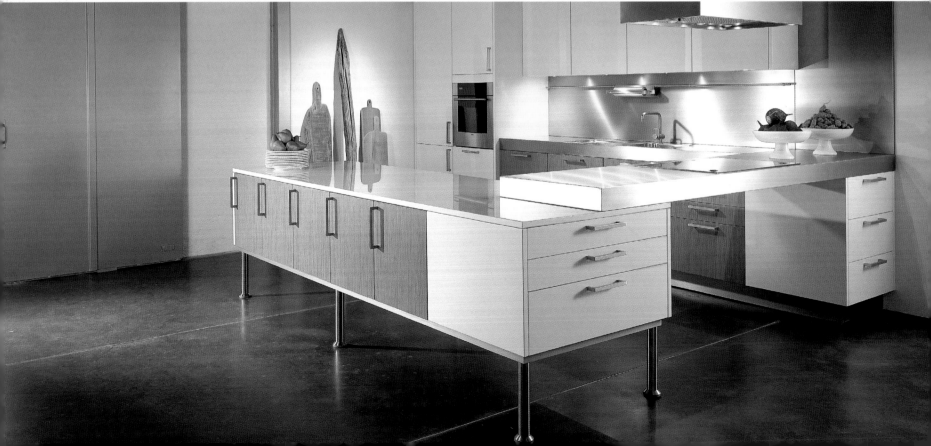

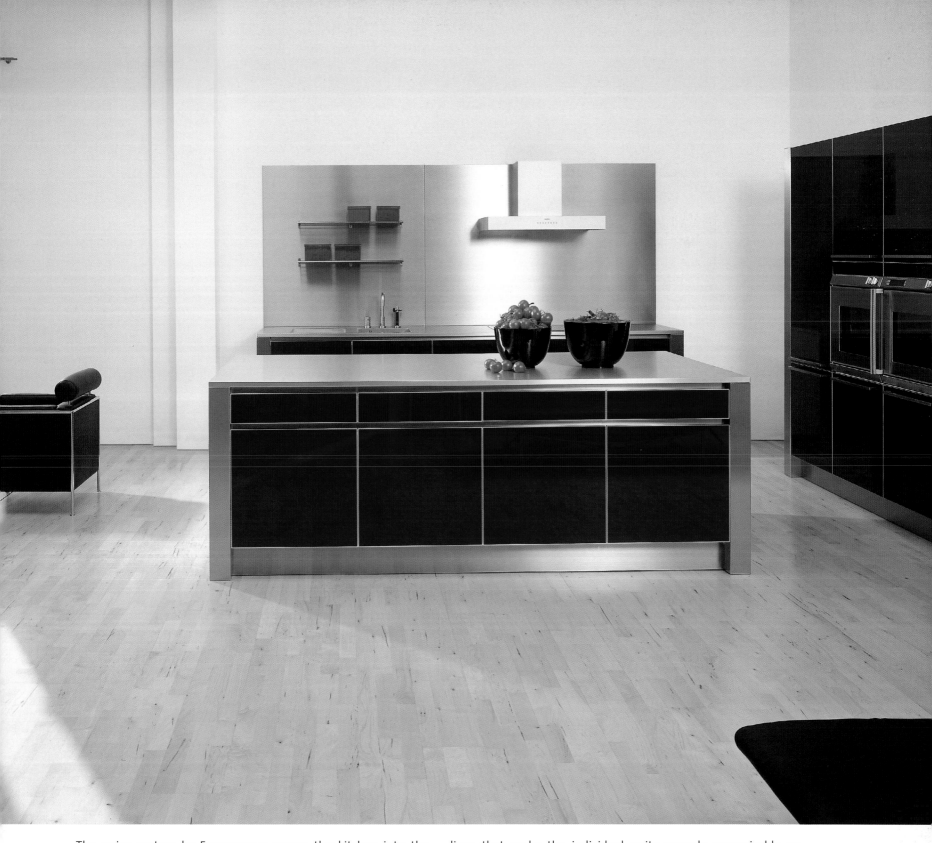

The *e:sign* system by Eggersmann moves the kitchen into the center of domestic architecture. Hidden behind the severe straight lines that make the individual units scarcely recognizable as kitchen equipment is an ingenious modular system.

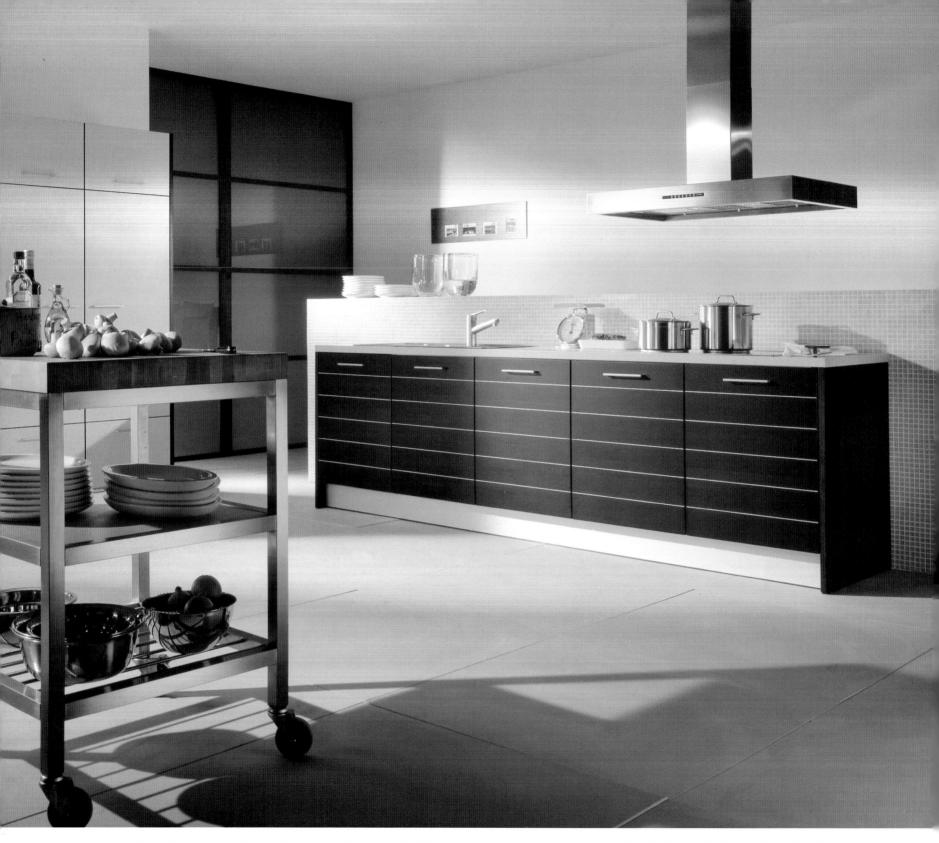

Every Eggersmann kitchen is unique. Nothing is left to chance: Swiss pearwood and oak veneer that is the color of wenge wood have aluminum strips inlaid flush with the surface. Gray fineline veneer contrasts with a massive granite worktop.

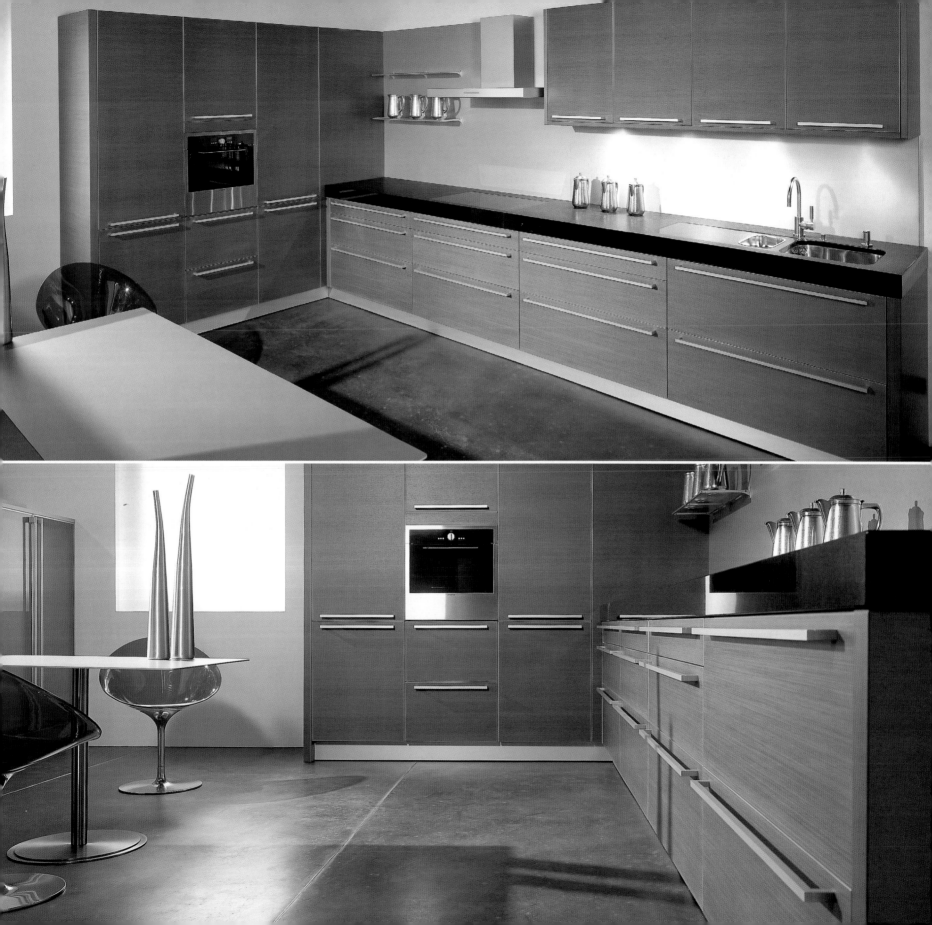

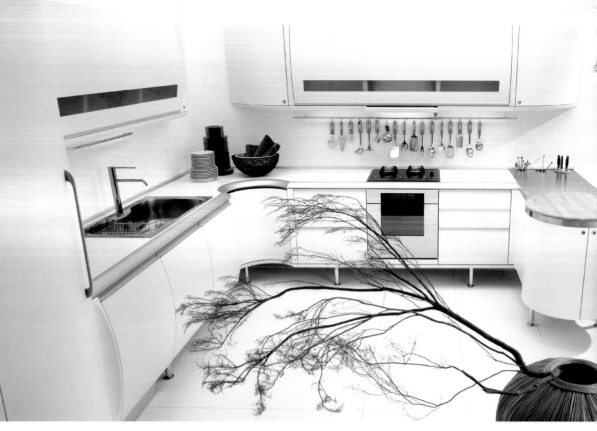

Make circles or semicircles the dominant geometric shapes, and every kitchen is immediately given a new face – including a deliberate element of surprise. The Italian manufacturer Giemmegi relies on quality craftsmanship and recollections of natural beauty.

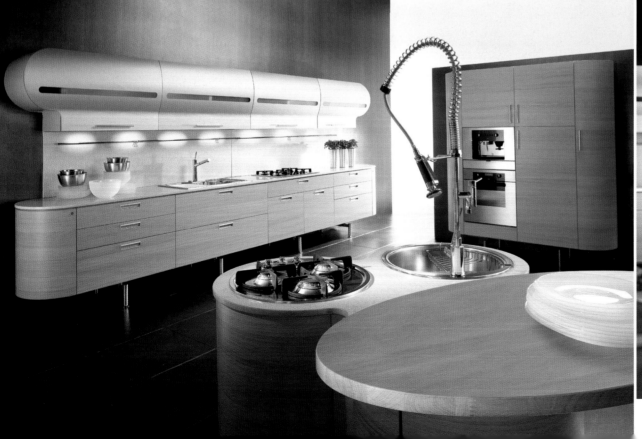

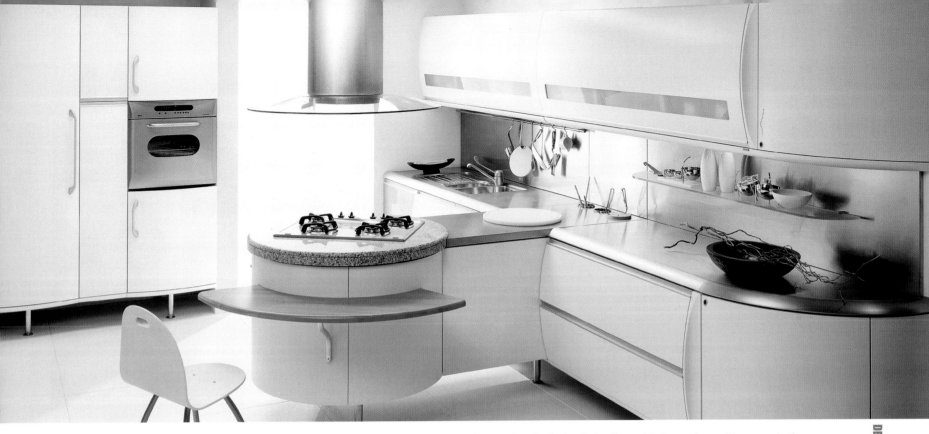

Round, soft, natural, with no sharp corners or edges. The light colors and wood tones underline the gentleness of *Air Florence* (above) and *Round Iride* (below). In these kitchens from Giemmegi, the owners can experience a feeling of perfect well-being.

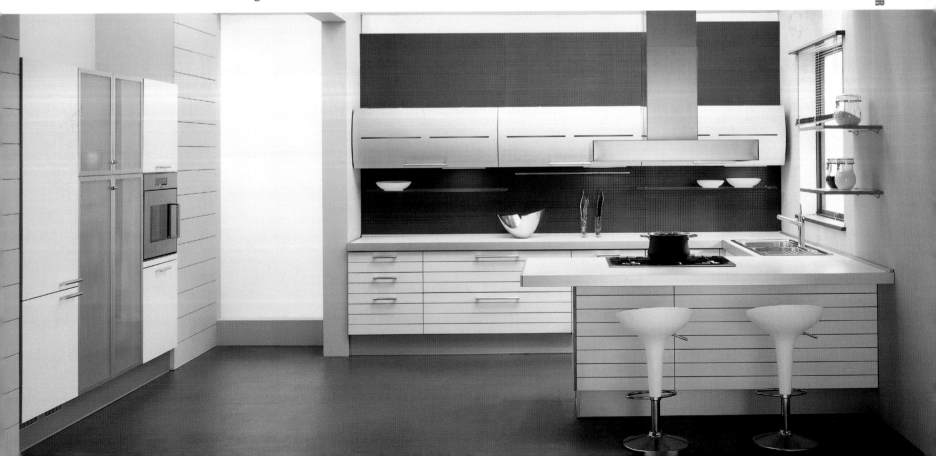

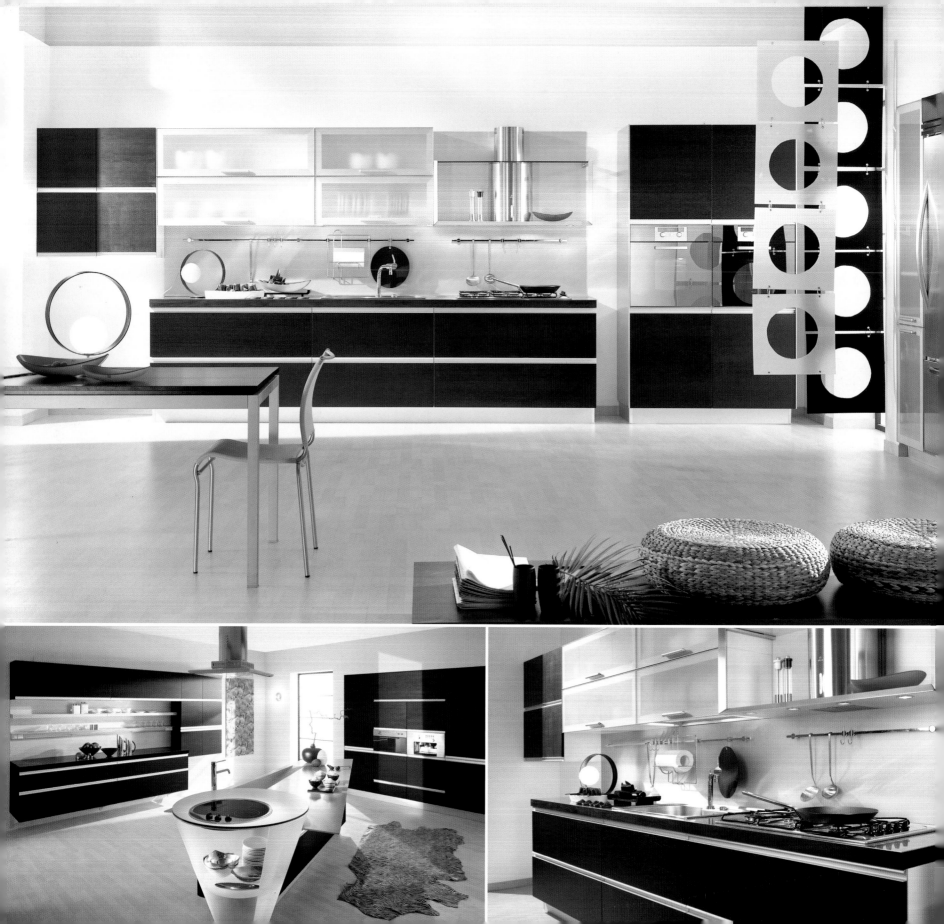

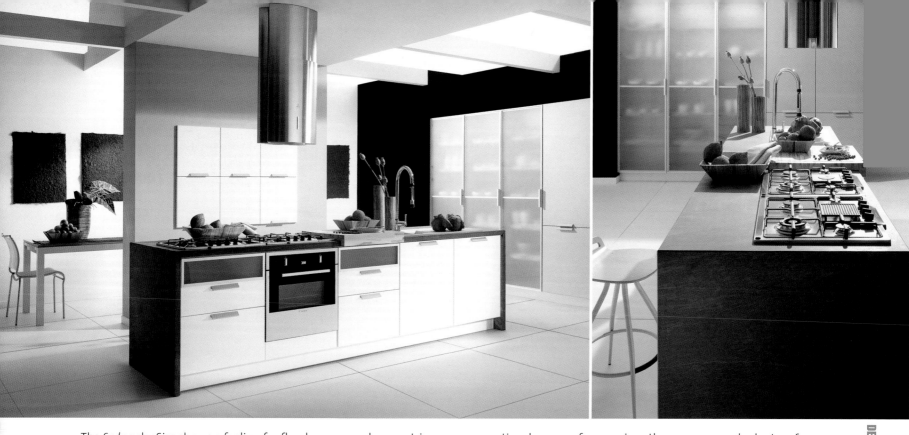

The *Sydney* by Sira shows a feeling for flamboyance and geometric shapes. The *Aurora* (above) and the *Leonardo* (below) also offer unconventional ways of arranging the room – and plenty of storage space in the rows of tall cabinets.

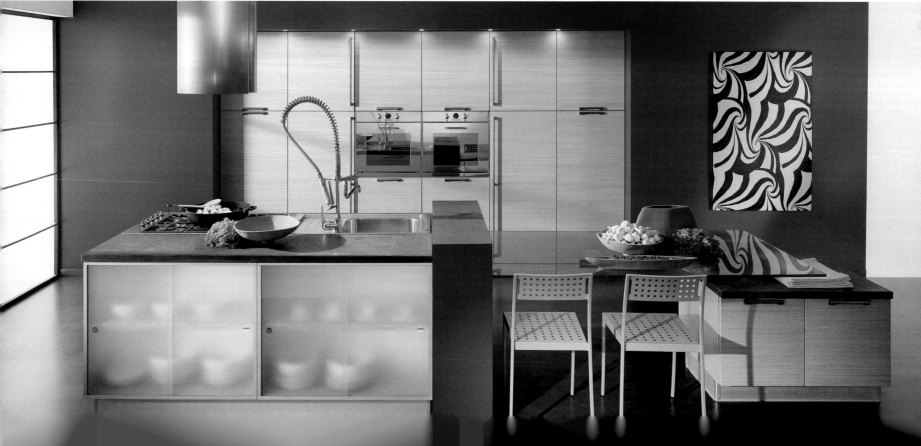

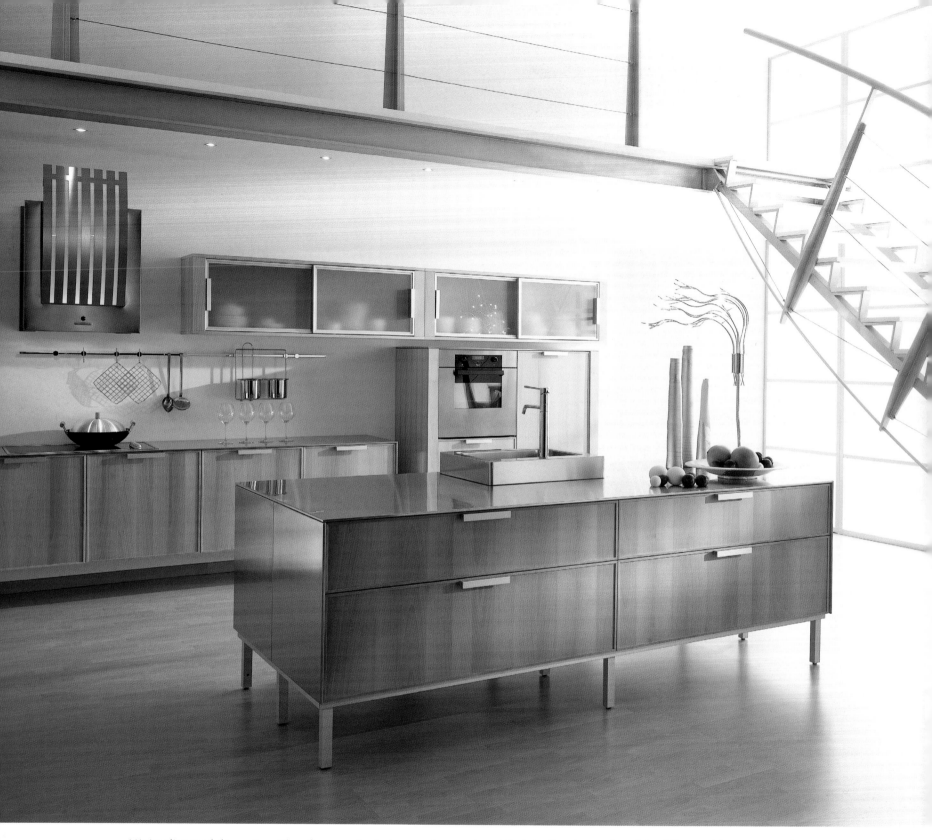

Minimalist modular units with soft geometry in harmonious and friendly colors, practical and elegant down to the smallest detail.

Nicole by Sira does not push itself forward, but once you have taken it to your heart, you will never let it go.

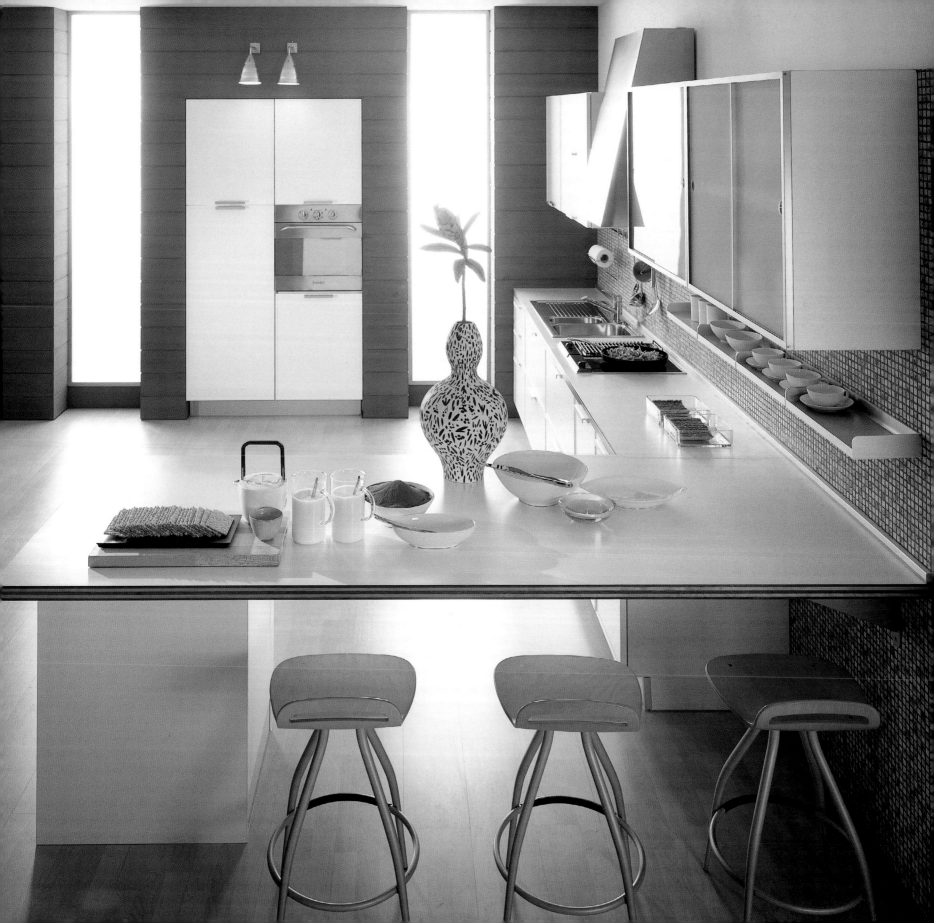

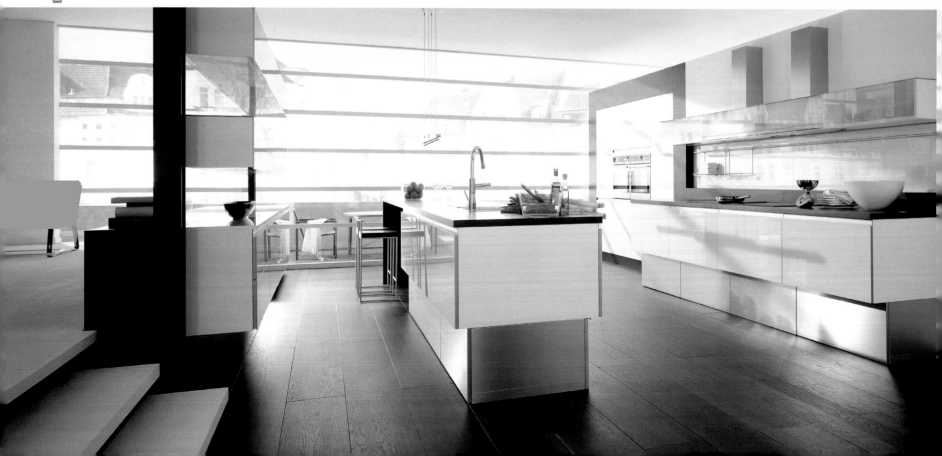

Neos by Rational (below and above right) is sheer beauty, with its uninterrupted straight lines, surfaces unspoiled by any handles, and the fascinating sheen of its lacquered glass doors that come in black or cream.

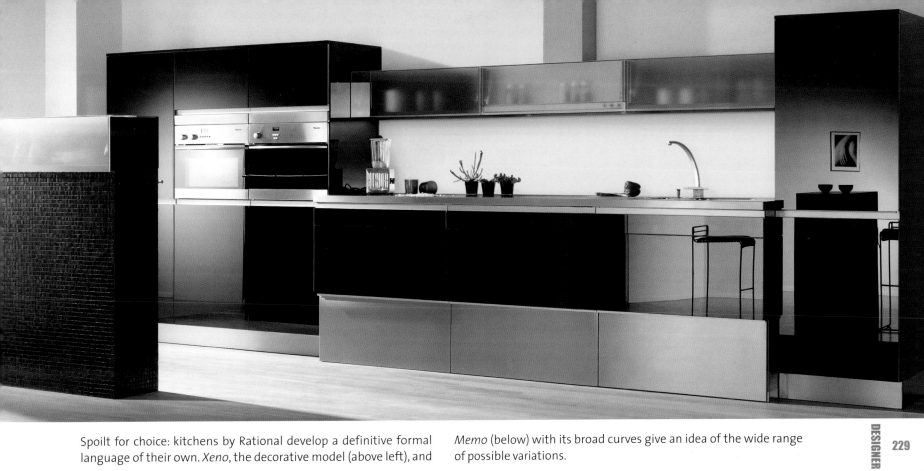

Spoilt for choice: kitchens by Rational develop a definitive formal language of their own. *Xeno*, the decorative model (above left), and *Memo* (below) with its broad curves give an idea of the wide range of possible variations.

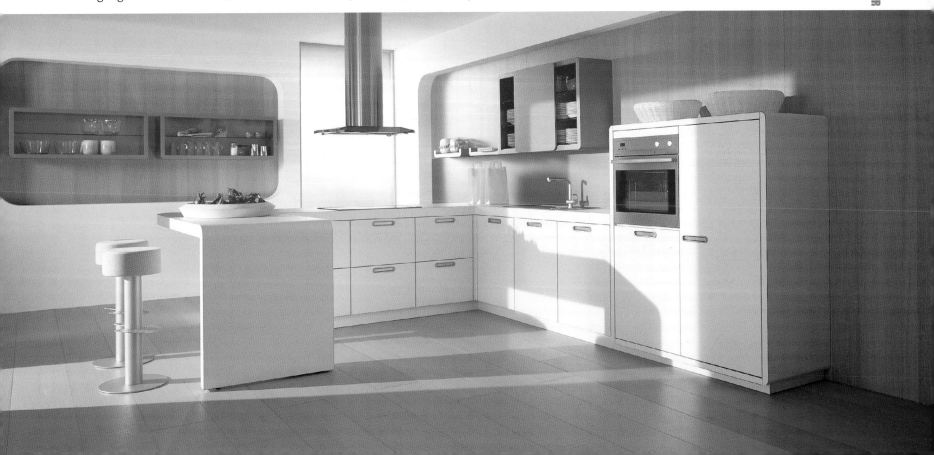

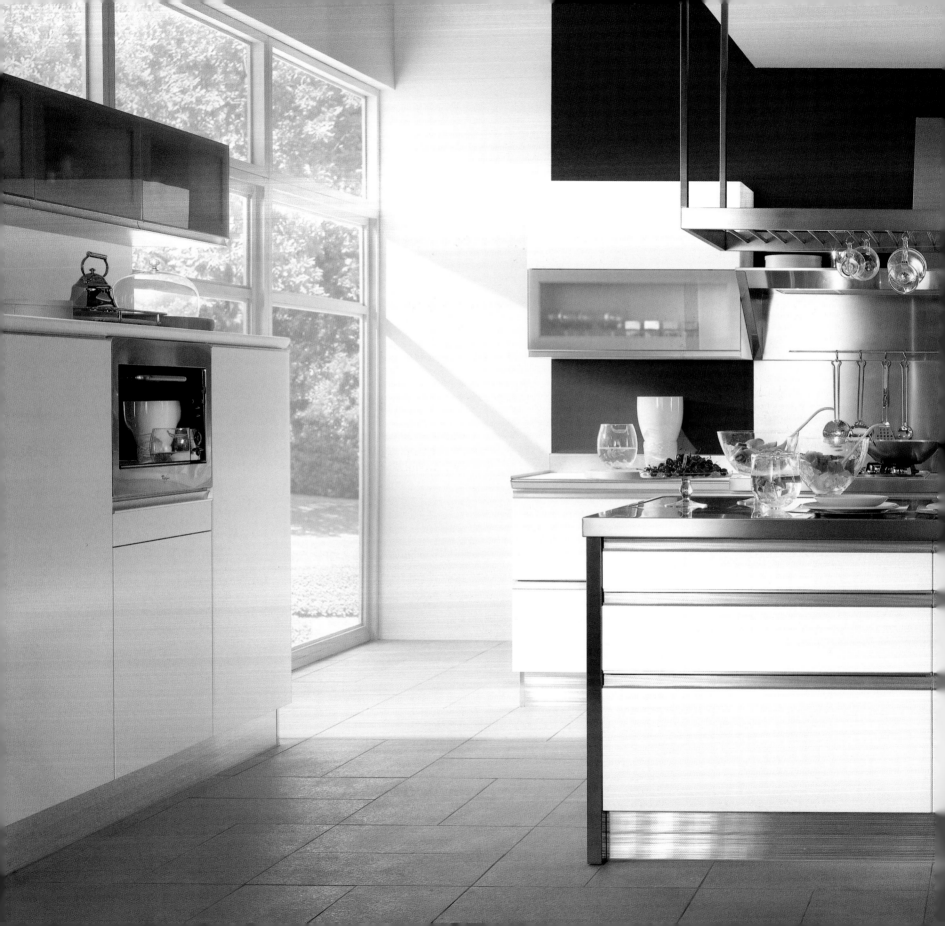

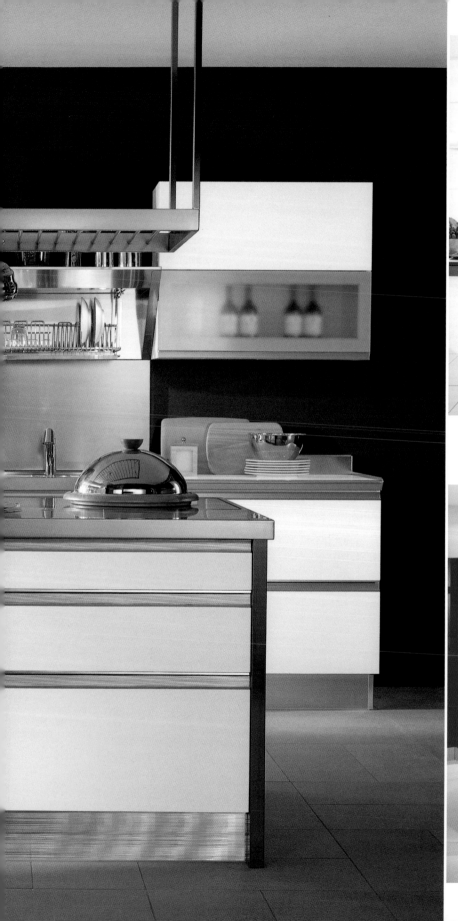

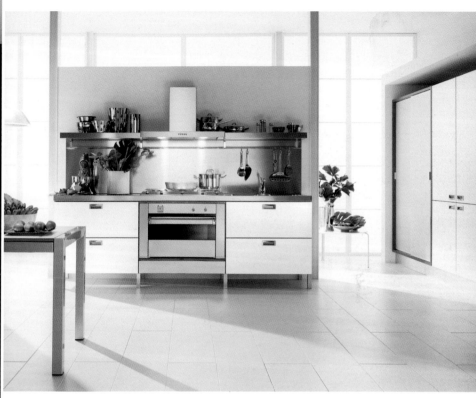

Because you can never have enough storage space, cabinets in all sizes and combinations play an important part in kitchens by Scavolini. Lines and colors are shown to the best advantage.

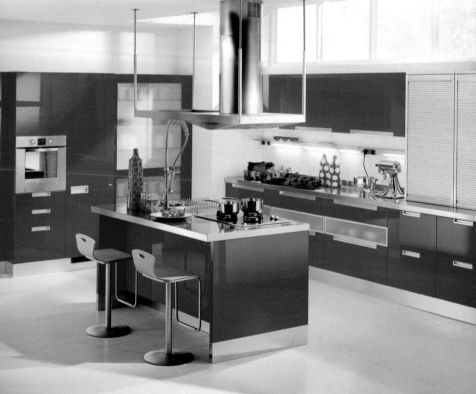

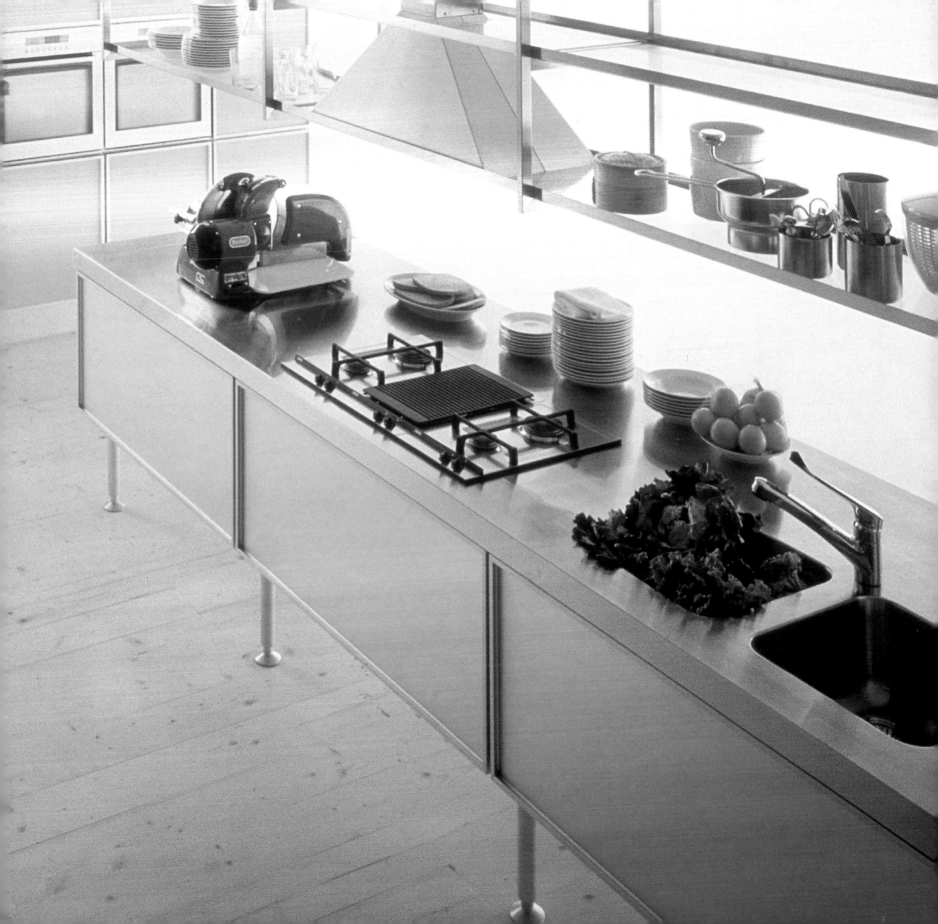

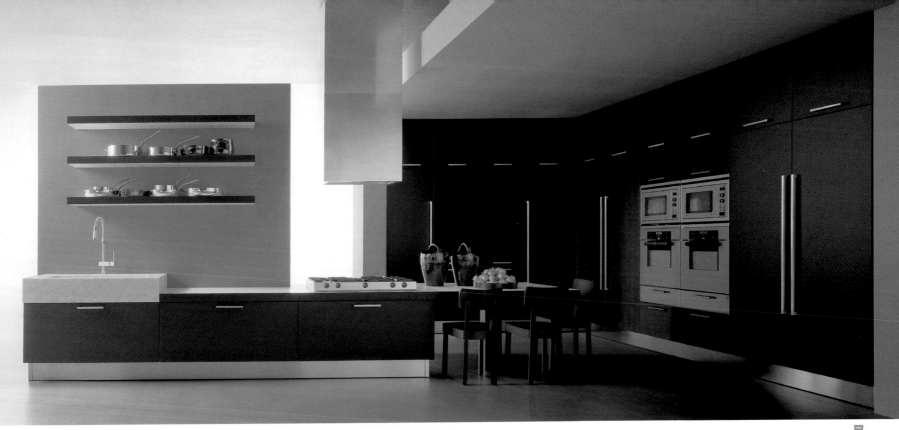

The elegance of rounded shapes, the play with effects of light and shade, and the calculated charm of marble, stone, and satinized glass are the ingredients of kitchens that make not just Italian hearts beat faster (*Quadra*, left, *Aqua*, above and *Luce*, below, by Effeti).

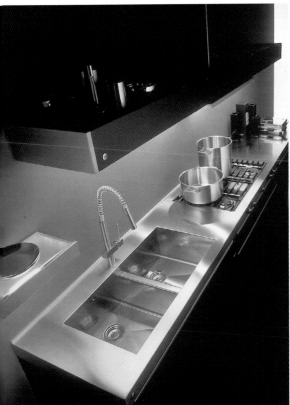

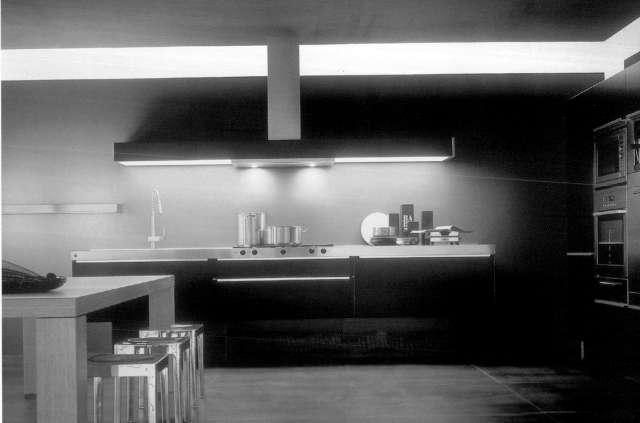

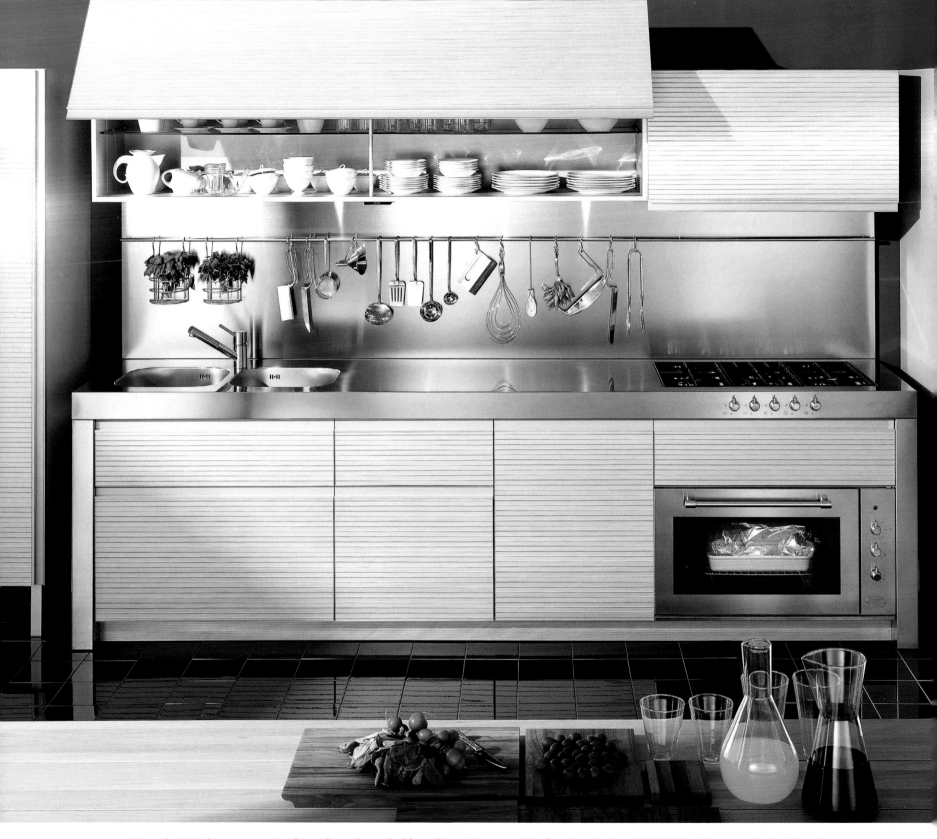

Kuoco by Driade was conceived as a large household appliance in accordance with structural simplification. A few variations allow you the freedom to place this kitchen in any context without spending a huge amount of time and effort on planning.

The heart of the *Kuoco* is the workbench which, if it can stand freely in the room, can be completed by a hanging structure. The cooking area is fully incorporated, and the double sink is sealed into the worktop.

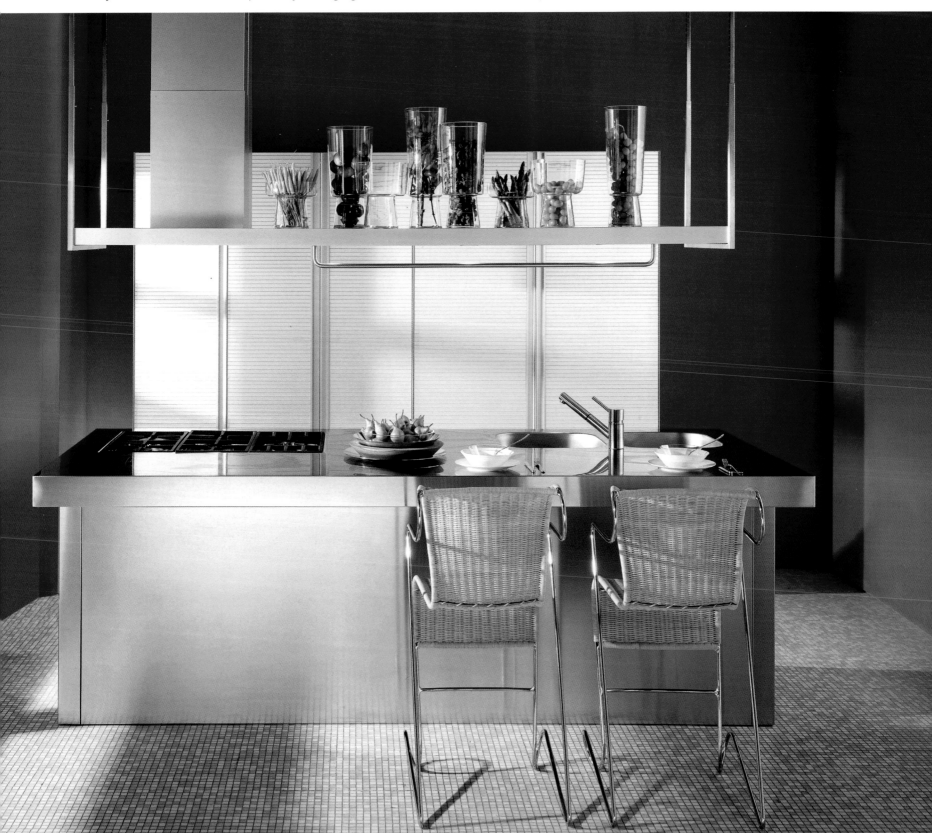

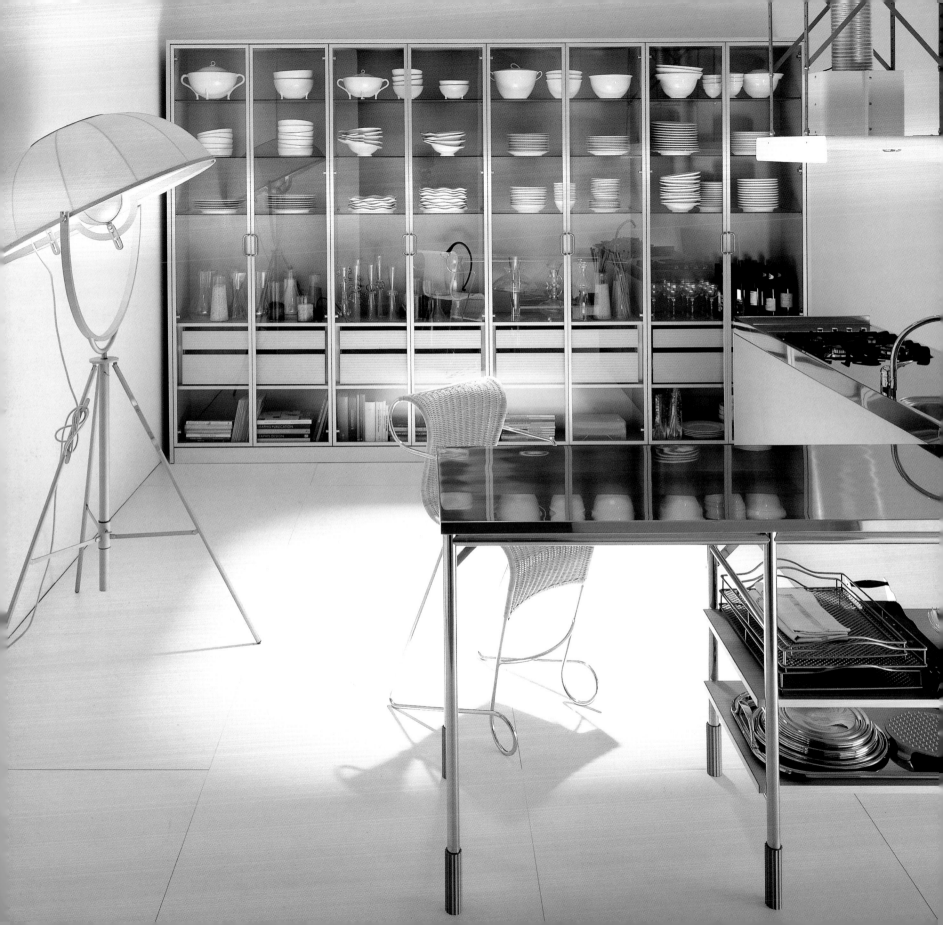

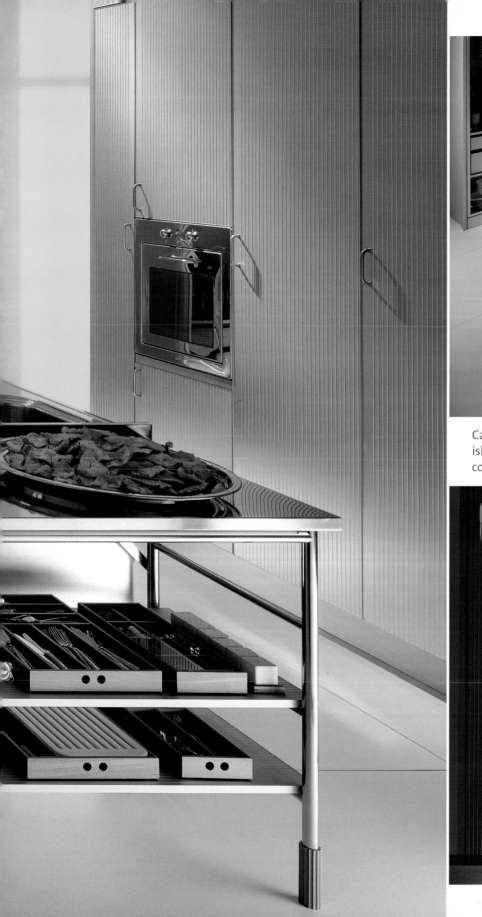

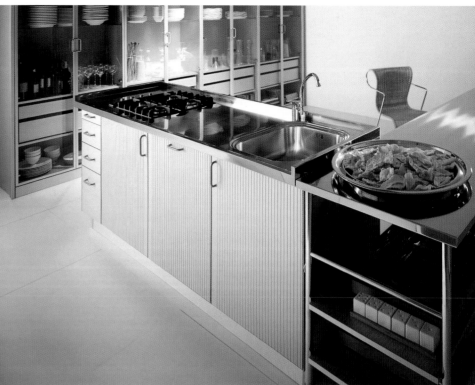

Cabinets that do not want to hide their inner life and a cooking island composed of two L-shaped blocks: *Angelica* is a remarkable companion for those who favor unconventional cooking (Driade).

MANUFACTURERS

The publisher and editor wish to thank the companies named below for their kind support, and for generously making their materials available to us. The list below gives the address and telephone number of the company headquarters. The websites offer an overview of current products, lists of dealers, and contact details.

AEG HAUSGERÄTE GMBH
Muggenhoferstraße 135
90429 Nuremberg
Germany
Tel. +49 (0) 911 323-0
www.aeg-hausgeraete.de

THE AGA FOODSERVICE GROUP
4 Arleston Way
Shirley
Solihull
West Midlands B90 4LH
UK
Tel. +44 (0) 121 711 6000

ALESSI S.p.A.
Via Privata Alessi, 6
28882 Crusinallo (Vb)
Italy
Tel. +39 0323 868611
www.alessi.com

ALLMILMÖ
Zeiler Möbelwerk GmbH & Co. KG
Obere Altach 1
97475 Zeil am Main
Germany
Tel. +49 (0) 9524 91-0
www.allmilmoe.de

ALNO AG
Heiligenberger Straße 47
88630 Pfullendorf
Germany
Tel. +49 (0) 7552 21-0
www.alno.de

ARCLINEA S.p.A.
Viale Pasubio, 50
36030 Caldogno (VI)
Italy
Tel. +39 0444 394 111
www.arclinea.it

BAU-FOR-MAT
Küchen GmbH & Co.KG
Kattwinkel 1
32584 Löhne
Germany
Tel. +49 (0) 5732 102-0
www.bauformat.de

BAUKNECHT HAUSGERÄTE GMBH
Gottlob-Bauknecht-Straße 1-11
73614 Stuttgart
Germany
Tel. +49 (0) 711 78860
www.bauknecht.de

BAX-KÜCHEN GMBH
Westerfeld Straße 5
32758 Detmold
Germany
Tel. +49 (0) 5231 6007-0
www.bax-kuechen.de

BOFFI S.p.A.
Via Oberdan 70
20030 Lentate sul Seveso (MI)
Italy
Tel. +39 03626 5341
www.boffi.com

ROBERT BOSCH HAUSGERÄTE GMBH
Carl-Wery-Straße 34
81739 Munich
Germany
Tel. +49 (0) 89 4590-00
www.bosch-hausgeraete.de

BRAUN GMBH
Frankfurter Straße 145
61476 Kronberg im Taunus
Germany
Tel. +49 (0) 6173 30-0
www.braun.com

BULTHAUP GMBH & CO. KG
84153 Aich
Germany
Tel. +49 (0) 8741 80-0
www.bulthaup.de

DADA S.p.A.
Strada provincial, 31
20010 Mesero (MI)
Italy
Tel. +39 02 9720791
www.dadaweb.it

DORNBRACHT GMBH & CO. KG
Köbbingser Mühle 6
58640 Iserlohn
Germany
Tel. +49 (0) 2371 433-0
www.dornbracht.de

DRIADE S.p.A.
via Padana Inferiore 12,
29012 Fossadello di Caorso (PC)
Italy
Tel. +39 052 3818618
www.driade.it

EFFETI S.p.A.
Via B. Cellini, 174
50028 Tavarnelle V.P. (Firenze)
Italy
Tel. +39 055 807091
www.effeti.com

EGGERSMANN KÜCHEN GMBH & CO. KG
Herforder Straße 196
32120 Hiddenhausen
Germany
Tel. +49 (0) 52 21 96 29-0
www.eggersmann.de

ELECTROLUX DEUTSCHLAND GMBH
Muggenhofer Straße 135
90429 Nuremberg
Germany
Tel. +49 (0) 911 323-0
www.electrolux.de

ELEKTRA BREGENZ AG
Pfarrgasse 77
1230 Vienna
Austria
Tel. +43 (0) 1 6153900
www.elektrabregenz.com

EWE KÜCHEN GESELLSCHAFT MBH
Dieselstraße 14
4600 Wels
Austria
Tel. +43 (0) 7242 237-0
www.ewe.at

FM KÜCHEN GESELLSCHAFT MBH
Galgenau 30
4240 Freistadt
Austria
Tel. +43 (0) 7942 701-0
www.fm-kuechen.at

GAGGENAU HAUSGERÄTE GMBH
Carl-Wery-Staße 34
81739 Munich
Germany
Tel. +49 (0) 89 4590-03
www.gaggenau.com

GAGGIA GMBH
Fritz-Reichle-Ring 6
78315 Radolfzell
Germany
Tel. +49 (0) 7732 939-1200
www.gaggia.de, www.gaggia.it

GEBA MÖBELWERKE GMBH
Scheidkamp 14
32584 Löhne
Germany
Tel. +49 (0) 5732 1011 0
www.geba-kuechen.de

GIEMMEGI srl
Via Morandi, 35
50050 Gambassi Terme (FI)
Italy
Tel. +39 0571 632121
www.giemmegi.it

HÄCKER KÜCHEN GMBH & CO. KG
Werkstraße 3
32289 Rödinghausen
Germany
Tel. +49 (0) 5746 940-0
www.haecker-kuechen.de

HUMMEL KÜCHENWERK GMBH
Schweriner Straße 14
22844 Norderstedt
Germany
Tel. +49 (0) 40 526090-0
www.hummel.de

IMPERIAL-WERKE OHG
Borries-/Installstraße 10-18
32257 Bünde
Germany
Tel. +49 (0) 5223 481-0
www.imperial.de

IMPULS KÜCHEN GMBH
Hinterm Gallenberg
59929 Brilon
Germany
Tel. +49 (0) 2961 778-0
www.impuls-kuechen.de

RUPS GROUPE SEB
DEUTSCHLAND GMBH
Herrnrainweg 5
3067 Offenbach am Main
Germany
Tel. +49 (0) 69 8504-0
www.krups.de

KÜPPERSBUSCH
HAUSGERÄTE AG
Küppersbuschstraße 16
5883 Gelsenkirchen
Germany
Tel. +49 (0) 209 401-0
www.kueppersbusch.de

EICHT KÜCHEN AG
Gmünder Straße 70
3550 Waldstetten
Germany
Tel. +49 (0) 7171 402-0
www.leicht.de

INEA QUATTRO S.p.A.
Via degli Artigiani, 9
0032 Castelplanio (AN)
Italy
Tel. +39 0731 813676
www.lineaquattro.com

MELITTA
Postfach 2780
2384 Minden/Westfalen
Germany
Tel. +49 (0) 571 4046-0
www.melitta.de

MIELE & CIE. GMBH & CO. KG
Carl-Miele-Straße 29
3332 Gütersloh
Germany
Tel. +49 (0) 5241-89-0
www.miele-kuechen.de

MK-KÜCHENMÖBELFABRIK
2566 Löhne
Germany
Tel. +49 (0) 5732 1086-0
www.mk-kuechen.de

NEFF GMBH
Carl-Wery-Straße 34
81739 Munich
Germany
Tel. +49 (0)89 4590-04
www.neff.de

NOLTE KÜCHEN GMBH & CO. KG
Windmühlenweg 153
32584 Löhne
Germany
Tel. +49 (0) 5732 899-0
www.nolte-kuechen.de

PHILIPS GMBH
Hammerbrookstraße 69
20097 Hamburg
Germany
Tel. +49 (0) 40 27323-574
www.philips.de

PINO KÜCHEN GMBH
Buroer Feld 1
06869 Klieken/Coswig
Germany
Tel. +49 (0) 34903 60-0
www.pino-kuechen.de

POGGENPOHL
MÖBELWERKE GMBH
Poggenpohlstraße 1
32051 Herford
Germany
Tel. +49 (0) 5221 381-0
www.poggenpohl.de

RATIONAL EINBAUKÜCHEN GMBH
Rationalstraße 4
49328 Melle
Germany
Tel. +49 (0) 5226 58-0
www.rational.de

RÖSLE GMBH & CO.KG
Postfach 1263
87610 Marktoberdorf
Germany
Tel. +49 (0) 8342 912-0
www.roesle.de

ROWENTA GROUPE SEB
DEUTSCHLAND GMBH
Herrnrainweg 5
63067 Offenbach am Main
Germany
Tel. +49 (0) 69 8504-0
www.rowenta.de

RWK EINBAUKÜCHEN
R. & W. Kuhlmann GmbH
Südstraße 16
32130 Enger
Germany
Tel. +49 (0) 5224 9730-0
www.rwk-kuechen.de

SAECO HANDELSGSELLSCHAFT MBH
Hermann-Laur-Straße 4
78253 Eigeltingen
Germany
Tel. +49 (0) 7774 505-100
www.saeco.de, www.saeco.it

SANITAS TROESCH AG
Bahnhöheweg 82
3018 Bern
Switzerland
www.sanitastroesch.ch

SCAVOLINI S.p.A.
Via Risara, 60/70-74/78
61025 Montelabbate (PU)
Italy
www.scavolini.com

SCHIFFINI MOBILE CUINE S.p.A.
Via Genova, 206
19020 Ceparana (La Spezia)
Italy
Tel. +39 0187 9501
www.schiffini.com

SIEMATIC MÖBELWERKE
GMBH & CO. KG
August-Siekmann-Straße 1-5
32584 Löhne
Germany
Tel. +49 (0) 5732 670
www.siematic.de

SIEMENS-ELECTROGERÄTE
GMBH
Carl-Wery-Straße 34
81739 Munich
Germany
Tel. +49 (0) 89 4590-09
www.siemens-hausgeraete.de

SIRA S.p.A.
Cucine componibili
Via Fontevannazza 9/a
62010 Treia (MC)
Italy
Tel. +39 0733 540111
www.siracucine.it

SNAIDERO R. S.p.A.
Viale Europa Unita, 9
33030 Majano (UD)
Italy
Tel. +39 0432 9521
www.snaidero.it

STRATO srl
Via Piemonte 9
23018 Talamona (SO)
Italy
Tel. +39 0342 610869
www.stratocucine.com

TECTA
Axel + Werner Bruchhäuser KG
37697 Lauenförde
Germany
Tel. +49 (0) 5273 37890
www.tecta.de

TUPPERWARE
DEUTSCHLAND GMBH
Praunheimer Landstraße 70
60488 Frankfurt am Main
Germany
Tel. +49 (0) 69 768020
www.tupper.de

VALCUCINE S.p.A.
Via Malignani, 5
33170 Pordenone
Italy

Tel. +39 0434 517911
www.valcucine.it

VARENNA CUCINE
Via Monte Santo 28
22044 Inverigo
Italy
www.varennapolifom.it

GUSTAV WELLMANN
GMBH & CO. KG
Bustedter Weg 16
32130 Enger
Germany
Tel. +49 (0) 5223 165-0
www.wellmann.de

WHIRLPOOL CORPORATION –
GENERAL OFFICE EUROPE
Viale G. Borghi 27
21025 Comerio (VA)
Italy
Tel. +39 0332 759111
www.whirlpoolcorp.com

WMF – WÜRTTEMBERGISCHE
METALLWARENFABRIK AG
Eberhardstraße
73309 Geislingen/Steige
Germany
Tel. +49 (0) 7331 25-1
www.wmf.de

ZANUSSI
AEG Hausgeräte GmbH
Muggenhofer Straße 135
90429 Nuremberg
Germany
Tel. +49 (0) 911 323-0
www.zanussi.de

ZEYKO MÖBELWERKE
GMBH & CO.KG
Am Fohrenwald 1
78087 Mönchweiler
Germany
Tel. +49 (0)7721-9420
www.zeyko.de

FURTHER READING

Aicher, Otl: *Die Küche zum Kochen. Das Ende einer Architekturdoktrin*. Munich, 1982

Andritzky, Michael (Ed.): *Oikos. Von der Feuerstelle bis zur Mikrowelle. Haushalt und Wohnen im Wandel.* Exhibition catalog. Giessen, 1992

Binger, Lothar and Susanne Hellemann: *Küchengeister. Streifzüge durch Berliner Küchen*. Berlin, 1996

Carugati, G.R. Decio: *Di cucina in cucina*. Milan, 1998

Conran, Terence: *Kitchens: the hub of the home.* Conran Octopus, 2002

Grey, Johnny: *The art of kitchen design*. Cassell illustrated, London 2002

Hoepfner, Wolfram (Ed.): *Geschichte des Wohnens, vol. 1: 5000 bc–500 ad*. Stuttgart, 1999

Jankowski, Wanda: *Modern kitchen design workbook.* Rockport Publishers Inc., 2001

Königer, Maribel: *Küchengerät des 20. Jahrhunderts. Kochen mit Stil und Styling*. Munich, 1994

Lee, Viny: *Küchen. Andere Zeiten / Neues Design.* Berlin, 1999

Mitchell, Beazley (publ.): *The new kitchen planner.* London, 1999

Noever, Peter (Ed.): *Die Frankfurter Küche von Margarete Schütte-Lihotzky: die Frankfurter Küche aus der Sammlung des MAK – Österreichisches Museum für angewandte Kunst, Vienna*. Berlin, 1992

Plante, Ellen M.: *Live-in kitchens (for your home).* Friedman/Fairfax Publishing, 2002

Plante, Ellen M.: *The American Kitchen. 1700 to Present: From Hearth to Highrise*. New York, 1995

Savill, Julie: *101 kitchens, stylish room solutions.* BBC Consumer Books, 2002

Stilwerk AG (Ed.): *Wie schön wohnt die Zukunft?* 1. Stilwerk Trendstudie. Hamburg, 2002

ILLUSTRATIONS

The publisher wishes to thank the museums, archives, and photographers for kindly granting permission to use their material and for their support in the production of this book. The editor and publisher have made every effort to trace the owners of the reproduction rights. In the rare event of our not having succeeded, please notify us.

All the photographs originate from the manufacturers named in the captions, with the exception of the following:

6/7 Gaggenau, Munich
12 above left: akg-images, Berlin/Photo: Erich Lessing
12 right: Bridgeman/Giraudon, London
13 left and center: Bayerische Saatsbibliothek, Munich
13 right: Bildarchiv Preussischer Kulturbesitz, Berlin
14 left: akg-images, Berlin
15 above right: Lothar Binger, Berlin
16–17 center: Elektra Bregenz, Vienna
17 above: Lothar Binger, Berlin
18 3rd and 4th from the left: Stuttgarter Gesellschaft für Denkmalpflege, Stuttgart

19 left: Stuttgarter Gesellschaft für Denkmalpflege, Stuttgart
20–21 Lothar Binger, Berlin
22 above, 2nd picture: Wirtschaftsgeschichtliches Museum "Villa Grün," Dillenbu
25 left: Deutsches Hygiene-Museum, Dresden
26 center: Bayerische Saatsbibliothek, Munich
26 right: akg-images, Berlin/Photo: Heiner Heine
26 2nd from left: Bildarchiv Preussischer Kulturbesitz, Berlin
32 1st and 2nd from left: Lothar Binger, Berlin